# Mark Rothko
# Subjects in Abstraction

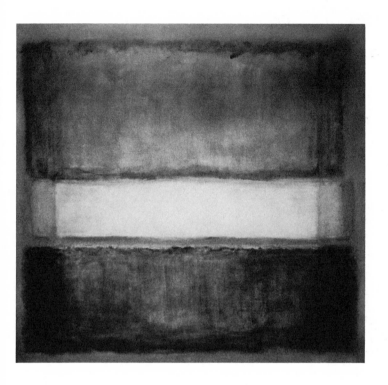

# Anna C. Chave

Yale University Press
New Haven and London

Designed by Ken Botnick
and set in Optima type at Brevis Press.
Printed in the United States of America by
Thomson-Shore, Inc.

Chave, Anna.
    Mark Rothko : subjects in abstraction / Anna C. Chave.
        p.    cm.—(Yale publications in the history of art ; 39)
    Based on the author's thesis (Ph. D.—Yale University, 1982).
    Bibliography: p.
    Includes index.
    ISBN 0–300–04178–0 (cloth)
    0–300–04961–7 (pbk.)
    1. Rothko, Mark, 1903–1970—Criticism and interpretation.
I. Title. II. Series.
ND237.R725C5  1989
759.13—dc19
                                                    88–16881
                                                    CIP

The paper in this book meets the guidelines for
permanence and durability of the Committee on
Production Guidelines for Book Longevity of the
Council on Library Resources.

10  9  8  7  6  5  4

# Contents

# Acknowledgments

This book is based on my doctoral dissertation, completed at Yale University in 1982, and I want first to express my deep appreciation to Robert L. Herbert, my thesis adviser there, for the benefit of his wisdom, his circumspection, and his skepticism. I am thankful also to Anne Coffin Hanson for her assistance during the writing of the dissertation. The present book is changed considerably from my doctoral dissertation, and I owe a large debt of thanks to Timothy J. Clark, my colleague at Harvard University, for his remarkable generosity in giving the manuscript an exceptionally considered and thorough reading at a difficult moment in its transformation. Some other of my colleagues at Harvard, Henri Zerner and Neil Levine, also offered criticisms for which I am grateful. (As a matter of course, however, I must add that I alone should be held to account for the foibles of the product at hand.)

My warmest thanks are also due to Dana Cranmer, formerly the conservator at the Mark Rothko Foundation, who was generous with her help in every way. And I will take this opportunity to express my deep gratitude to my parents, Priscilla and Grant C. Chave, for their unwavering support. Besides myself, finally, the person who has done most to see this project through has been my husband, Calvin Brown, and it is to him that I dedicate this book.

# 1

# Introduction

Mark Rothko was among the founders of the New York School, that extraordinary ensemble of artists who rose gradually to international preeminence in the decade following World War II. Rothko's contributions to that movement, the paintings for which he became well known, consist of a few broad rectangles superposed and centered on large, tall canvases. In their fundamental simplicity, their symmetry and flatness, Rothko's characteristic pictures have an austere, iconic presence. The planarity of the paintings and the stillness that follows from their symmetry are mediated, however, by the visible directness of the artist's brush and the nuanced painterly surfaces he coaxed with it. The effect of Rothko's images, as realized with his eloquent coloring, can be at once monumental and subtle, stunning and gradual. So elementary are his pictures that they can seem at once commanding and unassuming, as their magisterial presence is bound up in an unsettling and affecting way with their haunting suggestions of emptiness or absence.

The atmosphere adduced by Rothko's pictures, by this poignant conjunction of presence and absence, strikes a deep chord in many viewers, evoking emotions and associations that have often been described in mystical, spiritual, or religious terms. "Rothko: Art as Religious Faith" is how Hilton Kramer headlined a review in the *New York Times* of the major Rothko retrospective exhibition held at the Guggenheim Museum in 1978,[1] and a correspondent from the *London Financial Times* concurred that seeing the show "was like nothing so much as going to church."[2] The fact that he had accepted a commission to create a cycle of paintings for a chapel to be built in Houston, Texas, probably encouraged such responses, but "Rothko's art was always putting people in mind of chapels," as Lawrence Alloway observed;[3] and the use of religious and mystical terminology in relation to his work long predated that project, which was only completed at the end of his life. *Art Digest*'s staff reviewer referred to "the vaporous, mystical Mark Rothko" in 1950, for instance,[4] and John Canaday was writing in 1961 that "the weightiness of the color and the hugeness of the surrounding rectangles" in Rothko's pictures "suggest the ritual symbols of a harsh and primitive religion."[5]

A religious vocabulary may suggest itself in connection with Mark Rothko's achievement in more ways than one. By the time he died, a sui-

cide, in February 1970, Rothko had been canonized as a major figure of the vaunted New York School—enshrined, as it were, as an immortal high modernist. The pious terms used to laud not only Rothko but many of the artists of this school and the metaphysical dimension ascribed to their art have often been tellingly mixed with a physical and secular terminology, however: if these artists were saintly, then they were warrior saints. As the story of the New York School has been retold, Rothko and his peers have not only been celebrated for their glorious, unearthly visions but also lionized as the crusaders and shining victors in a decisive battle of the epic of modern art. The New York School artists have been portrayed as a mighty band of believers who put raw nerve, muscle, and guts to work in capturing for themselves and their country the elusive grail—the mantle of high modernism previously held only by such European masters as Picasso, Matisse, Kandinsky, Mondrian, and Miró.

The New York School artists surmounted formidable obstacles in achieving this feat, and this was their heroic "triumph"; while living and working in the United States, they managed to create art that commanded international interest, art that arrested and even to a degree reversed the migration of artists from the United States to Europe, art that secured for a city outside of Europe, for the first time ever, the status of modern art's center of authority. The triumphalism that has surrounded the New York School (I allude here particularly to the title of Irving Sandler's well-known book), generated mostly if not exclusively by American critics, has provoked a backlash from some European and, especially, French quarters where the eclipse of Paris as the center of the avant-garde is still keenly felt. Serge Guilbaut has charged most vehemently that the contest (as he and other critics persist in seeing it) was fixed through the hegemonial strategies or conspiracies of American governmental agencies and that "the idea of modern art" was "stolen" rather than rightfully won by the Americans.[6] To begin with, however, there is certainly more than one idea to modern art, and the ideas of modern art were never, like so many microchips or industrial secrets, the property of any one group or entity. Neither have the ideas of modern art ever been trophies earned through superior competition or performance by a team hailing from one nationality or place. If Paris was the most frequented home of the avant-garde before World War II, further, it was still one of many notable homes; the preeminent artists who worked there, such as Picasso, Mondrian, and Brancusi, were an international assemblage—as were the members of the New York School, encompassing, as it did, numerous immigrants and sons of immigrants. If the central staging ground for the avant-garde moved from one continent to another after the Second World War, then the cast of characters remained more or less an international one. And the richness of the history of avant-garde art in the twentieth century remained more credibly associated with that very internationalism than with a spirit of national contest—which hardly ever animated the work of the artists in question, in any case.

## Rothko and the New York School

The present text is not principally aimed at debunking the myths of the New York School or motivated by doubts about the real achievements of Rothko, Jackson Pollock, David Smith, Barnett Newman, and Willem de Kooning. But to approach these artists afresh it is necessary to prune some of the dense verbal foliage that has grown up around them. My objective is to clear a path to an alternate view of Rothko's achievement: a different view of the structure—the surface and deep structure—of his art. The surface structure of Rothko's art is unremittingly abstract, uncompromising in its refusal of narrative and mimesis; and that surface is by no means a feint. But throughout his career, Rothko was wracked by doubts about abstraction. For reasons that will become clearer in what follows, he consistently rejected the notion that his classic paintings were abstract, referring to them instead as "realistic," as having "real and specific meaning," and above all as possessed of significant "subjects."[7] Though Rothko continually insisted on the primacy of his "subject matter," he was calculatedly vague or elliptical about just what those subjects might be and how, or how much, he expected them to communicate. What I am exploring in this book is the crucial question: What, and how, do Rothko's classic paintings signify? I will not accept the artist's protestations that his work is not abstract—in the prevailing usage of the term, certainly it is—but I am concerned precisely with how abstract art may be coded, how it may communicate and resist communicating.

I propose that Rothko's pictures have subject matter insofar as they can be shown to implement traces of certain elemental and symbolically charged pictorial conventions. Rothko's hesitations about occupying that alien terrain or "enchanted ground" of abstraction (as Van Gogh once called it) led him to keep alluding to received pictorial codes, even as he set about effacing them. Critics who content themselves with applauding Rothko's evocative color and sensitive touch are missing an essential dimension of his art, then, or so I will argue. Conveyed by that atmospheric brushwork and color, as well as by the simple arrangements of form in these pictures, are some complex and difficult tidings. The Rothko who emerges in this book, in other words, is less the opulent decorator, the American cousin to Matisse, or the elated visionary than is commonly claimed and more of a conflicted figure. His intentions or ambitions for his art may not have been more vexed than those of his contemporaries, but he acted on them in some distinct and compelling ways.

The founding members of the New York School—William Baziotes, Willem de Kooning, Arshile Gorky, Adolph Gottlieb, Franz Kline, Robert Motherwell, Barnett Newman, Jackson Pollock, Mark Rothko, David Smith, and Clyfford Still, by my account—are often considered a unified group with a shared vision and purpose. The by-now familiar romance of the New York School (or the Abstract Expressionists, as they are also known) evokes the image of an American equivalent to the cafe society of the School of Paris: a compatible, even close-knit community of artists

who enjoyed each other's company not only in frequent studio visits but also in Greenwich Village's neighborhood Cedar Bar and the famous gathering place of these artists, the Club. What the New York School more nearly constituted, however, from the time it began to coalesce in the 1940s was the loose and mutually leery association of often-crusty individualists—artists who hailed from disparate places, professed diverse ideas, and gave shape to remarkably dissimilar visions.

Some comparative biographic information may help to locate Rothko within the group. The birth dates of the New York School artists span a dozen years, with Rothko and Gottlieb (both born in 1903) being the group's oldest members, and Motherwell (born in 1915), Baziotes (born in 1912), and Pollock (the group's most precocious member; born in 1912) as the youngsters. The artists' birthplaces range the globe, from the settlement of the Pale in Russian-occupied Latvia (Rothko, who emigrated from Dvinsk to Portland, Oregon, in 1913), to war-torn Armenia (Gorky, who came to the United States in 1920), and the Netherlands (de Kooning, who emigrated in 1926), to the western United States (Pollock, Still, and Motherwell), the Midwest (Smith), and New York City itself (Gottlieb and Newman, like Rothko, the sons of Jewish immigrants). Some artists of the group had extensive formal training (notably de Kooning and Kline), whereas many others spent a few years at most in the relatively informal programs at the Art Students League in New York City (Pollock, Newman, Smith, Gottlieb, and Rothko, who regarded himself as essentially self-taught). Although a few of these artists had college degrees and even some postgraduate education (Motherwell, Newman, and Still), others had a briefer exposure to college (Gottlieb, Smith, and Rothko—a dropout from Yale) or lacked even a high school degree (Baziotes and Pollock). Their commitments to their profession were made over a twenty year period: Rothko got his start in the mid-1920s; Motherwell decided on his vocation as a painter rather than a scholar in 1941.

Although an extended trip to Europe, especially to Paris, was historically regarded as indispensable for an American artist determined to attain more than a strictly local reputation, Pollock had the nerve to declare in 1944, "I don't see why the problems of modern painting can't be solved as well here as elsewhere."[8] Like Pollock, many members of the New York School (Baziotes, Newman, Still, and Rothko) did not go to Europe until after they had fully matured as artists, if at all (Rothko made his first trip to Europe in 1950, the year after he arrived at his characteristic format). These artists became acquainted with modern European art from the examples in American museums and galleries, from the reproductions in increasingly available foreign art periodicals and little magazines, and from an earlier generation of such American artists as Thomas Hart Benton and Max Weber, who served as their teachers. Some of the New York School artists were exposed to European art in Europe, however: besides de Kooning, who was born and trained in the Netherlands, David Smith made an extended tour of Europe at a formative phase of his career, Gott-

lieb and Motherwell spent time abroad, and Kline studied in England.

New York City, with the specially intense urban experience it offers, is generally regarded as the New York School artists' common ground; and insofar as they had one, the city was it. But what is rarely remarked is that many of these artists shunned urban life in general, and New York in particular, outside of the occasional visit. After 1941 David Smith worked in near isolation in upstate New York; from 1945 Jackson Pollock worked in a barn on rural Long Island; Clyfford Still, who painted in California and then in rural Maryland, spent little continuous time in the city; and Arshile Gorky moved to Connecticut in 1945. De Kooning and Motherwell moved from the city later on, leaving Rothko and Newman among the few resolute urban dwellers—ironically, given that Rothko is usually presented as having the most pastoral vision of all the artists in the group. Apart from several brief stints as a visiting professor of art (in San Francisco in the late 1940s, Boulder and New Orleans in the 1950s), Rothko spent no longer than summers outside of the "paradise" he deemed Manhattan island.

The usual image of the New York School as an integral urban community is, in short, distorted. There were some meeting places: the Cedar Bar, which attracted Kline, de Kooning, and Pollock (on his visits to the city); the Club, which attracted only a few of the founding New York School artists on a regular basis; and the parties that marked exhibition openings. There were also some friendships—individual alliances that formed, dissolved, and re-formed over the years. Early in his career, Rothko felt closest to Gottlieb, Newman, and Still, and later (after sharp breaks with Still and Newman), to Motherwell. However frequently he encountered them, Rothko remained aloof from Pollock (whom he resented), Smith, Gorky, Kline, and de Kooning (with whom he maintained cordial but fairly distant relations). When they were first coming to public attention, a mutual consciousness of being misunderstood outsiders with ambitions in common forged makeshift bonds among the New York School artists, and they occasionally elected, or at least agreed, to exhibit together. So intense were the personal politics among the group, however, that they were often more than willing to defenestrate their own. Rothko and Newman were favored targets for such treatment because their work and their artistic personae deviated from the virile, violent "action painters" image that became associated with the group as a whole.[9] As the press and curators became more attentive and the stakes began to look unimaginably high, disparities in reputation exacerbated underlying jealousies, and the artists avoided showing together, sometimes going to extraordinary lengths to prevent their work from being seen in the same vicinity.

In art historical terms, a *school* suggests a group of artists from the same general time and place with congruent or substantially overlapping visions. That the New York School artists had dissimilar visions is plain from even a glancing knowledge of their work. Many critics have tried to

diminish the heterogeneity of the group by proposing that, if there is not a homogeneous New York School idiom or style, there are two New York School styles: the "action painting" or bold gestural idiom exemplified by the art of Pollock, de Kooning, and Kline, and the supposedly meditative "color-field painting" exemplified by the work of Rothko and Newman.[10] Whatever taxonomic functions these categories serve, however, they fail to contain that art which evidences both obvious gestures and extended areas of color, such as Still's and Motherwell's; and they deflect attention from the subtle use of gesture that is important to both Rothko's and Newman's work. What the labeling of Rothko and Newman as "color-field painters" does facilitate is the designation of art historical precursors for a subsequent generation of "color-field artists," such as Kenneth Noland, Jules Olitski, and Ellsworth Kelly. No doubt these artists were indebted to Rothko and Newman, but they "misread" their elders' art (to borrow a term from Harold Bloom)—necessarily so, as they had substantially different aims of their own.

## New York and Paris Schools: Directness versus Finish

However diverse the New York School artists appear on close inspection and however little they agreed on, some reasons for considering them as a group remain. In the first place, they shared a heritage from the so-called modern masters of Europe, along with a resolve not to merely imitate or follow those artists. Further, almost all of the New York School artists were indebted to surrealism, although they differed otherwise in their art historical debts or points of reference—from Pollock and de Kooning, who wrestled directly with the examples set by Picasso and cubism, to Rothko and Newman, who more or less worked their way around cubism via Matisse and the late impressionism of Monet. Another thing these artists shared was a sense of what they were *not* doing: they were not making abstract designs or bloodless decorations but art pumped full of the pungent, sometimes caustic juices of real feeling, art weighty with content. The New York School artists did not set out to make art that would be tasteful or seductive to wealthy collectors (who had historically proved highly immune to the appeal of American art, in any case). On the contrary, they were generally determined to make their work so raw as to be almost undigestible: Pollock rudely flung black house paint at bolts of canvas unrolled on a barn floor; and Rothko made pictures so uncooked, as it were, that they were often perceived as the barest beginnings of paintings or as "first-class walls against which to hang other pictures," as one critic acerbically put it.[11]

Cultivated taste caught up with the New York School artists, as it had with the impressionists and subsequent outlaws from artistic convention. By the mid-1950s some wealthy collectors had recognized how stunning these bold, vivid, outsized paintings looked in domestic or office interiors; and in spite of itself—to the mixed emotions of the artists—the art acquired a veneer, at least, of tastefulness and respectability.

One sign of this shift was an article in *Fortune* magazine in December 1955 that urged investors to consider living American artists—de Kooning, Rothko, and Pollock, in particular—as a good buy or good use of venture capital (whereas the old and modern masters of Europe qualified respectively as gilt-edged or blue chip investments). It was tastefulness, domestication, and finish, however, that the New York School artists had impugned in the art of their European counterparts, which they saw as generally diminutive and refined, polished and meticulously crafted. Among the ways they found to separate themselves from the Europeans was by working big, often very big. They took the canvas off the easel, got up off their stools, and stopped painting pictures with controlled, touch-by-touch motions; they made art in a newly physical way, with extended energetic movements of the whole hand, arm, and body, and with housepainters' brushes and buckets of paint.

By working in an overtly physical way on an expansive scale, the New York School artists were looking for not only the means to make the most impressive statement—the big statement—but also a way to engage the viewers' perceptual faculties more directly and intensely, a way to enhance the viewers' awareness of both the artists' and their own relation to the work of art. The move to a monumental format was not conceived in the tradition of large-scale painting of the past, where the purpose was generally official and institutional and the aim to create paintings powerful enough to impress a crowd of people all at once. With the largeness of their work, the New York School artists meant to reduce the disparity between the object's scale and the scale of the viewer's body, facilitating a closeness between object and viewer. These artists' paintings were generally meant to be hung fairly low—Rothko was explicit on this count—so that they faced and paralleled almost the whole of the viewer's body. They were generally conceived for private rather than public spaces and were intended to be seen by one or two persons at a time—persons who could involve themselves in the experience, not by entering an imaginary, illusionistic space but through the immediacy of the encounter. These pictures do not involve that perspectival space that seems to open up behind the wall and that viewers perceive by constricting their optical focus; instead they expand laterally along the space of the wall, continuous with the actual space of the viewers' experience and nearly filling the viewers' visual field. Rothko stated explicitly that he painted large canvases because "I want to be very intimate and human. . . . However you paint the larger picture, you are in it. It isn't something you command."[12] More than the others of his circle, Rothko was intent on the relation between his pictures and the viewer, asserting that the true criterion for the success of his paintings was whether they answered "human need."[13]

The New York School artists' interest in the physical presence and impact of their work was bound up with their interest in the physical properties of their materials and techniques. Although this is less evident with Rothko than with de Kooning, Smith, or Pollock, for example, all of

these artists were concerned to some degree with exploring and expanding the conventional processes of their media and with revealing the workings of those processes to viewers. Rothko could be mysterious about the techniques and combinations of materials he used, including diluting and mixing various substances with his pigments, to achieve his evocative surfaces. But Rothko was a self-described materialist as an artist,[14] and he cultivated an effect of directness, both in the bold frontality of his image and in the way he often exaggerated the brushstrokes around the perimeters of his rectangular shapes, making feathery marks that would appear more emphatic, as they are silhouetted against the color of the background or margin.

The directness, however self-conscious, that the New York School artists brought to their work was critical to their sense of breaking with European painting and one of its hallmarks, its high state of finish. The New York School artists' prizing of directness followed initially from their respect for the basic tenet of surrealism that artists should work in an unguarded or "automatic" way, fueled by the fresh, undiluted juices roiling in their unconscious minds. The surrealists themselves had given little more than lip service to this principle, however, as they engaged in substantial preplanning and reworking of their art. The belief in working directly and with an unflinching, visceral honesty became in practice a far more vital tenet for the New York School than it had ever been for the surrealists (with Pollock's working methods being the most exemplary case). The New York School artists' directness of approach lent their work a somewhat unfinished look; or, it could be argued, they contrived an unfinished look, a lack of visual closure, to convey directness. In either case, a quality of indeterminacy characterized the work of all the artists of the New York School. De Kooning once said of his art: "I didn't work on it with the idea of perfection, but to see how far one could go— but not with the idea of really doing it"; he later elaborated, "That's what fascinates me—to make something I can never be sure of, and no one else can either. I will never know, and no one else will ever know. . . . That's the way art is."[15]

The New York School artists' privileging of the effect of directness led to certain emphases in the critics' responses to their work. In an influential essay published in 1952, Harold Rosenberg characterized their work as "action painting," constituting "events," which were essentially dadaist or existential *actes gratuites* performed in the "arena" of the canvas.[16] In the public mind, these artists acquired an identity as "wild ones," as *Time* christened them,[17] that is, as artists who, to an extent undreamed of by the Fauves or "wild beasts" of yore, worked in a spirit of recklessness, violence, and abandon, oblivious to accepted aesthetic concerns. Rosenberg set the tone again in referring to Abstract Expressionism as "a style born of native rawness and virility, perhaps one even cowboyishly Wild West."[18] The romance that was built around the New York School artists is a tiresomely familiar one; in other words, a paean to

machismo centered on that signal American hero, the rugged individualist who lives and dies by violence, more or less outside the law.

Some members of the New York School, including Newman, Gottlieb, and for the most part Rothko, led relatively normal private lives; others were notorious for their brutal, reckless, or destructive behavior—most notably Pollock and Smith, who both died in motor vehicle wrecks at relatively young ages. Excessive drinking was a problem for some of these artists (it was a complicating factor in Rothko's state of mind and health in later years), a few of whom were notorious as violent drunks. But no matter how reckless any of these artists were in their personal lives the evidence shows they were far from reckless in their methods of making art. The years when Pollock abstained from drinking, from the late 1940s until 1951, are widely acknowledged as the years when he created his greatest paintings, the classic Pollocks. And when *Time* magazine headlined an article on Pollock, "Chaos, Damn It!" (on 20 November 1950), he swiftly cabled back, "No Chaos, Damn It!" Although the work of some of the New York School artists—Pollock, de Kooning, and Kline especially—has an explosive energy that may suggest a surrender of control, that effect was a highly calculated one. Film footage of these artists at work reveals what sure control they exercised over the effects of their gestures and what concentrated and sustained attention they brought to bear on their radical procedures. If that concentration might have been feigned for the cameras, other evidence is available. One study of de Kooning has documented how, in the process of reworking a picture, he recorded on the verso of another canvas in minute detail some complex passages that he found particularly effective so as to recreate them at a later stage.[19] De Kooning was capable also of producing dozens of preparatory drawings and sketches in the course of creating a painting, as he is known to have done, in particular, in the case of that watershed painting *Woman I* of 1950–52.

*Woman I* impressed most critics as a work created in a wild fit or frenzy of activity, but paintings radiating an explosive energy are not necessarily the product of explosions. Another painter famed for the spontaneous, calligraphic effect of his art is also known to have used less extemporaneous techniques than the prima facie evidence of his pictures might suggest: Franz Kline worked regularly from small-scale preliminary studies that he painstakingly transposed to canvases with the aid of an opaque projector. Although the New York School artists rejected the fastidious touch and finished look they saw as typically European, they were fastidious about attaining the raw, direct look that constituted their own type of finish. De Kooning was especially renowned, or notorious, for reworking his pictures endlessly, while consciously sustaining their appearance of incompleteness. Rothko also cherished a look of open-endedness, manifest in the fluctuations of his pictures' surfaces and the torn-looking edges of his not quite rectangular shapes. Those rough or fuzzy edges testify to his refusal to finish, close, or square off his squares or to set

immutable borders that would decisively separate shape from field, inside from outside.

Throughout his career Rothko made a point of keeping the activity of his brushes evident in his work, but he explicitly rejected the catchy tag of "action painter" that became attached to the group as a whole. In 1958 de Kooning's wife, Elaine, a painter and critic, did a feature story for *Art News* on Rothko and Kline entitled "Two Americans in Action." Rothko talked to her at length before she wrote the article but was not consulted about the title, which he protested immediately in a letter to the editor.[20] He dissociated himself from Rosenberg's rhetoric and views, which were rife in de Kooning's essay. His own influence on de Kooning can also be detected in the article, however, in passages that typify not only his views but those of some others in his circle. Elaine de Kooning wrote, for example, of the "misplaced effort to identify them [the New York School artists] with movements of their immediate European past. What distinguished these Americans was the moral attitude which they shared toward their art; that is to say, they saw the content of their art as moral rather than esthetic. Subject matter, not style was the issue, and they had a new attitude to it. . . . There is still prevalent . . . the superficial notion that abstract art is without content or subject matter. But while there are a few abstract artists who illogically support this view, most of them vehemently oppose it."[21]

Not only errant artists, but some critics as well, believed that abstract art was by definition devoid of subject matter. And many New York School artists tried actively to counter this view. The mandate for creating art with significant subject matter, impelled by a moral imperative, is another and crucial bond that unites these artists. They repudiated the widely held view that they were formalists engaged in making art about art, "pure" art, or elegant decorations, just as they dismissed the perception that they were latter-day dadaists perpetrating nihilistic, anti-art gestures. Rothko stubbornly asserted that he was "concerned with his art not esthetically but as a humanist and a moralist." In an interview in 1952 (as on some other occasions) he went so far as to insist, "I do not like paintings"; and in 1954 he declared that "in the presence of the [his own] pictures my preoccupations are primarily moral."[22]

In spite of his attempts to portray himself as a stringent moralist creating a humanistic and tragic art, most critics persisted in viewing Rothko as an aesthete or as "the apotheosis of the individualist painter, hyper-sensitively concerned with his own processes, and afflicted with chronic virtuosity," to cite a representative phrase. The author of that phrase, Max Kozloff, further described Rothko in terms of his "extravagant attempts to gratify the eye" and the experience of "sheer delectation" yielded by his pictures.[23] In most critics' eyes, Rothko's art was not—as he would have had it—less self-involved, hedonistic, or decorative than Matisse's (a standard point of comparison) but rather more so. To Carter Ratcliff, Rothko was a "mannerist . . . self-consciously con-

cerned with the act of painting,"[24] whereas to John Canaday his achievement was "great decoration (impossible to avoid the word) rather than great painting."[25]

One factor that undermined the New York School artists' claims for the raw immediacy of their art was their practice of reusing their images. Some found it comical, for instance, when Barnett Newman was overheard to say that he never knew what he was going to paint next; anyone could say, in general, what the next Newman, Pollock, or Rothko would look like, and that fact called into question the degree of directness involved in the creation of the work. The repetitiveness of New York School art was also taken as evidence of the artists' single-minded commitment to exclusively pictorial concerns, to making purely abstract art. Rothko and Newman were most frequently characterized as purists because of their pictures' clean expanses of color; but purity was never an aim or even an issue for the artists of the New York School—except, on occasion, as something to repudiate. De Kooning observed that the very idea of a pure art was an absurdity, a vain attempt to "free art from itself."[26] The critics, not the artists, tended to imagine abstract art as a pristine form of expression, unbesmirched by any trace of the world beyond the picture plane. Over their objections, then, the New York School artists were often portrayed as blindered creatures laboring along the narrowest conceivable artistic path, oblivious to all but the most specialized aspects of their job; or as Donald Kuspit put it, Rothko "ultimately . . . presents the painting as a tautology, repetitiously declaring its self-identity."[27]

## The Signature Image

Most people who are even casually knowledgeable about modern art feel fairly secure in recognizing the work of individual New York School artists. This is due to another phenomenon that unites these artists: they each formulated one or more signature images realized through a signature technique. The most radical example was Pollock's pouring or drip methods, which he developed around 1947; but in the few years that followed most of the New York School artists evolved a signature format and technique. For the remainder of their careers—in some cases for ten or twenty years or more—they applied themselves largely to working variations on those and subsequently formulated motifs. The name Mark Rothko evokes a prototypical image: planar, symmetrical, and colored, just as the name Jackson Pollock evokes an image in black and white of an intricate web of poured and tangled skeins of paint. The phenomenon of the signature image has fostered a tendency to regard artists like Rothko, Pollock, or Newman as if they had painted only a single painting. The usual procedure has been to write or speak about Rothkos, Pollocks, or Newmans in generic terms, as if singling out any given painting would be an idle or irrelevant gesture. In the three most widely read books on the New York School, by Dore Ashton, Irving Sandler, and

Serge Guilbaut, the authors rarely or never focus on specific works of art.[28] Scarcely any are illustrated in the Ashton and Guilbaut books, and in Sandler's book the reproductions may as well have been selected at random, so rarely are they discussed in specific terms or at length in the text.

This practice of circling around New York School art without lighting for long on actual examples also characterizes the literature on Rothko. The first doctoral dissertation completed on Rothko (by Robert Fulton Porter, at the University of North Carolina at Chapel Hill) was a critique of the criticism on the artist; the first book (by Lee Seldes) concerned the litigation surrounding the settlement of his estate. In the exhibition catalogues devoted in full or in significant part to Rothko, the same is true: the pictures reproduced are rarely mentioned individually or discussed at length in the text. Typically, Rothko's classic paintings are treated as a bloc, or at best as two blocs, with a division between the dark paintings and the bright ones. Critics often allude to the profundity of contemplating the pictures (and lament the inadequacy of reproductions), while discussing them as though they were uniform or interchangeable. Critics have paid little attention to the internal mechanisms of particular compositions or to how the paintings relate to one another. To make free with Freudian terminology, the pictures themselves have been repressed; and I shall propose some reasons why.

Rothko painted the first of his familiar images, with their stacked or floating rectangular shapes, in 1949. Although his rectangles are not strictly geometric but are frayed or softened at the edges, the pictures insinuate themselves loosely within that abstract pictorial tradition, already of several decades' standing, of structuring images through geometrical forms or the use of the grid. The name that springs to mind in this context is that of Piet Mondrian, the first-generation abstract artist who was one of the first to develop a signature image characterized by a restricted formal language. Many critics have felt a rightness in comparing Rothko to Mondrian, and the comparison is useful up to a point.[29] As with Mondrian, so with Rothko: the viewer marvels at how rigorously prescribed the formats of his paintings were and at how he stubbornly, invariably refused to admit the diagonal, the curve, or the amorphous. These self-imposed strictures notwithstanding, Rothko regarded his characteristic format as potentially so resonant that he used it almost exclusively, creating hundreds of pictures virtually according to a pattern. But despite the steady sameness of the pictures on a schematic level, as with Mondrian, so with Rothko: the attentive viewer knows that, within its parameters, the art was always changing. The scale and proportions of the canvas changed; the number and scale of the rectangles changed; the palette changed; and the final effect differed accordingly, sometimes subtly and sometimes dramatically, from picture to picture. No viewer would confuse the incandescent yellow and orange painting, *Number 22,* 1949, at the Museum of Modern Art with the smoldering *Four Darks in Red,* 1958

(pls. XII, XXI), at the Whitney Museum of American Art for example. For Rothko as for Mondrian, his preferred format was the opposite of constricting: it instantiated a concentrated worldview.

I emphasize at the outset the formulaic nature of Rothko's art, not to undermine his achievement, but to give due weight to one of its salient peculiarities. The phenomenon became more routine in subsequent decades, but Rothko belonged to the first generation of artists to establish its artistic identities through such paradigmatic formats; and of his generation, no one more dramatically exemplified the practice than he did. Only a few times in his mature career, when he accepted and executed commissions for suites of detachable murals, did Rothko stray significantly from his characteristic format.[30] The exceptional circumstance that an artist would rehearse a pictorial schema for twenty years raises questions of itself. To salute it as a magnificent obsession and let it go at that leaves unanswered questions: Why this specific image? What did the artist see in it that he found so gripping? Why does it exercise such a hold on so many viewers? These questions are at the center of this book. My working assumption is that Rothko rehearsed his image so tirelessly in order to insist that it was the most meaningful image he knew how to render. He was trying to ensure that viewers would concentrate on the unchanging facts of his schema, to ensure that he would not be misunderstood.

The almost obsessive nature of Rothko's vision has been seen by critics in various lights. A common assumption is that reusing a simple graphic format allowed Rothko to concentrate more deeply on the effects he could achieve by manipulating color. During his lifetime and since, critics have praised Rothko's feeling for color, often assuming that it was his focal preoccupation. The name Mark Rothko can be found with the names Matisse and Bonnard when the company of legendary and sumptuous colorists is invoked (in this reputation he is the exception among his peers). Color was the one aspect of his pictures that Rothko was willing to alter, vary, and experiment with, however, the one facet of his paintings that he did not relentlessly insist upon. Accordingly, and contrary to those who focused on his use of color, Rothko repeatedly protested, "I'm not interested in color" and "I'm not a colorist."[31] Color, he explained, was nothing more than an "instrument" for expressing something larger: the all-important "subjects" of his pictures.[32]

In the eyes of unsympathetic critics, Rothko's continued rehearsal of a single image signaled a failure of invention and a tedious testing of the public's capacity to withstand monotony. Marketing considerations have also occasionally been mentioned as a factor, because of the evident benefits for an artist in continuing to make what had become a recognized, saleable, and valuable product. But the underlying suspicion that artists who repeat themselves do something mercenary, impure, and contrary to the principles of the avant-garde—the expectation that a modern artist is bound or able to continually produce something novel or original—is

dubious in itself. Repetition and work in series have been endemic to the making of art all along, and modernism was never exempt from these practices—witness Monet's haystacks, poplars, and waterlilies. Even if innovation is understood as a mainspring of modernism, however, the question of whether radical innovation can ever be, or has ever been, an unrelenting feature of any artist's work remains.[33]

## Reception

Although some have held it against him that he repeated himself, for several decades Mark Rothko's paintings have met with a high degree of responsiveness from critics tolerant of abstract art. Along with Pollock, Newman, de Kooning, and Smith, Rothko has been widely recognized as one of the leading players in the New York School. His paintings have proved specially ingratiating because they evince little of the violence that has often given viewers pause in confronting Pollock's and de Kooning's work. But if Rothko's paintings can also be disconcerting because of their extreme simplicity, they still do not compare in that respect to the art of Barnett Newman, whose picture surfaces are rarely softened by the perceived humanizing effect of visible brushwork. What most critics have responded to in Rothko's art might be summarized as involving two qualities in particular: a quality of feeling, of sensuality and emotionality, associated with the artist's expressive brushwork and palette, and an ambiguous but intuited quality of spirituality or religiosity. This latter quality (which escapes about as many critics as it captivates) is associated particularly with Rothko's brushy, gently modulated or nuanced, hence what have been called "mysterious" and "atmospheric" surfaces, and with his frontal, symmetrical, and hierarchical, hence "iconic" compositions. Writers have often responded to these appealing pictorial qualities with heartfelt elegies wrought with extravagant prose. A painstakingly chosen, virtually poetic vocabulary is often employed to describe an experience that is said to defy description, while being charged with emotion and suffused with spirituality. Given what is seen as the inwardness of Rothko's art, most critics have preferred to approach his paintings from a subjective vantage point—the uniquely authentic vantage point, as they often represent it, of personal experience. In the end, his paintings often function as rhetorical springboards for earnest meditations on the arts, life, philosophy, and spiritual experience in general.

Taken as a whole, the literature on Rothko attests to the intense effect his art can have on viewers, how deeply it can move them. Like van Gogh or Matisse, Rothko commands strong personal attachments. Feelings run deep at the mention of his name, and private responses to his art may be jealously guarded. Further, the generation of critics who met or knew Rothko tends to be highly protective of his memory and of the specialness of the paintings' meaning as it was enhanced by their contact with the man and his studio. (Ironically, Rothko was with few exceptions

famously hostile to critics; he opened up only in the company of persons—sometimes casual acquaintances—who were safely distant from the art world.) The claims that Rothko made for his paintings' subjects have posed trying problems, however, even for those who had the opportunity to question him. Because the artist was loathe to be explicit about his cherished subjects, most critics have shied away from the problem of analyzing or interpreting them. But in other respects, those critics most sympathetic to Rothko's work have generally tried to affirm his vision of it, even to square their perceptions of the work with his. In trying at once to ratify and pay tribute to Rothko's vision, sympathetic critics have tended to bestow the highest praise they could muster, in terms that have been mustered for ages: those grand old adjectives—timeless, essential, universal, and humanistic—are to this day common currency in discussions of Rothko's art, despite the little-acknowledged reality that this currency has lately been considerably debased.

Rothko wanted his art to affect as many people as possible as far into the future as possible, and he and many of his patrons have alluded to the presence of certain transhistorical forms in his paintings that could reach people universally. Since Rothko's time, the notion that there are universal human qualities and values has been questioned, however, on the grounds that that purportedly universal humanist ethos involves, more specifically and insidiously, the projection or imposition by the dominant race, culture, and gender (read: white Western men) of its own codes of values (which are honored, most often, in the breach) as the universal norm. Nor does the fact that Rothko's paintings continue to be appreciated after his lifetime render them magically timeless, as some critics would have it. To insist on the possibility of a suspension of time is, for that matter, to attempt to evade or eradicate history. This book is concerned with how and why Rothko proposed to create images with universal significance, but it does not venture claims for any transhistorical essences embodied by his work. Instead, I have tried to locate Rothko within his historical moment and in relation to the particular traditions of Western pictorial art to which his work pertains. Although he came to regard the established rhetoric of Western art as too archaic to meet his needs, it was the only language available to him for addressing the subjects that he wanted to address, and so he was impelled to reinscribe it, even as he acted to erase it.

The literature on New York School artists has come under criticism for its inwardness and for taking what is usually described as a narrowly formalist approach. Loosely speaking, the division that tends to be drawn is between inside and outside perspectives, the former generally identified with old-guard or mainstream criticism, with the latter presented as a new approach, at least by the self-identified revisionists themselves. Not only have mainstream critics come under fire for their blindness toward the political and social context of the New York School, but the artists and the art have been subject to attack on the same grounds. This attack

on the artists is an old cne, however, which has been bound up with the resistance to the New York School from the outset. In 1952 Harold Rosenberg charged, "About the effects of large issues upon their emotions, Americans [artists] tend to be either reticent or unconscious. The French artist thinks of himself as a battleground of history; here one hears only of private Dark Nights."[34] Max Kozloff contended in the early 1970s, further, that the New York School's

chromatic abstraction would solace those in upper echelons who could not abide the inertial tugs and irate spasms in the over-heated ghettoes of our national life. . . . The gap between their [the artists'] technical motives, the demi-urge of form pursued for its own sake, and the rarefied prestige their art conferred upon its backers, does not seem to have occasioned any comment among them—nor did it have to. On the contrary, they had been socially insulated by a critical framework—an explanation of purpose and a means of analysis—called formalism.[35]

   Though Rosenberg was a principal figure of the old guard of critics, he was not averse to framing his subject in a social perspective. Neither (when he is read closely) was that other principal, Clement Greenberg. For that matter, an "outside" approach has been more or less the standard one for books on the New York School as a group: Dore Ashton introduced her book on the subject as being "not about paintings or artists, but milieu—including literature, music, philosophy, theatre, politics." Irving Sandler's book also set out to encompass the "milieu in which the Abstract Expressionists flourished." Annette Cox produced a study on *The Abstract-Expressionist Avant-Garde and Society.*[36] And Serge Guilbaut wrote about the Abstract Expressionists and the cold war in *How New York Stole the Idea of Modern Art.* An assumption revisionist critics have tended to make is that the "inside" work on the New York School, if it needed doing at all, has been done to excess, that more than adequate attention has been paid to the formal realities of the art and that what is lacking is a hard, cold look at the political and social realities surrounding the rise of these artists. So recent is the phenomenon of the New York School that truly acute looks at any aspect of it are still in short supply. But insofar as an inside approach has dominated the discourse on Rothko, the inside in question has mainly been the interior or subjective experience of critics, rather than any thorough and sustained visual analysis.

   The reluctance to analyze actual pictures by Rothko might be explained not only by their sameness but also, and more justifiably, by the widely felt sense that the content of those pictures is simply unutterable; the artist himself turned aside some opportunities to discuss his work, saying, "Silence is so accurate."[37] A great deal has been written by those most partial to Rothko's memory about the futility of writing about his paintings, of even pretending to capture the experience that they offer in words. Dore Ashton (who has written far more about Rothko than anyone else) says the experiences afforded by his paintings "could not be para-

phrased in written language. Or, if they could be captured in the word, they would be as condensed as a poet's most arcane metaphor."[38] In a critical essay on Rothko, the poet John Ashbery wrote about the impossibility of writing criticism on his paintings, contending that they summarily "eliminate criticism."[39] With any work of visual art there is the impossibility of making an exact transposition into words; to some degree, any art not created with language is by its nature outside of or beyond language. But in Rothko's case, the felt failure of language seems to go beyond the expected. Ashton, Sandler, and many others have insisted on the "magic" and "mystery" of Rothko's pictures, on their "ineffable" and "enigmatic" qualities; and in this connection, the philosophical category of the sublime has often been invoked.[40] Jean-Francois Lyotard has gone so far as to suggest that modern art in general "finds its impetus and the logic of the avant-gardes finds its axioms" in the aesthetic of the sublime. In painting, certain of those axioms involve "making an allusion to the unpresentable by means of visible presentations. The systems in the name of which, or with which, this task has been able to support or to justify itself . . . remain inexplicable without the incommensurability of reality to concept which is implied in the Kantian philosophy of the sublime."[41]

Many of the New York School artists could be said to have attempted to represent the unpresentable; from that perspective, the category of the sublime may prove apposite in studies of their work. The usefulness of the category is limited, however, by the lapsing of the term, in its philosophical connotations, from present-day language usage. Even in contemplating the Grand Canyon or the great cathedrals, the modern person does not readily describe a sensation of awe in terms of sublimity. To frame a discussion of New York School art in terms of the sublime is to imply that this art, which still impresses the viewing public as eminently modern, can not be understood without recourse to a philosophical category that will impress the public as archaic (now, as in Rothko's time) or as signal of the visions and preoccupations of an earlier era.

Within the circles of the New York School, the concept of the sublime enjoyed a modest vogue, at least during the 1940s. Two of Rothko's good friends of that time, Still and Newman, were intrigued by the category of the sublime and its possible relation to their own undertakings. (Newman especially among the New York School artists, was known for his philosophical turn of mind.) The notion of the sublime did not, however, explicitly engage Rothko,[42] who distrusted high-flown approaches to his art and preferred to discuss the aims and effects of his art in the more "concrete" terms, by his own reckoning, of the emotions. It could be argued that here also Rothko had wandered unknowingly into the arena of the sublime, however; the sentiment of the sublime is, "according to Kant, a strong and equivocal emotion: it carries with it both pleasure and pain."[43] Evoking a conjunction of pain and pleasure was a task that Rothko took most seriously—though for him the opposition was more

fundamentally that of the "awareness of death" versus "sensuality."
When he took it upon himself to name the "ingredients" of his art in the
order of their importance (in a lecture delivered in 1958), the items lead-
ing the list were "intimations of mortality," followed by "sensuality . . . a
lustful relation to things that exist."[44]

The sensuality of Rothko's art is a quality that critics have especially
appreciated but that has also elicited the subtly deprecating practice of
classing his work, with the art of Matisse and Bonnard, as no more than
a form of pleasure mongering. A preoccupation with pain or death—in
his own eyes, the artist's primary concern—more often eluded critical
attention, at least until the advent of the very dark paintings that distin-
guished the final decade or more of his career. Prior to that time, the
harsh or "violent" notes that Rothko regarded as predominant in his pic-
tures were heard only faintly, if at all, by most critics. Rothko wanted his
paintings to convey a "maximum of poignancy";[45] and poignancy means
"painfully [and] . . . deeply affecting, . . . piercing . . . touching . . .
moving," "being to the point," and "pleasurably stimulating" (*Webster's
Ninth New Collegiate Dictionary*). It is a term that connotes precisely a
conjunction of pleasure and pain. Rothko was heard to say that he was
concerned with "expressing basic human emotions, tragedy, ecstasy,
doom and so on;" and here again is the coupling of pleasure and pain.[46]
In a Freudian schema (in place of a Kantian or Burkean one), corre-
sponding to this dualism of "sensuality" and the "awareness of death"
are Eros and Thanatos, the drive to create life and the drive toward its
destruction.

Without ever saying exactly what he meant in referring to the "sub-
ject matter" of his art, Rothko made plain that he arrived at his subjects
by "dealing with human emotion: with the human drama as much as I
can possibly experience it."[47] The "human drama" was a key phrase for
Rothko. To him, it connoted "human experience" and the cycle of life,
the "varied quickness and stillness" of "the human spirit" with the plea-
sure and pain it enjoins.[48] "In all the years I knew him," said Dore Ash-
ton, a friend from the early 1950s onward, "Mark talked like that
[philosophically] with me. About, as he so often said, life, dissolution
and death."[49] As Rothko saw it, the human drama was a tragedy:
"Rothko spoke of his desire for an art that would express the human con-
dition—and so would perforce be a tragic art,"[50] related Robert Gold-
water, another longtime friend. A fellow painter, Willem de Kooning,
confirmed this: "From his point of view, Mark's paintings projected some
kind of tragic image."[51] During the war years, Rothko had been en-
thralled by Greek tragedy and by Nietzsche's writings on the subject; in
later years, he came to prefer Shakespearean tragedy.[52] Throughout, he
believed that "only that subject matter is valid which is tragic" and that
"all art deals with intimations of mortality."[53]

Many critics regarded such statements by Rothko as nonsensical, or
rhetorical at best: "Rothko spoke often of tragedy, Greek and Shakespear-

ean," observed Harold Rosenberg, who knew him for more than thirty years. "It is not easy to grasp the connection he had in mind between his mats of color and Orestes or Macbeth."[54] Differences of perspective between artists and critics can usually be anticipated; but such differences were especially pronounced in Rothko's time. To refer to the artists and the critics as if they formed unified camps is of course to oversimplify, but if the detailed complexities of these configurations are sacrificed for a broader view, some basic schisms can be seen to emerge. The ruptures occurred over the problem of abstraction and, more specifically, the problem of subject matter within abstract art. Whereas sympathetic critics described the New York School artists' work as abstract and ratified it as such, the artists generally regarded the concept of abstraction with deep ambivalence. Whereas the artists argued for the vital importance of the subject matter of their work, the critics considered that images devoid of literal imagery, anecdote, and narrative—purely abstract images, as they idealistically saw them—could not and should not be adulterated with subjects. Permeating both these disputes was a conflict about the artists' relation to art historical tradition.

## Tradition

The work of the New York School artists represented a bold and compelling departure in the history of art: the importing of a monumental scale and an unprecedented directness of execution to abstract art. The evident newness of the New York School's art caused many critics to presume that a search for novelty had been the artists' primary motivation: "Through Modern Art . . . a supreme Value has emerged in our time, the Value of the NEW," wrote Harold Rosenberg.[55] The New York School had perpetrated such a complete break with tradition, Rosenberg argued, that their "action painting" could not be regarded as art at all but should be seen as novel "events" instead. Rosenberg was stretching the conventional usage of the term *event* even more than the New York School had stretched the conventions of painting; as Mary McCarthy pointed out in a letter to the editor, it is impossible to hang an event on the wall. But with some notable exceptions (Clement Greenberg and Thomas Hess among them), many critics readily adopted Rosenberg's view that the New York School's art was ruthlessly iconoclastic and comparable, in that respect, to dadaism. The artists tried their best to change the critics' minds: "Dada found something hilarious to do, but it wasn't in any sense a part of painting," asserted Franz Kline. "No figure, no Rembrandt, no Titian, no-hands-Clancy—it's a nice attitude . . . but that doesn't make it painting."[56] And when an interviewer asked Willem de Kooning, "What about Marcel Duchamp and his painting of the Mona Lisa with a mustache on it?" de Kooning responded, "Maybe Duchamp's just not an art lover."[57]

Historically, dada emerged at the onset of a devastating world war fought because of a complex set of treaties, alliances, and governmental

allegiances—a war that to some, at least, exemplified the bankruptcy of existing regimes or even the intrinsic absurdity of government. The New York School movement emerged, by contrast, on the heels of a harrowing world war that was fought on ideological grounds—a war fought against fascism. The New York School artists were not moved to formulate anything like that explicit agenda of social and cultural criticism that fired the dada movement, then, largely because they were not in opposition but rather in a position of deep sympathy with their government's cause, the allied cause, in the war. Rather than identifying themselves as cultural subversives bent on undermining art historical traditions, the New York School artists wanted the altogether different privilege of appending to the narrative of the history of art its latest chapter.[58] When de Kooning suggested to Rothko that he was perhaps the most modern artist of their mutual generation, Rothko is said to have protested that his art came "straight out of Rembrandt."[59] For all their innovativeness, Rothko and his peers were art lovers who worked, in many respects, within the parameters of the traditional media, creating art objects for posterity. The New York School artists frequented the Metropolitan Museum of Art no less than the Museum of Modern Art; and although the Modern was just as indifferent to their work at first as the Metropolitan, it was the Metropolitan that these "irascible" artists—as *Life* magazine described them—petitioned and picketed in 1950, protesting their likely exclusion from a future show of contemporary American art.

Not even at the first did Rothko attempt to make tightly rendered mimetic pictures with Renaissance oil painting techniques. But an ever diminishing streak of conservatism can be traced from his career's beginning until its end. When Rothko first started to paint (years earlier than almost all of his peers), hardly anyone in New York was creating abstract art, and his initial essays as an artist reflect the climate of the time. In 1924 he enrolled in an anatomy class at the Art Students League; and in 1925 and 1926 he continued to take classes there part-time, studying painting primarily with Max Weber. Rothko's earliest work, of the mid-1920s through the late 1930s (figs. 1, 2, and 8 for example), was especially indebted to early American modernism, with John Marin, Milton Avery, and the later work of Weber being the most evident, immediate sources of inspiration. During the first full decade and more he was painting, Rothko rendered mostly prosaic modern subjects—figures in urban settings and landscapes—in styles often less adventuresome than those of the artists he emulated. His imagery was at times strange, and his technique could be raw, but these early pictures caused no difficulties for the critics. "Although he paints the figure chiefly, his peculiarly suggestive style, with its dependence on masses and comparative indifference to establishing any markedly definite form, seems better adapted to landscape, and to landscapes in watercolor at that," wrote the critic for the *New York Sun* in December 1933. The polite notice and mild acceptance afforded Rothko by the press at the outset of his career may only

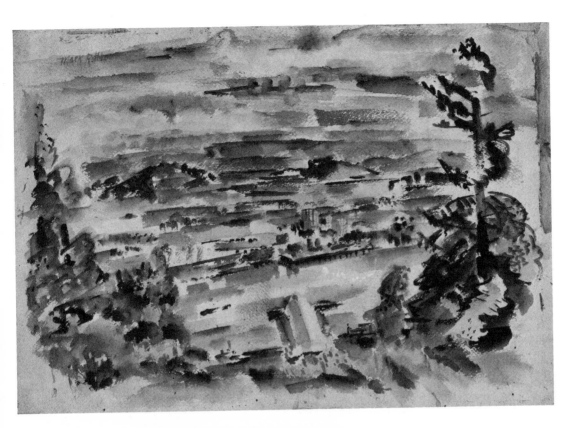

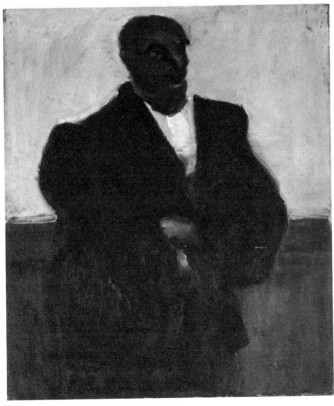

1
Untitled, late 1920s, watercolor
and ink on paper, 15½ × 22¹¹/₁₆
in. Collection of the National
Gallery of Art, Washington, D.C.
Gift of the Mark Rothko
Foundation, Inc.
(Photo: Quesada/Burke)

2
Untitled, 1930s, oil on canvas,
27¹¹/₁₆ × 23¹¹/₁₆ in. Collection
of the National Gallery of Art,
Washington, D.C. Gift of the
Mark Rothko Foundation, Inc.

have disconcerted him, however, because he imagined his work to be significantly more experimental than in fact it was.

Rothko tended to look askance at critics throughout his life, but his sense of being grossly misunderstood and misjudged by the press did not come to a head until he began to address mythological subjects with techniques and idioms culled from surrealism. Critics avoided deciphering the cryptic imagery in such pictures as *Antigone* of circa 1941 (fig. 3)[60] in the light of the subjects suggested by their titles to focus on basic descriptive tasks instead: "It might, if you like, be a figure or a still-life," said a *New York Times* reviewer in a typical comment about one of Rothko's surrealistic pictures, "but . . . I think I'd prefer just to call it nonobjective."[61] This resistance to the subjects that the artist consistently regarded as the pith of his art became all the more entrenched when his fantastic creatures began to yield first to almost random-looking arrangements of splotches (fig. 4) and then to his simple stacks of frayed, colored rectangles. The classic Rothkos—paintings like *Number 22,* 1949, and *Four Darks in Red,* 1958 (pls. XII, XXI)—were, and are, widely perceived as the product of a purist, formalist aesthetic, as utterly nonobjective, and so devoid of subject matter.

In view of the direction that his career finally took, it may seem inconsequential that Rothko passed more than a decade creating representational pictures formed along relatively conventional lines; these pictures are only rarely engaging, and after around 1940 the artist declined to show them, either privately or publicly (even in the full-scale retrospective of his work at the Museum of Modern Art in 1961). But this long early chapter to Rothko's career is instructive, because it proves how deeply wedded he once was to pictorial tradition, how steeped he was in the fundamentals of narrative pictorial structure. Rothko had considerable experience in laying out portraits, landscapes, genre paintings, and at least one crucifixion before he turned toward an abstract mode of painting. What I will argue in detail here is that this familiarity with the conventional formatting or codes of pictorial art (a familiarity that need not have been, but in his case was, reinforced through practical experience) continued to inform his work in a vestigial but significant way, even as he pursued an abstract mode of conceptualizing and realizing his pictures.

This firsthand experience with received pictorial conventions was another factor that united the New York School and tied them to such first-generation abstract artists as Mondrian and Kandinsky. The New York School artists' kinship with the pioneers of abstraction (with whom they had no personal contact) is reinforced not only by their common assimilation of received pictorial codes but also by their shared commitment to insinuating subject matter into abstract art. These factors that tie the New York School to abstract artists who were active for decades before them served also to effect a sometimes deeply felt breach between the New York School and the generation of abstract artists that came to attention on their heels—the Minimalist artists, such as Frank Stella and Kenneth

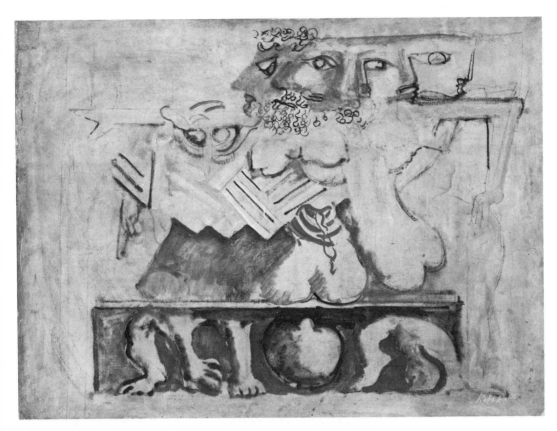

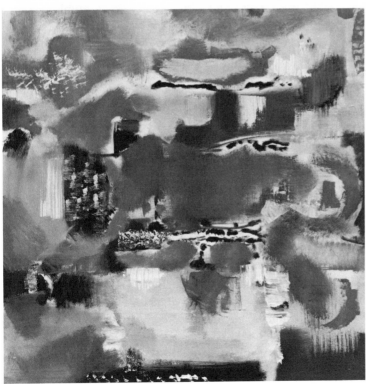

3
*Antigone,* circa 1941, oil on canvas, 34 × 45¾ in. Collection of the National Gallery of Art, Washington, D.C. Gift of the Mark Rothko Foundation, Inc.

4
Untitled, 1947, oil on canvas, 39½ × 38½ in. Collection of the Munson-Williams-Proctor Institute, Utica, New York.

Noland. Stella had effectually eluded conventional art training of any kind; and, as perhaps the first Western artist to work abstractly from the outset, even from his training in high school, his career represents a kind of watershed in the history of abstract art. Unlike abstract artists before him, Stella was blithely unconcerned about the possibility that his art would be perceived as empty because it lacked the presumably universal humanistic content that recognizable subjects were believed to supply to works of art. In contrast with the abstract artists who preceded him, Stella discounted the danger that his work would be seen as mere decoration or as a private language of merely private importance. In an interview in 1964 he commented: "I always get into arguments with people who want to retain the old values in painting—the humanistic values that they always find on the canvas. If you pin them down, they always end up asserting that there is something there besides the paint on the canvas. My painting is based on the fact that only what can be seen there *is* there. . . . What you see is what you see."[62]

Rothko was the kind of self-identified humanist who would gladly have given Stella the argument he describes, and the elder artist (elder by about thirty-three years) was predictably unreceptive to the younger one's art. Rothko's art first emerged into the limelight less than a decade before Stella's; Rothko's status as a leading figure in the avant-garde was secured, by comparison, nearly four decades after Kandinsky's. But from the vantage point of how these artists formulated and conceptualized their work and of the kind of prolonged evolutionary course that work underwent, Rothko was closer to Kandinsky (an artist about thirty-seven years his senior) than to Stella. With both Rothko and Kandinsky, the implementation of favored themes can be traced from the earliest to the final stages of their careers, from representational to abstract modes of painting.[63] As these artists transformed their means, however, their pictures' meanings were also changed.

Art historians have conventionally written monographs by delineating and describing the evolution of an artist's work as a continuum. This procedure is less well established and more problematic in the case of abstract artists, though it can still be used to illuminating effect, as I propose to demonstrate with Rothko. Some risks and problems come with this procedure, however: the risk of constructing a conceptual whole of an artist's oeuvre at the expense of acknowledging its ruptures or conceptual breaks, the risk of obviating the radicalness and difficulty of the work in particular phases of a career with the implicit suggestion that all of the work may be reduced to a single quantity, and the risk of implying that paintings grow in an internal and autogenous way out of other paintings and not as well out of the impinging of external factors. But declining to make the connections between early and late work brings consequences too. In Rothko's case, it means losing an important entree to the artist's subjects and missing the intriguing marriage of innovation and tradition, experimentation and conservatism at play in his art.

## Abstraction

Although Rothko came closer in his views and in the pattern of the development of his art to Kandinsky or Mondrian than to Stella or Noland, the surprising fact remains that he was not an admirer of any of these artists' work. One way Rothko's conservatism manifested itself was in his persistent rejection of what he deemed "abstract art," from cubism onward. In an interview in 1952, three years after he had arrived at his mature format, Rothko stated point-blank, "I have never had an interest in Mondrian." Further, "I never was interested in cubism. I painted in New York many years while the abstract artists [the American Abstract Artists group] were working. Abstract art never interested me; I always painted realistically. My present paintings are realistic."[64] However evident the abstractness of Rothko's pictures may be to the viewing public, what is obvious to the viewer was by no means obvious to the artist. From the time his work began to reflect his discovery of surrealism until the end of his career, Rothko swam obstinately against the tide of critics who represented him as an abstract artist. "You might as well get one thing straight," he told a skeptical critic in the 1950s. "I'm *not* an abstractionist. . . . I'm not interested in relationships of color or form or anything else."[65]

Other artists in Rothko's circle shared his aversion to abstraction—abstraction, that is, as they defined it. Barnett Newman charged that "the insistence of the abstract artists that subject matter must be eliminated, that art be made pure, has served to create a similar result to that of Mohammedan art which insisted on eliminating anthropomorphic shapes. Both fanaticisms . . . force the art to become a mere arabesque."[66] Newman made this criticism of abstraction in the mid-1940s, when he and Rothko both were exploring the abstract or ideographic idioms of surrealism. These artists saw a clear distinction between the hard-edged, geometric forms they branded *abstract* and the soft-edged, organic or biomorphic forms they used in their own paintings: their own forms were "alive," and thus subject to impregnation with real human feelings and ideas, whereas geometric forms were anything but. In the mid-1930s and early 1940s, Ad Reinhardt recalled, "Intellectually and aesthetically the important thing was that there was absolutely no relation between the abstractionists and the surrealists," by which (latter) sobriquet Reinhardt referred to the members of the as yet unformed New York School.[67] As Reinhardt indicated, many of the advanced American artists in this period were in effect divided into camps: on one side were artists (many of whom were affiliated with the American Abstract Artists) who were especially enthralled by the geometrically founded, mainstream modernist movements of cubism, constructivism, and de Stijl; on the other side were such artists as Rothko, Newman, and Gottlieb, who were more immediately engrossed by that maverick avant-garde movement, surrealism. Miró, who was admired by Rothko and others in his camp, was not regarded by them as an abstract artist; nor were his fellow surrealists Ernst, Dali, or Masson.

In the simplest formal terms, the departure represented by surrealism, and the dadaism of Arp before it, would be a break with the geometric morphology of cubism, constructivism, and de Stijl in favor of more organic idioms. But formal differences signify ideological and conceptual differences, and the break with the cubist grid had larger, more explosive connotations than a formal description implies. Miró swore that he would "smash the Cubist guitar," no less, while Masson was promising to "seize at last the knife immobilized upon the Cubist table."[68] The geometry identified with cubism and the movements it spawned was also identified with logic and rationality and, more broadly, with the machine, architecture, and utopian social visions. Many practitioners of a geometric aesthetic were embarked explicitly on an errand of depersonalizing and denaturing form; many dada and surrealist artists were concerned to retrieve natural form—but not naturalism. Organic or biomorphic form was resuscitated to stand for the very things the other modernists had generally despised it for: irrationality, individuality, and the interior realms of the unconscious. That the potency of irrationality was not to be trifled with or ignored had been demonstrated by fascism and, beforehand, by the events of World War I. The dada and surrealist artists insisted on a vision of the world that made a space for the irrational dimension in human activity and experience instead of denying or suppressing it. And as the utopian and spiritualistic aspirations attending the flowering of modernist abstraction ebbed in the 1920s and 1930s, this vein of fantasy art, these alternative avant-gardes, so to speak, kept the larger project of abstraction alive.

In the 1940s Mondrian and Kandinsky were still producing compelling pictures, but the lofty dreams that first nourished their art had dissipated. They retained devoted groups of followers; the American Abstract Artists, one such group, were part of a multinational network of associations of abstract artists active in the 1930s and 1940s including Abstraction-Creation, Art Concret, and Circle. Although several of the artists who eventually belonged to the New York School initially belonged to the American Abstract Artists association—Gorky, de Kooning, and David Smith—for the most part those artists whom I (with Reinhardt) am calling the American surrealists were less cosmopolitan and more ambivalent about the European modernist (in this case, read "abstract") tradition than were the members of the American Abstract Artists. For reasons both practical and ideological, most of the New York School artists did not make pilgrimages to Paris until late in their careers, if at all. Although they kept abreast of developments in Europe through exhibitions and periodicals, feeling an onus to reckon with the achievements of Picasso, Matisse, and Miró, among others, they also felt impelled to keep some distance and not to succumb to hero worship. The American surrealists were not nationalistic in outlook, and they had a healthy fear of remaining provincials, but they felt the need to come to terms with their own physical, cultural, and social environment and even—after the example of the Mexican muralists—to explore the American artistic heri-

tage in its prehistoric and tribal forms, as well as in its more recent manifestations. The American roots of the New York School have been comparatively little acknowledged or explored because art historians have tended to focus on the canonical modernist line of succession in which the New York School's major figures assume their places directly after Matisse, Picasso, Kandinsky, Mondrian, and Miró.

The American surrealists were from the outset more mindful than the American abstractionists of the need to consume, without being consumed by, developments in Europe. This greater wariness and ambivalence toward the visual culture of Europe reflects long-standing frustrations and compensatory wishful thinking on the part of some advanced American artists. These artists dreamed that they would not always be the poor relatives of their illustrious counterparts in the proverbial Old World; they dreamed that the New World might yet develop a viable modern expression of its own. Whether they or their parents had been displaced from the Old Country or had been Americans for generations, they had the sense of having something to prove. But the American surrealists' ambivalence toward Europe reflected something more—a disillusionment with certain of the values intrinsic, even crucial, to European modernism. A primary cause for skepticism was modernism's valorization of science and the machine and of the totalizing visions of the new social order these forces were supposed to bring about. As denizens of the most technologically advanced society of the time, Americans had reason to feel cautious about the promise of technology. Beyond this, to a generation of American artists coming to political awareness during the spread of fascism, these elements of the modernist program took on an insidious aspect, notwithstanding the (little appreciated) fact that they had been liberal and utopian in their inception. Whereas Mondrian, for example, had set out to depersonalize and denature his art in the wake of World War I, with the idealistic intention of elevating communal values over individual ones and so of facilitating a more perfect social order, the celebration of an imposed and impersonal order inherent in Mondrian's paintings took on a different odor in view of the ascendancy of the fascist imperative for order.

To Rothko, even as late as the 1950s, abstract art was depersonalized and arid, too remote and sterile, or too decorative. Abstraction connoted "Bauhausism" and "the industrialization of art," developments Rothko is said to have repudiated "based on a conviction of the harm which they have done to the human significance of art."[69] The paradox is that throughout the 1940s Rothko's own art became unmistakably abstract in its gradual exclusion of all unambiguous references to objects in the visible world. In the artist's eyes, the irregular and organic-looking forms in his own pictures were never abstract in the sense of constituting detached signifiers but were effective signs, replete with "signifieds." Rothko insisted, then, that "his substitution of ritual symbols for figures and his later replacement of these by areas has been in the interest of human content."[70] His explanation for the fact that he had "faltered in the

use of familiar objects," as he put it, was that he refused to "mutilate their appearance for the sake of an action which they are too old to serve; or for which, perhaps, they had never been intended."[71] Like certain abstract artists before him (most notably Kandinsky), Rothko felt that pictures with familiar objects elicit a materialistic response from viewers, who will tend to confuse the objects *in* paintings for the object *of* painting, to confuse the "object matter" with the subject matter, to borrow Meyer Schapiro's well-known distinction. "The familiar identity of things has to be pulverized," Rothko resolved, "in order to destroy the finite associations with which our society increasingly enshrouds every aspect of our environment."[72]

Also instrumental in Rothko's move away from a figurative or representational mode of painting was his distrust of illusion. Whereas representational painters must generally create some illusion of depth to contain their semblances of three-dimensional objects, abstract painters have the freedom to cover their flat canvases with forms just as flat. In his peculiar way of formulating principles verbally years before acting on them visually, Rothko stated early on that painters should use "flat forms" because "they destroy illusion and reveal truth."[73] On a literal level, the truth in question was truth to the medium, truth to the flatness of the picture surface. But to Rothko and some of his peers, material integrity stood for moral integrity: "reasserting the picture plane" was both an ethical and an aesthetic obligation. For an artist to contrive illusions of depth would be to propagate artifice, deceit, and thus bad painting.[74] From the time he was painting figuratively, moreover, Rothko was pondering "the proper development of the subject in the spirit of utmost integrity to its own materials."[75] In the end, not even his more or less flatly painted, nonoverlapping rectangles could completely safeguard Rothko from engendering a sense of spatial illusion. His rectangles did not simply define the picture plane: they may be seen as floating parallel to that surface, but they are also perceived as locked into spatial struggles both against the picture plane and against each other, as variously obtruding from and receding into space, and, in some viewers' eyes, as evoking mysterious and unsounded depths.

Eventually Rothko reconciled himself, in a limited way, to the concept of abstraction, but he remained averse to discussing his work in the terms typically used for abstract art. "To make this discussion hinge upon whether we are moving closer to or further away from natural appearances is somewhat misleading," he had written to the art editor of the *New York Times* in 1945, "because I do not believe that the paintings under discussion are concerned with that problem."[76] In 1943 he had explained that his pictures "depart from natural representation only to intensify the expression of the subject implied in the title, not to dilute or efface it."[77] To Rothko, his break from replicating natural appearances mattered far less than what he had sacrificed those appearances for: to effectively present more significant subjects.

## Subjects and Referents

Throughout his career Rothko maintained that his paintings had to have and did have subjects. But to his chronic frustration, during his lifetime most critics paid scant attention to this perspective, his own perspective on his art. For many critics or historians an inviolable working assumption is that with cubism came "a critical semiotic shift . . . a disjunction between signifier and signified . . . and a constant trend towards . . . the suppression of the signified altogether, an art of pure signifiers detached from meaning as much as from reference," to cite Peter Wollen.[78] To raise the specter of a "signified" in abstract paintings is to flout these critics' articles of faith about what makes modern art modern, or rather modernist. For those who believe that abstract art represents the triumph of the free-floating signifier, the notion that abstract art may be coded is not just wrongheaded, but heretical. In recent years the New York School artists' emphasis on subject matter has nonetheless become the focus of closer inquiry.[79] Many admirers of Rothko's art have felt all along that his pictures are imbued with deep meaning or content, if not specific subject matter. Skeptics and detractors have suggested, however, that to dignify such patently ornamental pictures with talk of subject matter is simply to be taken in by an artist's self-serving cant. And for critics prone to modernist orthodoxy, abstract artists' claims for their subject matter can be explained as a smoke screen—an apologia fabricated to appease disconcerted viewers by undercutting and so mitigating the violence that was being done to aesthetic convention.

The questions I address in this book devolve from a problem raised by an artist's stated intentions: What did Rothko mean by insistently calling attention to the subject matter of his paintings? Is there any way such patently abstract works of art might legitimately be understood as having subject matter? Few historians or critics regard artists' claims or stated intentions for their art as sufficient for an interpretation of that art (a prospect that would eliminate the place of critics altogether, after all). But as Stanley Cavell has observed, "The category of intention is as inescapable (or escapable with the same consequences) in speaking of objects of art as in speaking of what human beings say and do: without it we would not understand what they are."[80] For scholars toiling in the fields of modern art, with their abundance of primary sources, the factor of the artist's intentions is potentially a pivotal and richly problematic one.

That artists' intentions cannot be regarded as fully determinate of the content of their art is generally agreed. "The spectator will always understand more than the artist intended, and the artist will always have intended more than any single spectator understands," as Richard Wollheim observed.[81] Artists' stated intentions often yield rhetorical entrees into questions central to their work, however; and it is on this basis that I consider Rothko's intentions in the present study. Although I continually engage the problem of Rothko's intentions or program for his art, that is not the whole of my agenda; I did not want simply to reconstruct

an artist's view of his work, if that were possible, let alone to privilege it as the only correct or legitimate view. What concerns me instead is the dialectic between what Rothko said he did and what he did, as I (and other writers) perceive it from a historical distance.

Whether Rothko would have ratified the readings set forth here or recognized his conscious intentions in them is not the crucial issue at hand. There is strong evidence that he would have recognized some of them, but he himself understood that "the instant [a picture] is completed, the intimacy between the creation and the creator is ended. He is an outsider."[82] Some critics (notably E. D. Hirsch, Jr.) see consciousness as a key criterion in discussing intention, but others have persuasively argued that consciousness is a slippery, volatile, and to a certain extent extraneous factor. A distinction must be drawn, in any case, between the intentions of the artist, conscious or otherwise, and the intention or, better still, the intentionality of the work of art. As David Hoy explains, "The question is whether . . . one has to attribute . . . intention to a person. It may be possible to speak in a more limited way of the intention of the text [or picture] itself."[83] This intention, or intentionality, is not separate from the work of art—it *is* the work of art; and the intentionality of Rothko's art is the principal consideration here.

Not only Rothko, but the New York School artists in general, used the terms *subject matter* and *subjects* when they talked about the meaning of their work. By these terms (which they used interchangeably), they apparently meant nothing outside the scope of a standard dictionary definition: "that which forms or is chosen as the matter of thought, consideration, or inquiry; a topic, theme" (Compact Edition of the Oxford English Dictionary). These artists were not obsessed with the new or the pure: they were preoccupied with how and what abstract art might mean. When Rothko, Baziotes, Motherwell, David Hare, and Newman organized an art school in 1948, they gave it an ungainly but pointed name: The Subjects of the Artist. The school was mainly a venture to earn money (albeit unsuccessful), but it remains significant that these artists, all working in abstract modes, felt the need for a school whose curriculum focused on "what [the artist's] subjects are, how they are arrived at, methods of inspiration and transformation, moral attitudes . . . and so on."[84]

To art historians, the term subject matter normally designates a "sphere of specific themes or concepts manifested in images, stories and allegories," in Erwin Panofsky's words.[85] Because New York School art lacks conventional subject matter, critics who addressed the problem of meaning in this art preferred the term *content*, which as Panofsky would have it designates "intrinsic meaning."[86] Interpretations of the content of New York School art have varied substantially, not only in the heyday of the New York School but since as well. Of prominent critics at the time, Clement Greenberg was the leading voice for the argument that "the purely plastic or abstract qualities of a work of art are the only ones that count."[87] Therefore, "the message of modern art, abstract or not . . . is

precisely that means are content."[88] Thomas Hess asserted that "the painter is not interested in anything but being a painter, and the content of his art is its own biological growth."[89] The New York School artist emerges as a basically solipsistic figure in Harold Rosenberg's criticism as well: "The tension of the private myth is the content of every painting of this vanguard," he asserted.[90] Rosenberg also represented the content of New York School art as an all-out search for the new.

Nowadays the art of the New York School may no longer appear so radically new. But while it was first being made, its novelty impressed many critics as signaling a clean break with the past. In view of the narrow span of years (from 1947 to around 1950) within which the New York School artists almost all arrived at their characteristic mature forms of expression, many critics believed that the phenomenon in question was a collective breakthrough, the cumulative result of a series of private epiphanies by which these artists found their visions. Wrote Elaine de Kooning, "The cleavage between the present and the past for certain artists is as drastic as it was for Saul of Tarsus outside the walls of Damascus when he saw a 'great light' and heard a great question . . . 'Quo vadis?'" This was what happened to Rothko, as de Kooning would have it: "He is no longer Saul, he's Paul, and he knows where he's going. He didn't make a decision; he had a revelation; he is a Convert. His Present dates from the moment of his conversion. The works or actions that went before are part of his Past which no longer exists."[91] Thomas Hess resumed the Saul-becomes-Paul metaphor for the transformations undergone by the New York School artists, declaring that "Rothko, the most famous example, changed his name, his wife and his style in a few months of profound self-questioning"[92]—although the events in question took place over nearly a decade. The critics were so fascinated by the New York School artists' most advanced work that they quickly lost sight of the artists' more conventional beginnings—those prior and presumably misguided visions that supposedly evaporated in an instant of revelation. Because of the sharp separation that is typically made between Rothko's mature work, which interested critics, and the early work, which did not, the fact that the structure of the early work anticipates the structure of the mature work has become obscured. A useful way of approaching his subjects has also thereby been obscured.

"Primary or natural subject matter," according to Erwin Panofsky, "is apprehended by identifying pure forms, that is: certain configurations of line and color, or certain peculiarly shaped lumps of bronze or stone, as representations of natural objects such as human beings, animals, plants, houses, tools, and so forth, by identifying their mutual relations as events. . . . The world of pure forms thus recognized as carriers of primary or natural meanings may be called the world of artistic motifs."[93] The nonmimetic character of Rothko's art might seem to preclude the possibility of finding in it any "natural" subject matter or one-to-one correspondences with objects in the world. This has not proved to be the

case, however, as innumerable such correspondences have been invoked. Those most commonly made are with architecture and with landscapes, natural or preternatural, replete with light, clouds, and atmosphere. References have also been made to landscape viewed through an architectural frame, as in the open window paintings by Matisse, with the surrounding margins in Rothko's pictures being read as window or door frames. The correspondence to doors and windows, that age-old trope for pictures, has proved especially enduring. Rothko's classic image has been variously described, then, as: like a "window on an odd sunset," like "old stained glass windows," like "powerful sunlight pouring through thick panes of glass and open doorways," like "a stage set for a tragic drama," like "architecture [seen] through layers of moving fog," like "landscapes bathed in thick fog," "sidereal landscapes," and "cosmic haze." The sometimes brushy and transparent quality of the layers of paint forming Rothko's expansive rectangles not only elicits references to mists, fog, clouds, steam, ether, and the like but also to veils and screens or to "tinted, hallucinated cloth," "hovering bed spreads," and "transparent skin." More idiosyncratic references have been made to "segments of metal or stone tablets that once carried inscriptions," to the "phosphorescent surface of a t.v. screen," and, facetiously, to "a Buddhist's television set."

If there are "mutual relations" or correspondences between Rothko's images and natural or actual objects, their ambiguity renders them mutable and subject to multifarious interpretations, in other words. But if Rothko had meant to evoke a specific one-to-one correspondence between his images and the natural world, he would surely have made more explicit (either visually or verbally) his intention to do so. Instead, in 1947 he stated that the shapes in his pictures "have no direct association with any particular visible experience, but in them one recognizes the principle and passion of organisms."[94] Rothko's guarding of the indeterminacy of his images might well be taken as an indication that an abstract mode of expression appealed to him—in spite of himself—because of the very elusiveness or nonliteralness of its reference and the multiplicity of meanings it could therefore enfold.

Eugene Goossen once suggested that Rothko created "an omnibus image, sufficiently ambiguous to allow all manner of things to be expressed on the level of the emotions . . . but without that 'objective correlative.'"[95] Peter Selz suggested that Rothko's pictures were "mirrors, reflecting what the viewer brings with him."[96] That Rothko's paintings evoke emotions and states of mind, that they are portraits of a temperament or mood (to borrow a phrase from Eliza Rathbone) is a widely accepted view and one the artist himself explicitly endorsed. Here is a subject outside of Panofsky's realm of "primary or natural" subject matter, however; for although emotions are real enough, they are not directly tangible or visible. So too, when Rothko's art is described in terms of the sublime and the infinite, as representing "vast spaces of timeless silence,"

"infinite glowing voids," and "pigmented containers of emptiness," the no-
tion of natural subject matter is insufficiently inclusive. But Panofsky's def-
initions were hardly framed with art like Rothko's in mind, and art
historians have to retool their working definitions as the need arises. A
definition of subject matter that admits intangible and conceptual subjects
is clearly required in approaching Rothko's art. The question may still be
asked, however, whether the concept of natural subject matter pertains at
all to a discussion of Rothko's work. Is it entirely out of place to talk of
windows, doorways, and sunsets in relation to these images? Is that to
discount or unduly diminish the differences between Rothko and Matisse,
or Rothko and Turner? And why wouldn't Rothko have made such refer-
ences explicit, if he wanted to make them?

The idea that there are, albeit distant or ambiguous, mutual relations
between Rothko's images and objects in the natural world is not dis-
carded in this book, but neither does it form the sole basis for discussing
the subjects of these paintings. The objections raised above can be met
with the response that, although it is unreasonable to suggest that a sin-
gle, simple, and exclusive reading of Rothko's art based on one-to-one
correspondences with objects in the natural world exists, his images may
be polysemous, evincing multiple meanings by making overlapping and
even contradictory references in a way that an abstract mode of painting
uniquely permits. If Rothko's forms have correlatives in objects or scenes
in the world around us, however, I propose that they have a more direct
basis in the pictorial conventions for the presentation of such objects or
scenes in narrative and mimetic art. As Meyer Schapiro explained, while
the forms "in abstract painting are not simplified abstracted forms of ob-
jects; yet the elements applied in a non-mimetic, uninterpreted whole re-
tain many of the qualities and formal relationships of the preceding
mimetic art. This important connection is overlooked by those who re-
gard abstract painting as a kind of ornament or as regression to a primi-
tive state of art."[97] The method used here, in pursuit of Rothko's subject
matter, involves precisely this: a study of his classic images in relation to
the received conventions or "cultural habits of presentation," as Schapiro
also calls them, that characterize "the preceding mimetic art."

## Methods of Interpretation

The aim of the present text is to construct an approach to the subject
matter of Rothko's classic paintings and, more broadly, to explore how
and what his paintings mean. To focus on an artist's subjects has conven-
tionally been to do an iconographic study, to follow a well-traveled art
historical path. Some art historians have attempted to apply to the study
of abstract art the iconographic methods that were developed for the in-
terpretation of mimetic, narrative images. What is at issue in this book is
precisely the effectiveness and the limits of those methods traditionally
brought to bear on interpretive problems—iconography, semiotics, and

hermeneutics—when the work in question is a substantially nontraditional mode of visual expression, where the familiar *istòria,* or narrative subject, is lacking. The limitations presented by semiotics and hermeneutics stem from their having been formulated for the study of language and texts; and whereas iconography is an art historical method, the limitations it poses arise, again, from its privileging of text—the narratives, such as they are, in visual works of art. The drawbacks of iconographic methods do not arise only in relation to studies of abstract art, but they become more conspicuous in that context. The central problem lies with the presupposition that the subject, text, or istoria of the work of art can be investigated as if it were distinct from its form. The sheer convenience of separating or pairing in opposition the form and content of works of art renders it virtually irresistible to critics and art historians (as well as to artists). But this practice is insidious insofar as it occludes the reality that form and content are congruent, interdependent, and separable only at the peril of distorting or emptying both.

Iconographers are prone not only to maintaining this false duality between form and content but also to favoring one term at the expense of the other—content or text at the expense of form (as language is generally more valued and empowered than images in modern societies). "Iconography as a method is theoretically founded on the postulate that the artistic image . . . achieves a signifying articulation only within and because of the textual reference which passes through and imprints itself in it," Hubert Damisch has argued. If pictures are seen as image-signs, to shift to semiotic terms, comprised of a signifier (the form) and a signified (the subject or meaning), then iconography has privileged the signified and reduced the signifier to "a question of treatment, a connotation of style." In so doing, it has perpetrated a confusion between meaning and (verbal) denotation. What is necessary is to "break the circle of icon and sign," in order to pay due attention to "the sensible body of the image," the visual means of the visual arts.[98] Abstract art should logically provide a wedge for doing just this, because the "sensible body of the image" is what initially and ineluctably imposes itself on the viewer in the case of abstract images, whereas the text, if such there is, remains essentially immanent or intrinsic. The abstract image "imposes a different concept of 'signification,' of meaning . . . irreducible to the norms of communication (except insofar as it would be possible to determine what factors in the notion of information itself belong with a theory of form . . .)." This, Damisch argues, is the potential starting point for a semiotics of art, which could improve on received iconographic methods by "bringing to light the mainspring of the signifying process of which the work of art is, at the same time, the locus and the possible outcome," instead of simply attempting to state what the work of art represents or means.[99]

The term *subjects* is used in the title of this book in deference to the artist's preferred terminology. If the title moves the reader to summon the opposition of subject and form and to assume that the book constitutes a

study of the former at the expense of the latter, I must stress at the outset that this is not my errand. In Rothko's early paintings, it is possible to designate such subjects as a subway scene or entombment that can be readily, if artificially, isolated from the image itself. But in the work that represents the artist's most significant achievement, form and subject remain deeply identified one with the other. For purposes of interpretive analysis, however, I have made an artificial separation. As Peter Bürger has pointed out:

Although it is true that the avant-gardiste work imposes a new approach, that approach is not restricted to such works nor does the hermeneutic problematic of the understanding of meaning simply disappear. Rather, the decisive changes in the field of study also bring about a restructuring of the methods of scholarly investigation of the phenomenon that is art. It may be assumed that this process will move from the opposition between formal and hermeneutic methods to their synthesis, in which both would be sublated in the Hegelian sense of the term.

Bürger argues persuasively that "even the avant-gardiste work is still to be understood hermeneutically (as a total meaning) except that the unity has integrated the contradiction within itself." What is called for, he concludes, is a "critical hermeneutics" that "will replace the theorem of the necessary agreement of parts and whole by investigating the contradiction between the various layers and only then infer the meaning of the whole."[100]

This is what I attempt to do in this book: the structure of Rothko's pictures is gradually dismantled into its component parts or layers, considered in terms of the metaphorical and symbolic charge of those layers and of the contradictions arising among them, and then reassembled. It may be argued that the interpretation or intertext, as it were, that this study comprises countervenes the aim of Rothko's art as he conceived it. Rothko wanted viewers to be allowed to approach his paintings "as a pure and unique experience, for which [they] should not be prepared."[101] Like many abstract artists, he tried not only to eradicate narrative or text in his art but, by the same stroke, to render superfluous the interpretive texts of critics. But the artist's ideal of the direct or unmediated experience of the work of art has remained an elusive one. Viewers bring conditioned responses and collateral cultural information to their encounters with works of art, and this phenomenon is so deeply integral to the aesthetic experience that it is pointless to disparage it as a contaminant of that experience. Providing viewers with an intertext for Rothko's abstract pictures could not blunt the experience of those pictures, in any case, because no text could render transparent those muffling veils or that facade that the painter so carefully arranged to confront the viewer. If Rothko's pictures can be studied as icons (to borrow a semiological term), then they are not transparent icons. The fully iconic work of art is a familiarly clear or legible one; and no text could rob Rothko's pictures entirely of their indeterminacy, their illegibility, or their difficulty.

## Icons

In general usage, the word *icon* simply means "likeness, image, portrait, semblance" (*The Compact Edition of the Oxford English Dictionary*), but the term has more precise meanings in a semiological context (as invoked above) and in an art historical context. Art historically, the term icon is sometimes identified with the sacred art of the Eastern church, specifically, with a type of painting developed in Byzantium in the sixth century. Icons, in this sense, are sacred objects, the form and imagery of which reflect the direct influence of ecclesiastical guidance. Icons were designated to emphasize the spiritual over the material, in order to circumvent the sin of idolatry. To impart a dignified, dematerialized, and otherworldly quality, icons generally were made flat and stylized, hieratic and hierarchical in structure. Rothko's art has reminded some critics of this pictorial tradition: "The paintings sat quietly on the walls, calm, simple, glowing objects of contemplation possessed of the emotional power and impassive authority of the authentic icon."[102]

Mark Rothko
36

Icons were intended as the focus of prayer and devotion and not as the site of an aesthetic experience. In the doctrinal outcome of the iconoclastic controversies, the Eastern church decreed that icons partake of the spiritual essence of the figures they depict, that they constitute "the essential point of contact between the human and divine realms" and function, as such, as a vehicle for the spirit. The believers look not so much at the sacred picture as through it, "ascending mentally and spiritually from the image to the proto-type." "Comparisons of the divine creation of man with the reproduction of man by art were [a] commonplace of patristic literature"—which, oddly enough, Rothko claimed to enjoy.[103] Stories were told of icons having been produced through miraculous agencies, by heaven; and "icons of an established type, because of their sacred function and relation to a heavenly prototype, changed relatively little through the centuries."[104] Icon painters worked according to established compositional paradigms, and with a stigma, not a premium, associated with evidence of originality. The dignified hieratic and hierarchical aspects of Rothko's pictures—their symmetry, frontality, and flatness, as well as their rehearsal of a conventional prototype—have moved critics to see them in relation to the tradition of the sacred icon. Although the prototype in question was formulated by the artist himself, rather than being strictly traditional, Rothko's characteristic format bears a significant relation to established pictorial prototypes, by implementing a trace structure—or so I will argue.

I propose to demonstrate that the term icon, as it is found in a semiological context, is also germane to Rothko's work. The American founder of semiology, Charles Sanders Peirce, distinguished three different types of signs: the symbol, the index, and the icon, each involving a triadic relationship among the sign itself, the thing it signifies, and a "knower" or "interpretant." In the case of symbols, the relation between the signifier and the signified exists "by virtue of a law, usually an asso-

ciation of general ideas," as with words or language. The index "is a real thing or fact which is a sign of its object by virtue of being connected with it as a matter of fact," as smoke is an index of fire. By contrast with the symbol and the index, "the functioning of an icon as a sign is dependent upon its capability of similarity of structure," as James Feibleman explains. It follows that "anything whatever . . . is an icon of anything, insofar as it is like that thing and used as a sign of it."[105] If an icon is not generally used as a sign—that is, if people do not readily recognize it as such—it remains strictly an "iconic sign vehicle" or a "hypoicon," though Peirce often neglected to qualify his use of the term so precisely.

The category of the icon is useful to an analysis of abstract art because an icon is a sign that is or incarnates its referent. Further, as Peirce describes it, "The value of an icon consists in exhibiting the features of a state of things regarded as if it were purely imaginary." Though information may be derived from an icon, "a pure icon can convey no positive or factual information; for it affords no assurance that there is any such thing in nature." One example of an icon that Peirce explores is the "metaphor," in which the "parallelism is not a correspondence of simple qualities," or a corresponding relation of parts, but a more abstract relation;[106] I will invoke the notion of visual metaphors in what follows. Another example that Peirce especially explores is the graph or diagram, and I will exploit the schematic or diagrammatic aspect to Rothko's characteristic image while bringing semiology to bear. The paradigm of the diagram has real limitations, however, because art does not diagram what it expresses but more nearly reproduces it.

Up to a point, Rothko's art may fruitfully be analyzed as involving a language or sign system. The linguistic model is an imperfect one—its limitations are taken into account here—but it serves some purposes and is all but unavoidable, in any case: artists, critics, and viewers generally have been "reading" pictures for too long to give it up. Rothko himself believed that "painting, like every other art, is a language by which you communicate something about the world."[107] And he would surely have agreed with Barnett Newman that "abstract art is not something to love for itself, but is a language to be used to project important visual ideas."[108] In suggesting that Rothko's paintings are iconic, I am proposing to show that they are embedded with metaphor, that they function by means of similarity and by exhibiting the structure of "a state of things regarded as if it were purely imaginary." When these paintings are approached as icons or image-signs, however, their signifieds slide behind and among their signifiers and are not bound or constant. The very diversity of the readings of Rothko's work already in print testifies plainly enough to the remarkable mutability of his images.

I want to make it clear that my readings are proposed as provisional. I do not claim to have an arsenal of facts with which to prove irrefutable truths about the subjects of Rothko's pictures, and I do not suggest that the present reading of those pictures ought to supersede all others. That

there can be no exclusive, exhaustive, or definitive reading of a work of art is more and more accepted—though it need not follow that all readings are equal, as different interpretations will have greater or lesser epistemic value. For every interpreter there are "different ways of being aware of things and different aspects of a text [or painting] which compel a certain kind of awareness." What is at issue in this book is not simply conscious or unconscious meanings but "a whole range of what has been called 'modes of consciousness,' or modes of representation."[109] My purpose is to demonstrate how multiple meanings, a palimpsest of meanings, inhere in Rothko's pictures.

Rothko's paintings, like abstract art generally, have been inscribed in art history with the rhetoric of liberation and the rhetoric of transcendence, purity, and metaphysical presence. In the standard accounts, the advent of abstract art in the West represents the revelation of a pure and nonmaterial or nonobjective aesthetic space, reached through the release of the signifier from the signified (the form of the work of art from its meaning or referents). In the dominant accounts or narrative of the history of modernist art, that is, the advent of abstract art is described in valorizing terms, as the moral and epic tale of the ascension of the free-floating signifier, the victory of pure spirit and feeling over the debased realm of the material, empirical, and everyday. Thus William Rubin could write regretfully of Pollock, "It is as though the triumphal elimination of the image in the forties was never a complete victory. . . . [for] figuration returned to haunt Pollock in his later work." Whereas Pollock finally succumbed to the temptations of the figure and fell from the grace of abstraction, Rothko managed, in Rubin's terms, to sustain an art of pure painting, "an art of sensations independent of poetic allusion." But if Rothko's paintings "have an infinite calm, a stability and order, doing for sensations what the late Mondrian achieved for the intellect," that feat was "achieved at the cost of an *a priori* exclusion of great areas of possible artistic experience," according to Rubin. Such was widely assumed to be the cost of attaining a "passive, detached and meditative art of sensations;[110] and, in some other critics' eyes, the price was too high. The perceived detachment of abstract art, its aloofness from the tasks of describing the literal weighs heavily against it in accounts that oppose the orthodox modernist line. At the very least, abstract art is disparaged because any meanings it might instantiate are so vague and equivocal as to be assimilable to almost any explanation or ideology. But more often, in accounts that dissent from the modernist line, abstraction is vilified as an agent in the decline of Western visual culture into a morass of meaningless and pretentious decoration.

What propels my argument is the conviction that the key presupposition behind these lines of reasoning—that abstract artists could carve out and occupy some privileged aesthetic space aloof from history, politics, and the real—is crucially flawed. Despite their individual ambitions, neither Rothko or Pollock, nor Mondrian or Kandinsky before them, could

find a way to make an art that would be truly nonreferential or nonsignifying. No painter could ever perpetrate an "elimination of the image." A picture of a white square on a white ground (I refer to the famous suprematist canvas by Malevich) is no less an image than is a picture of apples on a tablecloth. To create paintings is to make images, images that will ineluctably be seen within the context of a given history of image making. Rothko was engaged in a process of imaging, and the space that he worked in—the space that his pictures must still be seen in—is the well-trafficked space of the symbolic. Rothko's pictures function through metaphor; they function through the implementation of traces of that etiolated rhetoric that underwrites the Western pictorial tradition. His pictures do not assert "the primacy of the purely visual," as so many critics would have it; nor do they yield pure sensation, pure spirit, or light. They are not, after all, immaterial; neither was their maker, and neither are their viewers. What makes Rothko's best paintings so compelling is not that they stand apart, outside, or beyond any specific historical situation but is, on the contrary, the many (historically charged) valences of their poetic allusions.

# 2

# The Mutilated Figure

From the age of twenty-one on through the first seventeen years of his career, Rothko worked as a representational painter because, as he put it, "that was what we inherited."[1] In the 1910s there had been numerous American artists experimenting effectively with abstract modes of painting, including Marsden Hartley, Georgia O'Keeffe, and Arthur Dove of the Stieglitz group and Patrick Henry Bruce and Morgan Russell of the erstwhile Synchromist circle. By the mid-1920s and 1930s, at the start of Rothko's career, this impetus had largely been checked, and a conservative trend had taken hold—even more conservative than the so-called new classicism that emerged simultaneously in Europe. In the 1920s Hartley and O'Keeffe returned to representational modes of painting; and although some dissidents, like Dove and Bruce, remained abstract painters, they did so at the price of isolation, neglect, and censure.

The careers of Rothko's teacher Max Weber and Pollock's teacher Thomas Hart Benton are symptomatic of the sharp reverse turns that modernism took in the United States in the 1920s and early 1930s, when the climate for abstract painting became so inhospitable. Weber and Benton each had made three-year long pilgrimages to Paris, arriving in 1905 and 1908 respectively, to gain firsthand knowledge of the activities of the European vanguard. Weber became a welcome visitor at Gertrude Stein's salon and was even instrumental (with her sister-in-law Sarah Stein) in convincing Matisse to open an art school, where he promptly signed on as a student. Though Benton was never as integrated in the fabric of the European avant-garde as Weber, he became caught up in the activities of the Paris-based American Synchromist circle and so, indirectly, in the orphic cubism of Robert and Sonia Delaunay.

In Paris Weber proved a relatively gifted disciple, not only of Matisse but also of Henri Rousseau (who became a friend). Weber shared avidly in the emerging interest in tribal art among avant-garde artists in Paris, and this interest in ethnographic art had an impact on his work. In the 1910s the central figure in the avant-garde for Weber (as for many other emerging artists) became Picasso, more than Matisse; and Weber acquited himself as a creditable painter in a cubist mode, taking the American landscape, both rural and urban, as the focus of his pictures. But by 1920 after years of successfully catching the vanguard's waves, Weber

was working in a fully representational, if expressionistic, mode. He concentrated on the human figure, often with a special, sentimentalized focus on Jewish life.

During his years in Paris, Thomas Hart Benton devised his own small-scaled but vivid and fairly sophisticated approach to cubism. But he soon found the heroic, muscular, and sensual art of Michelangelo, El Greco, and the Italian Mannerists more alluring than modernism. By 1916 Benton was rendering heavily stylized, Michelangelesque figures in dense, rhythmic, and robust compositions that eventually assumed a heroic scale. Benton's experience with the compositional demands of the cubist idiom helped inform the complex and peculiarly abstract organizations of form he contrived in his figurative paintings, but he saw no relation between the two ways of working. In the 1920s and 1930s Benton became known for his virulent denunciations of abstract art and as a crusader for a vital, populist, self-consciously American art. This all-American art was to be based on European models, but on Renaissance and Mannerist models, instead of more recent abstract ones.

The early 1930s marked the height of the American Scene or Regionalist movement and of the popularity of its best exemplars, Benton and Grant Wood. In the mid-1920s, when Rothko first started painting, a vigorous campaign was already afoot in a nexus of lively little magazines to instigate an authentic, dynamic art movement that would be distinctively, natively American. Seeds for this campaign can be traced to those gadflys of the European avant-garde, Marcel Duchamp and Francis Picabia, who had sojourned in New York during the liberal 1910s—both to escape the war and in a purposeful reversal of the customary American artists' pilgrimage to Europe. Picabia and Duchamp remonstrated with American artists for longing for the proverbial Old Country, with its immutably museumlike surroundings, rather than looking for inspiration from their own modernized, technologically advanced society. "If only America would realize that the art of Europe is finished—dead—and that America is the country of the art of the future, instead of trying to base everything she does on European traditions!" Duchamp exclaimed in an interview with an American journalist in 1915.[2]

In the wake of World War I, as the United States was rapidly acquiring a profile as an economic and political power, the shame of not having a commensurate cultural stature was keenly felt by American artists—the literati, in particular. In magazines such as *Broom, Contact,* and *Soil* a mandate was issued that artists should draw on American themes, traits, and techniques in formulating a new aesthetic vision. The Precisionist art of Charles Demuth and Charles Sheeler, which often focused on American industrial subject matter rendered with techniques resonant, respectively, of mechanical drawing and that mechanical means of reproduction, photography, exemplified this drive. "Since machinery is the soul of the modern world, and since the genius of machinery attains its highest expression in America, why is it not reasonable to believe that in America the

art of the future will flower most brilliantly?'' Picabia had asked in 1915.[3] And while Demuth was in Paris in 1921, he wrote to Alfred Stieglitz in New York: "Sometimes it seems impossible to come back—we are so out of it. Then one sees Marcel [Duchamp] or Gleizes and they will say, 'Oh! Paris. New York is the place—there are the modern ideas—Europe is finished.'"[4] Nor were Europeans the only ones with a newfound confidence that a successful art movement would arise in the United States. In 1922 the New York critic Henry McBride wrote that France

still leads . . . but it would require subtler mathematics than we possess to figure out by what percentage. It moves by previously acquired momentum rather than by actual force. . . . The real dramatic interest for us Americans begins to be here. . . . Communities all over the United States are, to use the old fashioned phrase, in an interesting condition. We have just fallen heir to the proud position of world supremacy that was Spain's at the time she produced Velazquez. We, too, can now afford to produce expensive geniuses, and we intend to do so—in fact have commenced. The general opinion is that they are to be as lusty as those that Walt Whitman prophesied for us.[5]

In 1931 Fernand Leger wrote from Manhattan: "New York and the telephone came into the world on the same day, on the same boat, to conquer the world. Mechanical life is at its apogee here."[6] Surely it is not a mere accident that the leading country in manufacturing telephones and washing machines also gradually emerged as a leading producer of art; but neither is there a simple or ready cause-and-effect explanation for this coincidence, and no one could suggest it was a foregone conclusion. The connection between the emergence of a strong, independent, and original American vision in art and the emergence of the United States as a leading economic and political power has been discussed primarily in relation to the era of the Second World War, the Marshall plan, and the cold war,[7] but its many, tangled roots are longer still and buried earlier in the twentieth century. A distinct and self-assured American artistic identity did not emerge full-blown with the rise to prominence of the New York School after World War II but was a long time in forming. The artists' sense of assurance that they might yet produce an art commanding international interest was slowly reinforced by the country's ascent to a position of international power, as well as by the devastation of Europe in two world wars.

In achieving their success, the New York School artists were indebted not only to the European modernists but also to the early American modernists who began the protracted process of finding ways to image the American experience. Although New York School artists were not nationalistic in orientation and American modernists were generally ambitious to make a statement that transcended national boundaries, American artists needed to find ways of making art grounded in their own experience before they could formulate modes of expression that would exceed that experience. "Art is not a cloak that an artist borrows

from someone else but a fabric he improvises for himself," wrote McBride in 1929.

Younger Americans in search of [a style] are herewith gratuitously advised that the chances of acquiring one in cosmopolitanism are noticeably less than they were a generation ago. The reason for this . . . is that the center of the world has shifted. Paris is no longer the capital of Cosmopolis. All the intelligence of the world is focused on New York; it has become the battleground of modern civilization; all the roads now lead in this direction, and all the world knows this save the misguided artists who are jeopardizing their careers for the dubious consommations of the Café de la Rotunde.[8]

The drive in the 1920s to found an authentic, indigenous modern art movement surely made some impression on Rothko, but the transformation of this drive in the 1930s into something overtly conservative and nationalistic repelled him. He was contemptuous of the chauvinism and false optimism of the Regionalists, and he despised the affected rural and provincial tone of their art. His own work of the 1930s was closer in spirit to the urban vision and pessimistic or critical tone of the art of the Social Realists (painters like Raphael Soyer, Ben Shahn, or Reginald Marsh), although he refused the anecdotal and illustrative aspects of their work.[9] When he first started painting, Rothko looked for mentors to such artists as John Marin, Max Weber, and Milton Avery, who had made efforts to assimilate aspects of European modernism and to engage it in their work.[10] Until around 1941, Rothko was for the most part not prepared or inclined to grapple directly with the example of contemporary European art as his mentors had done because he was more attracted to his mentors' work, more at ease with the predigested modernism it offered him. Rather than attempt to come to terms with the morphology or the implications of cubism, that lingua franca of the international avant-garde, Rothko hoped to transcend the provincial in his art by essaying subjects of universal significance. The influence of Max Weber on Rothko—which is plain enough on stylistic grounds—may also have been a factor in this respect, for Weber stressed the importance of seeking a universal, spiritual basis for art.

Weber articulated his commitment to retrieving a spiritual role for art in a book of essays on art published in 1916. Although he was a Russian Jew—like Rothko—his program was initially, at least, nonsectarian: "The qualities of art blend the spiritual, the ethical and the physical," Weber declared. "Art is spiritual belief or truth, the symbol of the most tender or virile instincts conceivable." Weber emphasized the importance of maintaining continuity between past and present art, cautioning that "to scorn or slight the real of the past, the unswayable, makes one conspicuous, but not creative."[11] But the task that he set for his students of bringing a renewed spiritual focus to art proved to be a Sisyphean one. In the twentieth century in the West, finding an effective visual form to convey spiritual feeling was a problem not due to be resolved—or not to the sat-

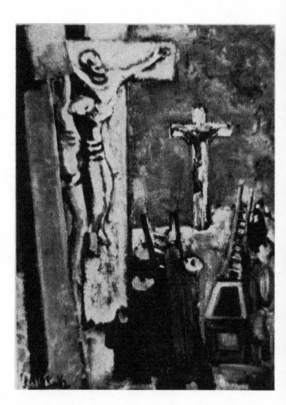

5
*Crucifixion,* before 1936, oil on
canvas. Whereabouts unknown.
Copyright © estate of Mark
Rothko, 1988.

isfaction of the society as a whole—given the increasingly vexed or un-
certain status of that category of experience in modern times.

In centuries past Christian artists embarked on spiritual or religious
errands had recourse to the preexistent genres and modes of sacred art.
But even if Rothko had been Christian and had shared more directly in
that visual heritage, he would have found that the continued rehearsal of
those established forms met with a diffident reception in a society that
was increasingly estranged from religious dogma. "Most of the subject
matter of the past—religious, classical, romantic—is closed to [the mod-
ern artist], being too remote from the mentality of today," observed Lloyd
Goodrich, curator at the Whitney Museum, in 1933. "And . . . our mod-
ern beliefs (what we have of them) are too abstract and impersonal to be
easily expressed in pictorial form."[12] Rothko reportedly shared this dour
outlook: "The myth is dead," he complained to a friend in the 1930s,
"The old stories having lost appeal, credibility, there are no loved, widely
known themes for the painter today (one cause for abstractions)."[13] Those
who aspired to make art with significant subject matter were forced to
invent and explore alternatives. "If [the modern painter] is to survive,"
suggested Lee Simonson, editor of *Creative Arts,* in 1928, "he must find
subjects and themes that can symbolize what is to us the meaning of our
world as effectively as the image of a sun-god, the face of Buddha, or the
Passion of Christ once did for other times."[14]

In the 1930s Rothko made an occasional attempt to resuscitate tradi-
tional Christian imagery, by painting a *Crucifixion* (fig. 5), for example.

To give the timeworn image immediacy, he positioned the cross so that it appeared to be propped against the picture's left edge with its fore-shortened transverse bar poking out at the viewer. The result was more clumsy than compelling, but Jacob Kainen, an old friend and fellow painter, sensed that this early picture expressed "the essential Rothko—a compassionate, sensitive man; and although the esthetic means changed in time, his spiritual outlook remained."[15] Most of his friends seem to agree that Rothko's "preoccupation with spiritual values was almost traditional," as Dore Ashton phrased it, although he was never given to religious orthodoxy.[16] As a young child in a "mildly religious, intensely political" (Zionist) family in Russia, Rothko had been sent to cheder and given a rigorous religious schooling—a training that lapsed, however, when he departed for the United States.[17] The more "cheerful" Jewish and Christian holidays were reportedly celebrated in Mark Rothko's own household once he had children by his second wife, Mary Alice Beistle (called Mell), who had been raised a protestant. The elder of Rothko's two children, Kate, born in 1950, has said that "Religion didn't play a role in the Rothko house, but . . . the Jewish holidays were observed."[18]

Though it means anticipating the course of my narrative, it may be useful to indicate at this early juncture that Rothko revisited the terrain of sacred art throughout his career in overt, as well as oblique and subtle, ways. In the 1940s he painted numerous surrealistic crucifixions and en-tombments (figs. 33, 34, and 38, for example). In the 1950s he referred in conversation to the "religious experience" he had as he painted; and in the same period, he proposed to paint a chapel.[19] Toward the close of his career, in the mid-1960s, he did just that: he created a cycle of fourteen paintings for a chapel in Houston, Texas (fig. 50). Although these pictures did not exhibit any explicit religious imagery, they made use of the traditional forms of sacred art in other ways: the number of paintings in the cycle is the same as the number of paintings in a conventional stations of the cross series; included among the fourteen paintings were three triptychs—which are not customary in such a series but which are a traditional format for an altarpiece. Further, Rothko conceived and designed his cycle of paintings for an octagonal sanctuary, the conventional shape of the structure of an Eastern orthodox church, envisioning that he could thereby cause East and West to merge symbolically; so he told Dore Ashton.

At the outset the Rothko chapel (as it is known) was intended as a Catholic chapel or so the artist believed and intended, according to Ashton, who has suggested that Rothko would not have liked the broad, non-traditional purposes to which the sanctuary was finally dedicated.[20] When Rothko said he hoped to see East and West merge, he was not referring (as some other artists of his generation, such as Ad Reinhardt, would readily have done) to the Orient and the Occident; he was not fascinated with Asian religions. Elaine de Kooning reported in 1957 that "When someone once asked him if his thinking had anything to do with

the Zen Buddhism that was sweeping the art world recently, he replied, 'It took five hundred years to produce a Renaissance man: here I am.'" Neither would Rothko admit to any leanings toward mysticism: "His paintings are sometimes explained in mystical terms," noted de Kooning, "but Rothko disclaims mysticism."[21] Rothko's religious affinities centered around the Judeo-Christian tradition, in short, or at least around the outward forms of that tradition—as hollow as he knew they had become.

### Expressionism

In the 1920s and 1930s Rothko's favored subjects were predominantly secular rather than sacred. The majority of the pictures from these years involve figures, either in domestic and urban settings or in landscapes, although he also turned his hand to the uninhabited landscape or the cityscape from time to time. When he was most under Avery's influence, Rothko's modest figure studies and genre scenes could be tranquil and banal (pl. I), but as often they were disturbingly enigmatic (figs. 6, 7). This enigmatic quality stems from ambiguities in the relations among the depicted figures, who often look as if they were in the midst of some tense but inexplicable domestic or social drama. In other instances a sense of anomie or estrangement prevails, either among the figures or between them and the places they inhabit. Throughout, Rothko's technique as a painter of the human figure was suffused with a heightened emotionalism manifest in the deliberate exaggerations of his drawing and, in the case of the gouaches and watercolors, in his ejaculatory brushwork. From the first, Rothko was an earnest and emotional artist, if not what would be called a natural or born painter. He handled watercolor and gouache with a degree of facility and authority, but he struggled for years to acquire a touch with oil paint. His early canvases often betray a muddied palette and a touch that was tentative and leaden by turns. (Not until the late 1940s did Rothko finally resolve his difficulties with oil paint, manipulating it to attain the delicate and direct effects he achieved from the first as a watercolorist.)

The style of Rothko's earliest pictures reflects his dependence on the Stieglitz circle modernism of Marin and Weber and his reverence for the Matissean art of Avery. By the 1930s, when those initial models became combined with and filtered through others, Rothko's pictures could safely be characterized as eclectic, though the dominant strain (as in Weber's mature work), is expressionist. Rothko's art of the thirties may be seen in relation to a broad, generally undistinguished vein of expressionist social realism found in New York in this socially conscious decade of the depression and the Works Progress Administration (WPA), the artists' assistance program that sustained him in 1936 and 1937. Rothko's work of the 1930s—such as his *Subway* scenes and his nudes (figs. 8, 7)—may invite comparison with Kirchner, Nolde, and German Expressionism generally, and with a diverse range of other sources, including Soutine,

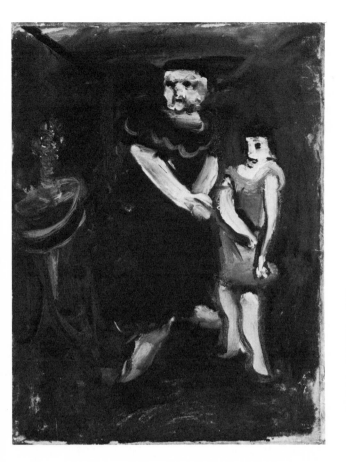

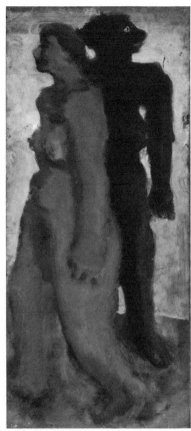

Rouault, Matisse, Hopper, and De Chirico. Usually the influence of the Europeans seems filtered by the mediating influence of one of Rothko's American mentors, however, for he effectually grappled with Matisse through Avery or Rouault and Soutine through Weber.

The exaggerated proportions of the figures in Rothko's early pictures and the skewed spaces they inhabit reflect the penchant for distortion that is associated with expressionism. Distortion was meant to manifest "an intensity of vision which tries to catch the throb of life, necessarily doing violence to external facts to lay bare internal facts," the artist Jacob Kainen explained.[22] In Rothko's paintings of the 1930s the internal facts tell visibly if obliquely of the strains, malaise, and privations of the depression. Though he was disinclined to paint slums, beggars, or unemployment lines, the misshapen figures that populate his pictures appear oppressed or even menaced by the cramped, tilted, and flattened spaces they inhabit. Color is only meagerly in evidence; the pictures of the early 1930s are typically dark and murky (fig. 6), and those of the later 1930s (fig. 8) generally whitened or bleached-looking. The human figures in the dark scenes of the early 1930s often appear bloated, almost elephantine (fig. 7), and are sometimes rendered with strangely colored, red, green, or chartreuse skin (the man in fig. 2, for instance, has a green head). In

6
Untitled, 1930s, oil on canvas, 25¼ × 19³⁄₁₆ in. Collection of the National Gallery of Art, Washington, D.C. Gift of the Mark Rothko Foundation, Inc. *above left*

7
Untitled, 1930s, oil on canvas, 39½ × 17⅝ in. Collection of the National Gallery of Art, Washington, D.C. Gift of the Mark Rothko Foundation, Inc. *above right*

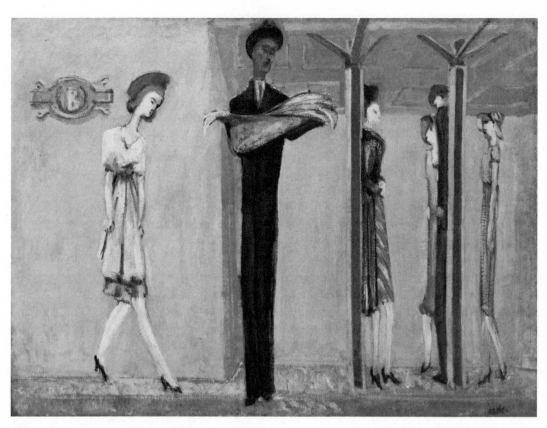

8
*Subway,* 1930s, oil on canvas,
34⁵/₁₆ × 46½ in. Collection of
the National Gallery of Art,
Washington, D.C. Gift of the
Mark Rothko Foundation, Inc.

the pale paintings of the later 1930s, the human bodies are often spindly, attenuated, and ashen (as in fig. 8). Throughout, Rothko's figures tend to be solitary or, if in groups, mutually uneasy or disconnected. Discussing in later years the problems associated with painting the human figure, Rothko referred to the figure's inexorable isolation: "Nor could the solitude be overcome. It could gather on beaches and streets and in parks only through coincidence, and, with its companions, form a 'tableau vivant' of human incommunicability"—a passage that evokes unmistakably the tone of his own early pictures.[23]

In New York in 1935 Rothko and Adolph Gottlieb helped organize a group of more or less like-minded, struggling artists, which they called The Ten (although the number of members and the members themselves were often in flux). The organization was formed in an attempt to surmount through collective action the difficulties of finding gallery representation or patrons for unknown and unproven artists with such implacably glum visions. Expressionist painters in the 1930s felt that they "had in a way the mark of the damned on them and were homeless in the art arena," as one member of The Ten, Joseph Solman, put it. "This was because the term expressionist was esthetically subversive at the time."[24] The Ten held fairly regular exhibitions until 1939, including "The Ten: Whitney Dissenters," a show timed to coincide with the Whitney Annual Exhibition of 1938, to illustrate the distinction between those artists fol-

lowing an approved line and the self-identified subversives who were challenging the status quo. "The symbol of the silo is in ascendency in our Whitney museum of modern American art," charged Rothko and Bernard Braddon in the Dissenters' catalogue. Further, "A public which has had 'contemporary American art' dogmatically defined for it by museums as a representational art preoccupied with local color has a conception of an art only provincially American and contemporary only in the strictly chronological sense."[25]

Some leftist critics gave a cordial reception to The Ten, praising them for combining "a social consciousness with [an] abstract, expressionistic heritage, thus saving art from being mere propaganda, on the one hand, or mere formalism, on the other."[26] To many advanced artists in the 1930s, propaganda and formalism were the twin perils—their Scylla and Charybdis—and expressionism promised a legitimate course between the two. Rather than illustrate politically charged scenes as the propagandizing or ideologically motivated Social Realists were doing, Rothko tried to make activist art by expressing his concerns directly and materially through the emotionalism of his drawing, the exaggerations of his palette, and the urgency of his touch. Expressionism is "a cry of distress, like a stream of lava forcing itself forward prompted by the soul's misery and a ravenous hunger after life," wrote Oskar Pfister, a pioneering amateur scholar of psychoanalysis and art whose writings Rothko read in the late 1930s.[27] Pfister further observed that "we encounter . . . expressionism in our artist at a time when he is in a state of mental discord, when there is a rift between him and reality or even when there is such a rift within the soul itself."[28] For those who felt the need to describe or communicate turmoil, both inward and external, expressionism could appear to offer an effective rhetoric or means.

Many leftist artists embraced expressionism during the 1930s as a radical art form, a suitable "vehicle for a socially revolutionary consciousness."[29] The fact that the Nazis (after initially courting and winning the allegiance of some expressionist writers and artists—the handiwork of Goebbels in 1932–33) denounced and ridiculed expressionist modes of art, calling it degenerate *kulturbolschewismus,* only served to reinforce this viewpoint. Less often observed were the similarities and the relation between the rhetoric of the expressionists and that of the fascists, a relation that became especially manifest in the case of Emil Nolde, who joined the Nazi party as his romance with the myth of his Nordic roots, with "blood and soil," seeped into racism. In an essay on the "Rise and Fall of Expressionism" written in 1934 (one year after the National Socialist Party's victory), the Marxist Georg Lukacs stated categorically: "Without doubt, expressionism is only one of the many bourgeois ideological currents eventually leading to fascism, and its role as ideological preparation is not any more or less important than currents of the imperialist epoch, inasmuch as they express decadent parasitic features, including all the fake revolutionary and oppositional forces." Expressionism's "extraor-

dinary poverty of content marks a blatant contradiction of the pretense of its performance, of the hybrid subjective pathos of its representation," argued Lukacs, a partisan of realism.[30]

Expressionism was also decried as a reactionary movement by those leftists who (like Theodor Adorno rather than Lukacs) were inclined to champion modernism rather than realism. In the face of the radical assaults made by Picasso, Duchamp, Malevich, and others on the languages of mimetic representation, the expressionists clung tenaciously to the practice of depicting the human figure, and declined any far-reaching challenge to the authority of the coherent, recognizable, or readable image. A contrast may be drawn between those "artistic movements with great potential for the critical dismantling of the dominant ideology" and those artists who "act to internalize oppression . . . in haunting visions of incapacitating and infantilizing melancholy," as Benjamin Buchloh phrased it, arguing that those visions that insist on despair and powerlessness convey a message of the futility of taking action and thereby serve to ratify social and political inactivity. Buchloh argues further that the expressionists' project of giving visual form to suffering and psychic distress was confined largely to the plane of personal or private, in contrast to social or collective experience, with the expressionist idiom serving as a vehicle for the sublimation of anguish rather than as a mode of converting anguish into something disruptive; thus, "The bourgeois concept of the avant-garde as the domain of heroic male sublimation functions as the ideological complement and cultural legitimation of social repression."[31]

Whereas Rothko and The Ten intended their work as a form of radical activity, from any perspective but that of academic painting their art was less extreme than they pretended, and mainstream critics did not hesitate to point this out. A despondent woman painted with feeling by Rothko was not so different from a despondent woman painted with feeling by Raphael Soyer, unless it was for Rothko's lesser technical facility. Although he had ambitions to belong to the vanguard from the outset, Rothko did not arrive at a radical way of painting for many years. Not until 1938 did he pronounce himself willing in principle to forego the conventions of local color and mimetic form; and not until three years later did he find the courage to follow through with this scheme. The only type of radical art that Rothko could envision in 1938 was radical in the sense of relating to roots; it demanded of artists that they "see objects and events as though for the first time, free from the accretions of habit and divorced from the conventions of a thousand years of painting."[32]

Rothko eventually mustered the willingness to reexamine the means of painting, to attempt to begin art over again, to renew it. In the end this ambition enabled him to set himself apart from the most recognized of the preceding generation of American artists, the Regionalists and the Social Realists. What reinforced that separation was Rothko's disavowal of a narrowly ideological or nationalist perspective. In practice, his readi-

ness to come to terms with contemporary European art seems to have been hastened by the growing necessity to become informed about international politics. Two years after the onset of the Second World War, the scope of Rothko's vision became noticeably wider, as he struggled to strip his art of anything insular or niggling. By 1943 he, Gottlieb, and Newman could finally declare, with some measure of justification, that their art should "insult anyone who is spiritually attuned to interior decoration; pictures for the home; pictures for over the mantle; pictures of the American Scene; social pictures; purity in art [a euphemism for nonobjectivity]; prize-winning pot-boilers; the National Academy, the Whitney Academy, the Cornbelt Academy; buckeyes, trite tripe; etc."[33]

## Rothko's Political Education

Rothko's vision of himself as a dissident and his scorn for provincialism must be seen in the context of his background. He was born Marcus Rothkowitz, a Jew, in Dvinsk in Russian-occupied Latvia in 1903. His father, Jacob, was a pharmacist, and Marcus was the fourth and youngest child, the third son. His infancy—whatever imprint it left on him—was passed in tumultuous times. While the Russo-Japanese war diverted Russia's armies, the country erupted with peasant uprisings and strikes culminating in the Bloody Sunday Massacre and the violent revolution of 1905. Counterrevolutionary propaganda blamed Russia's ills on an accustomed scapegoat and target of persecution: the Jews, who were subject to pogroms and to ghettoization, on top of a multitude of other abuses, deprivations, and indignities.[34]

Like many Jewish families, the Rothkowitzes planned to emigrate but managed to do so only in a staggered process that resulted in difficult and disjointed childhoods for their offspring. When Marcus was seven years old, his father left for the United States, settling near relatives in Portland, Oregon. One year later the two older boys made the trip, escaping before they were old enough to face conscription. Several years later still, Marcus, his mother, and sister joined his father and brothers in Portland; but within months of the long-awaited reunion, his father died, leaving the family with scarce resources besides the charity of relatives. As a child, Marcus had to hawk newspapers on the street corners of Portland to help support his family. His early paintings frequently involved scenes of a mother alone with one or two children, often a girl and a small boy—sometimes in public or institutional-looking spaces, like waiting rooms, sometimes on a city street or in a domestic setting (figs. 9, 6). These scenes, which seem to have been painted from memory rather than from models, suggest that Rothko may have been conjuring his own hard, fatherless youth. One painting entitled the *Rothkowitz Family* (fig. 10) might be seen as Rothko's fantasized image of his mother proudly presenting a naked male infant, presumably Marcus, to her overjoyed husband.

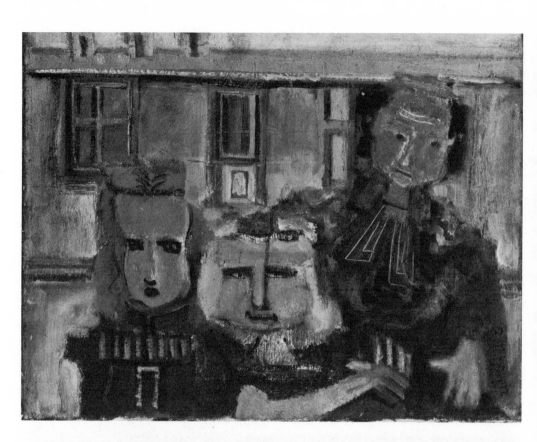

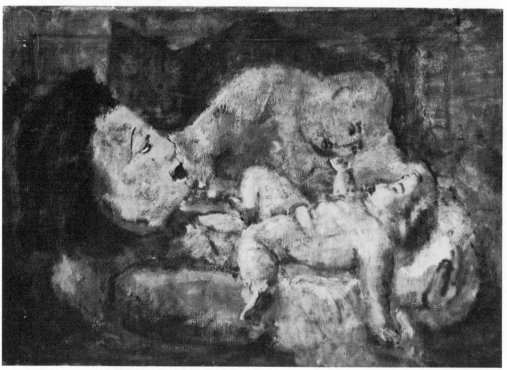

Though he left Russia when he was still a child, Rothko remained "very conscious of his sources, both as a location—place of birth—and as a cultural heritage," according to a friend, the poet Stanley Kunitz. Rothko "often referred to the fact" that he was born in Russia, Kunitz added. "I think in a way it suited his feeling of alienation."[35] Whether his heritage simply suited or rather helped induce and reinforce his feelings of alienation, friends and acquaintances almost invariably remark on his pronounced ethnicity when describing Rothko. "I always thought of Rothko as very Russian," said Dore Ashton. "Or at least Russian like the Russians in Turgenev. . . . His childhood language was Russian, and he remembered the knout on the end of the Cossack's whip."[36] That whip had politicized Rothko's parents, and as the self-described "son of political radicals" Rothko was politicized at a tender age. He reminisced that he "grew up as an anarchist long before I could understand what politics was all about. While I was still in grade school I listened to Emma Goldman and to the I.W.W. orators who were plentiful on the West Coast in those days. I was enchanted by their naive and childlike vision."[37] He became politically active in high school, partly in response to the discrimination he experienced as a Jew and a poor Russian émigré.[38] As a teenager he took up debating and dreamed of becoming a lawyer and a labor leader.

The ostracism that Rothko experienced growing up in Portland prepared him only marginally for the institutionalized prejudice he encountered subsequently as a Jewish immigrant at an ivy league college in the 1920s. Rothko's strong scholastic record gained him a scholarship to Yale University, where he studied from 1921 until 1923, when the school revoked its support and he abandoned plans for a college degree.[39] Though he spent just two years there, he managed to leave his imprint at Yale. Appalled by the complacency and conservativism of his privileged fellow students, Rothko started an anarchist student newspaper with a couple of friends. It was a confused and sophomoric effort, alternately brash and tentative, but a feisty gesture all the same. The editors of the *Yale Saturday Evening Pest* proclaimed: "We are lost when we make any attempt to account for the undergraduate not being in the vanguard of every new and old political, artistic, philosophic or scientific movement, and the campus not being the most sanguinary battle field for all conflicting ideas." They hoped to provoke debate and politicize the unobservant student body. "Politics, national and international, will receive our attention," they promised. "The tropics of Africa and the steppes of Russia will get their due share of discussion. In economics we shall express our views on the capitalist system of production. And if then we are not suppressed, we shall continue to tell you what we think of socialism and sovietism, immigration and poverty."[40] Modest controversy ensued: the *New Haven Journal-Courier* reported that the *Pest* was run by " 'foreign intellectuals' who have a reputation for radicalism"; an alumnus deemed the *Pest*'s "muckraking" worthy of "malcontents and foreign agitators";

The Mutilated Figure
53

9
Untitled, 1930s, oil on canvas, 16¹⁄₁₆ × 20¹⁄₁₆ in. Collection of the National Gallery of Art, Washington, D.C. Gift of the Mark Rothko Foundation, Inc. *opposite above*

10
*Rothkowitz Family*, 1930s, oil on canvas, 20³⁄₁₆ × 30¹⁄₈ in. Collection of the National Gallery of Art, Washington, D.C. Gift of the Mark Rothko Foundation, Inc. *opposite below*

and Sinclair Lewis (another alumnus) communicated his congratulations: "I trust that [the *Pest*] has been successful enough so that you will have been severely blamed."[41]

Soon after Rothko dropped out of Yale, he moved to New York City and enrolled at the Art Students League. His interest in politics waned, he said, because "everything seemed so frozen and hopeless during the Coolidge and Hoover era."[42] The Roosevelt years were a different story, and Rothko's political interests were rekindled for a time. In 1934 he joined the Artists' Union, and in 1936 he joined the newly formed American Artists' Congress, groups that lobbied for expanded federal relief programs for artists. Rothko held the welcome lifeline, employment on the easel project of the WPA, during 1936 and 1937. Joseph Solman, a fellow member of The Ten and "the project," recalled:

The WPA artist quickly became aware of his social environment; first, because he had to go through the gauntlet of home relief before he was eligible to be employed by the project; second, he felt an inevitable alliance with the new surge of trade unionism for un-skilled workers (CIO) sweeping the country; third, the heated discussions taking place everywhere concerning the New Deal, the welfare state, socialism and communism in the U.S.S.R., particularly as depicted by the heroic films of Pudovkin and Eisenstein.[43]

The Artists' Union was one of the "most active participants in aiding picket lines anywhere in New York City," Solman boasted. Like his colleague, Rothko is said to have looked back with some nostalgia on the comradely activism of these otherwise ruinous years.

For artists on the project, the meager stipends they received were effectually enhanced by an unaccustomed sense of social integration. So heady was this newfound feeling of belonging that some artists were moved to renounce the elitism endemic to difficult forms of modern art in favor of more accessible styles and explicitly relevant subject matter. This budding spirit of populism gave rise to some extravagant expectations by critics. "Art for art's sake has completely disappeared, and art has been given a purpose," wrote Martha Davidson of *Art News* in 1936. "There is no waste in work that has this function. . . . The eclecticism of the past is gone and the government, in the role of the Medici, is fostering an American Renaissance."[44] The artists on the project failed to justify such inflated expectations but not for want of trying. One year after heralding an American Renaissance, Davidson reviewed one of the numerous exhibitions with political themes in the 1930s, a show called "In Defense of World Democracy: Dedicated to the Peoples of Spain and China." She was disappointed to find that the mania for relevance had resulted in kitsch, and that the art, however timely, was characterized by "crass realism" and "obnoxious sentimentalism." The great problem confronting artists, Davidson sagely concluded, was the bonding of subject matter and medium into "an artistic language that has esthetic value."[45]

Like his future associates in the (as yet unnamed) New York School, Rothko never made explicitly political or propagandistic art, and he did

not fall prey to obnoxious sentimentalism. A writer who met Rothko in 1935 has recalled that the painter "had no objection to picketing for the immediate preservation of jobs, but he strenuously opposed the injection of politics into art, which he felt simply resulted in bad art."[46] But Rothko's often labored renderings of mundane subjects scarcely answered the mandate for an art that was deeply responsive to the gravity of current events. By the late 1930s he felt more keenly than ever the disconcerting lack of fit between the relative conservatism of his artistic vision and the liberalism of his other views. The visual idioms of realism had begun to acquire an unfamiliar bad odor in certain liberal circles in New York, further, both because of the odious chauvinism of some of the most prominent realists, the American Scene painters, and because realism was championed (and all manifestations of modernism banned) by the fascists and the Soviets. The more abstract modes of modernist art—or "art for art's sake," as it was often referred to in the press—were hardly in much better odor, however, being regarded as either elitist or decorative and trivial. Rothko was caught in a bind, and he began to cast about for a different way, a more apposite and compelling way, to paint pictures.

## The Mandate for Social Content

At the beginning of his career, Rothko had nurtured profound expectations for the potential significance of painting the human figure. Gradually he found he could not imbue the figure with the intense and complex emotions, the existential anguish, he wanted to impart to it and wanted it to impart in turn. He became disappointed with the figure when he realized, as he phrased it some years later, that it "could not raise its limbs in a single gesture that might indicate its concern with the fact of mortality and an insatiable appetite for ubiquitous experience in face of this fact."[47] In spite of these limitations, Rothko regretted having to give up the figure: "It was with the utmost reluctance that I found that the figure could not serve my purposes," he later remarked. "But a time came when none of us could use the figure without mutilating it."[48] It took a mutilated figure to express the violence against humanity rife in the late 1930s and early 1940s; Rothko found himself repelled by the act of distorting or maiming the figure, if only with a paintbrush.

Rothko's move to stop painting the human figure was hardly path breaking. Challenges to the primacy of figurative or representational modes of painting had been made since the 1910s. A multitude of factors underlay the decline of those modes (which began in the late nineteenth century), and the ways in which that decline occurred are highly complex. Certain implications of the advent of abstract modes of visual expression (for the first time in the West) can be at least broadly drawn, however. "Not the processes of imitating nature were exhausted," as Meyer Schapiro succinctly put it, "but the valuation of nature itself had changed."[49] Modern painters "do not believe, as did the poets, the philosophers and painters of the nineteenth century, that nature can serve as

a model of harmony for man, nor do they feel that the experience of nature's moods is an exalting value on which to found an adequate philosophy of life. New problems, situations and experiences have emerged: the challenge of social conflict and development, the exploration of the self, the discovery of its hidden motivations and processes, the advance of human creativeness in science and technology."[50]

Even before the onset of World War II, the 1930s had brought an onslaught of new problems, situations, and experiences. And in the midst of social crisis and conflict, many artists and critics felt a tacit challenge: to prove that art still had a valid place, a role of some significance, however reduced or altered, and a claim on the public's attention. The perceived burden was to prove that art is, in its own way, not merely a luxury but a form of social necessity—or at least a salutary force in society. In American art periodicals the call went out for art with "social content," whereas "art for art's sake" (the supposed antithesis of art with social content) came under even more attack than usual. Abstract artists were scolded to leave their proverbial ivory towers and charged to make of their work something newly responsible, purposeful, and timely, to make art as gravely serious as the seriousness of the moment at hand. Rothko's prolonged aversion to abstract art and his quest for an art with significant subject matter must be seen in light of these attitudes or pressures and the time that gave rise to them.

By the late 1930s in the United States and Europe, artists were faced with formidable questions: whether and how to take political action, whether political action should or could be explicitly implemented in art work, and how works of art might convey a seriousness in keeping with that of world events. "Essentially the problem is no longer that of knowing whether a picture can 'hold its own' in, for instance, a cornfield," observed André Breton in 1939, "but rather whether it can hold its own beside a daily newspaper, which is a jungle." Speaking for the surrealists, Breton explained: "We are not, of course, suggesting for a moment that artistic themes should be tied strictly to actuality; on the contrary. . . . But we still condemn as tendentious and reactionary any image in which the painter or poet today offers us a stable universe."[51] Judged by these criteria, the prevailing schools of American art in the 1930s revealed significant failings. The Social Realists doggedly offered visions of a universe that, however unpleasant, was at bottom coherent and stable, and the reactionary attitudes of the American Scene painters were betrayed both by their stylistic conservatism and by their staunch parochialism. Rothko and his friends viewed American Scene painting as a wrongful, shameful demonstration of jingoistic and isolationist sentiments. Said Barnett Newman, "First, the isolationists preached their cardinal political nationalist dogma that to have your own life you must repudiate the world. It followed that if you are to have your own art you must repudiate the art and artists of the world."[52]

Though Rothko was alienated from the American Scene, the School of Paris did not accommodate him either, despite its internationalism. Unlike earlier generations of American modernists, Rothko's generation was largely prevented from making the once requisite pilgrimage to Paris—still glamorous, if fading perceptibly in its role as capital of the art world. But the distance between Rothko and the School of Paris was more than a matter of geography or funds. What impressed him adversely about the School of Paris was its lack of a moral and political con-science—as he saw it—and its concomitant failure to respond to the prevailing state of political emergency. Eventually, Rothko came around to acknowledging the achievements of Matisse, for one; but the students he taught in California in the late 1940s report that he and Clyfford Still "yakked, yakked, yakked against" the "French tradition,"[53] and in an in-terview in the early 1950s Rothko was still making a point "of the differ-ence between his work and the French tradition."[54] Despite widely held assumptions to the contrary, in short, Rothko consistently disclaimed an affinity between his art and that of the School of Paris, which he dispar-aged as an arena for aesthetes. Rothko "esteemed Matisse as the greatest revolutionary in modern art," he told Irving Sandler. "Yet he himself in-sisted that he was no colorist, wishing to disassociate himself from hedo-nistic painters."[55]

The ethical impetus behind the enterprise of the New York School has been noted often enough. Elaine de Kooning believed that what dis-tinguished Rothko and his circle from "their European fore-runners or contemporaries," was "the moral attitude which they shared toward their art; that is to say, they saw the content of their art as moral rather than esthetic. Subject matter, not style, was the issue, and they had a new atti-tude toward it."[56] A moralistically motivated insistence on the implemen-tation of serious subject matter and a heightened emotionalism separated Rothko from the School of Paris, as well as from the constructivist and neoplasticist strains of abstraction that had emerged from Russia, Ger-many, and the Netherlands. The same factors helped align Rothko, first with expressionism (or "Germanizing" tendencies as Greenberg termed them) and subsequently with surrealism.

Transition: The Early Years of the War
During the turning years of each successive decade, Rothko passed through his most intense periods of exploration and change; and this was never more the case than at the beginning of the 1940s. The transforma-tion that occurred in his art then can be seen by comparing one of his plainly legible images of daily life, *Subway* of the 1930s, with a fantasy painting like *Antigone* of circa 1941 (figs. 8, 3). Mundane scenes yielded to mythological fantasies rendered in an idiom informed by surrealism. Although there remain some links between Rothko's representational

paintings and his subsequent work, he regarded this particular transition as so fundamental that he later declined to exhibit or discuss his figurative work, except to state that his viewpoint had been "reformed."

The crisis of artistic identity that Rothko underwent around 1941 followed a crisis of political or national identity brought on by world events. As the Soviets were in the process of befriending the Nazis, Rothko severed his remaining ties with Russia: he became a U.S. citizen in 1938 and soon afterward began using an anglicized version of his name— Marcus Rothko, at first (though the change was not made legal until 1958). In 1940 Rothko joined a group of artists who broke with the American Artists Congress because it sanctioned the Soviet invasion of Finland. With the same renegade group, he helped found the Federation of Modern Painters and Sculptors, which denounced totalitarianism unconditionally and espoused a globalist perspective. After the United States entered the war, Rothko reportedly volunteered for military service but failed to pass the physical exam.

Artists are by profession ill-suited to help with military campaigns except in marginal ways like making posters or designing camouflage. But American art magazines charged artists with weighty responsibilities during World War II. Art was said to represent the freedoms the Allies were fighting for, and American artists were told that by virtue of their geographical advantage they might be responsible for the very survival of art. They were told, in short, that the war presented them with an awesome and unprecedented opportunity—that a crippled Europe might be forced to cede artistic hegemony to the United States. "When peace comes our culture will be offered the dominant place in the world," prophesied Alfred Frankfurter, editor of Art News. "Can we do it? Can we forge an artistic pattern fit for leadership?"[57]

In some circles, the war effort and the efforts of artists were considered mutually reinforcing. This attitude was countered, however, by "the threatening public conviction that art is a mere sunny-day pastime unconcerned with human realities and therefore a dispensable luxury in wartime."[58] Philistine bromides like What good is painting, anyway? sounded rather thought-provoking in wartime, and many artists felt compelled to answer that tacit challenge, to explain or justify their work. The 1940s brought an outpouring of artists' writings and a proliferation of the little magazines that printed them: VVV, View, Tiger's Eye, Iconograph, Possibilities, and Dyn, to name a few. Rothko made more public statements during the 1940s than at any other time of his life. Despite his reputation for being loquacious, he was ill at ease issuing written position statements and felt impelled to do so only by the circumstances and the opportunities that were pressed upon him. "When the intellectual habits of his culture become radically changed, the artist must concern himself with 'theories' whether he wants to or not," suggested Wolfgang Paalen, the surrealist who founded Dyn in 1942.[59] Besides formulating theories, many artists felt impelled to renovate their work to reflect their height-

ened social consciences. Roberto Sebastiano Matta Echaurren, one of the so-called surrealists in exile, recalled that he "tried to pass from the intimate imagery . . . to cultural expressions, totemic things."[60] Later he explained, "The war was becoming a ferocious thing. I couldn't ignore it any more. I began to feel 'society' in a new way, for the first time. . . . And then I passed, in my work, to these anthropomorphic things."[61]

Matta remembered that the American artists he knew were also moved by concern for the human condition to work with anthropomorphic things. Pollock "wanted to reach the figure too, to return to the 'old-new,' as I see it. One of the last things Gorky said to me was that he wanted to get some kind of human reference in his work. And de Kooning did too."[62] Matta evidently did not know Rothko, who was also trying to maximize the human reference in his work. Paradoxical as it may seem, Rothko stopped painting the human figure in order to achieve this. As he began to depart from the conventions of mimetic art, Rothko looked to the example of the surrealists, who were actively subverting and transforming those conventions. Following the example of some of the surrealists, Rothko also turned to myth and to Greek tragedy in search of the weighty subjects called for by the cataclysmic times.

# 3

# Mythmaking

André Breton published the "First Surrealist Manifesto" in Paris in 1924 with the following definition of the term:

Surrealism, *n.* Pure psychic automatism by whose means it is intended to express verbally, or in writing, or in any other manner, the actual functioning of thought. Dictation of thought, in the absence of all control by reason and outside of all aesthetic or moral preoccupations.[1]

This ambition to pursue the process of creation free of controls and conventions, either moral or aesthetic, Breton assimilated in part from the disintegrating dada movement. From dada also came the surrealists' interest in finding mechanisms for disruption, in the exploitation of chance and accident, and in importing radical new freedoms to art and literature generally. In the ways they cultivated this artistic freedom, the surrealists were less anarchic and impulsive than the dadaists, whose unswerving commitment to irregular media and techniques contrasted with the surrealists' at times highly conventional modes of working. Although surrealism was often theorized in political terms, further, it tended in practice to be a less politically directed movement than dada. The devices of psychic automatism that the surrealists contrived placed a greater burden and emphasis on internal processes, on plumbing the unconscious, than on external affairs. But by injecting elements of the irrational, the disorderly and unexpected into the accustomed order of things, fantasy into the stream of daily realities, the surrealists hoped to dislocate or dislodge common sense and so to reap real social consequences.

The surrealists were committed to engaging the processes of the unconscious mind—dreaming, fantasy, and hallucination—in the processes of creating art: "Surrealism is based on the belief in the superior reality of certain forms of associations hitherto neglected, in the omnipotence of dream, in the disinterested play of thought," wrote André Breton, the self-appointed (if not universally acknowledged) spokesman for the group.[2] The surrealists proposed to facilitate the expression of the unconscious by writing or drawing from a stream of consciousness and through contrived aesthetic accidents—techniques designed to disarm the habitual functioning of the rational, skeptical conscious mind. By augmenting their visions of the empirical or so-called real world with material from the

world of fantasy, the surrealists hoped to construct a fuller, more profound realism—*sur*-realism. In the 1940s some American artists formulated a parallel objective; Rothko, Gottlieb, Newman, and others proposed to combine the real and the unreal to arrive at the more profound realism of myth. They came to see themselves as mythmakers.

Surrealism made its existence known in the United States gradually over the course of the 1930s and 1940s. The Museum of Modern Art held a major exhibition called "Fantastic Art, Dada, Surrealism" in 1936; and there were gallery exhibitions (most notably at Julien Levy's and in the 1940s at Peggy Guggenheim's Art of This Century gallery), catalogues, magazines, and occasional emissaries from abroad. By the time a group of "surrealists in exile"—Breton, Masson, Ernst, Matta, Tanguy, and others—came to stay in the United States during the war, American artists had already had opportunities to acquaint themselves with surrealism. The artists of the fledgling New York School were among those most decisively affected by this latest news from Paris; and the arrival of the Europeans themselves appears to have been the catalytic factor, as the influence of surrealism became most apparent only after 1940 or 1941. Rothko was reportedly among the American artists who were deeply impressed by a series of lectures by a surrealist latecomer, the English artist Gordon Onslow-Ford, at the New School for Social Research in New York in 1941.[3]

Onslow-Ford had become a convert to surrealism in 1937 through a friendship in Paris with Matta. Within a year of encountering Matta's work, he had stopped working from nature to "let nature work through me in the guise of automatic drawings." His newfound aspirations were "to paint things felt but not seen . . . to give form to sensations . . . to metamorphose two entities such as a woman and water, not in an illustrative way but in a concrete way" and above all to work his way "towards a new subject in painting." "For me the most vital element of a painting is subject matter," declared Onslow-Ford, who added that he conceived of subject matter "in terms of drama rather than aesthetics."

The subject matter of a painting is the personal affair of the painter. Its interest lies in its novelty, and its capacity to communicate vision. Hence it cannot be taught, nor can it be sought after directly with the intellect. The painter's subject is the core of his life. . . . I believe that, after a period of unprecedented experimentation, we are at the threshold of a new art in which the subject matter will be derived from a world of vision that has only recently been isolated as worthy of attention in itself. . . . This new art will be a synthesis of the "how to paint" and "what to paint." It will incorporate a new poetic subject in terms of a new plastic form.

What Onslow-Ford also found in surrealism (and what helped to attract many of the Americans to it as well) was help in shaping "an ethical attitude suited to that particular moment in Europe. . . . It was a great privilege . . . to be admitted to a group that had done so much to transform

the world and whose members lived with such devotion to their beliefs and with so little regard for pecuniary gain," he exulted.[4]

Of the artists in the nascent New York School, Motherwell and Baziotes became friendly with some of the surrealists, and Gorky was even a recognized member of the movement for a time, but Rothko and others of his circle were more inclined to keep their distance. This was in part a matter of language and cultural barriers, but it was also because the Americans did not want to risk becoming or becoming known as camp followers of the Europeans (some of whom were the same age or not much older than they were: Matta was born in 1912, Tanguy in 1900, for example). Further, the surrealist that the Americans generally respected most, Joan Miró, was not among those who had come to New York. Although there was only a limited personal closeness between the surrealists and the Americans they had influenced, their work could be seen side by side at Peggy Guggenheim's gallery in New York, which opened in 1942. As an émigré resident of Paris before the war, Guggenheim had been an early supporter of Alexander Calder's and—although she was generally more involved and interested in the European vanguard—as a dealer, she distinguished herself with a vision that was distinctly international and relatively nonprejudicial toward contemporary American artists. This evenhandedness proved a strong tonic to the Americans, who were used to taking a backseat to their more famous, more forward-looking European contemporaries. Guggenheim and her able advisers, including Howard Putzel and her erstwhile husband Max Ernst, have been credited as being principally responsible for launching the careers of some key New York School artists (most notably Pollock). Rothko could be numbered among them, as the first solo exhibition of his surrealist pictures took place at Art of This Century in 1945 and he was previously included in a group show there.

The American art that Guggenheim showed was predicated on the art of the surrealists but differed from it nonetheless: the Americans' work looked cruder, more direct, open, and unresolved, in part, no doubt, because they were charting unfamiliar territory, experimenting with borrowed idioms and a foreign set of aesthetic premises. The American surrealists were also less prone to using realistic and narrative imagery than most of the Europeans (although there were American artists outside of the New York School circle, the so-called Magic Realists, who emulated Dali's practice of using hyperrealistic techniques to realize his fantasy scenes).

Of the Americans, Gorky, Gottlieb, and Baziotes eventually arrived at cogent, distinctive modes of expression founded on and suffused with the idioms of surrealist art, and there are works of art from the early 1940s by Pollock and Smith that use surrealist models and techniques to compelling effect. The early work of other New York School artists generally reveals a less complete or sustained assimilation of surrealism, however, and Rothko took an especially eclectic approach to the surrealist

program. The stylistic diversity in his work of the 1940s bears witness to an omniverous curiosity and a continuous process of experimentation (figs. 3, 12, 13, 34, 37, 38 and pls. II, III, for example). That process intermittently yielded a group of more or less successful works in a similar vein, but no truly distinctive vision ever coalesced. Rothko approached surrealism with the spirit of an unabashed and impressionable explorer, looking at whatever he could find and taking note of whatever looked useful. A knowledgeable viewer might detect in his art of around 1941 to 1946, the influence of Miró, Masson, Ernst, Matta, and Gorky, as well as of artists who influenced them: De Chirico, Kandinsky, Klee, Picasso.

Another artist who may have helped to inform Rothko about surrealism was the eccentric Russian émigré painter John Graham (who was briefly a member of The Ten). Because he had traveled abroad and met some major European artists, Graham passed in New York as an expert on artistic developments in Paris. In articles for *Art Front* and in *System and Dialectics of Art,* a quirky treatise he published in 1937, Graham expounded ideas culled from surrealism and obliquely from Jungian theory. "The purpose of art in particular," Graham asserted, "is to re-establish a lost contact with the unconscious (actively by producing works of art), with the primordial racial past and to keep and develop this contact in order to bring to the conscious mind the throbbing events of the unconscious mind."[5] The titles of Rothko's paintings from the early 1940s indicate that he was intrigued by the possibility of such psychic telegraphy. His titles allude to atavistic memories (*Prehistoric Memory, Geologic Memory, Vernal Memory, Tentacles of Memory*) and oneiric images (*Heraldic Dream, Dream Struggle, Dream Imagery*). Many of Rothko's titles from this period consist of a word suggesting an unguarded, intuitive state of mind paired with a word that suggests prehistory, myth, or ritual, thus: *Archaic Fantasy, Ancestral Imprint, Geologic Revery,* and *Votive Mood.* Other recurrent themes involve ritual, rites, and archaic dramas: *Processional, Ceremonial Vessel, Baptismal Scene, Ritual, Rites of Lilith, Incantation, Olympian Play, Nocturnal Drama, Aquatic Drama* ("I think of my pictures as dramas," Rothko said in 1948, after he ceased using such titles).[6] Also recurrent are titles alluding to primordial origins (*Beginnings, The Source, Conscious Genesis, Genetic Instant, Matinal Orgy, Vibrations of Aurora*) as well as to rites of death (*Sacrifice, Crucifixion, Entombment*).

## Surrealism and Subject Matter

Herbert Ferber, a sculptor in the New York School ambit, has said that Rothko "often mentioned that Surrealism was one of the strongest and most fruitful influences in his work";[7] and Rothko was rarely given to such acknowledgments. What continued to impress him and his peers about surrealism, even as they rejected other aspects of the movement,

was its innovative and effective approach to subject matter. "In New York it is now admitted that Surrealism is dead," wrote Barnett Newman around 1943–45. "[But] while the dying are being kicked, it is well to remember that Surrealism has made a contribution to the esthetic of our time by emphasizing the importance of subject matter for the painter."[8] Subject matter was a focal concern for Newman, Rothko, and others of their group throughout their careers, but that concern reached a peak during the war years. Faced with the need to devise a thoughtful strategy for making meaningful art—art with significant subject matter, as they saw it—at a time of global crisis, Rothko and his contemporaries were largely (if understandably) stymied. They had come to feel keenly the limitations of realist or representational techniques, which entailed constructing a falsely coherent and stable picture of the world; but in a time of rampant destruction, they did not want to fracture wantonly their images of the world; nor did they want to give up making images that the viewing public might expect to understand.

The art of the surrealists—especially that of Miró, Masson, Matta, Ernst, and eventually Gorky—demonstrated a fertile middle ground between those supposedly arid realms of realism and abstraction. The surrealists had shown, too, that the subject of a work of art need not be a closed or circumscribed theme, plainly legible to artist and viewer alike, but that artists could reveal or realize their sense of turmoil by scrambling their subjects and images in hopes of eliciting an answering uneasiness from viewers. The New York School artists admired the way the surrealists evaded a conventionally narrative or illustrative approach to their subject matter without succumbing to the perceived esoterism and unintelligibility of so-called pure abstraction. The surrealists' subjects were not completely unintelligible but worked by means of suggestion and evocation. Most importantly for the course New York School art would take, the surrealist model implied that an artist's subjects could be grounded in and integral to the process of creation itself.

It was not just the surrealists' concern for subject matter but also their bias against abstraction that appealed to the artists in Rothko's circle. "Have you ever heard of greater nonsense than the aims of the abstractionist group?" Miró once asked. "And they invite me to share their deserted house as if the signs that I transcribe on a canvas, at the moment when they correspond to a concrete representation of my mind, were not profoundly real, and did not belong essentially to the world of reality! As a matter of fact, I am attaching more and more importance to the subject matter of my work. . . . To me it seems vital that a rich and robust theme should be present to give the spectator an immediate blow between the eyes."[9] Although he initiated them, at least in principle, by conjuring signs from his unconscious, the themes of Miró's pictures are often surprisingly traditional. Miró painted portraits, landscapes, genre scenes, and whimsical anecdotal stories, about a *Person Throwing a Stone at a Bird* (fig. 11), for example. The person in this picture of 1926

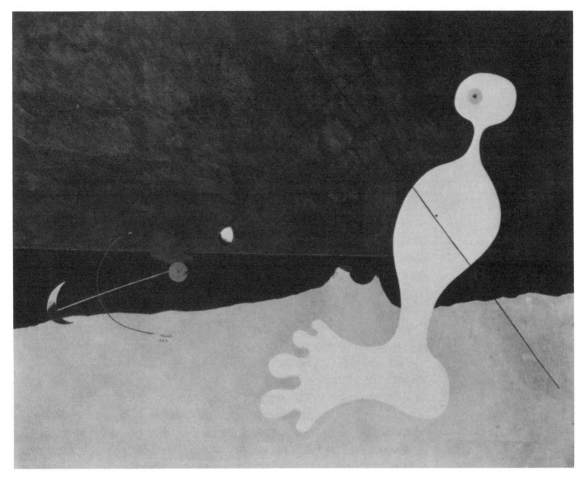

11
Joan Miró, *Person Throwing a Stone at a Bird,* 1926, oil on canvas, 29 × 36¼ in. Collection of the Museum of Modern Art, New York. Purchase.

is a bald, white cyclopean figure shaped like a baluster with a giant foot. The bird is a crossbow-shaped, stick figure, whose round head is capped with a cock's comb. And the trajectory of the stone used to pelt the bird is graphically indicated with a dotted line. Despite their fantastic aspect, Miró's signlike or cartoonlike person and bird are readily discerned; they are not so strange as to be unintelligible, just strange enough to create an engaging ambiguity. Does the person stone the bird out of fear, hunger, or cruelty? Is the person too primitive to know of other ways of felling a bird? Set in a stark, schematic, otherworldly landscape, the scene assumes an evocative, timeless, and primal quality that it would lack if rendered as a realistic hunting scene with literal period details.

In affirming that artists could involve the unconscious in determining and realizing their subjects and in shaping subjects that were purposely enigmatic, the surrealists made strides down a path initially ventured by the symbolists. The artists in Rothko's circle found the path equally alluring, and they traveled further along it. As the Americans experimented with ways of working from the unconscious, they discovered for themselves the slippery subject matter—multivalent subjects, half-revealed,

half-concealed—that the surrealists had pointed to. For artists in Rothko's circle, as for many of the surrealists, pioneering these ways of realizing subjects meant retrieving subject matter itself as a proper concern of the avant-garde and as an arena for expressing concern and distress when they felt most urgently the need to do so. Breton had at first pronounced surrealist art to be free of moral considerations, but wartime pressures caused an about-face, as he and some other surrealists talked increasingly in moralizing terms of the need for meaningful subject matter. When Miró commented in 1941 that he "attached more and more importance to the subject matter" of his work, then, he was not speaking only for himself.

The surrealist movement was initially dedicated—on paper if not always in practice—to acts of subversion, to sowing confusion, but the onset of the war brought a changed view of art as the "formulation of meaningfulness," to borrow a phrase from the surrealists Wolfgang Paalen and Edward Renouf. The idea that art should be an instrument and a mode of emancipation was not discarded, but it acquired some more immediate connotations. The mandate to use art to upset the complacent bourgeoisie was replaced, at least in some quarters, by a mandate to use art as an instrument for healing—with the assumption that the bourgeoisie was, along with everyone else, sufficiently distressed for the time being. The attitudes of Paalen and Renouf are representative of the surrealist movement in this regard: as founders and editors of the magazine *Dyn,* these "surrealists in exile" devoted themselves to reconstructing the deteriorated "bridge between art and life." For an exemplar of the integration of art and life, they pointed to tribal societies. They praised the Indian sculptors of the Pacific Northwest, for example, because these sculptors talked of art in terms of truth rather than beauty. Paalen suggested that "conceiving of works of art in terms of 'right' or 'wrong' implies their perfect interrelation with the fundamental problems of the community which produces them."[10] He endorsed surrealism because it also was devoted to seeking truth—devoted, that is, to using psychic automatism as a tool for reaching into the unconscious in search of inner truths. Psychic automatism could also be seen as "an attempt to give a new collective basis to artistic creation through the liberation of the unconscious."[11] What automatism dared to promise, in short, was nothing less than the revelation of buried truths, the reintegration of the subject, and the "perfect interrelation of art and society," that paradisiacal state supposedly achieved by tribal cultures.

Automatism

The concept of psychic automatism was essential to surrealism from the outset. Breton equated the two when he first defined surrealism, and in 1941 he could still declare, "the essential discovery of surrealism is that, without preconceived intention, the pen that flows in order to write and

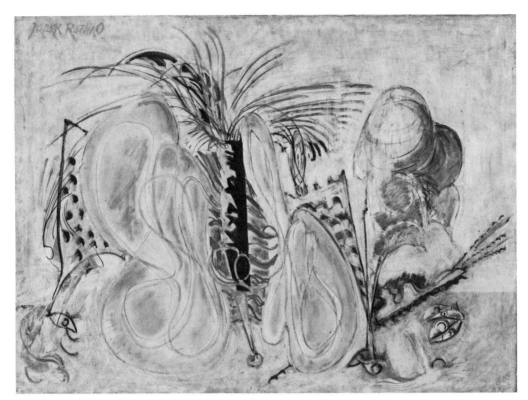

12
*Birth of Cephalopods,* 1944,
pencil and oil on canvas,
39⅝ × 53¹¹⁄₁₆ in.
Collection of the National Gallery
of Art, Washington, D.C. Gift of
the Mark Rothko Foundation, Inc.

the pencil that runs in order to draw spin an infinitely precious substance which . . . appears charged with all the emotional intensity stored up within the poet or painter at a given moment."[12] The claims the surrealists made for automatism eventually captivated the imagination of Rothko and others in his sphere. William Baziotes was reportedly "so deeply inspired by the significance of psychic automatism that he entered a crisis and was virtually unable to paint for a year."[13] Barnett Newman explored both automatic drawing and automatic writing: "How it went," he remembered, "that's how it was. . . . my idea was that with an automatic move you could create a world."[14]

Automatist calligraphy can be found in many of Rothko's pictures from the early 1940s: the looping lines that form the octupuslike creatures at the center and center left of *Birth of Cephalopods,* 1944 (fig. 12), for example, demonstrate the most characteristic type of automatic drawing. These lines were executed first in a freely penciled line that was then traced over with a paintbrush, which necessarily offered a less continuous flow. Automatic drawing typically involved fluid continuous motions of the pencil or pen resulting in chaotic tangles or if interrupted sooner in the sinuous contours of loosely zoomorphic shapes—those biomorphic shapes that Rothko and his group had come to regard as an acceptable, humanistic alternative to the geometric shapes of pure abstraction. As the title of *Birth of Cephalopods* suggests, Rothko saw his freewheeling pencil and brush as conjuring a cluster of octupuslike crea-

tures, thus yielding a prehistoric memory, insofar as cephalopods have existed since the Cambrian era. To the right of the freely looping lines that constitute the undulant pink octopuslike creatures in the *Birth of Cephalopods* is a configuration of two prominent and two or more less prominent globular forms that in toto may evoke the form of a prehistoric fertility goddess comprised almost wholly of massive breasts and buttocks. The birth alluded to in the title invokes not only the primal, aqueous origins of a species, however, but also the originating process of the artist who (re)created the cephalopods.

In principle, making a work of art strictly through automatist practices would mean acting in a spontaneous and unguarded way throughout the creative process, acting from a welling up of unconscious internal forces, free of moral and intellectual inhibitions and without the influence of learned aesthetic criteria. But this idea of making the unconscious conscious constituted an obvious impossibility, a contradictory or self-canceling proposition. The ideal of the purely spontaneous gesture, a gesture motivated by authentic primal drives and charged with the mythy juices of the unconscious, necessarily remained just that—an ideal—mediated by the impossibility of sustaining a wholly unguarded frame of mind in an awake state for an extended period of time.

The surrealists tended to hypostatize the unconscious and to regard even highly contrived, fastidiously worked and finished images as somehow having issued from their unconscious minds. The New York School artists remained more faithful to an abstract notion of the unconscious as a fluid mental space and to the ideal of a process of working which engaged that space. By surrendering the controlled touch of brush against canvas in favor of a poured stream of paint, Jackson Pollock in particular found a working method that approximated a continuous flow of impulses from the unconscious. Although the other New York School artists maintained less risky or audacious standards of directness, some of them experimented with starting their work through spontaneous impulses and used the results as a springboard for extrapolating something more deliberately arrived at. Alternatively, some of these artists began with a preexistent structure in mind, such as the tiering Rothko used, and then improvised within that structure. In Rothko's pictures the subtle *sgraffiti* and the layering of color that make up his painterly surfaces form a network of traces reminiscent of the "mystic writing pad" (like a child's tablet that is marked by pressing with a stylus and erased—though never completely—when its clear cover sheet is lifted) that Freud once used as a metaphor for the memory and the unconscious. The structure of experience as Freud describes it is—like Rothko's classic pictures, in a sense—a palimpsest of traces.[15]

As they initially experimented with developing automatist or direct working procedures, the New York School artists, like the surrealists, were generally prone to artificially enhancing the legibility of their diffuse scrawls and free-form configurations. They aimed thereby to illuminate

the relation between their personal fantasy images and the images of the putative collective unconscious revealed in mythology—an objective that was sometimes also fostered by a suggestive title. But the mythological allusions that the New York School artists tried to insinuate in their work could be barely comprehensible, and their titles often seem to betray an effort to secure a narrative or conceptual focus for images that were otherwise bound to impress the viewer as utterly obscure. In the case of the *Birth of Cephalopods* (fig. 12), bracketing the gaggle of loosely drawn octupuses are two more deliberately rendered avian creatures, poised with their spotted wings and stick figure bodies upside down and their large disembodied eyes on the ground. When he titled this picture, Rothko was conceivably recalling a tale from the *Greek Anthology*, the tale of the "sharp-eyed eagle" who saw an octupus "from the clouds and seized him, but fell, unhappy bird, entangled by his tentacles, into the sea, losing both its prey and its life."[16] Cephalopods can be fierce predators who disable their victims with powerful tentacles and suckers and crush them with strong jaws. Cephalopods can also become monstrously large, capable of attacking and overpowering more evolved forms of life, including human beings. On a broader level then Rothko's cephalopods may signify—after a Jungian model—the survival into modern times of primordial elements capable of menacing or even undoing civilization.

Rothko employed a mixture of techniques in creating the *Birth of Cephalopods*. The erect black caterpillarlike creature at the center of the painting and the configurations that I have called birds and a fertility figure were evidently not rendered in the free, fluid, and continuous line that was used to realize the octupuses, but a quality of directness remains in the sketchiness and crudeness or abruptly executed look of these figures. Watercolor generally adapted itself more readily than oil painting techniques to the immediate activity encouraged by the surrealists, however; and during his surrealist period Rothko turned to paper as a support more often than not. In an untitled watercolor of the mid-1940s (fig. 13), for example, he combined long, quick, fairly straight strokes with some blots, squiggles, and fillips on a sheet prepared with broadly brushed, atmospheric dark washes. What resulted was the outlined form of a surrealistic personage whose body comprises a kind of transparent window on a tiered backdrop. The personage's face, inside a balloon of reserved white paper, has inky eyebrows, button eyes, and a bulbous nose; its body is formed by a disjointed and segmented post or column. Rothko's surrealistic personages were often, as in this case, indistinctly articulated, not as discrete or coherent as the whimsical creatures of artists such as Miró or Ernst, for example. This willingness to admit more visual chaos or obscurity in his pictures should perhaps be seen as indicative of Rothko's effort to more truly or vividly describe the inchoate character of the imagery of the unconscious mind.

In theory the surrealists believed that artists could use automatic techniques to engender images that would resist deciphering by ordinary

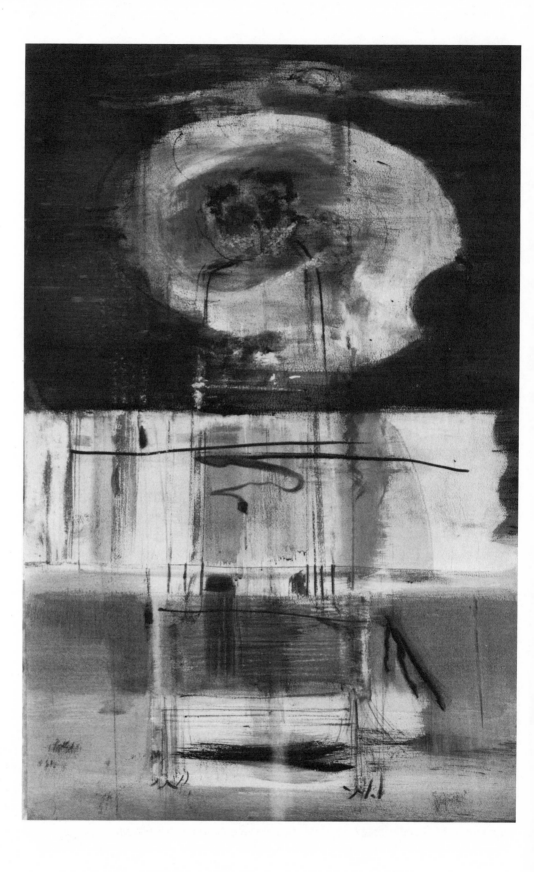

means while communicating to viewers in a direct and essential way on an unconscious plane. But in practice the surrealist artists contrived to render most of their imagery somewhat legible or decipherable to the viewer. Rothko and some of his peers took more seriously than the surrealists themselves the notion that automatic techniques could yield images or symbols capable of communicating on a deeper level.[17] In an interview in 1953, Rothko distinguished between the Europeans and the Americans in terms of their approaches to the symbols that issue from the unconscious: "None of the American artists accepted the symbolism of the Surrealists"; "While the Surrealists were interested in translating the real world to dream—[we] were insisting that symbols were real . . . Pollock made them real."[18]

To elicit authentic symbols from his unconscious mind, Rothko made some sincere attempts at automatic drawing, if not without a view to aesthetic criteria. For the most part—and with the occasional inspired exception—he was a competent but not especially felicitous draughtsman: Gorky, de Kooning, and Pollock outdistanced him in that respect. Although Rothko could passably execute the lively linear calligraphy associated with surrealist automatism, he had a deeper feeling for working with broader lines and areas. Like some other artists of the group, he eventually developed a large-scale mode of automatic drawing, using housepainter-sized brushes to make broad, physical strokes on outsized canvases. As Robert Motherwell explained, speaking for Rothko and himself, "When I talk about automatic drawing—the method we used—I don't mean doodling, something absent-minded, trivial and tiny. If we doodled—and perhaps you can say that we did—it was ultimately on the scale of the Sistine Chapel. The essential thing was to let the brush take its head and take whatever we could use from the results"[19]—a description of a fundamentally automatist way of working.

In his untitled oil paintings of around 1947 (figs. 4, 14, 15, for example), Rothko veered from the figuration of his earlier surrealist essays, developing a broader but still spontaneous-looking technique. The paintings of this period have an undirected but searching quality—with their amorphous, often splotchy, puffy, or wispy shapes drifting almost aimlessly about—as Rothko struggled to separate himself more decisively from the surrealists' nonliteral but still legible modes of figuration. The pictures from this transitional period, just after the war and just prior to his arrival at his classic format, ventured deep into that territory of nonobjectivity or abstraction where allusions to specific referents are banished as fully as possible. Rothko spoke of the shapes in these pictures as "organisms," however, continuing the biotic analogy that in his eyes preserved him from making vacuous abstract art. Few of his pictures from this period suggest specific images or invite specific readings, but when they do the images often recapitulate motifs or themes encountered in earlier pictures. In the upper third of *Number 11*, 1947 (fig. 15), for example, viewers may decipher a row of merged heads similar to those at

13
Untitled, mid-1940s, watercolor, pen and ink on paper, 40$^{11}$/₁₆ × 27$^{1}$/₁₆ in. Collection of the Museum of Modern Art, New York. Gift of the Mark Rothko Foundation, Inc. (Photo: Quesada/Burke)

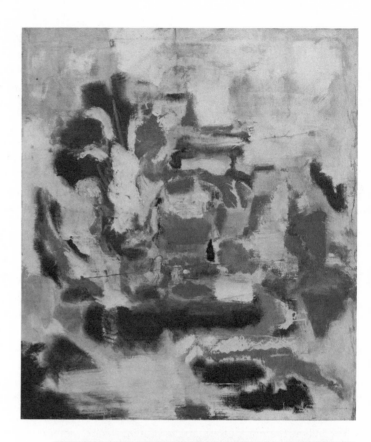

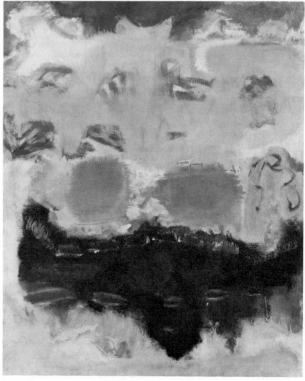

14
Untitled, 1947–48, oil on canvas,
49¾ × 44 in. Collection of the
National Gallery of Art,
Washington, D.C. Gift of the
Mark Rothko Foundation, Inc.

15
*Number 11*, 1947, oil on canvas,
39¹¹⁄₁₆ × 33¹⁄₁₆ in. Collection of
the Seattle Art Museum. Gift of
the Mark Rothko Foundation, Inc.
85.61.

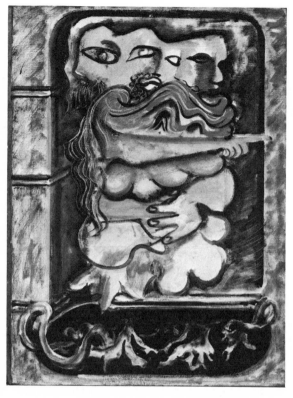

16
Untitled, circa 1941–42, oil on
canvas, 32 × 23⅞ in. Collection
of the Neuberger Museum, State
University of New York at
Purchase. Gift of the Mark
Rothko Foundation, Inc.
(Photo: Quesada/Burke)

the top of *Antigone,* circa 1941, *The Omen of the Eagle* of 1942, and
several other paintings of this period (fig. 3, pl. II, and figs. 16, 26, 31,
33). In *Number 11,* 1947, the heads have an aspect more animallike than
human, however, with their long pink snouts, high pointy ears, and out-
sized eyes. A row of more humanly proportioned head or facelike shapes
can be detected at the top of an untitled painting of around the same
time (fig. 14); and if another untitled painting of this period (fig. 4) is
turned ninety degrees counterclockwise, several figures defocused almost
to the point of unintelligibility may come into view. (Rothko signed some
of his paintings of the 1940s more than one way up, and often the drips
of paint on their surfaces fall in two or more directions, suggesting that
he sometimes reoriented the pictures of this period as he made them and
even after they were completed.)

Although the pictures from this transitional period of Rothko's career
appear unremittingly abstract, in other words, viewers may gradually and
tentatively recognize indistinct or fragmentary images in some of them.
Viewers may slowly perceive, for example, that the gestalt formed by the
black and yellowish splotches in a painting known variously as *Number
10,* 1947 or *Number 12,* 1948 (pl. V) suggests the image of a massive fig-
ure against a white background. The snowmanlike creature in question
might be described as having a broad, blocky lower body, a patchy up-
per body bracketed by long armlike shapes, and a squarish head, which
might even be read as having been rendered in right profile. But, with its

multiple blotchy parts floating free of one another, this figure remains a tenuous proposition whose components may or may not coalesce in the viewer's eyes. The figures, such as they are in Rothko's paintings of this period, cohere even less than those in his earlier paintings because he purposely defocused or dissolved them, "disguising" and "pulverizing" the "familiar identity of things," to use his own words. Not all viewers will be convinced of the existence of the imagery described above, but the persuasiveness of my readings of specific paintings is less important than the viability of the broader case I am building here: that the techniques Rothko used in making these pictures represent an extension of his engagement with surrealist automatism. His own account of his working method at this time suggests an essentially automatist process: his pictures "begin as an unknown adventure in an unknown space," he stated in 1947. "It is at the moment of completion that, in a flash of recognition, they are seen to have the quantity and function which was intended. Ideas and plans that existed in the mind at the start were simply the doorway through which one left the world in which they occur."[20]

For those who see Rothko's classic paintings in architectural terms, in 1949 he quit moving through this imaginary doorway and made the viewer stop once and for all at the threshold with the door thrown open on an unknown, unmarked space or—depending on the picture and the viewer—with the door slammed shut in the viewer's face. The threshold metaphor is a suggestive one insofar as thresholds are a recognized trope for crucial turning points in life, for the popular as well as the Duchampian "passage of the virgin to the bride," for example. There are reasons why Rothko's pictures should not suggest doorways, however, including the fact that their would-be doorframes are not in front of their would-be landscapes or open spaces but in back of them, having been laid down first. In addition, the color of the would-be doorframes does not simply surround the unknown space with a discrete rectangle but usually continues into the space itself, filling the interstices between the broad rectangular areas. The ramifications of these factors will be explored in more depth below (in a discussion of the relation of Rothko's art to landscape in chapter 4), but regardless of whether Rothko's images ought logically to be read as doorways, it remains significant that they often are. The proportions of the pictures—usually taller than they are broad and at once broad and tall enough to walk through were the canvas itself not in the way—reinforce the doorway reading. More importantly, the doorway or threshold reading offers viewers an explanation for why they feel as if they were at a brink, as if the artist were on the verge of revealing or expressing something that never does become clear. Though Rothko finally realized it differently than the surrealists had, the expressive force of the brink, of the image resolved to be unresolved, was one of the most significant lessons he learned from surrealism.

Rothko's interest in automatism has been associated only with his art

of the early and mid-1940s, but in a sense it lasted longer. "I remember some years ago talking to Rothko about automatism" said Motherwell in 1967. "When he developed the style in the late 1940s for which he is now famous, he told me that there was always automatic drawing under those larger forms."[21] After 1949 Rothko had firmer "ideas and plans . . . in mind at the start," but in carrying out those plans he continued to pursue his "unknown adventure in an unknown space." Close scrutiny of the surfaces of Rothko's classic paintings reveals that their rectangular areas are often comprised of or underpainted with a heavy tracery of freely rendered brushwork or painterly language, the legacy of the earlier more explicitly figurative and surrealist calligraphy. (In photographs this drawing can best be seen in areas where Rothko mingled two distinct colors, such as in the bottom rectangle of *Reds, Number 16,* 1960 [pl. XXII], for example.) Because Rothko ordinarily suppressed color contrast within each rectangular area, the "drawing" in his mature pictures tends not to describe specific configurations and only rarely lends itself to being described in terms of specific images. Such occasions do arise, however—disputable though they may be; and I will propose that the familiar row of fused heads emerges again at the top of a picture of 1951 (fig. 30 and pl. XV), for example (a suggestion discussed at greater length in Chapter 4).

The vestigial imagery that occasionally crops up in Rothko's mature pictures is symptomatic of his continued involvement with certain precepts or ideals of surrealism; but to dwell on this imagery or expend time seeking it out would be to belie the pictures' high degree of abstractness. Rothko wanted to "disguise" the figure, if not to banish it completely, and he was not the only artist in his group who was "pulverizing" or defocusing his figures until they were virtually indecipherable. In Willem de Kooning's Woman series of the 1950s, in *Woman VI,* 1953 (fig. 17), for example, the figure is so fractured that only her eyes (at the top center of the canvas) can be discerned with certainty. The figures in Jackson Pollock's work of the early 1940s were obliterated or supplanted by the intricately tangled, poured skeins of paint in his classic paintings and then reemerged intermittently in his work of 1951 and later. In Pollock's *Number 7,* 1952 (fig. 18), for example, a portrait head in right three-quarters profile takes shape from the knotted strands of paint. In conversation with a critic in the 1950s Pollock explained (in an often cited phrase): "I'm very representational some of the time, and a little all of the time. But when you are painting out of your unconscious, figures are bound to emerge."[22]

In comparison with the work of Pollock, de Kooning, Still, and Kline, Rothko's mature work is usually described as nongestural and removed from the automatist practice of painting out of the unconscious. Certainly Rothko used gesture less emphatically than most New York School artists, but compared with Newman or such younger artists as Stella, Noland, and Kelly, Rothko was a decidedly gestural painter. His

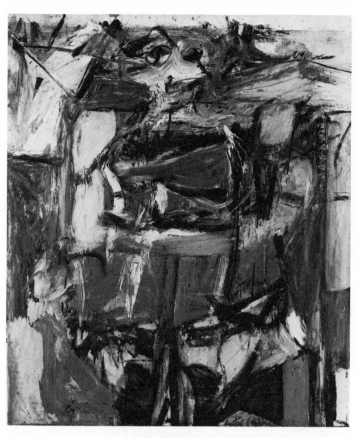

17
Willem de Kooning, *Woman VI*,
1953, oil and enamel on canvas,
68½ × 58½ in. Collection of the
Carnegie Museum of Art,
Pittsburgh. Gift of G. David
Thompson, 55.24.4.

18
Jackson Pollock, *Number 7*, 1952.
Enamel on canvas. Collection of
the Metropolitan Museum of Art,
New York. Purchase, Anonymous
gift, 1987. Acc. no. 1987.92.

brushwork is unobtrusive because it is contained by broad areas of close-keyed colors of paint. Where de Kooning made a broad, bold stroke with white paint over red, Rothko might make a similar but less conspicuous stroke with red or red-orange paint over red. The terms that are typically used to describe Rothko's pictures often discourage awareness of their gestural underpinnings; the shapes in his paintings are usually described as "rectangles," and comparisons with the rigorously rectilinear art of Mondrian sometimes follow. But Rothko's geometry was softened, ragged, and irregular, without the sharp precision or sense of absoluteness that characterized the neoplasticist aesthetic.

Rothko's pictures are also often said to be comprised of "sheets" of color, a term suggesting flat and uniform surfaces, but closer study reveals modulations of color and a varied surface. More apt is the (also commonly used) term *veils,* evoking a quality of transparency and a sense of things only partially apprehended through an intervening screen. The veil is an age-old metaphor used from Plato through Hegel and Heidegger for the concept of truth as *aletheia* or unveiling. Some surrealist artists used the term veiled to describe what they regarded as a desirable pictorial attribute: that of the indistinct image, half-buried and half-dislodged from the unconscious mind (because anything fully dislodged and distinct would, by definition, no longer be unconscious). The term *transparency* was also used to describe a surrealist desideratum; transparency meant getting "beyond the surface [to] embrace the whole." So said Gordon Onslow-Ford, who further suggested in 1948 that "the new art may well take as rallying point—*transparency.*"[23] Some critics have observed of Rothko's pictures that his rectangular areas are rendered in varying degrees of transparency, from gossamer sheerness to total opacity. Of itself, this effect—of forms emerging, coalescing, receding, and dissolving—may evoke natural cycles.

Automatism led Rothko to a way of making pictures that he practiced as long as he painted. But automatism was never merely a technical device for Rothko. It was a means of conjuring and realizing subjects by probing the unconscious, where the seeds of myth were supposedly stored. This is why Rothko was still extolling the Surrealists long after he overtly emulated them in his work—because they had "rediscovered mythical possibilities in everyday life."[24]

## Myth and *The Birth of Tragedy*

Rothko was one of many artists who turned to mythological subjects in the early 1940s. He may even have taken a respite from painting around 1940 to devote himself to the study of myth. His first wife (Edith Sachar, whom he married in 1932) remembered lengthy discussions at their home in the early 1940s, revolving around the problem of subject matter and

involving Newman and Gottlieb, as well as other former cronies from The Ten. Gottlieb's wife recalled that her husband and Rothko were both "extremely programmatic about their artistic direction and deliberately chose to concern themselves with myth so that they could break with what they considered stagnant in European tradition and with the provincial American past."[25] Myth seemed to offer Rothko the subject matter he so badly wanted. But he found his subjects not in the anecdotal fabric of myth—in myth out of Bullfinch—but in myth as espoused by Nietzsche, as dramatized by Aeschylus, as mapped by Sir James George Frazer, as probed by Freud and Jung, and as reanimated or revisualized by the surrealists.

Gottlieb began using themes from mythology at around the same time Rothko did, painting "pictographs" with such titles as *Oedipus* and *Labyrinth*. He organized his pictographs using grids, with a cryptic symbol or body part (eye, hand, face . . .) in each square compartment. "Rothko and I temporarily came to an agreement on the question of subject matter," Gottlieb later recalled.

We embarked on a series of paintings that attempted to use mythological subject matter, preferably from Greek mythology . . . Now this is not to say that we were very absorbed in mythology, although at that time a great many writers, more than painters, were absorbed in the idea of myth in relation to art. However, it seemed that if one wanted to get away from such things as the American Scene or social realism and perhaps cubism, this offered a possibility of a way out, and the hope was that given a subject matter that was different, perhaps some new approach to painting, a technical approach might also develop. . . . Eventually, of course, we did not remain loyal to the idea of using mythology and ancient fables as subjects because it immediately became apparent that if you are dealing with the Oedipus myth, you're involved with Freud, Surrealism, etc.[26]

In hindsight, in other words, Gottlieb regarded myth as a fortuitous link between the tentative essays of a young artist and the mature artist's more pregnant way of working. Unlike Gottlieb, Rothko remained loyal to mythology and continued to believe in its relevance to his work. In a lecture at Pratt in 1958, he discussed the importance of myth to modern art, and in conversation with an art historian around 1959, he actually "defined his painting as something like a 'mythical action.'"[27] The significance of myth to Rothko's mature art is hardly obvious. But a study of the relation between his mature paintings and his earlier work—especially the surrealist work with its sometimes overt mythological content—will help to illuminate the connections. Most critics have ignored the surrealist work (at least until recent years), but Rothko himself was not so dismissive of that period in his career: he faithfully kept and declined to edit his own sizable collection of his early pictures, and he was "a constant visitor to the fabulous museum of his own collections of his own work," according to a studio assistant.[28] A review of some of the holdings of that museum will help reveal how myth is an abiding factor in Rothko's art: myth, that is, as "a concentrated image of the world, an em-

blem of appearance," to borrow a phrase from Nietzsche.[29] Like various artists before him (William Blake, for instance), Rothko proposed not to illustrate but to make myth. The themes of myth that engaged him were fundamental ones, concerning the relation of the human being to the world and the cycle of life, "the human drama" or "tragedy," as he called it.

Rothko indicated to William Seitz that his approach to art was initially "reformed" through "a study of the dramatic themes of myth . . . and an early reading of Nietzsche's *The Birth of Tragedy.*"[30] Nietzsche had regarded the Greeks as "the chariot drivers of every subsequent culture" and considered Greek tragedy "the profoundest manifestation of Hellenic genius." The signal attainment of Greek tragedy, as Nietzsche saw it, was that it concerned itself directly and effectively with the crucial reality of death and assisted its audience in confronting the unbearable fact of its own mortality. Greek tragedy managed to console its audience by revealing that "the eternity of true being surviv[es] every phenomenal change"; though the individual must expire, life itself is eternal.[31] The revelations afforded by Greek tragedy amounted to an assurance of the perpetuity of life and so to a kind of redemption: "Dare to lead the life of tragic man," Nietzsche urged, "and you will be redeemed."[32]

Nietzsche's account of the birth of tragedy was also the story of its death, because modern science had effectually eliminated myth, which is indispensable to the creation and to the understanding of tragedy. As Nietzsche saw it, the "loss of myth, of a mythic home, the mythic womb" was responsible for the deracination of the modern person: "Man today, stripped of myth, stands famished among all his pasts and must dig frantically for roots, be it among the most remote antiquities." The loss of myth spells the end of art because "every culture that has lost myth has lost, by the same token, its natural, healthy creativity. Only a horizon ringed about with myths can unify a culture. . . . The images of myth must be the daemonic guardians, ubiquitous but unnoticed, presiding over the growth of the child's mind and interpreting to the mature man his life and struggles."[33]

Rothko shared with Nietzsche this vision of the crucial role played by daemonic guardians: "Without monsters and gods," the painter wrote, "art cannot enact our drama. . . . When they were abandoned as untenable superstitions, art sank into melancholy." In the face of that melancholy, however, Rothko shared Nietzsche's belief in the importance of miracles: "The most important tool the artist fashions, through constant practice, is faith in his ability to produce miracles when they are needed. Pictures must be miraculous."[34] The miracles that Rothko hoped to produce were pictures that answered the same "eternally familiar needs" that Greek tragedy had answered, despite modern society's estrangement from myth, pictures that yielded a catharsis by responding to and assuaging the viewers' primal terror—their terror of mortality. To make such pic-

tures without a recognized cast of monsters and gods, meant finding new dramatis personae or a new visual rhetoric to take the place of the devalued one, and this is what Rothko set out to do. He did not make miracles happen in the end—he did not discover a visual mode with the capacity to reach across the social fabric as fully as Greek tragedy had done—but there is testimony suggesting that he eventually effected a kind of minor miracle. In his classic paintings, he created images that stirred the emotions of a sector of his society, at least, and that moved viewers to ponder the condition, the life and death, of the human spirit.

In some respects, *The Birth of Tragedy* is less a meditation on art per se than on the role of the artist and the experience of the audience, Stanley Cavell has observed. Nietzsche contended that "An audience of spectators, such as we know it, was unknown to the Greeks,"[35] so strongly did they identify with the chorus; according to Cavell, "Nietzsche's profoundest wish was to remove the audience from art"—audience in the sense of "'those present whom the actors ignore', those beyond the fourth wall. Deny that wall—that is, recognize those in attendance—and the audience vanishes."[36] Nietzsche formed an ideal of a public that participated in the drama and thereby experienced a catharsis that no aloof spectators could hope to undergo (in the same sense that analysands are debarred from being detached observers of their own emotional dramas if they hope to experience the therapeutic catharsis). The relations among artist, art, and public were a central concern for Rothko, as well. He longed to find a way to bridge the separation between art work and viewer, fostering a more immediate and intimate encounter; what he envisioned occurring in that encounter was nothing less than a "marriage" or a "religious experience."[37]

In the 1940s Rothko identified himself in Nietzschean terms as a mythmaker whose paintings were characterized by tragedy and drama. He declared repeatedly that tragedy was essential to his art, using such emphatic phrases as: "Only that subject matter is valid which is tragic," "the tragic concepts with which art must deal," "the exhilarated tragic experience which for me is the only source book for art."[38] These phrases date from 1943 to 1945, a time when the word *tragedy* evoked first the state of world affairs and, only secondarily, a form of Greek drama. But Rothko and some of his contemporaries perceived their rehearsals of the themes of Greek tragedy as a valid and appropriate esthetic response to the tragedies unfolding around them. From their perspective, wrestling with the tragic themes of myth and reckoning with the raw contents of the unconscious mind, where those themes supposedly originated, was a potentially risky and courageous act: "Art is justified by its adventuring into unknown lands which can be traversed only by those who are willing to take the risks," Rothko contended in 1943, in a formulation he had learned from the Surrealists.[39] In 1942 Breton asserted, "In art there is no great expedition which is not undertaken at the risk of one's life. . . . each artist must set out on his own search for the Golden Fleece."[40] the

same year Edward Renouf suggested, "An artist is an artist by virtue of his psychological veracity, and where hell yawns the artist looks into its jaws."[41]

At the time of the Second World War, this is how Rothko and others in his circle saw themselves responding to the mandate for art with social content. In attempting to unleash in their art the primal forces lurking in the unconscious mind and in eliciting their subjects from those forces as privately experienced or as collectively transposed into myth, these artists could regard themselves as engaging in a socially munificent act, at their own not inconsiderable peril. Comparatively safe though they actually were during the war, the artists' representation of their project wishfully cast them as brave heroes facing terrible dangers and untold harm in the interests of dispensing a kind of healing and protection. Renouf claimed, citing Freud as his authority, that "art sublimates destructive impulses into cultural values—making the persistence in human nature of man's primordial and animal past a source of culturally productive power."[42] Nietzsche had also counted art "an antidote to barbarism" and a "sorceress expert in healing."[43] Faced with the rending cataclysm of World War II, then, the New York School artists joined some of the surrealists in importing a concept from ancient and tribal cultures of art as an agent of mediation and healing.

The turn to mythology and the popularity of the notion of a universal mythic consciousness represented a kind of nostalgic impulse in a time of conflict and crisis—a summoning into modern times of a cherished vision of a long-lost, whole, and integral community with shared monsters and gods, shared beliefs and values. Terry Eagleton has emphasized the conservatism that animates this romanticizing of myth in an analysis of the impetus behind T. S. Eliot's use of myth, particularly in the *Waste Land,* which was greeted in its time as a daring effort. What Eliot hoped, as Eagleton acerbically put it, was that "the crisis of European society . . . might be resolved by turning one's back on history altogether and putting mythology in its place. Deep below finance capitalism lay the Fisher King, potent images of birth, death and resurrection in which human beings might discover a common identity. . . . His [Eliot's] scandalous avant-garde techniques were deployed for the most arrière-garde ends: they wrenched apart routine consciousness so as to revive in the reader a sense of common identity in the blood and guts."[44]

In *The Myth of the Eternal Return,* a study begun in 1945, the anthropologist Mircea Eliade cast the same phenomenon in a more understanding but no less salutary light. Noting that "the work of two of the most significant writers of our day—T. S. Eliot and James Joyce—is saturated with nostalgia for the myth of eternal repetition and, in the last analysis, for the abolition of time," Eliade suggested: "As the terror of history grows worse, as existence becomes more and more precarious because of history, the positions of historicism will increasingly lose in prestige. And, at a moment when history could . . . wipe out the human

race in its entirety—it may be that we are witnessing a desperate attempt to prohibit the 'events of history' through a reintegration of human societies within the horizon (artificial, because decreed) of archetypes and their repetition."[45]

However dissimilar Rothko's and Eliot's politics may have been in general, this conservative aspect to the project Rothko set himself during the war remains, even as he painted his first comparatively modern-looking paintings. And the conservatism that Rothko and others in his circle manifested in their attempts to revive and reinstate myth was plainly related to the terror of history referred to by Eliade. These artists' use of explicit mythological references and their tenure as self-identified mythmakers coincide precisely with the war years. But even in the late 1930s Rothko had believed strongly, almost as a kind of law, that the artist had to reach backward in order to move forward: "The return to the past comes about regularly even in the conscious life. . . . The renaissance went back to antiquity for the purpose of going forwards. . . . Rousseau preached the 'return to nature'. Tolstoi, the revolutionary innovator, did actually go back to the primitive life, and without such retrogressions no great progressions are possible, and no fresh creation, however cleverly imagined, has any prospect of a future unless it has borrowed from the past."[46]

Political and social factors contributed to the interest of artists in mythology and Greek tragedy during the war, but Rothko's preoccupation with myth and tragedy was more enduring than that of most of his contemporaries. He "continued to describe his . . . paintings as tragic dramas" until the end of his life, although his vision of tragedy changed somewhat with time.[47] "As I have grown older," Rothko told Peter Selz around 1961, "Shakespeare has come closer to me than Aeschylus, who meant so much to me in my youth. Shakespeare's tragic concept embodies for me the full range of life from which the artist draws all his tragic material."[48] As he grew older, further, Kierkegaard seems to have supplanted Nietzsche as Rothko's preferred philosopher and interpreter of myth; *Either/Or* and *Fear and Trembling* are said to have particularly interested him.[49] And Kierkegaard's meditation on "The Ancient Tragical Motif as Reflected in the Modern," in *Either/Or* may help explain Rothko's shift away from Aeschylus:

In ancient tragedy the action itself has an epic moment in it; it is as much event as action. The reason for this naturally lies in the fact that the ancient world did not have subjectivity fully self-conscious and reflective. Even if the individual moved freely, he still rested in the substantial categories of state, family, and destiny. . . . In modern times, [by contrast] situation and character are really predominant. The tragic hero, conscious of himself as a subject, is fully reflective, and this reflection has not only reflected him out of every immediate relation to state, race, and destiny, but has often even reflected him out of his own preceding life. . . . Hence, modern tragedy has no epic foreground, no epic heritage. The hero stands and falls entirely on his own acts.[50]

During the war Rothko and his peers had the heady but daunting sense of making art in an epochal, historical moment. They were drawn together by their need to devise a form of artistic activity with a scope commensurate with the scale of the time. The inescapable awareness of the exigencies of the human community moved many artists to form at least loose communities of their own, to pool their concerns, ideas, and efforts. That sense of membership in a community—the larger human community and a local community of artists—ebbed away soon after the war, replaced by the more familiar modern sensations of isolation and aimlessness. In the first few years following the war, when Rothko painted possibly some of his most diffuse or incoherent pictures, the circumstances and pressures under which he was working were substantially changed: the impinging of political and social events had sharply dissipated with the sense of community. In a statement made in 1945, the year the war ended, Rothko foresaw the direction his art would increasingly take—toward a focus on internal experience: "If previous abstractions paralleled the scientific and objective preoccupations of our times, ours are finding a pictorial equivalent for man's new knowledge and consciousness of his more complex inner self."[51] For Rothko, however, this interest in finding a metaphor for the complexities of the inner self was never a matter of expressing merely individual and private experiences or of abandoning a concern for the public but was instead a shift of strategy for the most direct and effective way to reach the public. The model for the inner self that Rothko began to look for, and that he effectually found in 1949, was still meant to be one with resonances for all viewers. It no longer looked to archaic mythologies as an instrument for attaining that hoped-for universality, however, but pioneered new instrumentalities instead.

## Themes from the *Oresteia*

Rothko's way of confronting the enormity of political events in the early 1940s, through an art grounded in myth and Greek tragedy, may in retrospect seem an oblique and contrived one. But it was the most direct and meaningful solution he could find at the time to a virtually insoluable problem. And, for all its awkwardness, the solution was a considered one, worthy of closer examination through an analysis of the programs of specific pictures. In devising the programs for his mythological pictures, Rothko tended to favor broader themes—such as *Gods and Birds* or *Ritual*—to particular ones, which might well prove obscure to his viewers. When his chosen themes were specific, they came almost entirely from Greek mythology with only an occasional reference to Judeo-Christian legends—such as the *Rites of Lilith* and *Gethsemane*—and the odd reference to Egypt (*Room in Karnak*), Syria (*Syrian Bull*), and *Oceanea*. The cast of specific mythological characters Rothko portrayed included *Oedipus, Antigone*, Iphigenia (*Sacrifice of Iphigenia*), *Tantalus, Tiresias, Leda, Orison*, Orpheus (*Altar of Orpheus*), *The Furies*, and Aurora (*Vibrations*

*of Aurora).* Sometime after the war Rothko decided that he did not want the specificity of reference afforded by any titles, however broad, and he abandoned titles altogether. But even "though he hesitates in titling his pictures," as he reportedly told a critic in 1947, "they are all painted in terms of definite representation."[52] Only once did Rothko associate a picture with a particular text, indicating in his statement for an exhibition catalogue that *The Omen of the Eagle* of 1942 (pl. II) was inspired by "the Agamemnon Trilogy of Aeschylus," the *Oresteia.* Rothko noted also on this occasion, in characteristically grand and ambiguous phrases, that the painting "involves a pantheism in which man, bird, beast and tree—the known as well as the knowable—merge into a single tragic idea."[53]

*The Omen of the Eagle* is composed hierarchically by rows or registers: a row of five fused heads (with the two at the right and left ends, respectively, locked together at the lips in a kiss) rests atop a row of two bald eagles with stylized feathers, which rests atop a row of several free-form columnades (set one behind the other, moving back into the distance), which rests in turn atop a cluster of dismembered hoofs and feet.[54] This hierarchical stacking and merging of multifarious elements constitutes a kind of tablet-shaped totem pole, loosely patterned after the structure of the human body, with heads at the top, feet at the bottom, and the dangling tentaclelike forms in the register above the feet vaguely evocative of pendulous breasts or male genitalia. Rothko and his peers had taken up the surrealist practice of making hybrid, totemic personages, partly human, partly animal and vegetable. The concept of the totem was important to these self-consciously mythologizing artists, because they aspired to attain for their own art something akin to the vital position in the structure of beliefs occupied by the totemic objects of tribal societies. Totemic objects are not works of art in the Western sense but function in an essential way in community rituals and religious practices. As rendered by the tribal artist or carver, the totem is not only the sacred symbol or emblem of the tribe but also its venerable ancestor. "In totemism, man does not merely regard himself as a descendent of certain animal species," Ernst Cassirer has observed. Rather, "A bond that is present and actual as well as genetic connects his whole physical and social existence with his totemistic ancestors."[55]

In Greek mythology and Greek tragedy, birds and animals serve less as totems than as attributes of the gods or as omens and emblems of human and divine activities. Rothko's title *The Omen of the Eagle* may have particular implications in this context. A review of the myths involved in the *Oresteia,* and a look at Rothko's other images of those myths, are necessary, however, before the title's significance can be effectively discussed. The *Oresteia* tells the story of the royal House of Atreus, whose family members were trapped for generations in a cycle of treachery, retaliation, and revenge. To condense a long and complicated story: when Atreus was cuckolded by his brother, Thyestes, he retaliated by having two of Thyestes' children killed, cooked, and served to their father at a banquet. Repeatedly, the lives of innocent children were the price paid

for vengeance in the saga of the House of Atreus. Atreus' son Agamemnon sacrificed his own daughter Iphigenia to gain favorable winds for sailing to Troy with his brother, Menelaus, to recapture Menelaus' abducted wife, Helen. The unfavorable winds that had delayed the brothers' departure for Troy had been sent by the goddess Artemis, because the warriors had slaughtered an animal sacred to her, a hare—in fact, a pregnant hare. The slain fetal rabbits serve effectually as an emblem for the heritage of sacrificed or murdered children in the House of Atreus.

Rothko painted *The Sacrifice of Iphigenia* (fig. 19) around the time he painted *The Omen of the Eagle*. The figure at the left of the picture is most likely Iphigenia, a slim girl with long, pink legs clad in a short, shroudlike, black cape, with horizontal, white pinstripes scratched into the black. What may be Iphigenia's moony face (above and slightly detached from the tip of the cone-shaped cape) recoils from a pair of long, disembodied arms that reach for her ominously from an unseen being standing outside and to the right of the pictured scene. Behind those fateful arms, a large, wide-eyed woman stands in profile facing Iphigenia. This woman, who might be the child's mother, Clytaemestra, has a cape with a swirling pattern draped over her shoulders. The front of her body is nude, however, with her full bosom and the torn skin of her stomach and leg exposed. Her jagged silhouette may describe graphically, then, how her child—her own flesh and blood—has been ripped from her.

What I am calling the Iphigenia figure, the Clytaemestra figure, and the disembodied arms are the most prominent and intelligible elements of *The Sacrifice of Iphigenia.* But there are other elements as well: a flesh-pink structure, the color of Iphigenia's legs, joins Iphigenia and Clytaemestra at their legs or feet. This multilegged stand is also attached to what could be read as a large, schematically rendered masculine head, its brooding brow and nose visible in left-profile at the far left. This white, vaguely headlike shape is surrounded by what might be an elaborate red and green headdress finished at the extreme left with a jagged edge. The abstract head-shape, which is turned away from the female figures, might stand for Agamemnon, the callous king who acquiesced to the killing of his daughter despite the "structure of kinship" uniting her with him and his wife.

The events in the *Oresteia* take place some years after the sacrifice of Iphigenia, but the tragedy's doleful chorus remembers Agamemnon's ruthless deed and even frames it verbally as a tableau. The chorus recalls how Iphigenia's

> supplications and her cries of father
> were nothing, nor the child's lamentation
> to kings passioned for battle.
>
> .  .  .  .  .  .  .  .  .  .  .
>
> She struck the sacrificers with
> the eyes' arrows of pity,
> lovely as in a painted scene.[56]

Agamemnon's killing of Iphigenia had so enraged Clytaemestra that when
her husband returned from battle she murdered him, assisted by her
lover, Thyestes' son, Aegisthus. In an echoing and extension of prior
events, in other words, Atreus' son, Agamemnon, is cuckolded and killed
by the man whose siblings Atreus himself had killed to avenge their fa-
ther's act of cuckoldry. Nor does the cycle of retribution end here; for
Clytaemestra is murdered in turn by her own son, Orestes, in revenge for
his father's death. (Rothko may have meant to invoke Clytaemestra's
treachery and duplicity in the row of heads atop the *Omen of the Eagle,*
as each of the sultry pair of closed eyes in the face located at the center
of the row belong also to each of two faces turned in left and right pro-
file, respectively, to kiss the round or open-eyed faces in profile at the
ends of the row.)

Around 1943 Rothko painted *The Horizontal Phantom* (fig. 20), with
a scene similar to that in *The Sacrifice of Iphigenia.* At the far right of
*The Horizontal Phantom* stands an adolescent-looking Iphigenia-like fig-
ure with a small, round head, cone-shaped cape, and gangly legs. Close
by to the left stands a matronly figure dressed in a patterned cape and
high-heeled shoes, with a face consisting of a black circle surmounted by
bobbed grey hair. Suspended in midair between the mother and daugh-
terlike figures is the likeliest candidate for the horizontal phantom of the
title: a long, colorless figure of death—its legs scissored apart, its arms
akimbo, and its neck and head (formed like an extra attenuated limb)

cutting between the two women and so serving a comparable symbolic function to the fateful arms in *The Sacrifice of Iphigenia*. In electing not to name the characters in *The Horizontal Phantom*, Rothko purposely evoked a less specific story of death than in *The Sacrifice of Iphigenia*; if he still had the tales of the *Oresteia* in mind when he painted *The Horizontal Phantom*, however, the latter picture might be considered in relation to that story, if only in a conjectural way. Iphigenia, Clytaemestra, and the specter of death from *The Sacrifice of Iphigenia* might be associated with the similar groupings of figures in the foreground of *The Horizontal Phantom*. The latter trio would be huddled together on the dark shore of their homeland, and the blue and white striped islandlike area across the sea that stretches behind them could be read as Troy. On that distant plot of land is a small cluster of dismembered human appendages that could be seen as betokening the carnage of the Trojan War. In the blue and white striped sky at the top of the picture, an eagle-man—perhaps Agamemnon—flies from Troy toward home. Red flamelike shapes connect the eagle-king and his queen, just as in the *Oresteia* a chain of bonfires signaled to Clytaemestra that Agamemnon was returning home from battle. But regardless of whether the scene in *The Horizontal Phantom* relates in any specific way to the tales of the *Oresteia*, this picture can be read as depicting a family grouping: a mother and daughter with the specter of death interposed between them and an eagle man, a patriarchal figure, soaring through the sky from a distant island to the shore where the threesome is gathered.

The eagle-man in *The Horizontal Phantom* (fig. 20) recalls the two eagles in *The Omen of the Eagle* (pl. II) and reintroduces the question of the eagle's significance. In the *Oresteia*, a "wild bird portent" signaled the onset of war, and the eagle is specifically associated with the warrior brothers, Agamemnon and Menelaus, when the chorus describes their battle cry:

Their cry of war went shrill from the heart,
as eagles stricken in agony
for young perished, high from the nest
eddy and circle
to bend and sweep of the wings' stroke,
lost far below
the fledgelings, the nest, and the tendance.

It follows later in the trilogy that the surviving children of the murdered Agamemnon refer to themselves as "the eagle's brood" and "the orphaned children of the eagle father."[57] In the *Oresteia*, then, the eagle signifies the patriarchal ruler and the warrior, fated to kill and to be killed in his turn. The association of eagles with warfare and power is traditional and well-known: "from the Far East to Northern Europe, the eagle is the bird associated with the gods of power and war."[58] The world was

at war in 1942, when Rothko painted *The Omen of the Eagle,* and he may well have had the eagles in the national emblems of the United States and Germany in mind, in addition to the eagles in the *Oresteia.* The United States was embroiled in a modern-day, worldwide cycle of retribution, and the parallel with Greek tragedy was not lost on Rothko and his contemporaries. "After more than two thousand years we have finally arrived at the tragic position of the Greek," wrote Barnett Newman in 1945. "Our tragedy is again a tragedy of action in the chaos that is society (it is interesting that this Greek idea is also a Hebraic concept), and no matter how heroic or innocent or moral our individual lives may be, this new fate hangs over us. We are living then through a Greek drama and each of us now stands like Oedipus and can by his acts or lack of action, in innocence, kill his father and desecrate his mother."[59]

Although some American artists tried earnestly to portray contemporary war scenes (at the risk of being outdone by photojournalists), Rothko, Newman, and others of their circle submerged themselves in the ancient epic of the Trojan War and in the remote dilemmas of Agamemnon, Oedipus, and their kin. This Nietzschean insistence on a return to Greek tragedy as the "fountainhead of art" (as Newman called it)[60] is symptomatic of the desperation of these artists, who were searching urgently for a way to make a viable pictorial statement in the absence of an accepted rhetorical mode for doing so. Because circumstances of such epic proportions seemed to demand an epic art, an effort was mounted to resuscitate what is for Western culture the paragon of epic art forms. The example of Greek tragedy held appeal as well because it placed the suffering caused by war in a salutary light. The chorus in the *Oresteia* insists that suffering is elemental to aware human experience: "Justice so moves that those only learn / who suffer." Suffering emerges as an indirect force for good, as the chorus repeatedly intones: "Sing sorrow, sorrow; but good win out in the end."[61] The *Oresteia* even ends on a positive note. After Orestes is absolved for the murder of his mother, the goddess Athene promises the citizenry that the cycle of treachery and revenge can be ended:

Such life I offer you, and it is yours to take.
Do good, receive good, and be honored as the good
are honored.[62]

Rothko probably did not anticipate that viewers would read the *Oresteia* and examine *The Omen of the Eagle* in light of the text as I have done here; the fact that this was the only time he cited a literary source for a painting suggests that he did not expect viewers to read texts in order to understand his pictures. That Rothko did not designate texts for his subjects or make a habit of using specific subjects whose stories could readily be researched should not be taken to mean that he intended his pictures' subjects to remain a private matter that he alone understood,

however, even if that generally turned out to be the case. When Rothko was concocting a cast of fantastic performers, and using mythological titles, he imagined that the imagery he produced in his pictures stemmed from imagery traceable to the unconscious—his own and the collective unconscious. He hoped this would render his pictures accessible to all viewers on a profound preconscious or precognitive level. The "modern mythological painter must invent his types as he goes along," asserted Robert Goldwater in 1946, "And this he can do only in the very process of painting, when, as he simultaneously evolves his compositions and his subjects, he comes upon forms which through association and suggestion carry meaning in them. . . . And so his types are never fully developed, his myth or allegory never precisely articulated. . . . But just for this reason his picture carries connotations far beyond itself, and the work is rich with collected meanings."[63]

This richness was precisely what Rothko aimed for in the pictures he was painting during the war. But his collected meanings were destined to remain hypothetical because the viewers—or the critics, in any case—generally pronounced themselves unaffected by these mythical meanings that they could not decipher. Eventually, Rothko acknowledged the difficulty of working with a concept of myth that did not engage beliefs or images held openly and in common, but given the absence of such an accepted mythological structure he felt initially that he had no alternative. In 1947 Rothko frankly admitted his envy of "the archaic artist," who "was living in a more practical society than ours," a society where "the urgency for transcendent experience was understood, and given an official status." Whereas the archaic artist could "create a group of intermediaries, monsters, hybrids, gods and demigods," the modern artist did not have recourse to such a ready and colorful cast of characters. Rothko understood this in 1947—at which time he more or less banished his exotic surrealistic characters. At the same time he worried (as he had since the late 1930s) whether he or any other artist could continue to work without the benefit of such characters. He pondered whether the only option remaining to artists was simply to draw attention to this terrible lack or loss: "Without monsters and gods, art cannot enact our drama: art's most profound moments express this frustration. When they are abandoned as untenable superstitions, art sank into melancholy. It became fond of the dark, and enveloped its objects in the nostalgic intimations of a half-lit world."[64]

In 1947 Rothko wrote of the monsters and gods he had been impelled to abandon, and of the objects that remained only to be cloaked in a nostalgic half-light. This latter metaphor was premonitory of Rothko's eventual solution, his practice of veiling or disguising his objects or subjects to the point where they would be only dimly visible, recognizable as traces if at all. Whether such a practice still counts as a "mythical action," as Rothko claimed, depends on how mythology is defined. His own vision of the promise of mythology changed gradually over the

course of the 1940s, but there are broader definitions of myth that readily apply not only to what he did in his surrealistic period but also to his classic pictures.

## Myth, Psychology, and Emotion

Rothko was most sanguine about the role myth played in modern art during the war years; he saw himself then as part of a vigorous new movement, as one of "a small band of Myth Makers who emerged here during the war."[65] Although Rothko alone used this name, Mythmaker, it applied equally in that period to Gorky, Pollock, Gottlieb, Newman, Baziotes, David Smith, David Hare, and others. Rothko outlined the Mythmakers' position in a letter to the art editor of the *New York Times* in 1945: the Mythmakers "have no prejudices either for or against reality," he explained. "Our paintings, like all myths, combine shreds of reality with what is considered 'unreal' and insist upon the validity of the merger."[66] Rothko perceived myth as a medium, in effect, that permitted a synthesis of the real and the unreal, the tangible and intangible, in a fuller, more authentic image of reality. To make myth was to make truths, not fictions or abstractions. From the Mythmakers' standpoint, representational art could be considered realistic in only a superficial sense: "Certain people always say we should go back to nature," Gottlieb commented. "I notice they never say we should go forward to nature. It seems to me they are more concerned that we should go back than about nature. If the models we use are the apparitions seen in a dream, or the recollection of our prehistoric past, is this less part of nature or realism than a cow in a field? I think not. . . . To my mind, certain so-called abstraction is not abstraction at all. On the contrary, it is the realism of our time."[67] By Rothko's account, the subject that the Mythmakers proposed to treat with this new, all-embracing realism was the inner being of the modern person; they were creating "a pictorial equivalent for man's new knowledge and consciousness of his more complex inner self."[68]

To compose their metaphors for the inner self, the Mythmakers attempted to recombine old and new models: the models for the expression of inner states that they believed they had found in tribal and archaic art and the models concocted by the surrealists for imaging the finds they claimed to have made in ransacking the unconscious. But the proposition that art could be both new and primitive at the same time was greeted with skepticism by critics. And the artists were sometimes charged with playing esoteric games at the viewers' expense by using (that is, copying) arcane symbols in their work. The critics, unaccustomed to subject matter that was encrypted or veiled, questioned the designated subjects of the Mythmakers' art. And some critics insinuated that it was pretentious for the artists to affect mythological titles for such patently abstract pictures: "At best he is individually suggestive," a *New York Times* reviewer said of some of Rothko's surrealistic pictures, "though titles such as *Phal-*

*anx of the Mind* and *Orison* seem hardly to the point."[69] Another *New York Times* critic described Rothko's *Syrian Bull* of 1943, as "eluding" and then asked sardonically, "Or if we repeat often enough the words 'archaic' and 'hierarchical' and 'omen' may our quest be speeded?"[70]

Rothko and Gottlieb answered questions about their use of myth on a radio program in 1943. Gottlieb chose to invoke art historical precedent, reminding his listeners that Rubens, Titian, Veronese, Renoir, and Picasso had all employed subjects from mythology. Rothko explained to an interviewer in later years that "Gottlieb was interested in the symbolism of archaic forms," whereas he himself "was interested in the feeling associated with them."[71] The justification Rothko offered in 1943 for using myth was, indeed, an essentially psychological and emotional one. He explained that he used myth "because it expresses to us something real and existing in ourselves." He returned to the myths of antiquity, "because they are the eternal symbols upon which we must fall back to express basic psychological ideas. They are the symbols of man's primitive fears and motivations, no matter in which land or what time, changing only in detail but never in substance. . . . And modern psychology finds them persisting still in our dreams, our vernacular, and our art, for all the changes in the outward conditions of life."[72]

Rothko believed he needed myth to portray the inner self, then, because he had a vision of mythology as encompassing the essence of human psychology and emotion. Myth constituted a "glossary" for the artist, as Rothko also described it, in that the "eternal symbols" of myth stood in a lapidary way for complex emotional states or terms and their meanings.[73] Such a generous and idealistic view of the power of myth is most likely a result of the influence of the prominent philosopher of symbolism Ernst Cassirer, whose work was known in Rothko's ambient at that time. "The real substratum of myth is not a substratum of thought, but of feeling," wrote Cassirer.[74] "Myth cannot be described as bare emotion, because it is the *expression* of emotion. The expression of a feeling is not the feeling itself—it is emotion turned into image."[75] Increasingly, Rothko concentrated on doing just this: turning emotion as directly and effectively as possible into image and so, in that sense, making myths.

Another view of myth germane to Rothko's vision, though probably unknown to him, is that of Merleau-Ponty, which was built upon Cassirer's ideas. "In order to realize what is the meaning of mythical or schizophrenic space," Merleau-Ponty suggested, "we have no means other than that of resuscitating in ourselves . . . the relationship of the subject and his world which analytical reflection does away with. We must recognize as anterior to 'sense-giving acts' of theoretical and positing thought, 'expressive experiences'; as anterior to the sign significance, the expressive significance, and finally as anterior to any subsuming of content under form, the 'pregnancy' of form in content."[76]

An elemental connection between myth and emotion had been proposed before Cassirer or Merleau-Ponty by "modern psychology," as

Rothko noted. Freud had found paradigms in mythology—particularly in the Oedipus myth—for basic psychological complexes or cathexes. The vision of myth found in the writings of Freud's disciple, turned dissident, Carl Jung, would likely have been even more appealing to Rothko, however: Jung regarded myths not as detached paradigms for psychological complexes but as the outcropping of "living entities which cause the praeformation of numinous ideas or dominant representations."[77] Jung contended that the human unconscious contains inherited psychological patterns or "archetypes" that belong to a transpersonal unconscious psyche, "the collective unconscious."[78] The primordial psychic material that makes up the collective unconscious finds its most condensed expression in the symbology of myth, ritual, and religion, but in a more diffuse or dilute form, the collective unconscious is expressed in the symbology of individual dreams and fantasies.

Jung taught that balanced relations between the conscious mind and the collective unconscious are crucial to the welfare of both the individual and society. Excessive repression of unconscious impulses results in the disintegration of the personality and so, eventually, of the society as well. "The change of character that is brought about by the uprush of collective forces is amazing," Jung warned. "A gentle and reasonable being can be transformed into a maniac or a savage beast." All told, "psychical dangers are much more dangerous than epidemics or earthquakes." Following Nietzsche's lead, Jung disparaged our scientifically oriented society for its denial of humanity's primal, unconscious impulses: "Our modern attitude looks back proudly upon the mists of superstition and of medieval or primitive credulity and entirely forgets that it carries the whole living past in the lower stories of the skyscraper of rational consciousness. Without the lower stories our mind is suspended in mid-air. No wonder that it gets nervous."[79] In the interest of fostering integrated personalities and peaceful societies, Jung argued for the necessity of channels of expression for the impulses of the unconscious. Besides the increasingly disused outlets of myth, ritual, and religion, another outlet recognized by Jung was the creation of "visionary" images—images that pointed to complex truths not yet fully comprehensible to the conscious mind. An artist's inspired dreams and revelations could potentially bring visionary symbols to life, though "only at the expense of a relative depreciation of the object."[80]

As Freud recognized, artists and writers have in a sense always done what the psychoanalyst and the analysand do together in attempting to come to terms with certain unconsciously apprehended elements (manifest through dreams, fantasies, and free-associative thinking) by working them into the texture of conscious experience. The surrealists understood that psychoanalysis conferred an unprecedented legitimacy on the dubious realms of the unconscious and the imagination, and they were the first group of writers and artists to try to exploit the revelations of psychoanalysis in a programmatic way. The surrealists assumed the psychoana-

lysts' commitment to exploring and emancipating what they could discover of the hidden or repressed contents of the unconscious mind—but in the interest of accomplishing artistic and social objectives rather than scientific or therapeutic ones.

Some of the surrealists extended their interest in the fantasies of the unconscious to encompass themes from mythology, but others rejected that option: "It has been suggested . . . that the role of the artist consists in creating new myths," noted the surrealist magazine *View* in 1943.

But the progressive forces of history have always followed an opposite trend. To the theological explanation of the cause of the world, man of the western civilization has finally opposed the infinitely profounder theory of evolution. Likewise, to the virtues of a deified man and to the advantages of Grace, we oppose the infinitely more advanced because more human interpretation of motivations which Freud has given us. If we are against myths of questionable historic significance, be they pagan or Christian, we are naturally still more violently opposed to degenerate forms of myths which some suggest ought to inspire us in the present or immediate future, such as the hitlerian adaptation of the theory of a chosen race. . . . It is the forces of reaction, not we, that cling to the mythical explanation of the world![81]

The fascists' enchantment with certain kinds of mythmaking rendered the association between myths and reactionary forces plain enough in this period. Those surrealists who avoided the mythic, cultic bases of modern art and refused the retrogressive impulses of Jungian theory, with its stress on the primal, collective fantasies of myth, involved themselves in exploring and realizing personal dreams and fantasies, which they understood from Freudian theory to have more than a strictly private significance. Rather than pursuing "escapism through myths," the editors of *View* encouraged artists "to follow their ideas and emotions to the utmost limit," to privilege imagination and the search for the "exceptional": "Insofar as artists can decide by their own volition what shall affect them, they regulate their conduct according to methods that help perpetually to renew our deepest emotional contact with the world."

No matter how fantastic the surrealists' images became, the idioms they used to realize their visions remained explicitly, if loosely, tied to the conventions that underpin mimetic art. The artists in Rothko's circle finally came to view the surrealists' dependence on those conventions as contradictory and regressive. The Europeans' interest in the private realms of dreams and fantasies was viewed by some Americans, further, as solipsistic and escapist: "To us it is not enough to illustrate dreams," charged Gottlieb in 1943.[82] And Rothko observed in later years, "While the Surrealists were interested in translating the real world to dream, [we] were insisting that symbols were real."[83] In attempting to ground their art in myth more than in oneiric imagery, Rothko and his contemporaries hoped to make art with a more universal basis and significance. Insofar as the Europeans also took up subjects from mythology, the Americans

pursued a distinct objective: attempting to use myth as a medium, to *make* myths more than to narrate them and so to further dismantle the conventions of representation (necessarily so, by Jung's reckoning). In effect, this ambition led to the New York School's art becoming progressively less legible and resulted in a narrower public than the Europeans' instead of the larger public the Americans had hoped for.

In the 1940s Rothko was engrossed by the vision—conjured by Nietzsche, as well as by Freud and Jung—of the synchronous existence of diachronic elements in the modern person's mind. Rothko relished the idea that "an atavistic memory, a prophetic dream, may exist side by side with the casual event of today," as he phrased it,[84] and he imagined that such apparently strange juxtapositions would lead him to the wellsprings of art. Rothko credited the surrealists for discovering this vital resource, believing that it was they who had "uncovered the glossary of myth and . . . established a congruity between the phantasmagoria of the unconscious and the objects of everyday life. This congruity," said Rothko, "constitutes the exhilarated tragic experience which for me is the only source book for art."[85]

For an artist to name his only source book is to make a momentous pronouncement. If his exuberant rhetoric obscures the implications of that pronouncement, the revelation Rothko had experienced was that the rebirth of myth urged by Nietzsche was nigh, that artists would have recourse to mythology again, despite the modern bias against it. Using mythology had become legitimate because a congruity had been established between the phantasmagoria of the unconscious and the objects of everyday life. That congruity had been imaged convincingly by the surrealists but was established also—so Rothko and others were evidently persuaded—by contemporary scholars of mythology. Though modern persons see themselves as divorced from mythological systems and modes of thought, mythographers suggested that they evince a kind of "crypto-religious behavior," as Mircea Eliade described it, in spite of themselves: "It could almost be said that in the case of those moderns who proclaim that they are nonreligious, religion and mythology are 'eclipsed' in the darkness of the unconscious—which means too that in such men the possibility of reintegrating a religious vision of life lies at a great depth."[86] Rothko could draw on his treasured source book, then, with the legitimate expectation of reaching his viewers in their psychic depths—an objective that psychoanalysis seemed equally to have corroborated. "Freud, Jung and their followers have demonstrated irrefutably that the logic, the heroes, and the deeds of myth survive into modern times," Joseph Campbell wrote. "In the absence of an effective general mythology, each of us has his private, unrecognized, rudimentary, yet secretly potent pantheon of dream. The latest incarnation of Oedipus, the continued romance of Beauty and the Beast, stand this afternoon on the corner of Forty-second Street and Fifth Avenue, waiting for the traffic light to change."[87]

Rothko credited the surrealists with originating this unexpected image of myth and modernity as bedfellows, but others—most notably James Joyce—had previously given shape to this vision. Joyce's *Ulysses*, with its overlay of modern and mythical tales, foreshadows the modern, mythical pictures of Rothko and his fellow Mythmakers. In 1922 T. S. Eliot had greeted *Ulysses* as "the most important expression which the present age has found, and in his discussion of this seminal novel the poet voiced expectations that an increasing number of artists and writers gradually came to share. *Ulysses*,

is a book to which we are all indebted and from which none of us can escape. . . . In manipulating a continuous parallel between contemporaneity and antiquity, Mr. Joyce is pursuing a method which others must pursue after him. . . . It is simply a way . . . of giving a shape and a significance to the immense panorama of futility and anarchy which is contemporary history. . . . Psychology, . . . ethnology, and *The Golden Bough* have concurred to make possible what was impossible even a few years ago. Instead of narrative method, we may now use the mythical method. It is, I seriously believe, a step toward making the modern world possible for art.[88]

The endeavors of the many practitioners of the mythical method active in this period—Eliot, Ezra Pound, Igor Stravinsky, André Masson, Martha Graham, and Rothko himself, to name an assortment—seemed to be corroborated by a growing consensus in the scholarly community ("psychology, . . . ethnology, and *The Golden Bough*") concerning the centrality, universality, and timelessness of myth. These artists were aware that the popular view of myths as childish stories and remote superstitions had been challenged and revised. "We have tried to rescue mythical consciousness from those premature rationalizations which . . . make the myth incomprehensible, because they look to it for an explanation of the world and an anticipation of science, whereas it is a projection of existence and an expression of the human condition," wrote Merleau-Ponty. "If all myths are true, it is insofar as they can be set in a phenomenology of mind which shows their function in arriving at awareness."[89] In the same vein, Ernst Cassirer asserted: "Mythology itself is not simply a crude mass of superstitions or gross delusions. It is not merely chaotic, for it possesses a systematic or conceptual form."[90]

### *The Golden Bough* and the Single Theme of Myth

By the 1940s the idea that mythology possesses a systematic or conceptual form was increasingly accredited by scholars. Sir James George Frazer's *The Golden Bough*, published in England in 1890, gradually generated widespread interest in the idea that mythology is underpinned by a unified conceptual form. With a naive use of comparative mythology, Frazer tried to show that a universal theme underlies all mythological traditions, despite their apparent disparities. The single theme that Frazer

found immanent in all myths concerned origins and endings—the cycle of life and death and the promise of new birth or rebirth in an afterlife. Frazer isolated the recurrent story of a dying or martyred king or god who was resurrected or replaced. Frazer traced the origins of this dying and reviving deity to vegetational and fertility cults, but he recognized the story also in the comparatively modern religion of Christianity.

Many scholars after Frazer have returned to this notion that there is a universal theme or themes to myth. Their amplification of those themes have differed (as have their methodologies), but most of them retained Frazer's focus on the cycle of life: "The basic principle of all mythology is this of the beginning in the end," wrote Joseph Campbell. "Full circle, from the tomb of the womb to the womb of the tomb, we come: an ambiguous, enigmatical incursion into a world of solid matter that is soon to melt from us, like the substance of a dream."[91] Robert Graves, the poet and mythographer, proposed that there is a single underlying theme not only to all of myth but also to all of poetry: the theme of life, death, and " 'the question of what survives of the beloved.' "[92] Mircea Eliade focused (as Nietzsche had before him) on the "myth of the eternal return." And Ernst Cassirer described his understanding of the content of myth as follows: "In a certain sense the whole of mythical thought may be interpreted as a constant and obstinate negation of the phenomenon of death. By virtue of this conviction of the unbroken unity and continuity of life, myth has to clear away this phenomenon."[93] This vision of the role of myth parallels Nietzsche's view of the function of Greek tragedy and, for that matter, is consonant with Rothko's view that "all art deals with intimations of mortality." An impending, irrevocable death sentence renders the "human drama" a tragedy, although the tenure at life beforehand may make that drama, at least, an "exhilarated tragic experience."

Besides T. S. Eliot, such writers as Robert Graves, William Butler Yeats, Ezra Pound, and Edith Sitwell made use of *The Golden Bough,* which Eliot referred to as "a work of no less importance for our time than the complementary work of Freud—throwing its light on the obscurity of the soul from a different angle."[94] The influence of *The Golden Bough* on visual artists is not as well documented, but the ideas the book broached, considered together with the claims of such contemporary mythographers as Campbell and Graves, appeared to hold a comparable promise for many of them.[95] By assuming the basic themes of myth for their own thematics, visual artists could hope to appeal to their viewers' most deep-seated spiritual needs—or so they came to believe. For Rothko, responding to such needs remained his primary objective; he insisted that "the picture must be . . . an unexpected and unprecedented resolution of an eternally familiar need."[96]

That Rothko embraced the notion of the universality of mythological themes is clear from numerous statements he made: in 1943 he argued that ancient myths constitute viable subjects for the modern artist because myths change "only in detail but never in substance, be they

Greek, Aztec, Icelandic, or Egyptian. And modern psychology finds them persisting still in our dreams, our vernacular, and our art, for all the changes in the outward conditions of life."[97] In 1944 he said that the *Omen of the Eagle* (pl. II) was concerned "not with the particular anecdote"—that is with the specific stories of the *Oresteia*—"but rather with the Spirit of Myth which is generic to all myths at all times."[98] In working with the universal spirit of myth, Rothko expected to gain the whole of mythology as a resource for subject matter, a glossary of eternal symbols. In 1946 he described the subject matter of Still's art as "the tragic-religious drama which is generic to all Myths."[99] This description (which Still later repudiated) was perhaps more a summary of his own thematic concerns, with the term *tragic* referring not simply to Greek tragedy but to human suffering and mortality generally, the term *religion* referring to ritualistic efforts to face or transcend mortality, and the term *drama* referring especially to the "human drama." Among the titles of Rothko's paintings from this period are *Beginnings, Birth of Cephalopods, Attenuated Life, Sacrifice, Immolation,* and *Entombment.*

## Primitivism and the Concrete Image
In his initial surge of faith in the efficacy of surrealist methods applied toward Nietzschean ends, Rothko romantically imagined that he could reconstitute the situation of the tribal or archaic artist. As the self-appointed heir to the archaic artist who "first stumbled upon the symbols to give them life," Rothko could view his work as "simply a new aspect of the eternally archaic myth."[100] Feelings of affinity with so-called primitive artists were common in Rothko's circle as a corollary of the interest in mythological subject matter. "The subject is crucial and only that subject matter is valid which is tragic and timeless. That is why we profess spiritual kinship with primitive and archaic art," Rothko, Gottlieb, and Newman asserted in a collaborative statement in 1943.

By the time the artists in Rothko's sphere became interested in it, tribal and archaic art were long since established as an essential resource for modern artists; from Gauguin to Picasso, Brancusi, and Kirchner, primitivist currents had coursed through the development of modern art. In New York the Museum of Modern Art recognized the importance of tribal, archaic, and ethnographic art for contemporary artists by mounting exhibitions such as "African Negro Art" in 1935, "Prehistoric Rock Pictures in Europe and Africa" in 1937, and "Indian Art of the United States" in 1941. Rothko's primitivist leanings may well have arisen even earlier, however: while he was still an undergraduate at Yale, he and his fellow editors on the *Pest* toyed with the idea that " 'there is no apparent difference between the average good citizen of our civilization and the medicine man of barbarism,' " with the possible exception that "the barbarians lead a life that is more interesting" than "our smug contented Bourgeoisie."[101] When he studied at the Art Students League in the mid-

1920s, further, Rothko encountered an ardent primitivist in his teacher Max Weber.

Rothko's primitivizing impulses found an outlet in his involvement with children's art, which had also been an element in the primitivist enthusiasms of numerous European painters, including Kandinsky and the Blue Rider group. Rothko taught children's art classes in Brooklyn for twenty-three years, from 1929 through 1952, and although the job was above all a source of income, for a while he took it extremely seriously, inspired by Franz Cizek's writings on "child art." A Viennese scholar, Cizek believed in the "eternal child" "who follows—unconsciously—eternal laws in his production, and these laws are the same, to a large extent, as those which guided and still guide the primitive. Those laws are independent of time and nation."[102] Young children and "primitives" express themselves vividly in pictures, according to Cizek, because they do not have command of written language: they make art "to make real [their] own desires, inclinations and dreams."[103] This explains "the tremendous power of expression in primitive and Child Art."[104] Cizek also suggested that "only those who really have remained children will preserve their creativeness to the age of maturity,"[105] and Rothko apparently took this maxim to heart. In the late 1930s he was a self-styled innocent who wanted to "see objects and events as though for the first time, free from the accretions of habit."[106] In one of his earliest exhibitions, at the museum of his hometown of Portland, Oregon, in 1933, Rothko exhibited his own work alongside the work of his pupils from the Center Academy. And in 1940 a critic could still report that Rothko's students "helped to make him see and feel with their own simplicity and instinct for truth."[107]

The childlike qualities in Rothko's work of the 1930s are plain enough, especially if a viewer knows of his interest in children's art. But around 1941 the primitivist impulse in Rothko's work was redirected, as he permitted himself more license in distorting and imagining forms and relied more on archaic and tribal art as a justification and a model for doing so. "If we profess a kinship to the art of primitive men, it is because the feelings they expressed have a particular pertinence today," said Gottlieb in 1943 on behalf of Rothko and himself. "All primitive expression reveals the constant awareness of powerful forces, the immediate presence of terror and fear, a recognition and acceptance of the brutality of the natural world as well as the eternal insecurity of life. That these feelings are being experienced by many people throughout the world today is an unfortunate fact. . . . That is why we insist on subject matter, a subject matter that embraces these feelings and permits them to be expressed."[108]

Rothko's surrealistic pictures sometimes evince specific archaic forms, almost always from Mediterranean visual traditions. Some of his renderings of heads display characteristic traits of Greek and Roman heads, as in *Antigone* of circa 1941 (fig. 3) and *The Omen of the Eagle* of

1942 (pl. II) in which the fused rows of faces at the tops of the pictures—
with their straight noses in an unbroken line with their brows, their full
lips, big eyes, and ringletted hair—might evoke a row of faces on an an-
cient frieze. But for the most part, Rothko's allusions to archaic art re-
mained general or poetic. Perhaps he concurred with his friend Barnett
Newman that modern artists should attempt to follow the example of the
Greek tragedians but not the Greek sculptors, who fell into the "error" of
"play[ing] with an art of over-refinement, an art of quality, of sensibility, of
beauty." Newman insisted further, however, that "the artist today has
more feeling and consequently more understanding for a Marquesas Is-
land fetish than for the Greek figure."[109] Unlike Rothko, Newman and
Gottlieb—another of Rothko's intimates from this period—were seriously
interested in tribal art, particularly (in Newman's case) that of the North-
west coast native Americans.

    Explicit references to tribal art are practically nonexistent in Rothko's
surrealistic pictures. Only in loose ways do references surface, insofar as
he created mongrel figures of segmented human and animal body parts,
for instance, which loosely evoke fetish figures or totem poles. Rothko ad-
mired the expressiveness and the presence of tribal, ethnographic, and
archaic art, and he sought to capture something of those qualities in his
own work through analogous distortions and recombinations of forms.
The resemblance between the Mythmakers' pictures and "primitive" art
came about, Rothko said, "not because we are consciously derived from
them, but rather because we are concerned with similar states of con-
sciousness and relationship to the world. With such an objective we must
have inevitably hit upon a parallel condition for conceiving and creating
our forms."[110]

    Some critics have inferred, from both his statements and his images,
that Rothko was directly copying symbolic forms from archaic or tribal art
during the war years, and they have concluded that his images were
doomed to obscurity on that account. "Rothko and Gottlieb were unable
to endow their paintings with the relevance they insisted was inherent in
myth," said Diane Waldman, for one. "Removed from their original cul-
ture, the symbols lose their context, the connective tissue which is cru-
cial to their meaning and use; they become abstract signs without
significant mythic content."[111] The implication that Rothko used symbols
removed from a prior original culture cannot be supported, as far as I
can tell. His assertion that symbols were "eternal" referred to their con-
tent, not to the local details of their forms. Rothko indicated that he
would not resuscitate or copy disused mythological symbols because he
understood that they had "lost their pertinence in the intervening centu-
ries." He wanted to realize his own, new mythic visions instead. As he
wrote in a response to a critic in 1943,

To say that the modern artist has been fascinated primarily by the formal relation-
ship aspects of archaic art is, at best, a partial and misleading explanation. For

any serious artist or thinker will know that a form is significant only insofar as it expresses the inherent idea. The truth is therefore that the modern artist has a spiritual kinship with the emotions which these archaic forms imprison and the myths which they represent. The public, therefore, which reacted so violently to the primitive brutality of this [the Mythmakers'] art, reacted more truly than the critic who spoke about forms and techniques.[112]

Rothko would have been hard pressed to prove his claim that the public had successfully apprehended the emotional meanings of the Mythmakers' art whereas the overly technical and cerebral critics had failed to do so. For the viewing public, as for the critics, the Mythmakers' pictures probably looked like exercises in the use of an arcane or private language that defied translation by the uninitiated.

Rothko's freewheeling approach to myth and his notion that he could work in a creative way with the essence of mythology may be deemed misguided or disingenuous on the grounds that myths are meaningful only within the specific cultural contexts that give rise to them. If mythology is defined in terms of fixed codes of collective beliefs, then the ambition of an individual to make myths by formulating a personalized language appears contradictory and nonsensical (for Blake, in other words, no less than for Rothko). But Rothko was clearly disposed to a broader, more fluid definition of myth and symbolism, and his thinking was supported by some then current ideas in mythography, as he was evidently aware. Merleau-Ponty had written in the 1940s of the phenomenon of the "mythical consciousness," which "has not yet arrived at the notion of a thing or of objective truth." He explained that "subjectively it is a flux . . . it does not become static and thus does not know itself," although "if it did not tentatively suggest objectification, it would not crystallize itself in myths." To Merleau-Ponty, myth is above all "a projection of existence and an expression of the human condition"; further, "the myth holds the essence within the appearance; the mythical phenomenon is not a representation, but a genuine presence."[113]

Many scholars of myth, symbolism, and so-called primitive art concurred that basic themes recur in mythology, although the guises those themes take—the local details of myths and symbols—are variable. Even within a culture, new forms arise over time from antecedent, outworn ones through the agency of artists and storytellers or their tribal and prehistoric counterparts. "Wherever we have detailed information" about tribal cultures, according to Franz Boas, then a leading expert on what he referred to as "primitive art," "we see forms of objects and customs in constant flux, sometimes stable for a period, then undergoing rapid changes. Through this process elements that at one time belonged together as cultural units are torn apart. Some survive, others die; and . . . the cultural form may become a kaleidoscopic picture of miscellaneous traits that, however, are remodelled according to the changing spiritual background that pervades the culture and transforms the mosaic into an

organic whole."[114] Rothko painted in a society and period in which the cultural units had long been torn apart and artists were reduced to re-modeling with fragments that would not come together as a whole, trans-parent to the community at large. In spite of this circumstance, during the war considerable pressure was put on artists to find a mode of expression that would be accessible and meaningful to the community at large. But after the war, Rothko increasingly came to feel—and felt free to acknowledge—that he was condemned to work in a cultural half-light with the fragments of ruptured belief systems. From the time he discov-ered surrealism until the end of his career, Rothko nonetheless hoped quixotically that his symbols might yet legitimately lay claim to a univer-sal viability.

In 1946 Rothko advocated "creating new counterparts to replace the old mythological hybrids" because every age has to generate the images that meet its own needs, based on its own experiences.[115] The experi-ences of wartime shaped the period in which Rothko turned to myth, and he pointedly suggested that "those who think that the world of today is more gentle and graceful than the primeval and predatory passions from which these myths spring are either not aware of reality or do not wish to see it in art."[116] World War II showed conclusively that civilized people are less different from savages than they like to think; Franco, Hitler, Sta-lin, and Mussolini pumped fresh blood into outworn images of monsters and demons, demonstrating to Rothko's satisfaction, at least, that the pri-mal spirit of myth still lived. His awareness of the predatory passions afoot in the modern world moved Rothko to distort familiar objects as tribal artists had done. He valued the precedent tribal art offered because it employed distortion for symbolic purposes, for the sake of subject mat-ter—and distortion for any lesser cause was suspect in his eyes. This matter of an artist's motives for distorting forms was also important to Newman, who disparaged "the easy asumption that any distortion from the realistic form is an abstraction of that form. . . . In primitive tribes distortion was used as a device whereby the artist could create sym-bols."[117] Nietzsche, too, had suggested that people tend to see tribal and archaic art "in too complicated and abstract a way. Metaphor, for the au-thentic poet, is not a figure of rhetoric but a representative image stand-ing concretely before him in lieu of a concept."[118] Rothko pursued precisely this kind of metaphor, or icon: a concrete and representative image.

In 1945 Rothko wrote to Newman, "I have assumed for myself the problem of further concretizing my symbols, which give me many head-aches but make work rather exhilarating. Unfortunately one can't think these things out with finality, but must endure a series of stumblings to-ward a clearer issue."[119] Rothko was less tentative about his achievements in public statements; to him, concreteness was a critical artistic criterion; a criterion met by tribal and archaic art and by his own work but not by surrealist or abstract art. Later, in the 1950s, Rothko referred to himself

repeatedly as a "materialist," stressing that his pictures "are just made of things."[120] This emphasis on the concrete and material was directed at countering the tendency to interpret his pictures in mystical terms, but it was also calculated to counter the airy connotations of the term *abstract,* which he could not dissuade critics from appending to his work. "I adhere to the material reality of the world and the substance of things," Rothko had written in 1945. He differed with "the abstract artist" because "I repudiate his denial of the anecdote just as I repudiate the denial of the whole of reality. For art to me is an anecdote of the spirit, and the only means of making concrete the purpose of its varied quickness and stillness." And he "quarrelled" with surrealism because "I love both the object and the dream far too much to have them effervesced into the insubstantiality of memory and hallucination."[121]

What decisively separated Rothko's circle from the surrealists, by his own (later) account, was that whereas the surrealists were "translating the real world to dream, [we] were insisting that symbols were real. . . . This means that the artist gave form to the feeling which one would derive from the Surrealist dream. Thus it is real experience, tangible because it is material."[122] In other words, instead of conjuring objects, juxtapositions of objects, or scenes that would cue viewers to summon the emotions that they might summon in the actual presence of such scenes or objects, Rothko hoped to realize tangible, material, and so evocative equivalents for such feelings. He (and some others of his circle) aimed for the most direct transmission of feeling—raw feeling, that is, not banalized by quotidian experience.

To make emotions tangible or material would take an act of transubstantiation, perhaps; but Rothko was prone to discussing his undertakings in just such magical or animistic terms: "I would sooner confer anthropomorphic attributes on a stone than dehumanize the slightest possibility of consciousness," he declared in 1945.[123] Rothko considered his own shapes more alive, real, and concrete than surrealist and abstract forms, because his shapes were "organisms with volition and a passion for self-assertion." And once he quit painting "from life," as the saying goes—that is, from models or landscapes—Rothko conceived lives for the shapes in his paintings themselves. In 1947 he said that his shapes "move with internal freedom, and without need to conform with or to violate what is probable in the familiar world. They have no direct association with any particular visible experience, but in them one recognizes the principle and passion of organisms."[124] Rothko and others in his group regarded tribal and archaic artists as exemplary, in this respect, because for them, "a shape was a living thing, a vehicle for an abstract thought-complex, a carrier of the awesome feelings [they] felt before the terror of the unknowable. The abstract shape was, therefore, real rather than a formal 'abstraction' of a visual fact," as Newman described it.[125]

One way Rothko tried to make living things of his shapes was by drawing or painting them freehand with a technique grounded in the

premises of psychic automatism. His shapes remained "alive," by his own reckoning because they represented actual emissions from the psyche, not preconceived, preexisting, or regularized forms. Geometric shapes and areas with ruled edges occasionally crop up in Rothko's pictures, but straight edges are for the most part conspicuous only by their absence. The rectangular areas that are the hallmark of Rothko's classic paintings often have highly irregular edges. To an extent, the lively brushwork found at the rectangles' edges represents or signals the traces of the artist's search for the exact proportions of the rectangles—how broad, how high; but Rothko often exaggerated the irregular or frayed appearance of these edges by painting over them with a color brighter or deeper than that used for the rectangle as a whole. The result—as in *White Band (Number 27),* 1954 (pl. XVIII), for example—is a subtle optical vibration at the peripheries of the picture and of the viewer's field of vision that keeps the shapes "alive."

The idea that works of art are living entities was common among Rothko's contemporaries (as it had been with artists for centuries). "The painting has a life of its own," said Jackson Pollock. "The picture should be alive, the statue should be alive and every work of art should be alive," wrote Hans Hofmann. "A great work of art actually lives . . . and converses with man," suggested John Graham. Rothko, too, was engaged not only in an objectification of subjectivity but also in a subjectification of the object. Despite his rhetoric about being a materialist, he was never content to produce mere lifeless objects, and he always hoped to endow his objects with a subjectivity, as well as a subject: his classic paintings were his "children," he was often heard to say. He envisioned the connection between viewers and his paintings as one between companions or fellow beings locked in a vital symbiotic relationship: "A picture lives by companionship, expanding and quickening in the eyes of the sensitive observer. It dies by the same token," he wrote in 1947.[126] In 1943 Rothko, Newman, and Gottlieb termed the relation between viewers and pictures a "marriage," declaring that the "explanation" for their pictures "must come out of a consummated experience between picture and onlooker."[127] Rothko understood that he would have to induce viewers to feel a deep connection with his pictures if they were to become engaged with his "dramas." However he referred to that connection, what emerges again here is the Nietzschean ideal of the viewing public as not simply detached or even interested spectators but as defenselessly credulous participants who could be seduced, devastated, and finally solaced by the tragic dramas appearing before their eyes.

Untitled, 1930s, oil on canvas, 49¾ × 37 in.
Collection of Kate Rothko Prizel and Christopher
Rothko. Copyright © estate of Mark Rothko, 1988.

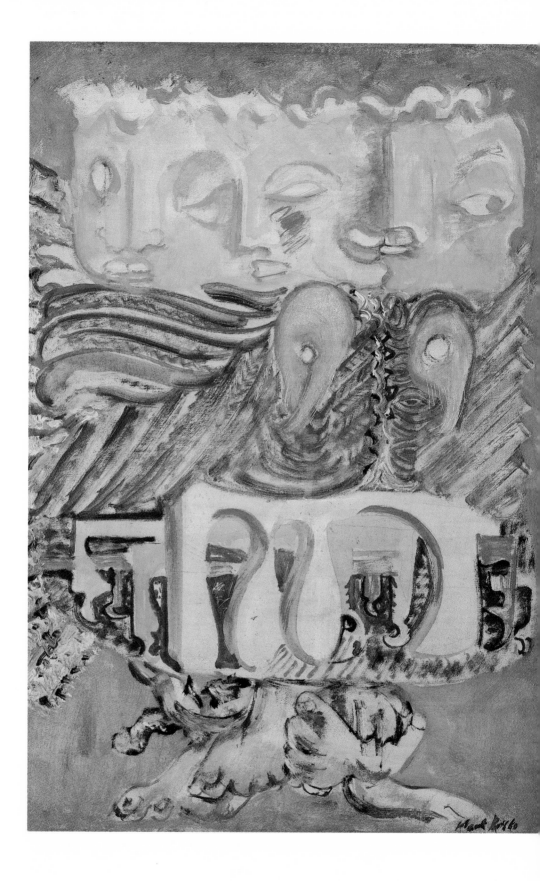

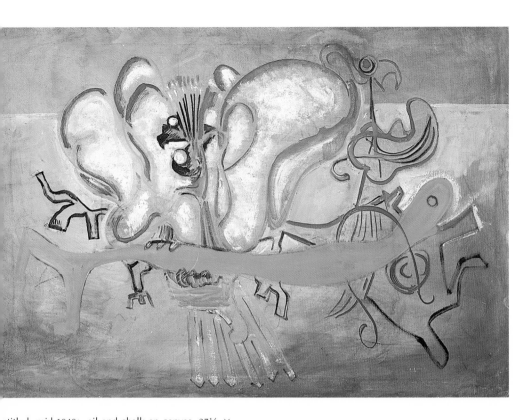

ntitled, mid-1940s, oil and chalk on canvas, 27¼ ×
) in. Collection of the National Gallery of Art,
Vashington D.C. Gift of the Mark Rothko Foundation, Inc.

1e Omen of the Eagle, 1942, oil and pencil on
1nvas, 25¾ × 17¾ in. Collection of the National
allery of Art, Washington D.C. Gift of the Mark
othko Foundation, Inc.

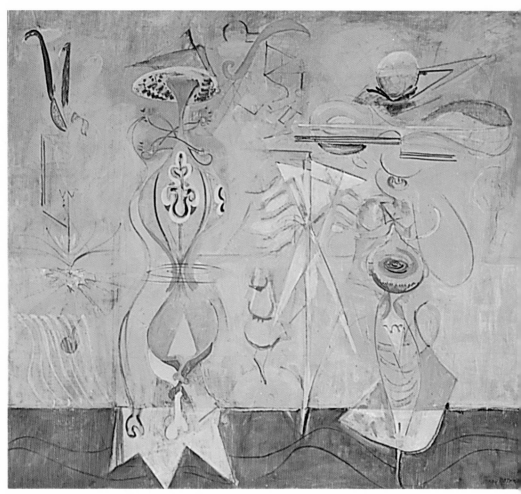

IV
*Slow Swirl by the Edge of the Sea,* 1944, oil on canvas,
75⅜ × 84¾ in. Collection of the Museum of Modern
Art, New York. Bequest of Mrs. Mark Rothko through
the Mark Rothko Foundation, Inc.

V
*Number 10,* 1947 or *Number 12,* 1948, oil on canv
64¹⁄₁₆ × 42⁹⁄₁₆. Collection of the National Gallery
Art, Washington D.C. Gift of the Mark Rothko
Foundation, Inc. (Photo: Quesada/Burke)

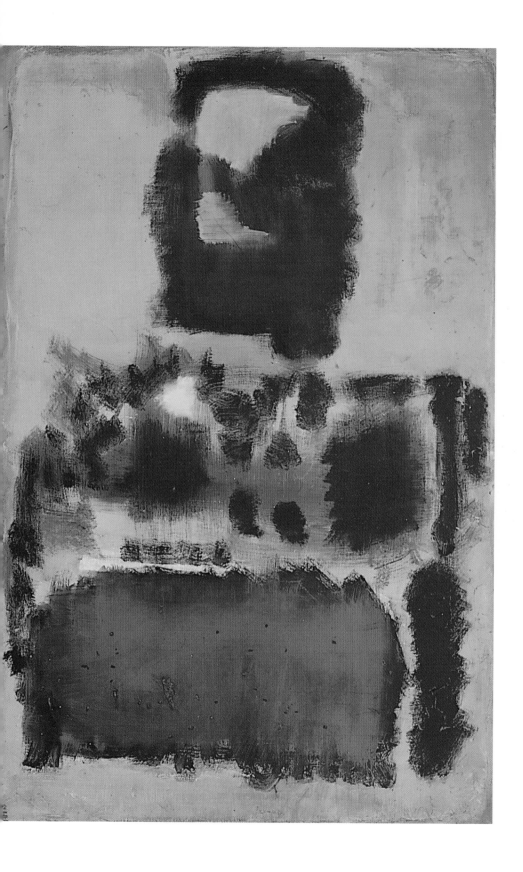

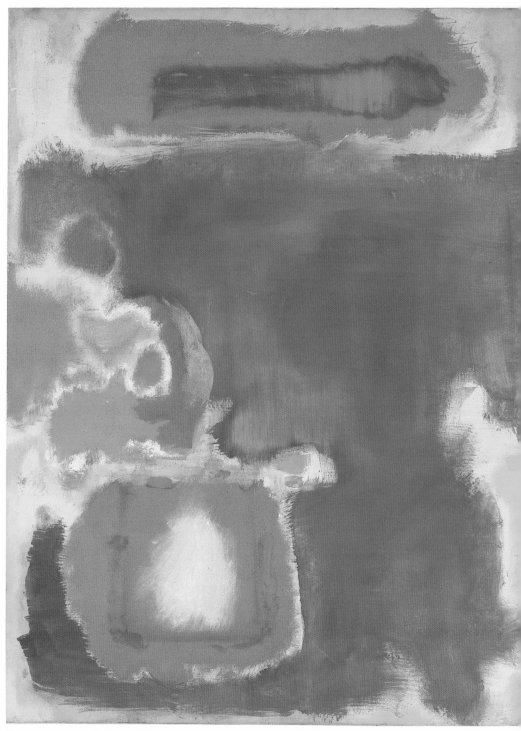

VI
*Number 17,* 1947, oil on canvas, 48 × 35⅞ in.
Collection of the Solomon R. Guggenheim Museum,
New York. Gift of the Mark Rothko Foundation, Inc.
Copyright © estate of Mark Rothko, 1988. (Photo:
Quesada/Burke)

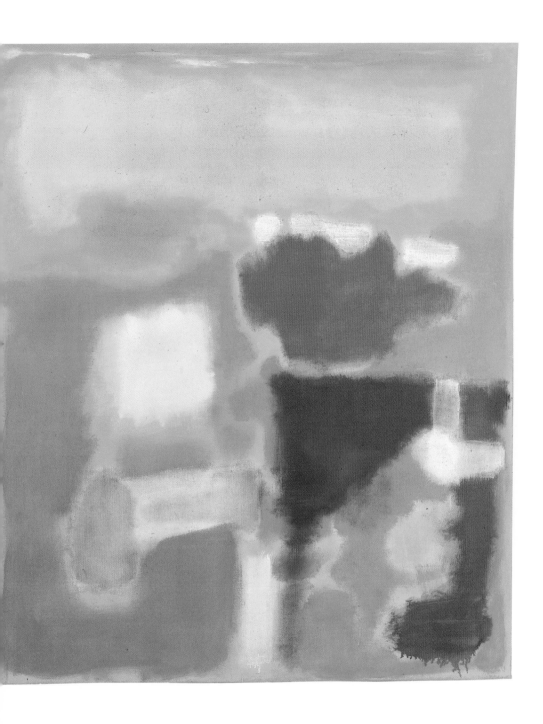

II
*Number 18,* 1948 or *Number 1,* 1949, oil on canvas,
7⅛ x 56 in. Collection of the Vassar College Art
Gallery, Poughkeepsie, New York. Gift of Mrs. John D.
Rockefeller III. 55.6.6.

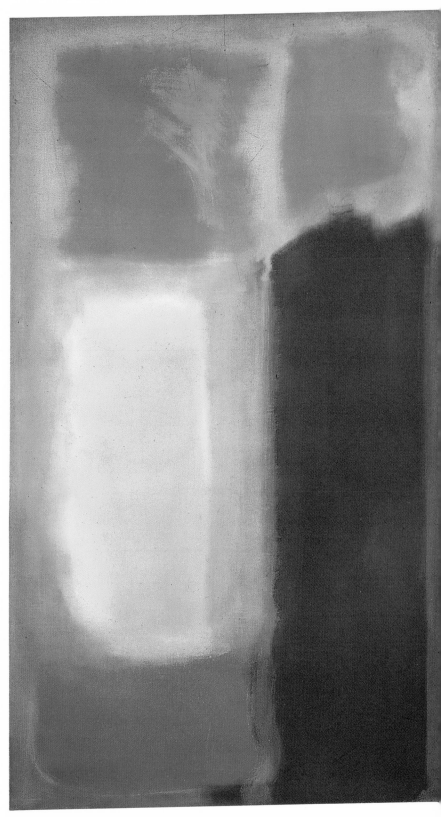

*VIII*
*Number 15,* 1948 or *Number 17,* 1949, oil on canvas, 51⅞ × 29⅛ in. Collection of the National Gallery of Art, Washington D.C. Gift of the Mark Rothko Foundation, Inc.
(Photo: Quesada/Burke)

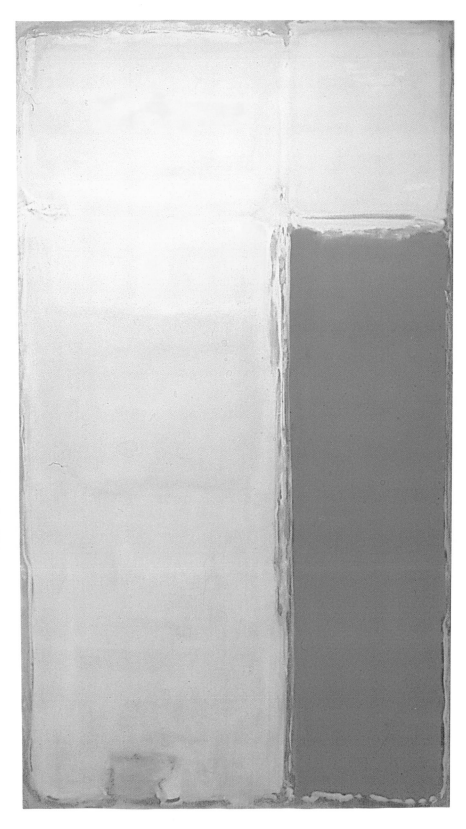

IX
*Number 20,* 1949, oil on canvas, 93½ × 53⅛ in. Collection of Kate Rothko Prizel and Christopher Rothko. Copyright © estate of Mark Rothko, 1988.

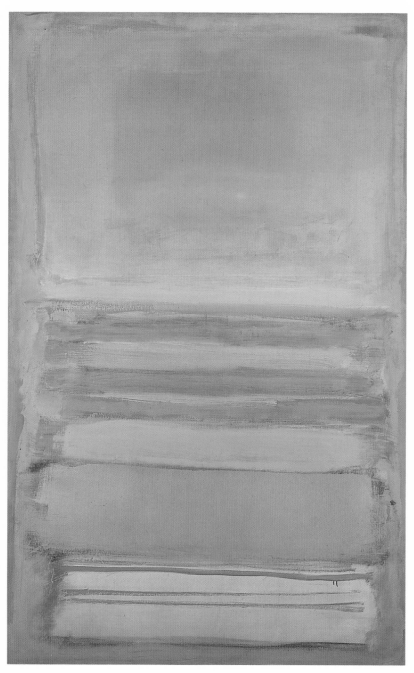

X
*Number 11,* 1949, oil on canvas, 68⅛ × 43⁵⁄₁₆ in.
Collection of the National Gallery of Art, Washington
D.C. Gift of the Mark Rothko Foundation, Inc.

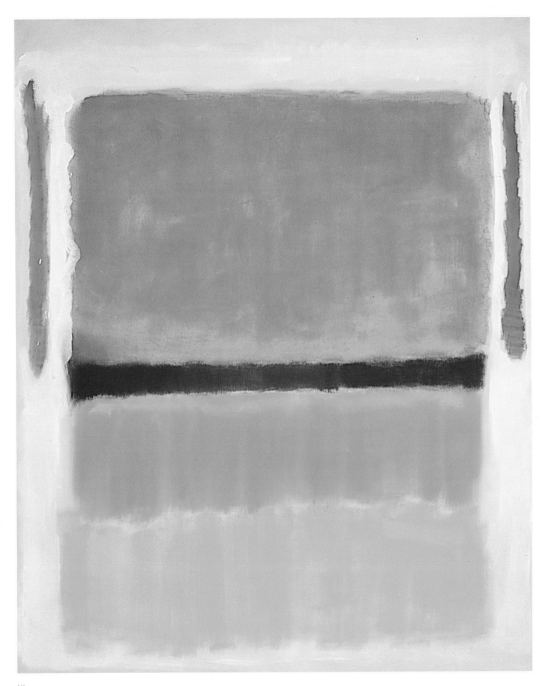

XI
*Violet, Black, Orange, Yellow on White and Red,* 1949,
oil on canvas, 81½ × 60 in. Collection of the
Solomon R. Guggenheim Museum, New York. Gift of
Elaine and Werner Dannheisser and the Dannheisser
Foundation. Copyright © estate of Mark Rothko, 1988.

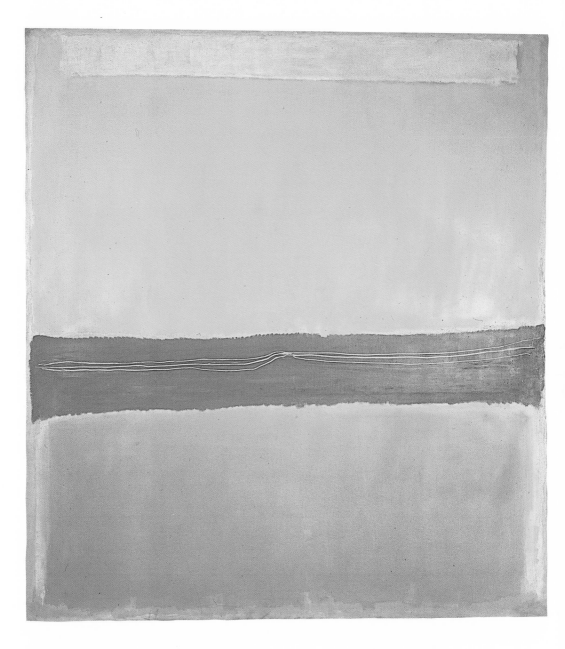

XII
*Number 22,* 1949 (also published as *Number 22,* 1950),
oil on canvas, 117 × 107⅛ in. Collection of the
Museum of Modern Art, New York. Gift of the Artist.
(Photo: Clements)

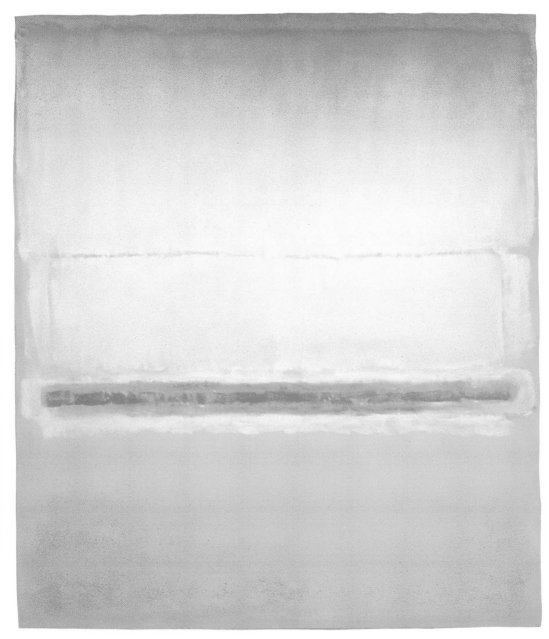

XIII
*Number 20,* 1950, oil on canvas, 116½ × 102 in.
Collection of Mr. and Mrs. Paul Mellon, Upperville,
Virginia.

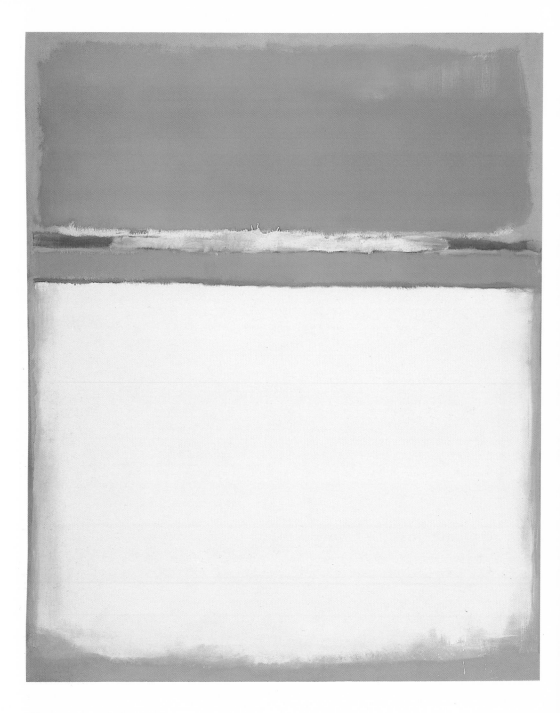

XIV
*Number 18,* 1951, oil on canvas, 81¾ × 67 in.
Collection of the Munson-Williams-Proctor Institute,
Utica, New York.

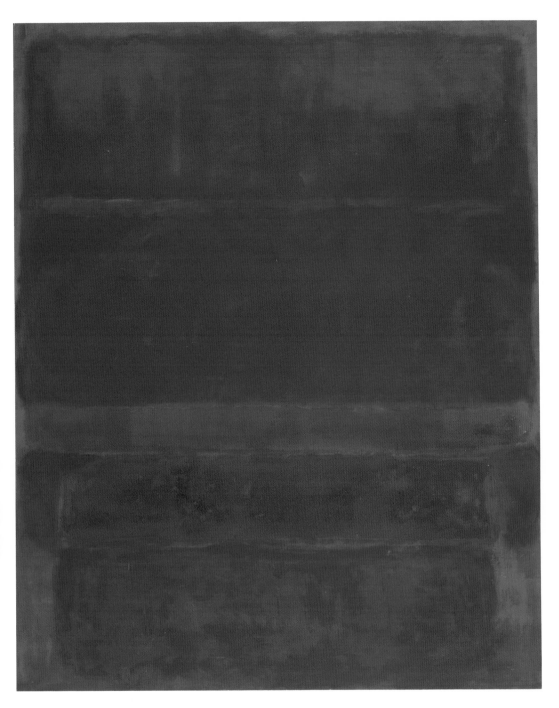

XV
Untitled, 1951, oil on canvas, 103 × 83 in. Collection
of Mr. and Mrs. Paul Mellon, Upperville, Virginia.

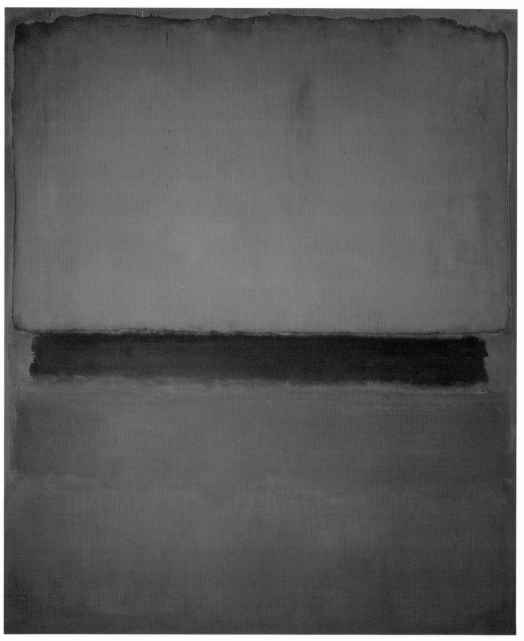

XVI
Untitled, 1952, oil on canvas, 95 × 81 in. Private collection.

XVII
Untitled, 1953, mixed media on canvas, 106 × 50⅞ in.
Collection of Whitney Museum of American Art, New
York. Gift of the Mark Rothko Foundation, Inc. Acq.
no. 85.43.2 (Photo: Quesada/Burke)

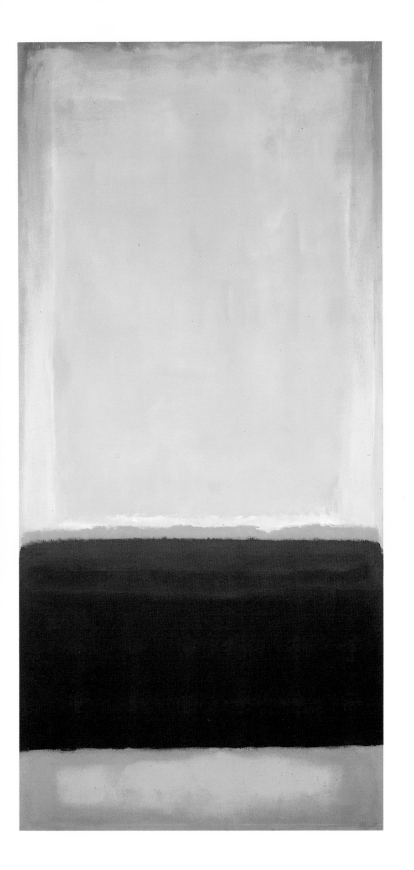

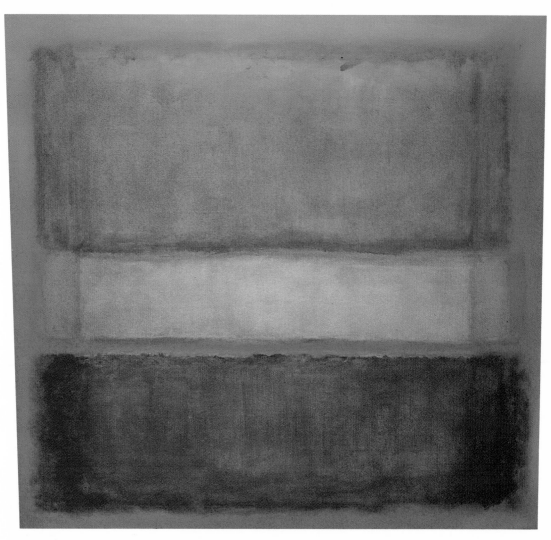

XVIII
*White Band (Number 27),* 1954, oil on canvas, 86⅝ × 81 in.
Private collection.

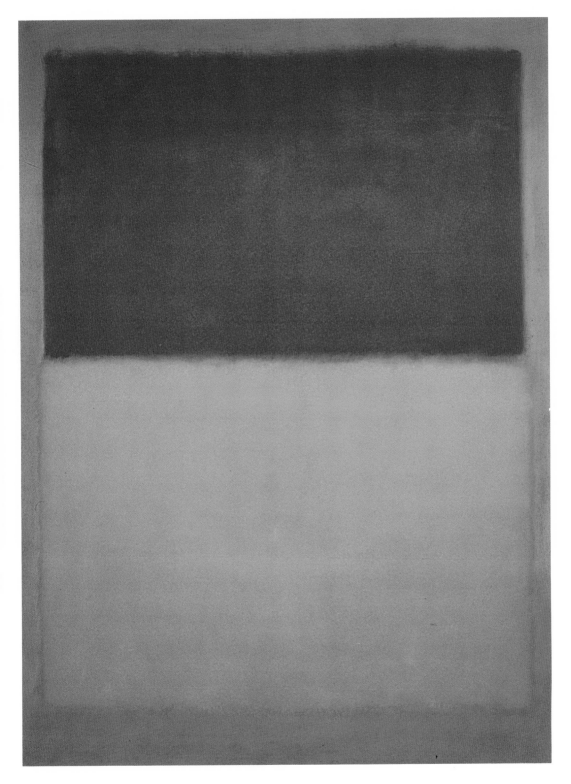

XIX
*Green and Tangerine on Red,* 1956, oil on canvas, 93½ × 69⅛.
The Phillips Collection, Washington D.C.

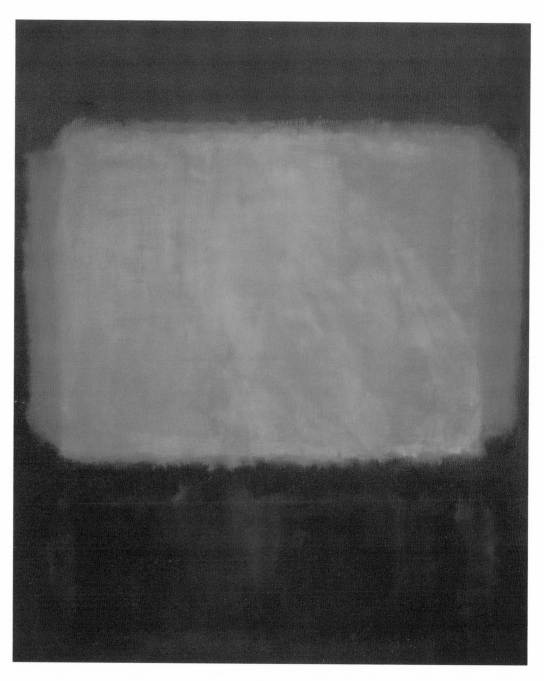

XX
*Browns,* 1957, oil on canvas, 91¾ × 76⅛ in.
Collection of Mr. and Mrs. S. I. Newhouse, Jr., New York.

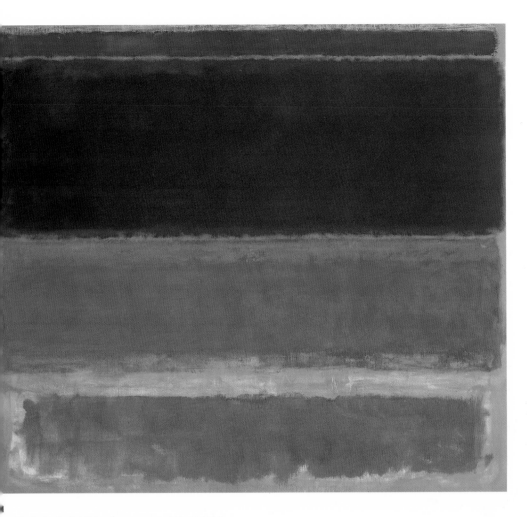

*ur Darks in Red,* 1958, oil on canvas, 102 × 116 in.
llection of the Whitney Museum of American Art,
w York. Purchase, with funds from the Friends of the
hitney Museum of American Art, Mr. and Mrs.
gene M. Schwartz, Mrs. Samuel A. Seaver, and
arles Simon. Acq. no. 68.9.

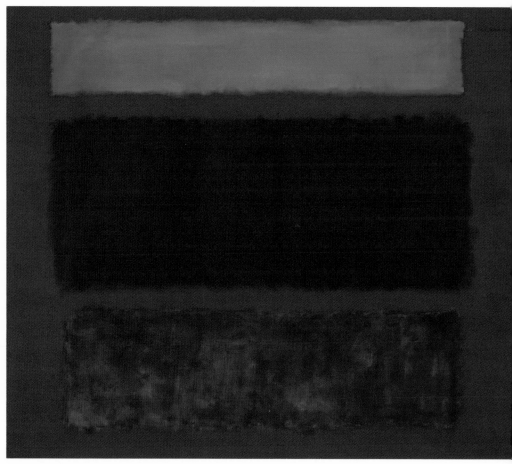

XXII
*Reds, Number 16,* 1960, oil on canvas, 102 × 119½ in.
Collection of the Metropolitan Museum of Art, New
York. Purchase. Arthur A. Hearn Fund, George H.
Hearn Fund, Hugo Kastor Fund, 1971.

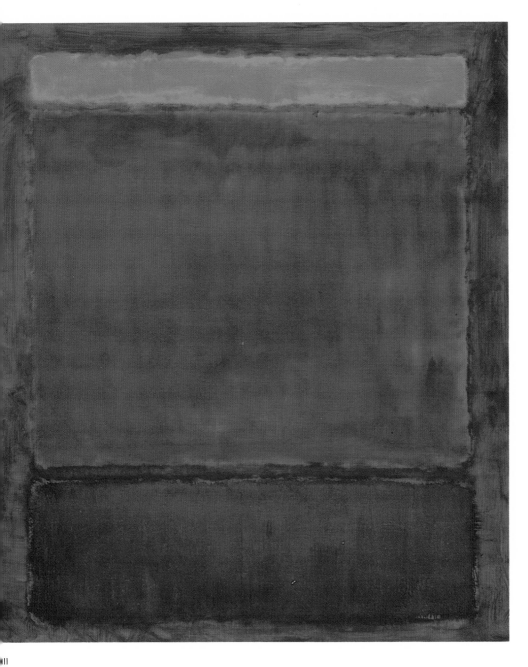

titled, 1961, oil on canvas, 93 × 80 in. Collection of
Houston Museum of Fine Arts.

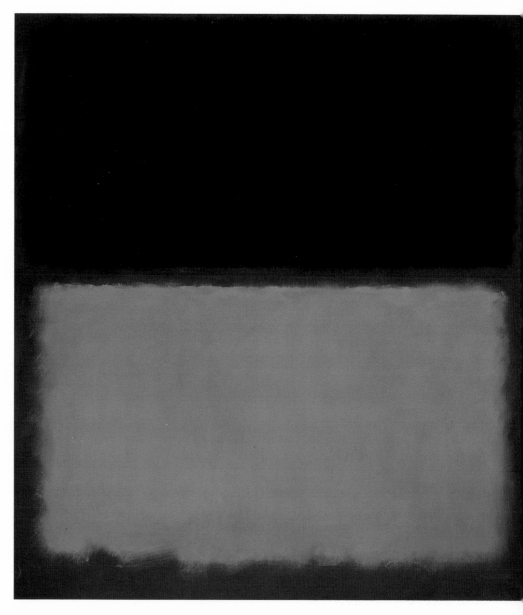

XXIV
*Number 18,* 1963, mixed media on canvas, 69⅛ ×
64⅛ in. Collection of the Solomon R. Guggenheim
Museum, New York. Gift of the Mark Rothko
Foundation, Inc. Copyright © estate of Mark Rothko, 1988.

# The Portrait and the Landscape:
# Microcosm and Macrocosm

Rothko conceived of his pictures as living entities made up of living forms. In 1947 he used a theater metaphor to describe the relation of the whole painting to its parts: "I think of my pictures as dramas; the shapes in the pictures are the performers. They have been created from the need for a group of actors who are able to move dramatically without embarrassment and execute gestures without shame."[1] Before 1947 Rothko's performers could often be read as just that—exotically formed and garbed actors poised against backdrops comprised of stagelike or landscapelike tiers. But in 1947 and 1948 the actors in Rothko's pictures became scrambled and diffused. And after 1949 his performers, such as they are, were more regular in form and fewer in number, consisting of a few essentially rectangular shapes arranged in a simple stack on an undivided background. Rothko's reasons for moving away from elements that were, however dimly, recognizable as humanoids, animals, and landscape emerged in the statement made in 1947: "The presentation of this drama in the familiar world was never possible, unless everyday acts belonged to a ritual accepted as referring to a transcendent realm." Because modern Western society lacked such shared, openly acknowledged rituals, Rothko felt that an artist's attempts at making mythic personages who could move dramatically without embarrassment were doomed, at least insofar as those creatures were recognizable enough to insinuate themselves into a received narrative or illustrative context. "Without monsters and gods, art cannot enact our drama: art's most profound moments express this frustration"; this was the stumbling block Rothko faced in 1947.[2] The surrealists had led him to believe that his fantastic beings would have greater effectiveness than they finally proved to have; so Rothko set about transfiguring those monsters and gods into something even more removed from the mundane and familiar, something stranger and— though it would never be his own choice of words—more abstract.

Prompted by the artist's use in 1947 of a dramatic metaphor for his art, as well as by his interest in tragedy and the theater generally, some critics have interpreted the broad rectangular areas in Rothko's classic paintings as theatrical backdrops for stages emptied of performers. "In many of the earlier mythic pictures, the forms themselves are the actors in front of a backdrop of horizontal bands," wrote Irving Sandler. "In the

abstractions after 1950, the backdrops become the sole image." Sandler further suggests that Rothko's mature work enlists the viewer as a substitute for the absent performer, that his pictures effectually cast the viewer as "an actor who plays his solitary self."[3] The structure of Rothko's pictures, with their rectangular module and their continuous border around the periphery, has long elicited architectural references from critics, though more often of doorways and windows than of stage sets. In the metaphor of the stage set, Sandler and some other critics believed they had identified a more innovative, meaningful, and characteristic subject for Rothko's art.

If Rothko's rectangular areas were backdrops, with their borders functioning as the architectural frame of a stage, then those backdrops should appear to be set behind, at a shallow depth in back of, the pictures' bordering edge. From a technical point of view, as well as on visual grounds, I maintain that the reverse is usually true of Rothko's pictures. The margin or border area was laid down first (as part of a layer of paint that covered the entire canvas), and the pictures' rectangular areas were painted over and on top of, not underneath or behind, the area that borders them. The border does not function the way a window mat does in a framed drawing, in other words, but instead—to extend the framing metaphor—the drawing (the rectangular areas) is floated on top of the mat. The rectangles in Rothko's pictures are not only compositionally dominant then but also constitute a kind of foreground, forward of the plane described by the pictures' borders. Because the translucent and brushy look of some of the rectangular areas lends them a sense of openness, however, many critics have been inspired to describe the effects of those areas in spatial terms, though more often as boundless and infinite spaces than as the contained space of theaters. Rothko did not endorse such readings; nor did he mean to create such effects, as he insisted categorically that "My paintings do not deal in space."[4] However spacious his rectangular fields sometimes appeared—in spite of himself, it seems—he kept the effect of recession in check, or at least in tension, by positioning the rectangles on top of the background area, which holds them subtly to the picture surface.

The relation between the colors of the rectangles and the color of the border or background is an extremely calculated one in Rothko's art. Often there is little difference in hue or tone between the border and at least one of the component rectangles, and this increases the visual tension over the relation between the rectangle and the border in space (as in pls. XV, XVII, and XXIII). Some of the rectangles seem almost to subjoin the border area, as at the top of *Number 18,* 1951 (pl. XIV). But most of the rectangular areas remain fairly distinct from the border or background, and often they are more or less subtly outlined in a way that assures that distinction (as in *White Band [Number 27],* 1954 [pl. XVIII]). If any element of Rothko's pictures tends to be insubstantial, it is most often not the rectangles, which always have a degree of opacity or solid-

ity, but the background or border. The border area is almost always less thickly painted than the rectangles (although in some of the earlier classic paintings—in *Violet, Black, Orange, Yellow on White and Red* of 1949 [pl. XI] for example—Rothko overpainted the borders), and often it appears more as an ethereal stain than as a solid, let alone an architectural element. This discrepancy between the substantiality of the borders and the rectangles helps account for the effect Rothko's rectangles are frequently seen as imparting (an effect often described in hallucinatory terms): that is, of something emerging and materializing out of nothing, to hover before the viewers' eyes. The term *hovering* is a favorite and apt one for the effect produced by the rectangles in Rothko's pictures, and it would not be so well suited if they appeared to be securely contained or bracketed by a rigid architectural frame.

As I see it, the space engendered in Rothko's paintings is typically a shallow space, even shallower than a stage set—let alone the boundless spaces that some critics see through his pictures' would-be window-frames or doorframes. The dynamic of the forms in these pictures remains contrary to any of these metaphors, in which the framed rectangular areas at the center, unlike the distinct and subtly obtrusive presence of Rothko's rectangles, would be expected to fall away or recede. Some critics have used the word *facade,* with its architectural implications, to describe the effect of Rothko's image, and the artist considered the term appropriate.[5] A facade is a face or front, often of a building—something solid, if not impenetrable. The term facade also implies that something more lies behind what is visible, that the face itself is an artifice or an enticing disguise for something unexpected and possibly unwelcome behind it. As with the metaphor of the veil or screen then, the metaphor of the facade helps to describe and so account for some of the potent tension, suspense, or mystery emanating from Rothko's pictures, the sense they impart of both revealing and covering, of exploring that affective brink between revelation and concealment. This state of tension between what is told and what is not, or what is known and what is not, is fundamental to literature and to drama, but in his classic pictures Rothko managed to construct this tension, or to construct an image that would induce such a tension, in a distinctly visual and nonliterary way. He created suspense by suspension, by suspending rectangular screens or veils.

## Slow Swirl by the Edge of the Sea

One factor that makes the stage-set metaphor an inviting one for Rothko's pictures, in spite of its drawbacks, is that the artist himself so often used the terms *tragedy* and *drama* in connection with his work. But what preoccupied Rothko was the human drama itself, not its backdrop. He said in 1958 that his work had come closer "to dealing with human emotion, with the human drama as much as I can possibly experience it."[6]

This favored phrase, the human drama, is a characteristically ambiguous and rhetorical one, but in 1943 Rothko gave a clue to what it meant to him in pictorial terms when he indicated that in "great portraiture" he recognized an effective portrayal of the human drama: "the real essence of the great portraiture of all time is the artist's eternal interest in the human figure, character and emotions—in short, in the human drama."[7]

Portraiture was a genre that interested Rothko from the early years of his career. As a figurative painter he made many pictures in a basically conventional portrait mode, easel paintings of men, women, and children—full-figure, half-length, and occasionally bust-length—often posed against simply detailed architectural backgrounds. In his surrealist period, Rothko's portrait subjects ceased to be paid models, friends, or family members and became instead the imagined figures of various anonymous gods and monsters and of such characters as Oedipus, Tiresias, Antigone, and Leda. Rather than paint costumed stand-ins for these mythological characters, as artists of another time had done, Rothko undertook to imagine and represent their experience or "inner selves," using improvised means. But he insisted that the resulting images should still be considered portraits. He entered *Leda,* for example, in a group show of portraits called "As We See Them" in 1943. And when the suitability of his entry was questioned, he responded smartly: "New Times! New Ideas! New Methods!"[8]

Perhaps the most important portrait from Rothko's surrealist period is a large double portrait, *Slow Swirl by the Edge of the Sea* of 1944 (pl. IV). Rothko may have painted this picture during the courtship of his second wife, whom he met in 1944 and married in 1945 (just a few weeks after divorcing his first wife). Diane Waldman has suggested plausibly that the principal figures in this painting are mythologized portraits of Rothko and Mell,[9] and whether or not this is the case, the picture clearly held a strong personal meaning for the artist. It was continually on view in the Rothko family townhouse in New York from 1961, after he had arranged to retrieve it from the San Francisco Museum of Art by offering them a mature painting (of far greater market value) in trade. If *Slow Swirl by the Edge of the Sea* is indeed a fantastic portrayal of Rothko and his wife, the logical candidate for the artist's self-image is the tall, green, hourglass-shaped figure with arms akimbo at the left of the painting. The figure sports a big tricornered hat with a round brim (Rothko was known for his love of dramatic hats), and the crown of that hat, surmounting a small, funnel-shaped, green face and neck, is shown in two positions—tipped up and lowered, as if the figure were rhythmically nodding his head. There are additional signs that this figure is moving: a spiraling red line encircles its wasplike waist, where its small, summarily drawn, green hands are planted at its hips. A turning or swirling motion is also indicated by the pendant hanging around the figure's neck; the loop of the necklace is drawn several times, and the stone suspended from it (with

surrounding graphic strokes indicating a glistening jewellike effect) is depicted in midair in four different positions.

Rothko rendered the legs of this gyrating, green humanoid with heels held together and knees spread apart, and he painted them in three different colors and positions: in green high off the ground (and continuous with the rest of the body), in blue halfway in the air, and in white on the ground, where they land on a jagged white carpet. The figure thus energetically jumps as it twirls, and the specific position of the jump, with heels together and knees turned out, recalls the successive moments of a male Russian folk dancer's distinctive squat jumps or leaps. This lively and peculiar personage sports an extravagant costume, moreover, with—in addition to the outsized hat and the bejeweled necklace—a shirt emblazoned across the chest and on the left sleeve with a bold flowerlike design rendered in white and black. Most likely the tone Rothko sought here was less folkish, however, than ritualistic or mythic; gyrating and spiraling are recognized as ritual dance movements performed by shamans and whirling dervishes, movements intended "to induce a state of ecstasy and to enable man to enter the beyond."[10]

The other tall figure in *Slow Swirl by the Edge of the Sea,* on the right side of the picture—traditionally the woman's side in a double portrait or pair of portraits—is a less coherent one. A plain, round, off-white circle serves as a head for this figure, and a broad-nosed, full-lipped face is visible in *pentimento* in that circle beneath some overpainting. Sharp, black lines define a shape that might be read as the figure's left arm, shown crooked behind the head in a conventionally coy feminine pose. The upper torso of the figure is drawn with expansive, looping lines that could suggest oversized, propellerlike, pendulant breasts bouncing away from the figure's sides (although this leaves unexplained the long, straight, staggered trios of red and black lines that stripe horizontally across the chest). The figure's round fig or fruit-shaped stomach is painted blue at the center with a swirling or eddying motion outlined inside of it in a black spiral. Spirals are emblematic of growth and fertility (among other things),[11] and this particular spiral suggests a view through the transparent wall of this humanoid's belly at its, or rather her, swirling amniotic waters. Just below and propping up the stomach is a pointed, triangular, yellow shape (the triangle is a conventional sign for the female pubic area) surrounded by a horizontally striped skirt that tightly hugs the figure's hips and thighs. An odd, large, birdlike creature with a human-shaped head is poised immediately behind, and surrounding or overlapping, the figure's calfs and ankles.

The spirals located at the centers of these humanoid bodies—outside and encircling what I am calling the male personage on the left, inside the female personage on the right—are what the two main characters in this picture have in common. Besides suggesting an ecstatic dance movement and being emblematic of fertility and growth, spirals may also sig-

nify the evolution of the universe itself, the rotating and orbiting of planets in the cosmos, and the perennially churning waters of the earth. For that matter, what also swirls in *Slow Swirl by the Edge of the Sea* are the waters at the sea's edge or shore, rendered with two undulant lines across the brown strand at the base of the picture. Broadly speaking, sea waters may be said to symbolize for the macrocosm or the universe what the waters of the womb symbolize for the human being or microcosm: "Flux, the transitional and mediating agent between the non-formal (air and gases) and the formal (earth and solids)" and by analogy between life and death. Symbolically, to emerge from the sea, the mother, the womb, is to be born; to return to the sea, the mother, the womb, is to die. Water is "not only the source of life, but its goal."[12] The basic theme of *Slow Swirl by the Edge of the Sea* may be the swirling or spiraling theme of the cycle of life then, the supposed single theme of myth.

Although principal areas and figures in *Slow Swirl by the Edge of the Sea* lend themselves to interpretation, however speculative, other elements in the picture are less intelligible. To the left of each of the figures described above is a stack of shapes and images organized around a vertical axis. The long black necks and heads of two birds with abbreviated red bodies top the stack on the far left, whereas the stack on the right, between the two humanoids, might be seen as incorporating a kind of abstract white scarecrow or conceivably a crucified figure mounted on a pole. The significance of these images remains unclear, though they probably had private associations for the artist. From the surrealists, Rothko acquired a penchant for elaborately embellished images characterized by a welter of cryptic and intricate signs. A few years after painting this picture, however, he began to wean himself from such arcane-looking imagery, which was not successfully conveying his subjects, and to explore new means for accomplishing that end.

## Toward Clarity

Since 1945 Rothko had had in mind "concretizing his symbols" in order to move "toward a clearer issue."[13] In 1949 he could confidently write: "The progression of a painter's work, as it travels in time from point to point, will be toward clarity, toward the elimination of all obstacles between the painter and the idea, and between the idea and the observer. As examples of such obstacles, I give (among others) memory, history or geometry, which are swamps of generalization from which one might pull out parodies of idea (which are ghosts) but never an idea in itself. To achieve this clarity is, inevitably, to be understood."[14] As he developed the format of his classic pictures, Rothko stopped formulating arrangements of cryptograms that look as if they could be or ought to be deciphered (perhaps yielding messages from history or memory) but which frustrated efforts at doing so. He became determined not to mystify viewers with such obfuscatory ghosts of ideas but to paint something clear instead. What replaced his typically small images laden with intricate lit-

tle signs, however, was in a sense a large image constituting one big sign or ideograph: an image that was clear, not in the sense of having a meaning that was transparent to the viewer, but in the sense of constituting a strong, simple, unified gestalt.

In a striking portent of the direction his later work would take, Rothko declared in 1943 (with Gottlieb and Newman): "We favor the simple expression of the complex thought. We are for the large shape because it has the impact of the unequivocal. We wish to reassert the picture plane. We are for flat forms because they destroy illusion and reveal truth."[15] To attain the simplicity and clarity he wanted, Rothko found that he needed to unify his compositions; and with the format of his classic images, in the balance and alignment of their rectangular forms, he did so: "I have created a new type of unity, a new method of achieving unity," he declared in an interview in 1953.[16] The unified image that Rothko arrived at was an iconic image, moreover, a form that "is significant . . . insofar as it expresses the inherent idea," as he had put it a decade earlier.[17]

In the simplest formal terms, the shift from Rothko's surrealistic pictures to his classic pictures could be said to have involved both a relentless editing of forms and an ambitious expansion of scale. This shift can be illustrated through a comparison of *Slow Swirl by the Edge of the Sea* (pl. IV) with *Number 17*, 1949 (pl. VIII and fig. 21), a painting also exhibited as *Number 15*, 1948, but more likely done at the later date. *Number 17* 1949, is one of a group of structurally similar pictures (including *Number 20*, 1949 [pl. IX]) from a stage just preceding Rothko's arrival at his characteristic format; and, with its two simple stacks of rectangles standing side by side, it is a bifurcated version of the classic pictures by Rothko soon to follow. The rectangles in these transitional paintings are less than half the width of those in the mature pictures, however, because the artist constructed exceptionally narrow vertical canvases to contain them. With their tall, slender proportions, these frayed and segmented pilasters evoke in a schematic way a pair of squarish snowman-like figures posed frontally, shoulder to shoulder: a highly simplified or clarified double portrait, in other words, compared with the baroque and filigreed *Slow Swirl by the Edge of the Sea.*

To explore the double portrait metaphor further, *Number 17*, 1949 (fig. 21 or pl. VIII), might be compared with more conventional double figure paintings—images from the 1930s of a formally dressed middle-class couple out for a stroll, for example, or a pair of nude women (pl. I and fig. 7). In these early paintings, Rothko depicted two distinct figures standing side by side in a vertical format, an essentially standard schema for a double portrait. But even at this early moment, Rothko's figures reveal a telling idiosyncrasy: a proclivity for unnaturally squared or blocky renderings of the human body. In the picture of the strolling couple, the body of the man in a suit and tie is almost planklike, and the perimeters of the woman's stiff dress also describe a rectangular shape. Further, the

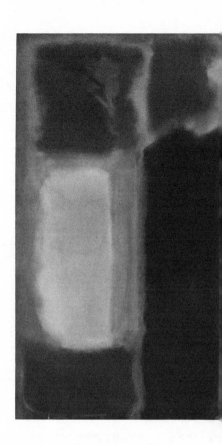

rigorously frontal pose of the figures, a pose uncharacteristically harsh by Western portrait standards, betrays Rothko's admiration for the straightforward, uncompromising poses of the figures in archaic art and children's art. In the painting of the two nude models, the black woman's body also assumes a squarely frontal position, with her head, Egyptian-style, in full profile—although the white woman's body is set at a slight angle. What is also distinctive about these early compositions, in view of the direction Rothko's work was to take, is the way the outsized figures have been made to nearly fill the pictorial space. There may be a connection here—as well as more distantly in the later work—with a firm dictum of Cizek's: that his juvenile students "must draw a narrow margin around their paper, and the figure must be big enough for its head to reach the top of the margin, and its feet the bottom, for . . . a picture looks poverty-stricken and miserable when it has only a tiny figure in it, and is mostly empty."[18]

The argument I am building here—as may by now be plain—is that the stacks of rectangular shapes in Rothko's classic pictures are less backdrops or backgrounds than the more schematic, abstracted, and regularized incarnations of the "performers" found in the foreground of his earlier pictures. Rothko's stacks of frayed rectangles are the symbolic descendants, so to speak, of the solid citizens of the 1930s' paintings and of such exotic beings of the 1940s as the couple gyrating on the beach in

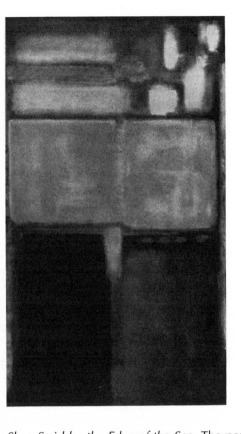

22
*Number 21*, 1949, oil on canvas,
93½ × 53¼ in. Whereabouts
unknown. Copyright © estate of
Mark Rothko, 1971.

*Slow Swirl by the Edge of the Sea.* The performer on the right in *Number 17*, 1949, to follow this line of reasoning, has a black, planklike "body" and a squarish red "head." The performer on the left is similar, but composed of three parts: a boxy, red base, a pale yellow, boardlike midsection, and a square, red "head." In Rothko's classic paintings, then, the single stack of rectangular shapes might constitute a unified structure that is, in toto, a single expansive abstract performer. That abstract figure resulted, in a sense, from the merging of a pair of abstract figures akin to those found in *Number 17*, 1949, a merging that occurred on canvas, as it were, in several paintings of 1949. In *Number 21* (fig. 22), for example, the yellow rectangles forming the "upper bodies" of this abstract couple are lightly fused together, and their "lower bodies," though separate, are of the same height and color. The expansiveness or broadness of the single abstract figure represented in Rothko's classic pictures obviates somewhat the sense of solitariness otherwise associated with it. Taking into account the origins of this image in the abstract and schematic double portraits of 1949 (pls. VIII, IX) and the rows of merged heads at the top of such pictures as *Antigone* and *The Omen of the Eagle* (fig. 3, pl. II), this solitary figure may be seen as projecting a "Companionable Solitude," to borrow the title of one of Rothko's paintings from the mid-1940s.

"In human perception and thinking, similarity is based not on piecemeal identity but on the correspondence of essential structural features,"

writes Rudolf Arnheim, the psychologist of visual perception.[19] With its tall stack of masses that are bilaterally symmetrical along a vertical axis, Rothko's characteristic image evinces some elemental structural features of the human body. In place of his complicated surrealistic personages with their odd mixtures of body parts, Rothko substituted a clarified, simplified abstract figure that was no longer explicitly humanoid.[20] He had determined that the protagonists of his paintings would have to be "pulverized," "disguised," or retired into a pictorial twilight, to shield them from the embarrassment of assuming ritualistic roles in a society where ritual is disdained. But because the human drama remained his primary concern, even as he pulverized or blurred the most unmistakable attributes of the human body—its facial features, sexual characteristics, and limbs—he recast and expanded the gestalt of the body as a whole. He expanded it to such an extent that the figures almost completely overtook the pictures' grounds.

In place of the sometimes capacious backgrounds surrounding the figures in his surrealistic compositions, the background in Rothko's classic paintings is often only a slender margin or border. In a sense, however, Rothko did not so much eliminate the schematic tiered background of his earlier pictures as incorporate it into his schematic figure; that is, he constructed his abstract figures of the rectangular, planar shapes that once comprised the pictures' backdrops but with the rectangles newly released from the edges of the support and newly softened at their perimeters. Without implying any direct or conscious act of borrowing—as I doubt that any existed—an instructive comparison might be drawn here between any one of Rothko's characteristic pictures and the *Mask of Fear* by Paul Klee (fig. 23), which was included in the surrealist exhibition at the Museum of Modern Art in 1936. In different ways, both artists play with the tiering of figure and ground—with Rothko tiering the figure instead of the ground, and Klee making the tiering of the figure partly and unexpectedly continuous with that of the ground. But although Klee's tiered figure is essentially as blank and blocky as Rothko's abstract figures, the Swiss artist's image is a more narrative one, as his figure has been characteristically, whimsically articulated or cartooned with a distinct nose, eyes, arm, two miniature sets of legs, and an enigmatic arrow popping out of its scalp.

In Rothko's watercolors of the mid-1940s, the forms that constituted his surrealistic figures sometimes mimicked or excerpted the rectangular forms of the background. In *Prehistoric Memory* of 1946 (fig. 36), for example, this coincidence of shapes can be seen in the outsized rectangular head of the woman seated at the center of the picture. In an untitled watercolor of the mid-1940s (fig. 13), Rothko overlaid or superimposed the delineated body of an abstract personage over the rectangular fields of the background; viewers can see through the partially transparent figure to the tiered zones of the landscape behind it: figure and landscape are fused. To put the case in the most basic terms, Rothko arrived at his unified, clarified image by taking the most schematic, regular aspect of

23
Paul Klee, *Mask of Fear*, 1932, oil
on burlap, 39½ × 22½ in.
Collection of the Museum of
Modern Art, New York. Nelson A.
Rockefeller Fund.

his surrealistic pictures—their tiered backgrounds—and substituting it for
the irregular forms of the figures that previously occupied those pictures'
foregrounds, until a newly simplified abstract figure emerged, comprised
of a stack of rectangles set against an undivided background.

Some critics have remarked on the similarity between the tiered
backgrounds of Rothko's earlier paintings and the typical schema of his
later paintings, with the usual deduction that he decided to dispose of
the figures and let the backgrounds or backdrops stand in their stead.
William Seitz explicitly proposed this interpretation to Rothko in an inter-
view in 1952, and his notes record that the artist

said this was silly. Showed the error in an evolutionary approach. It was not, he
said, that the figure had been *removed* . . . but that the symbols for the figures,
and in turn the shapes in the later canvases were new *substitutes* for the fig-
ures. . . . My new areas of color have nothing whatever to do with the three tier
backgrounds in the symbolic style. . . . My new areas of color are things. I put
them on the surface. They do not run to the edge, they stop before the edge. . . .
These new shapes say, he [Rothko] said, what the symbols said . . . [What was
involved was] Not a removal but a substitution of symbols. (Rothko's emphasis,
according to Seitz)[21]

In this crucial respect, then, Rothko read his own pictures as I am read-
ing them: insisting that the figures were never removed from his art but
that his rectangles or areas of color were new substitutes for the figures.
His rectangles were decidedly things in the artist's eyes, moreover, not

vaporous clouds, open spaces, or voids. It merits underlining, too, that Rothko still regarded and intended the forms in his classic pictures as symbols, although those pictures were no longer in the "symbolic style," as he termed it. Presumably, he meant symbols not in Peirce's sense of the term, where the relation between signifier and signified is largely arbitrary, but symbols in the sense of iconic signs and conceptual representations, for this is what he had formulated. Rothko's image-signs constitute metaphors of portraits and icons of the human form insofar as they exhibit a "similarity of structure" with those objects and insofar as there is "a relation of reason between the sign and the thing signified," to return to Peirce's terms.

## Portraiture

On a radio broadcast in 1943, Rothko made a lengthy statement on the subject of portraiture, and some of these observations remain relevant to the later work—when it is considered in relation to the structure of portraiture—though the techniques involved had changed considerably. "The word 'portrait' cannot possibly have the same meaning for us that it had for past generations," Rothko began.

There is, however, a profound reason for the persistence of the word 'portrait' because the real essence of the great portraiture of all time is the artist's eternal interest in the human figure, character and emotions—in short in the human drama. That Rembrandt expressed it by posing a sitter is irrelevant. We do not know the sitter but we are intensely aware of the drama. The Archaic Greeks, on the other hand, used as their models the inner visions which they had of their gods. And in our day, our visions are the fulfillment of our own needs.

It must be noted that the great painters of the figure had this in common. Their portraits resemble each other far more than they recall the peculiarities of a particular model. In a sense they have painted one character in all their work. This is equally true of Rembrandt, the Greeks or Modigliani, to pick someone closer to our own time. The Romans, on the other hand, whose portraits are facsimilies of appearance never approached art at all. What is indicated here is that the artist's real model is an ideal which embraces all of human drama rather than the appearance of a particular individual.

Today the artist is no longer constrained by the limitation that all of man's experience is expressed by his outward appearance. Freed from the need of describing a particular person, the possibilities are endless. The whole of man's experience becomes his [the modern artist's] model, and in that sense it can be said that all of art is a portrait of an idea.[22]

This express interest in portraiture was not a passing one for Rothko. In 1947 (around the time he painted the arguably portraitlike picture known as both *Number 10,* 1947, and *Number 12,* 1948 [pl. V]), he made a sweeping pronouncement: "For me, the great achievements of the centuries in which the artist accepted the probable and familiar as his subjects were the pictures of a single human figure—alone in a moment of

utter immobility."[23] Neither history and religious paintings nor spectacular landscapes, but the comparatively humble, single-figure portrait, was the genre that most commanded Rothko's admiration from the legacy of the history of art. In 1949 he arrived at an image which echoed just that: a single-figure portrait reformulated as an abstract, emblematic-looking icon. In its unity, frontality, symmetry, and rigorous simplicity, this icon was designed to capture the quality of utter immobility and aloneness that Rothko emulated in archaic and old master portraits. Whereas the pathetic inability of painted figures to "raise their limbs" in any meaningful gesture of existential protest had once distressed him, in his classic paintings Rothko took that immobility as a given and summarily excised the nonfunctioning limbs. He created a figure so broad and blocky, so closely fitted into the space of the support, that mobility was almost out of the question, almost but not quite. The type and range of movement admitted by Rothko's images became distinctly nonanthropomorphic and highly restricted. By leaving separations among the rectangles, or between them and the edge of the support, and by layering and modulating the surfaces of the rectangles, Rothko created a subtle visual vibration or friction, as between entities that are close to touching but stop just short or layers that closely blanket one another while retaining pockets of space between them.

In the Western tradition, whole solitary persons are conventionally painted facing forward in an upright posture near the center of a canvas oriented in a vertical way and built as often as not on a lifesized scale. The area intervening between the outline of the figure and the edge of the rectangular canvas is normally rendered as the environment or space that surrounds the figure, be it a room, a landscape, or a less specifically articulated area. On a strictly schematic level, the structure of a typical painting by Rothko—vertical, frontal, centralized, and with an abstract figure surrounded by a margin—parallels the basic structure of a conventional full-figure portrait, as a comparison between Whistler's *Arrangement in Flesh Color and Black: Portrait of Theodore Duret* (fig. 24) and *Reds, Number 16,* 1960 (pl. XXII) or *Browns,* 1957 (pl. XX), will serve to illustrate. I must stress that my point here (as in other comparisons to follow) is not that Rothko was specifically inspired or influenced by this particular picture but that the structure of his pictures bears a significant relation to certain conventional pictorial structures—in this instance that of the full-figure portrait. I have chosen this Whistler not because it is at the Metropolitan Museum of Art, where Rothko could have seen it, but strictly because of the typicality or conventionality of its pictorial structure; a Gainsborough, a Van Dyck, or a Titian could equally have been used to make this point. I have assumed that Rothko, as a man of his time and society, possessed a basic, tacit storehouse of cultural knowledge. The specific means by which he assimilated that knowledge—the particular pictures that introduced him to the genre of the full-figure portrait, for instance—are not important in the present context.

Any of Rothko's classic paintings could be described as having a

24
James A. M. Whistler,
*Arrangement in Flesh Color and
Black: Portrait of Theodore Duret,*
1883, oil on canvas, 76½ × 35¾
in. The Metropolitan Museum of
Art, New York. Wolfe Fund, 1913.

portraitlike aspect or as bearing a trace of portraiture, insofar as they par-
allel the basic structure of full-figure portraits and as their images evince
an elemental physical parity with the viewer's body, abstractly mirroring
its verticality, symmetry, and frontality. But Rothko created a recurrent
type of picture with proportions that are somewhat more specifically re-
lated to those of the human form—small at the top, bulky in the middle,
and medium-sized at the base. *Browns,* 1957, *Reds, Number 16,* 1960,
and an untitled painting of 1961 (pls. XX, XXII, and XXIII) are examples of
this format, which Rothko used frequently in this period of the late 1950s
and early 1960s. Often he organized the color in his pictures with the
brightest area at the top, moreover, appropriately for the locus of the
brain. *Violet, Black, Orange, Yellow on White and Red,* 1949 (pl. XI), is a
classic painting with an additional, conceivably anthropomorphic ele-
ment: the bracketing "arms" that occasionally appear, though rarely in
such a conspicuous way, along the sides of the rectangles—particularly
the central rectangles. But such occasional and fortuitous occurrences
are not essential to the argument at hand. The primary point I want to
make at this juncture is that Rothko's characteristic images bear a signifi-
cant relation to the preexisting conventions or codes for portraiture and,
as a corollary, bear a phenomenological relation to the human form itself,
the form of the viewer's body.

When Rothko developed the format of his classic paintings, he con-
solidated the relation between the painting and the viewer by working

consistently on canvases of roughly human scale (often somewhat larger; occasionally smaller), canvases that assume a kind of physical parity with the viewer. A large painting causes "an immediate transaction; it takes you into it," Rothko asserted in 1958,[24] and he consistently hung his pictures low on the wall to reinforce that effect. "I realize that historically the function of painting large pictures is painting something very grandiose and pompous. The reason I paint them, however . . . is precisely because I want to be very intimate and human" said Rothko in 1951.[25] In his move to a larger format, he acted on what was for him a new awareness of scale as a function of the relation between the size of the human body and the size of an object and its parts. And he began to use and manipulate scale as a way of extorting empathy from the viewer. Writes Peter Schjeldahl: "The felt relation of the painting as a (partially disembodied) body to one's own, the viewer's, body is the very fulcrum of Rothko's art, commented on by his most discerning critics, for instance Brian O'Doherty—who provocatively speculates" (as do Sandler and Rosenblum) "that the viewer of large Abstract-Expressionist painting is, in effect, the displaced 'figure banished [from art] by the imperatives of abstraction,' 'a figure for which Rothko had the highest regard and regret.'"[26] I am suggesting that the figure is not entirely banished from Rothko's art but remains in a residual, schematic, and abstract way to establish and maintain the very fulcrum that Schjeldahl describes.

To repair to semiological terms, Rothko's pictures may be described more precisely as iconic sign-vehicles or hypoicons, rather than as full-fledged icons, of the human body; for even the most nearly portraitlike of these images (by my account) fail to evoke in the majority of interpretants or viewers an immediate, conscious association with conventional portraiture. Although I perceive a relation between the structure of Rothko's images and the structure of portraits, I cannot claim that others regularly observe the same relation; what is involved here, then, is not a "genuine" but a "degenerate triadic relationship" amongst signifiers, "signifieds," and "interpretants." Nor would I propose that Rothko secretly hoped to invoke a reading of his images in terms of the structure of portraiture; the relation he tried to foster between his images and viewers was to transpire on less analytic, more emotional, spiritual, and physical planes. But on those planes Rothko likely both anticipated and desired that viewers experience, however subtly felt, a relation between their own bodies and the abstract body imaged by his pictures.

Rothko is said to have referred to his paintings as "portraits" on occasion, and there is anecdotal evidence, at least, that his response to a portrait reading of his work was positive.[27] But for the most part, the parallel between the structure of Rothko's paintings and the structure of portraits has escaped the attention of critics. The exception is Eliza Rathbone, who observed of Rothko: "As his pictorial style evolved, it grew to identify more and more with the single human figure. . . . As his vision became increasingly distilled, each canvas became a 'performer',

as it were, a single portrait of a temperament or mood. One experiences their command as one does that of a portrait."[28] Rathbone does not explicitly explore the structural parallels between Rothko's characteristic image and a conventional portrait, but she suggests (as I would) that the viewers' experience of Rothko's classic pictures is similar to their experience of portraits, that his paintings exercise a similar command.

There are reasons why most viewers do not consciously make this same association, why Rothko's pictures resist being read as portraits, and I do not discount those reasons. To isolate one problem, the top rectangle in Rothko's image, however narrow it may be, is typically the same width as the other, more massive rectangles and so is too broad to be immediately associated with a head. Further, the interstices that are often found between the rectangles (more so as the years went by) inhibit the viewer from visually connecting the rectangles and so from seeing them as forming a gestalt. But because human beings have a way of imaging things and sizing them up in relation to that primary reference point that the body constitutes, viewers will almost reflexively associate the uppermost solid in any given vertical series with a head. Further, all viewers have seen (and once themselves rendered) children's drawings that represent the human body with a few humble stacked blobs or masses. In the end, it does not take much to trigger anthropomorphic associations with an image or object (such as eyes to needles, feet and legs to furniture, lips to cups), though the habit is so ingrained that people are generally unaware of exercising it. Modern modes of sign-making have also conditioned people to respond often and instantly to schematic and reduced images of the human body. Rothko's image-signs are more schematic than the stick figures on Don't Walk signs, of course, but unlike those signs, Rothko's pictures were not meant to evince unambiguously any specific or single referent. As a modernist, Rothko refused easy communicability in favor of a more indeterminate mode of expression.

### Emotion and Expression: The Inner Self

In discussing Rothko's pictures as portraits "of a temperament or mood," Rathbone pinpoints a quality that has been perceived by many other critics as well—a subjective and emotional quality, as of something properly internal and unseen that has been successfully externalized and imaged. When Rothko discussed the modern artist's relation to the portrait tradition in 1943, he welcomed the freedom to use as a model human experience and emotion instead of the outward appearance of particular human subjects. He wrote in the 1940s of rendering "pictorial equivalents for man's new knowledge and consciousness of his inner self" (to return to that important phrase).[29] Rothko's interest in the inner self and his claims of painting human emotion and the human drama continued into the 1950s, when he evolved a kind of "iconography of color as sen-

sibility," as Lawrence Alloway described it.[30] Whereas Van Dyck or Whistler painted their subjects' physiognomy, posture, costume, and setting in a way that conveys the sitters' character and social stature, Rothko, working without a sitter, evolved alternative means for conveying subjective human qualities.

In many critics' eyes, the emotionalism of Rothko's pictures is their special forte. To Peter Schjeldahl, what accounts for the "enormous success" of Rothko's paintings is the way they "deepen and fortify the connection, the circuit, of color to inner experience. The messages that travel this circuit may be unclear, but they arrive."[31] Such a response to his work was precisely what the artist hoped for; Brian O'Doherty related that "Rothko once said, sounding a bit like Malevich, that his squares were not squares, but 'All my feelings about life, about humanity.'"[32] He arranged his squares in such a way as to echo both the elemental structure of the human form and the structure of the portrait that traditionally images the human form, but the proportional relations of his squares, their colors, color relations, and rendering were meant as pictorial equivalents for psychological and emotional states. As a portraitist of the inner self, Rothko wanted to represent and convey feeling directly and concretely, not abstractly.

When they are studied closely, the rectangles in Rothko's pictures have distinct qualities, positions, and aspects to which viewers may (and often do) attach an emotional significance. Some of the rectangles look sheer, fragile, and torn, whereas others appear solid, opaque, and impermeable. Sometimes the rectangles are rendered with turbulent or declamatory brushstrokes; at other times the brushwork is muted and self-effacing. The relations among the rectangles and between the rectangles and the edges of the support can also carry an emotional charge. Sometimes the rectangles are mutually attached or dependent (pl. XI); at other times they are barely touching (pl. XV), detached, or estranged (pl. XXII). Some of the rectangles take up so much space that they appear to threaten to explode the confines of the picture's support (pl. XII), whereas other rectangles, of relatively diminutive dimensions, can be found afloat in more open surroundings (pl. XXII). Such qualities, positions, and situations evoke a range of states of feeling and being, and Rothko wanted to encompass in his art nothing less than the full scope of human feeling. "I take the liberty to play on any string of my existence," he told Elaine de Kooning in 1957. "I might, as an artist, be lyrical, grim, maudlin, humorous, tragic."[33]

Because a work of art is an inert physical object, this figure of speech, that a work of art "expresses" something, is problematic and may signify various things. In the first place, there is the expression of the artist in making the work of art, a "natural expression," a "secretion of an inner state," as Richard Wollheim has described it. Once a work of art is made, however, a viewer may think of it as

expressive of a certain condition because, when we are in that condition, it seems to us to match, or correspond with, what we experience inwardly: and perhaps when the condition passes, the object is also good for reminding us of it in some special poignant way, or for reviving it for us. For an object to be expressive in this sense there is no requirement that it should originate in the condition it expresses . . . : for these purposes it is simply a piece of the environment which we appropriate on account of the way it seems to reiterate something in us.[34]

Wollheim refers to this latter type of expression as "correspondence," following the nineteenth-century usage of the word. He concludes that a work of art has characteristics that in the first instance were caused by and in the second instance mirror the viewers' emotions or psychological states. The practice of attributing these emotions to the objects themselves involves ingrained habits in the use of language, and "it is not at all clear that . . . we have any other way of talking about [these] objects" to which we attribute emotions. "Art rests," Wollheim suggests, "on the fact that deep feelings pattern themselves in a coherent way all over our life and behavior."[35]

What viewers feel in the presence of pictures does not necessarily coincide with what artists felt when they painted them then, nor with what those pictures were intended to express; and in Rothko's case, it seems that there was often a conspicuous lack of fit. Rothko referred to his pictures in terms of violence and tragedy, but critics rarely saw them as expressive of such negative or extreme states of feeling. More agreement between artists and critics could be found for the term *poignant,* a favorite adjective of Rothko's in relation to his work. But the critics' responses to the emotional pitch of Rothko's art have never been uniform, in any case, and have at times been highly disparate. Some regard it as problematic that the emotions these pictures evince cannot be definitely specified—not only because they vary from viewer to viewer but because even a single viewer often cannot describe exactly the emotions evoked by a given painting. Many critics have become tangled in strings of mixed metaphors in the effort to find verbal equivalents for what is expressed in Rothko's pictures. And some critics have reasoned, because it is impossible to pinpoint what the pictures express or mean, that the pictures' meanings are essentially arbitrary, that they can mean whatever viewers want them to, and so, in a sense, that they have no meaning at all. But as Wollheim has pointed out, it is generally agreed that works of art would have little or no value if what they express could be phrased exactly in words. Visual art is characterized by far more indeterminacy than language, an indeterminacy that "accommodates, or brings to a convergence, demands characteristically made of art" by both the viewer and the artist, namely that the viewer "should be able to structure or interpret the work of art in more ways' than one, . . . freedom in perception and understanding . . . [being] one of the recognized values that art possesses."[36]

Rothko is said to have regarded *Number 22,* 1949 (pl. XII), to focus on a specific painting, as a tragic and violent image, though his insistence on this point was evidently directed in part at countervening most viewers' reaction to it as a glorious Apollonian outpouring of consoling yellow and orange light.[37] It does not follow from the existence of these two contradictory readings that the picture has no meaning at all, however; it follows instead that the picture has at least two meanings, with the contradiction between them being part of the affective tension and the large sphere of reference that the picture engenders. In his own reading of this painting, Rothko may have focused on the way he had cut through an assemblage of soft, harmonious yellow and orange areas at or near its very center with an intense red stripe; in his eyes, the scarlet stripe may have been a sharp and bloody gash—a reading he effectually reinforced by the gashes or scratches he drew across it with the handle of his brush, exposing the white of the canvas in three long wobbly lines pinched together at the center. For some viewers, the red stripe may appear instead as the natural culmination of a coloristic progression—from yellow-white, to yellow, to orange, to red—with the red being the final, vital, percussive note in a soothing ensemble of tones or, to take another metaphor, the bright streak of heat in a large, warm, enveloping environment. Other viewers still (myself for one) may waver between these readings, seeing the painting now one way, now the other, and finding its deepest charge in the fact that it yields an experience that is not unmixed. As I see it, *Number 22,* 1949, induces sensations that pull in at least two directions at once; in an emotionally complex and risky way, that is, the picture subtly soothes as it distresses and distresses as it soothes.

## Decoding

In order to convey particular meanings or specific information to viewers, painters must avail themselves of known pictorial codes and conventions; the more closely those codes are followed, the more transparent the artist's meaning will be. Rothko might be said to have at once kept and broken or transposed the code for representing the human figure, the convention of the portrait—though not that convention alone, as will be shown. Insofar as he elected to alter the portrait code, he insured that his images would not be transparent to the viewer, even as he insisted that he wanted them above all to be clear and understood; he had found that to be effective his subjects could not be made transparent in the usual way. An impetus for artists to transpose rather than rehearse the established pictorial codes is the need to "defamiliarize" forms that are overly familiar (to import a concept from the Russian formalist, Victor Shklovsky). Viewers tend to respond to received codes and accustomed forms in an habitual or reflexive, and thus often unthinking and unfeeling, way. Unfamiliar forms may help to engage and prolong the viewer's attention

and so revivify the experience of perception itself, or "make the stone stony," in Shklovsky's terms.[38]

By 1947 Rothko had already decided that he could not present his vision of the human drama in the forms of the familiar world or in the existing codes for imaging those forms. For one thing, he wanted to find "a pictorial equivalent for man's new knowledge and consciousness of his more complex inner self,"[39] and there were few received conventions for accomplishing that errand. As for the outer self, the form of the human body, Rothko said that he would neither conform with nor violate the conventions for representing it. Instead, he devised an image-sign the schema of which echoes the schema of a portrait, and in place of depicting human physiognomy, he rendered rectangles with delicate, translucent films of color. Viewers of Rothko's pictures may have the sense of being in the presence of an arrangement of "things"—an abstract figure, as I would have it—but they will also have the sense of being able to see at least partway inside those things through filmy, veillike, or screenlike layers of color, of seeing into or through the "skin" of the abstract figure, as it were. Rothko formulated an image-sign, a pictorial metaphor or equivalent, that gave him the latitude to do what established pictorial codes could not, to do, in a sense, the contradictory and impossible: to encompass in a single image the outer and inner self at once.[40]

"The work of art arises from a background of other works and through association with them," observed Victor Shklovsky. "The form of a work of art is defined by its relation to other works of art, to forms existing prior to it. . . . Not only parody but also any kind of work of art is created parallel to and opposed to some kind of form."[41] To discuss Rothko's art in relation to the codes or conventions of pictorial art is not a new undertaking—though almost all the critics who have approached his work in this way have talked of landscapes rather than portraits. What the widespread identification of Rothko's art with landscapes has generally involved, further, is the positing of a one-to-one correspondence between the pictures and the reality of nature that is revealed as their latent meaning. But deducing hidden meanings or messages in abstract works of art by linking images to referents is a problematic practice because it obviates the complexity of the problems these works of art pose and so distorts their meanings. An abstract picture is not just a mimetic picture with its message or text disguised, awaiting disclosure by the canny critic who discovers the device for decoding it. What abstract and mimetic pictures signify cannot be the same because the signifying mode of abstract art, its language or syntax, has been transformed and reconceived; to flatly translate the message of the abstract picture into the terms of the language of mimetic pictures will lead to inaccuracy. As artists' means change, their messages also change, and abstract art represents such a considerable change of means as to call into question the very nature of what a work of art's message is or can be. The message of the abstract painting veers decisively away from the textual or narrative,

the explicitly recognizable and specifiable, into a more indeterminate realm.

Rothko's art was highly specific, as he claimed it was, in the sense that the means he chose—his colors, forms, and touch—were specifically considered and chosen. In any given painting, Rothko intended specific effects, and what those effects were calculated to do was specific as well up to a point: they were designed to induce affect—real, specific, pungent, and complex human feelings. But they were not designed to do so by telling a specific story or depicting specific objects that were directed at inducing such emotions; the impetus behind Rothko's art (as with much of abstract art) was to eliminate the middle term, the story or literal referent, which was seen as coming between the viewer and the painter's real message and means. From this perspective, to reach the viewers' emotions through a story or through objects was to work with indirect means and meanings, and the abstract artist's aim was to replace that circuitous approach with a direct and immediate one.

This idealization of the direct experience that abstract artists (and many critics who are partial to abstract art) indulge in is problematic: all experience is mediated in some degree in one way or another, and viewers cannot come to pictures without a storehouse of accumulated knowledge and expectations. Viewers will have some formed ideas or expectations about what pictures can be and do and about how they do it. The success of Rothko's pictures with viewers follows in part from his way of at once engaging and refusing those expectations, at once keeping and breaking the existing pictorial codes. Instead of immediately disorienting and so alienating viewers, Rothko found a way of engaging them by orienting them up to a point, the better to disorient and so disarm or even overwhelm them. If some viewers begin and end by looking at Rothko's pictures as landscapes—fitting them as best they can into known pictorial codes—those who look closer and stay longer will not be satisfied by a landscape reading. In the end, after all, Rothko's pictures are not landscapes—and neither are they portraits. They take and break the landscape and portrait codes; they are different, and so they are difficult.

This introduces some of the problems associated with relating Rothko's images to preexisting representational conventions, either landscapes, portraits, or anything else. The very history of abstract art, it may be argued, is the history of artists' attempts to subvert the identity of referent and meaning, the history of a struggle to repudiate the assumption that the visual realities pictures simulate constitute their meanings and their justification. In dismantling the mimetic aspect of representation, the abstract artists' objective was a conceptual representation, in which the concept could be at once a picture's form and meaning, in which percept and concept would be indivisible for the viewer. With this in mind, some abstract artists, such as Mondrian, tried explicitly to foil potential associations between their abstract images and mimetic represen-

tational imagery—tried, that is, to avoid any parasitism on preexisting conventions so as to banish any after-images that might linger in their work.

Even as abstract art has been fueled by this interest in breaking down the identity of referent and meaning from Kandinsky's time to Rothko's, many abstract artists have harbored doubts that an abstract and conceptual mode of art could ever be fully effective, or meaningful to viewers. Many abstract artists remained uneasy about how their work would be received by a viewing public that, if debarred from finding meaning in works of art according to recognized codes, was bound to deem them meaningless and trivialize them as decoration or idle visual exercises. Most artists found it difficult, further, to unlearn or jettison the established pictorial conventions that had been deeply ingrained by their often extensive professional training. And however ideal it may have seemed to some abstract artists to start from a tabula rasa, dismissing or forgetting the entire history of pictorial art was in any case impossible; for both the artist and the viewer were bound to continue carrying that history with them. For some abstract artists, then, the tactic that Rothko pursued of using elements or traces of elements from received pictorial codes did not represent compromise or capitulation but a decision to take control of a mechanism that could be used for engaging and orienting viewers at least to a marginal degree, used as a kind of insurance, however limited, against being misunderstood.

Much of what is called abstract painting from Kandinsky's time until Rothko's could in a sense be called disguised figuration, with Kandinsky's art an exemplary case in point. But although some abstract artists deliberately retained a referential dimension in their art, to uncover those referents is not to uncover the meaning of the art; to designate the human figure or landscape as the meaning of Rothko's pictures would be to propose an exceedingly circumscribed and textual construction of their potential for meaning (comparable, on a certain level, to proposing that a studio is the meaning of Matisse's *Red Studio* or that Venus' birth is the meaning of Botticelli's painting of that theme). A theme is not the same as a meaning, and the locus of meaning in any picture is pictorially and perceptually grounded. But although referents do not constitute a full or sufficient meaning in either representational or abstract art, neither can meaning be detached from referents. In occluding the referents in his work, Rothko purposely directed the viewers' attention to his abstract forms and means, but the existence of a referential dimension in his pictures need not be denied or dismissed on those grounds. It might be argued that the presence of metaphor in Rothko's art is only a residual one; but it can also be argued that as a residual presence metaphor constitutes the underpinning of the very structure and function of that art.

Like abstract artists before and since, Rothko undoubtedly wanted his art to defeat or subsume narrative and so to achieve a new type of import and autonomy. It is basic to modernist thinking that, as Adorno

wrote, using music as his point of reference, "the less musical portrayal continues to be the portrayal of something, the more the essence of the means comes to agree with the essence of that which is portrayed."[42] But historically, what abstract artists wanted to achieve and what they did achieve have not been (and could not be) one and the same. For his paintings to work as he wanted them to, Rothko needed viewers who would be "free of the conventions of understanding," in his words.[43] He believed that "almost everything depends on the viewer's being able to approach a painting as a pure and unique experience, for which he should not be prepared."[44] but this unprepared viewer, innocent of cultural conventions and ripe for a pure experience, was a proverbial figment of Rothko's imagination. No matter how unschooled they might be about art—and Rothko never attempted to expose his work to a public unschooled about art, in any case—all viewers come to paintings armed with collateral knowledge; among those who are schooled about art, such knowledge is accepted as a necessary and desirable adjunct to aesthetic experience generally. To bring collateral information to bear on Rothko's art may countervene the artist's ideal scenario of the viewing experience—"No possible set of notes can explain our paintings," he insisted early on,[45] but to possess a set of notes for an artist's pictures is not to have them all figured out, to coin a phrase. Further, to formulate or supply a set of notes, as I am doing here, is not necessarily to pretend that an exhaustive or fully sufficient explanation can be formulated. What is proposed here, by way of an intertext, is proposed in a far more speculative spirit.

Like many abstract artists, Rothko felt ambivalent about the concept of abstraction generally. On one hand, he described his pictures as realistic and stressed that they had subjects or specific meanings; on the other hand, he declined to specify what those subjects were. Although he referred to his art as a "language" through which he could "communicate something about the world," he also said ruefully that "silence is so accurate" when pressed to translate his language.[46] Rothko would not elaborate openly on the referential aspects of his art because for him to do so would likely have had a directive and inhibitory effect on critics' responses to the work, leading to a circumscribing of its meaning and by the same stroke to his "premature entombment" as an artist, as he dramatically put it.[47] With respect to his position as painter or author, Rothko decided that there was "more power in telling little than in telling all," both in the art itself and in his discourse on that art.[48] But Rothko would not have been more forthcoming and explicit about the referential content of his art for other reasons, even to the extent that the content was integral to a consciously formulated program (an extent impossible to specify). As will become clearer in what follows, Rothko was not working with a code of one-to-one referents but rather with layered traces of referents or with compounded visual metaphors. He could not explicitly privilege a particular metaphor or trace without compromising others or

occluding the subtle meanings that emerge from employing disparate and contradictory metaphors in conjunction. Taking the license of the abstract artist, Rothko could work with preexisting codes in a plastic or elastic way, erasing or dismantling and recombining them to constitute his subjects.

The larger purpose of this book is to show how Rothko's pictures function polysemically—how they are inscribed or coded in a residual but elemental way, and how the codes in question effectively overlap, forming almost a palimpsest of traces, each of which modifies, mediates, and enlarges the significance of the others. It has been suggested that this complex practice is endemically modernist: "One of the main characteristics of modernism, once the priority of immediate reference to the real world had been disputed, was the play of allusion within and between texts. Quotation, for instance, plays a crucial role in the *Demoiselles d'Avignon* and, indeed, in *The Large Glass*. . . . The effect is to break up the homogeneity of the work, to open up spaces between different texts and types of discourses," writes Peter Wollen.[49] No doubt Rothko, like Duchamp and Picasso, did not consciously make all the quotations that may be discerned in his art, but that does not mean that they are not there. The influence and the perpetuation of existing cultural forms is not something artists can fully escape, either by design or by ignorance. Tradition, as Harold Bloom wrote (following Freud), is "equivalent to repressed material in the mental life of the individual."[50]

### Landscape: Absence and Presence

One of the codes or traditions invoked by Rothko's characteristic image is the convention for the structure of landscape painting. Critics have associated Rothko's classic pictures with landscape imagery almost from the first and, although this connection is far from being as close or strong in my eyes as it is for many others, I would not deny its existence. The most literal rendering of the relation between Rothko's pictures and landscape was made by *Life* in 1959 in an article on those "pioneers" who were making "Baffling U.S. Art."[51] A photograph of Rothko casting a brooding silhouette against one of his more sunset-colored, multilayered paintings (done some ten years before) was juxtaposed in a full-page layout with another, same-sized photograph of a scenic, highly colored, multilayered sunset. Rothko was likely an unwitting accomplice of the picture editors at *Life*, however, as he was consistently unwilling to endorse this simple reading of his pictures. "One can see elements in his work of the nineteenth century painters of the Sublime, of the Hudson River School, even of Oriental art," said Donald McKinney, an executive of the Marlborough Gallery (which handled Rothko's work in the 1960s). "Yet he himself denied them all."[52]

When asked point-blank whether his work was inspired by landscape, Rothko reportedly answered, "Absolutely not: There is no land-

scape in my work."[53] In reality, he was a confirmed New Yorker, an urban dweller who got restless when he found himself in rural or provincial settings. Whereas some critics rhapsodized about "an inheritance from a youth spent in virgin Oregon," or placed his work alongside Hudson River School pictures in an exhibition on "The Natural Paradise," those who knew Rothko personally knew better, at least, than to ground such readings of the pictures in the interests of the artist himself.[54] Rothko cherished no sentiments about the benefits of contact with nature or rural life. Manhattan was his idea of paradise, and unlike most other members of the New York School, he saw no good reason to be away from it for long. "He was no nature man; no Thoreau," commented a friend whom Rothko visited in the country. "He was not, certainly not, a man of nature," said Dore Ashton.[55]

Notwithstanding the artist's personal disposition, a case for a landscape reading of his art can still be made. This has been done most authoritatively by Robert Rosenblum, who argues that Rothko's art is best understood as evolving not from School of Paris modernism, as is usually said, but from a tradition of "Northern Romantic painting" and, more specifically, from that genre of landscape painting in which nature is expressly meant to function as a metaphor for transcendental or religious experience and to induce the emotions of the sublime.[56] Rosenblum locates Rothko's classic paintings in the context of landscape paintings by Caspar David Friedrich and J. M. W. Turner, and this positioning may be persuasive insofar as Rothko's pictures, like Turner's and Friedrich's, are comprised of superimposed rectangular fields rendered with subtle mixtures of color that (in Turner's case, at least) beg to be described as atmospheric. Rosenblum's thesis further helps to account for that nonspecific but felt religious or spiritual sense that Rothko's art so often evokes in viewers. The hovering rectangles in Rothko's paintings, which at times appear on the brink of dissolution, have conjured in many critics' eyes the infinite spaces of the sublime and thus evinced as well the sublime emotions of vertigo or terror, awe, ecstasy, and the presentiment of divinity. Traditionally, sublimity is associated with vastness or magnitude, boundlessness and formlessness; as Rosenblum sees it, Rothko places us "on the threshold of those shapeless infinities discussed by the aestheticians of the Sublime."[57] Further, "Rothko's pursuit of the most irreducible image pertains not only to his rejection of matter in favor of an impalpable void that wavers, imaginatively, between the extremes of an awesome, mysterious presence or its complete negation. . . . As drastic as these reductions may seem, they again find many precedents in artists working within those Romantic traditions that would extract supernatural mysteries from the phenomena of landscape."[58]

However suggestive this thesis may be, certain factors besides the biographical ones argue against reading Rothko's pictures as landscapes. In the Western world, landscapes are conventionally presented in a horizontal format, which yields a lateral sweep, whereas Rothko strongly fa-

vored a vertical format. The would-be horizon lines in Rothko's paintings almost never extend fully from side to side of the canvas, as they would in a conventional landscape; and the interstices that frequently emerge between the rectangular areas result in repeated or schismatic "horizon lines" that also spell a departure from the conventional structure of landscape (if no more so than from the structure of the portrait). Further, the rectangular areas in Rothko's pictures are painted over the surrounding margin area (the margin being all that remains visible of the initial coat of paint used to cover the entire canvas), and this should countervene the idea that they comprise a view of landscape framed by a window or doorway. In other words, Rothko's would-be landscapes are improbably located in front of, not behind, their would-be frames.

To my eye, Rothko's rectangles generally read as planes that float parallel to the picture plane. To the extent that the color is modulated in these areas, it is more or less evenly modulated all over (or up to the very perimeters of the rectangle) and does not give an impression of gradual recession into space as renderings of skies, seas, or fields of land are usually meant to do. Rothko himself was deliberate about this: in 1961 he wrote, "In our inheritance we have space, a box in which things are going on. In my work there is no box; I do not work with space. There is a form without the box, and possibly a more convincing kind of form."[59] Though Rothko did—as he claimed—get rid of the standard pictorial box, there remained a subtle spatial quality to many of his rectangles, resulting from his practice of superimposing multiple filmy layers of paint. For the viewer, seeing through a top layer of paint to further layers beneath it inevitably evinces a degree of depth, however shallow. From the artist's perspective and my perspective, at least, Rothko was not painting "resonant voids from which any palpable form is banned," to return to Rosenblum but rendering things on top of the picture surface: in interviews in the early 1950s, he stressed repeatedly that he was "a materialist" whose "pictures are just made of things."[60]

The development of Rothko's art is typically described as a transition from a format involving figures set against a background to a format consisting only of background or empty landscape, as if the artist had finally decided that his backgrounds alone were equal to the task of constituting the most promising paintings of which he was capable. But if the figures were somehow extracted from one of Rothko's pictures with a tiered background, such as *Prehistoric Memory* of 1946 (fig. 36), the result would not be the format of a classic painting. In a classic painting, the yellow and grey rectangles that form the background of *Prehistoric Memory* would be presented as independent shapes set against their own background and would likely be spaced apart from each other. In other words, those superimposed rectangles that connote empty or negative space in *Prehistoric Memory* would assume, in a typical mature painting, the foreground role that the figure, ordinarily read as a solid or positive form, had previously occupied. In a sense, Rothko did not eliminate

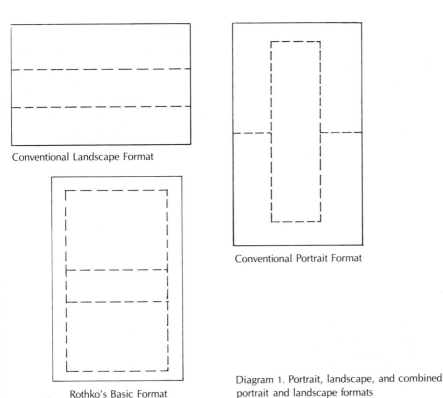

Conventional Landscape Format

Conventional Portrait Format

Rothko's Basic Format

Diagram 1. Portrait, landscape, and combined portrait and landscape formats

either the figure or the background in arriving at the format of his classic pictures, then, but adapted the sign for the background to constitute the sign for the figure, composing his abstract symbolic figures out of superposed rectangular shapes. On a schematic level, the format of Rothko's pictures represents a conflation of the basic schemas of portraiture and landscape, as a simple diagram may illustrate (diagram 1). A diagram will not trigger in the viewer the responses that actual paintings can trigger when these signs are deployed in conjunction in this unexpected way, but analyzing Rothko's image-signs in diagrammatic terms may help to explain how they function, to the extent that they do function, and to suggest why they are capable of inducing such intense and powerfully complicated feelings in many viewers.

To use schematic terms, a tiered pictorial composition—a simple stack of rectangles whose dividing lines run to the edges of the rectangular support—normally connotes open space or absence, with the dividing lines between the rectangles reading as horizons. Wherever there is a shape or constellation of shapes in the midst of such rectangular pictorial fields, that shape or configuration will generally be read as a positive form, a figure (at least in the most abstract sense of the term) or concrete presence. In a suprematist picture by Malevich (fig. 49), to take the most basic kind of example, the squares are read as positive forms whereas the area around the squares is read as empty space, void, or absence. These basic terms will prove useful in constructing a crucial point: what helps

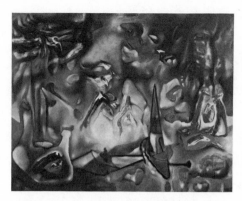

25
Matta Echaurren, *Inscape
(Psychological Morphology, No.
104)*, 1939, oil on canvas, 28½
× 36 in. Collection of Gordon
Onslow-Ford, Inverness,
California.

account for the extraordinary poignancy of Rothko's paintings is the way
the most basic and familiar sign for absence—the visual code for land-
scape or open, vacant space—has been insinuated into a sign for pres-
ence or positive form. Rothko's classic paintings may be said to
constitute, in other words, an image-sign for the union of absence and
presence, in which the sign for absence contradictorily comprises a sign
for presence. As Rothko successfully used it, this image-sign for pres-
ence, subtly suffused with or overhung by absence, or for absence, steal-
thily inhabiting presence, could impart those haunting intimations of
mortality that he regarded as deeply integral to the function and signifi-
cance of art.

### Inner Landscapes: Subject and Object
Long before Rothko conceived of it, the idea of adapting a landscape for-
mat to image the inner self, the idea of an "inner landscape" or "in-
scape," as Matta called it, was an established genre of surrealism. As
implemented by the surrealists, as in Matta's *Inscape (Psychological Mor-
phology, No. 104)*, 1939 (fig. 25), however, the basic schema of the inte-
rior landscape conformed essentially to the schema of conventional
landscape imagery, with a horizontal support divided horizontally into
more or less distinct zones that extend from edge to edge of the picture
plane. Matta was trying to chart a landscape of the unconscious, to visu-
alize the strange, inchoate scenery in the outer provinces of the human
mind, and the bizarre topography of his *Inscape*s renders them different
from conventional landscapes. Some critics have described Rothko's pic-
tures as interior landscapes (usually without expressly invoking the surre-
alist genre in question), but if this description is apposite it is not
because his classic images conform with the genre devised by the surre-
alists. The conventional schema of the landscape is not the governing
percept in Rothko's pictures that it is in the surrealists'; instead the
schema of the open landscape has been detached from the edges of the
support and subsumed into an abstract figural percept.

A subtle but tense visual tug-of-war is waged in Rothko's canvases
between the lateral pull of the individual rectangular areas and the verti-

cal movement of the gestalt comprised by the stack of rectangles. The ultimate and decisive tug is provided in a sense by the verticality of the support or canvas itself, a factor that subtly underlines the figural percept. Rothko was not exclusively committed to the use of a vertical support; a fair number of his canvases are slightly off-square, either toward the vertical or toward the horizontal (pl. XVIII, for example). This factor causes added tension, as the viewer struggles visually to square something that just misses being square and to discern which way it misses being square, by being too tall or too wide. Further, a small, if not negligible, percentage of the mature pictures are on canvases oriented horizontally—usually very slightly so, although in a few pictures Rothko experimented with a radically horizontal format.

In a sense, intrinsic to an artist's construction of the relation of figure and ground in a picture is a statement on the relation of subject and object, or on the dialectic between subjectivity and objectivity. In a statement written in 1945 that touched on this topic, Rothko argued for the equal status of object and subject: "I adhere to the material reality of the world and the substance of things. I merely enlarge the extent of this reality. . . . I insist upon the equal existence of the world engendered in the mind and the world engendered by God outside of it."[61] But in time Rothko became more specifically focused on the problem of rendering the inner self; in the schema he developed in 1949, subjectivity and objectivity were not on equal terms. Rothko became determined, in fact, to supply his art objects with not only a subject but also a subjectivity; that is, he became determined to make works of art that would be "alive." Further, if the percept of the abstract figure or inner self in Rothko's classic pictures subtly governs the percept of the landscape, as I have suggested, then his image-sign might fruitfully be considered in relation to the basic precept of phenomenology that subjectivity is prior to objectivity, that nothing can be known except by a knowing subject.

In adapting a landscape schema to constitute an abstract figure, Rothko created an exceptionally pregnant image-sign—a way of imaging the relation between a human being and his or her environment, the relation between the *innenwelt* and the *umwelt,* to borrow German terms. Rothko's icons may be seen as the "simple expression of the complex thought" that he had looked for since the early 1940s. His paintings function visually and structurally (but abstractly and covertly, as it were) as an image-sign of the pivotal relation between the inner self and the outer world. This question of the relation of subject and object is central to epistemology in general, and it would be inappropriate (and, in any case, beyond my expertise) to dwell on it here at length. A glancing reference to Hegel may prove useful, all the same, for casting light on the ramifications of Rothko's conceit. In place of Cartesian epistemology with its radical separation of subject and object, Fichte, Hegel, and German idealism generally offered a mapping of the intricate interrelation of these two terms. Hegel argued that the object "only has significance in rela-

tion, only through the ego and its reference to the ego"; that is, "the trained and cultivated self-consciousness, which has traversed the region of spirit in self-alienation, has, by giving up itself, produced the thing as its self; it retains itself, therefore, still in the thing, and knows the thing to have no independence, in other words knows that the thing has essentially and solely a relative existence." It follows that "the reality, both universal as well as particular, which observation formerly found outside the individual, is here the actual reality of the individual, his connate body."[62]

Mark Rothko
134

In his critique of Hegel, Adorno rejected this privileging of the subject at the expense of the object and argued further that "the picture of a temporal or extratemporal state of happy identity between subject and object is romantic . . . a wishful projection at times, but today no more than a lie."[63] There is a degree of fit, as it were, between the unitary emblem constituted by Rothko's image and Hegel's construct of the relation of subject and object, with its privileging of the subject and its vision of an ultimate unity between the two. Rothko made proud claims about the special unity he had achieved in his pictures, and his balanced, aligned, symmetrical compositions readily justified those claims. Rothko's cherished unity is a unity that encompasses disjunction, however, as his pictures' tattered and separated rectangles do not comprise whole integral percepts of either a figure or a landscape but only a ruptured and vestigial percept of both. The coincidence of a landscape schema, a schema for the sphere of objectivity, with the abstract schema of a figure or subject that we find in Rothko's art does not reduce it, then, to that nostalgic vision of a long lost oneness and wholeness to which Adorno caustically referred. But given the artist's own emphasis on the unity of his pictures, the thought of imaging such a vision of oneness and wholeness, of equality and identity between subject and object, may not have been far from his conscious design.[64]

### Microcosm and Macrocosm

Rothko's characteristic image-sign maps a percept of a landscape onto a schematic percept of a figure and in so doing proposes an analogy between the two structures. The interest in drawing an analogy between the structure of a human being and the structure of the world or universe has historically been a theologically motivated one, with a correspondence between microcosm and macrocosm (as it is often termed) summoned as evidence of the existence of a grand originary scheme for the universe. In Pythagorean philosophy, human beings were described as "little worlds" because they possessed "all the faculties of the universe."[65] In Plato's *Timaeus*, the gods who gave form to human beings are said to have begun by "copying the round shape of the universe . . . in a spherical body, the head . . . which is the divinest part of us and lord over all the rest." The rest of the body serves merely "as a vehicle for ease of travel," while "at

the top of us," according to a hierarchical plan, is "the habitation of the most divine and sacred part."[66]

In the fifteenth century, the idea that the structure of the human body mirrors the structure of the universe was an important premise of natural theology": "As the noblest heavenly bodies are those highest in the sky, so man's noblest part, his head, is uppermost; and as the sun is in the midst of the planets, giving them light and vigor, so is the heart in the midst of man's members," and so forth (the subordinate orders are usually less explicitly mapped out).[67] After the late nineteenth century, to followers of the syncretic doctrines of theosophy: "Man is a little world— a microcosm inside the great universe. Like a foetus, he is suspended . . . in the matrix of the macrocosmos; and while his terrestrial body is in sympathy with its parent earth, his astral soul lives in unison with the sidereal *anima mundi*. He is in it, as it is in him."[68] And closer to Rothko's own time, Jungian theorists—whose interests were not strictly archeological but directed at framing a transhistorical model for the evolution of human psychology and cognition—believed that "the correlation of certain cosmic bodies, directions, constellations, gods, demons, with the zones and organs of the body . . . is so universal for primitive man that the world-body correspondence may be looked upon as a law of the primitive world view. . . . In Egypt and Mexico, in India and China, in the writings of the Gnostics as in the cabala, we find the body schema as the archetype of the first man, in whose image the world was created."[69]

During his surrealist phase, that is to say during the war, Rothko allied himself generally with artists who were determined to retrieve a humanistic telos for art. "The point then," wrote the surrealist Wolfgang Paalen in 1944, "is not the pure and simple keeping or the abandoning of the subject; we are concerned with articulating with nonanthropomorphic elements a human message. No more models, internal or external . . . instead, paintings that are balance beams of scales whose plates are the microcosm and the macrocosm, *picture-beings*."[70] Around 1941–42, Rothko painted a group of paintings that may be read as picture-beings or as imaging the correspondence of microcosm and macrocosm. As can be seen in some untitled paintings of circa 1941–42 (figs. 16, 26, 31) and in *The Omen of The Eagle* of 1942 (pl. II), these pictures consist of hierarchically structured tiers. The uppermost tiers are invariably composed of a row of merged human heads, suggesting a realm of mind and knowledge, the realm of omniscient gods, the sky. The bottom tiers are usually comprised of animal and human feet and hands, of tentacle and genitallike shapes, or of roots and vegetation—images that might broadly be said to evoke a realm of dumb and instinctual functions, a base, benighted netherworld. The intermediate tiers of these picture-beings usually consist of human torsos, birds, or stylized feather motifs. As they maneuver freely between earth and sky, birds have conventionally signified the human spirit, commonly said to be housed in the human breast.

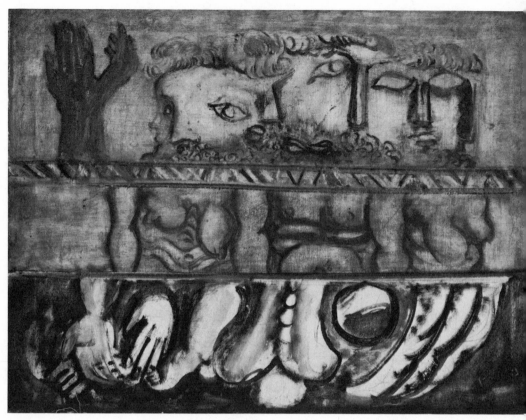

26
Untitled, circa 1941–42, oil
on canvas, 23⅞ × 31⅞ in.
Collection of the National
Gallery of Art, Washington,
D.C. Gift of the Mark Rothko
Foundation, Inc.

The tiered format of these surrealist pictures by Rothko may readily evoke parallels with a conventional landscape format. But the contents of the tiers and the hierarchical ordering of these stratified pictures may render them even more evocative of such traditional representations of the cosmos as that seen in a *Last Judgment* by Jan Van Eyck, for example (fig. 27). A comparison of this fifteenth-century painting and *The Omen of the Eagle* (pl. II) or the untitled paintings mentioned above reveals how Rothko implemented a convention for imaging a cross section of the cosmos as a stratified, hierarchical structure, adapting that construct by overlaying it with elements of the human form. (Although he may not have been aware of it, precedents for this kind of image can be found in images from occult and theosophical studies [figs. 28, 29].) The structural similarities between Rothko's classic paintings and his surrealistic picture-beings or microcosm-macrocosm pictures, as I am calling them, are unmistakable; both involve a rectangular stack of horizontally oriented rectangles suspended in the center of a (more often than not) vertically oriented rectangular support. The basic structure of Rothko's full-scale paintings could be said to have emerged in embryo, in other words, in these easel-scaled pictures of nearly a decade before. A number of critics have remarked on the correspondence of structure between some of Rothko's early pictures and his classic paintings, but the idea that there

27
Jan van Eyck, *Last Judgment,*
tempera and oil on canvas,
transferred from wood, 22¼ ×
7¾ in. The Metropolitan Museum
of Art, New York. Fletcher Fund,
1933. *above left*

28
Anonymous, *The Soul of the
World,* published in Robert Fludd,
*Utriusque Cosmi Historia,*
Oppenheim, 1617. *above right*

29
Anonymous, *Man is a Microcosm,*
published in Robert Fludd,
*Utriusque Cosmic Historia,*
Oppenheim, 1617. *left*

may also be some relation between the subject matter of these paintings has not been thoroughly explored—in part, no doubt, because the themes of the early pictures have only begun to be subjected to sustained and detailed analysis.

Richard Wollheim has observed that "in many instances, the kind of order that is sought by the artist depends from historical precedents: that is, he will assemble his elements in ways that self-consciously react against or overtly presuppose, arrangements that have already been tried out within the tradition. We might call such forms of order 'elliptical,' in that the work of art does not, in its manifest properties, present us with enough evidence to comprehend the order it exhibits."[71] Meyer Schapiro similarly suggested that "the elements applied in a non-mimetic, uninterpreted whole retain many of the qualities and formal relationships of the preceding mimetic art. This important connection is overlooked by those who regard abstract painting as a kind of ornament or as regression to a primitive state of art."[72] That Rothko's pictures have so often been treated as ornaments—whether by way of praise or by way of dismissal—is a reflection of the ellipticalness of their reference. Rothko's paintings recover certain established conventions of mimetic art but not without making some crucial and daring omissions. The viewer is left to supply the logical connectives—and that is one of the tasks I am pursuing here.

Although the missing links between Rothko's classic paintings and the conventions of mimetic art were omitted for a purpose, they merit investigation because the layers of metaphor intrinsic to the mature work hinge on those very relations. It is not my object to link Rothko's art with more accepted or accessible narrative art in order to legitimate it or ensure its bona fides; nor is my object to render his pictures less abstract or indeterminate than they are; rather my point is that, for all their abstractness, Rothko's pictures remain coded. They signify through the implementation of a trace structure that functions (insofar as it does function) through the power of suggestion and evocation, by "painting memories," as it were. By ridding art of unambiguous referential imagery, abstract artists acted to counter the overestimation of the object, or of the narrative enacted by objects, as the sole or privileged locus for meaning in a work of art. But abstract artists could not escape metaphor, whether or not they wanted to; they could not escape the lingering signifying power, the accrued symbolic and phenomenological associations of their arrangements of forms.

To point to the connections between patently different kinds of paintings is not necessarily to overlook or deny their obvious differences. But some of the evident differences between Rothko's mature pictures and paintings in the surrealist or old masters' tradition prove to be more significant or immutable than others. Although Rothko did not use recognizable referential imagery in his classic paintings, for example, he nonetheless occasionally left his brush free to develop some of the automatist imagery that animated his own earlier paintings. Motherwell had

heard Rothko say that "there was always automatic drawing under those larger forms";[73] and though it would be foolish to take this statement too literally—as indicating that recognizable figures lurk beneath the surface of most of Rothko's pictures—the rectangular areas in some paintings may betray the results of the automatic drawing to which he referred. In an untitled painting of 1951 (fig. 30 and pl. XV), for example, the top rectangle may be seen to constitute a row of merged faces like the faces at the top of such earlier paintings as *Antigone, The Omen of the Eagle, Number 11*, 1947, and some untitled paintings of 1941–42 (fig. 3, pl. II, and figs. 15, 16, 26, 31).

Whether any configuration in Rothko's later paintings is a face, for example, or merely an accident of the brush is bound to remain moot; such is the nature of automatic drawing. But if Rothko permitted some legible images to form during the process of painting, he subsequently took pains to efface or disguise them. Whether semilegible images are buried within the rectangular fields of some of his paintings is finally a peripheral issue then. What is most important to the present argument is the relation or coincidences of structure between Rothko's classic paintings and mimetic art—both his own quasi-mimetic surrealist pictures and the traditions of mimetic art in general. I am arguing that those coincidences justify approaching Rothko's pictures as image-signs for the relation of subject and object, icons for the conjunction of presence and. absence.

## Interior and Exterior: The New York School's Themes

In 1949 Clement Greenberg wrote, with the New York School artists in mind, "The best modern painting, though it is mostly abstract painting, remains naturalistic in its core, despite all appearances to the contrary. It refers to the structure of the given world both outside and inside human beings."[74] The themes of Rothko's fellow New York School artists fall outside the scope of this book, but it would be remiss of me not to indicate, however sketchily or schematically, how Rothko's preoccupation with the structure of the given world both outside and inside human beings compares with the preoccupations of others in his circle. De Kooning, Pollock, and Smith also dealt with the relation between subject and object, interior and exterior, though not using an iconic image-sign as Rothko did, but through manipulations of the oldest trope of pictorial art: the relation of figure and ground as they stand for solid and void. Detached and discrete shapes in any given picture are normally registered or imagined as solid, to reiterate, whereas the area surrounding such shapes and extending to the edge of the support is normally read as open space—though neither area is, in reality, any more or less solid than the other. De Kooning, Pollock, and Smith, each in his own way, exploded this elemental paradigm and reformulated the relation between figure and ground, subject and object, through solutions found in cubism. Those so-

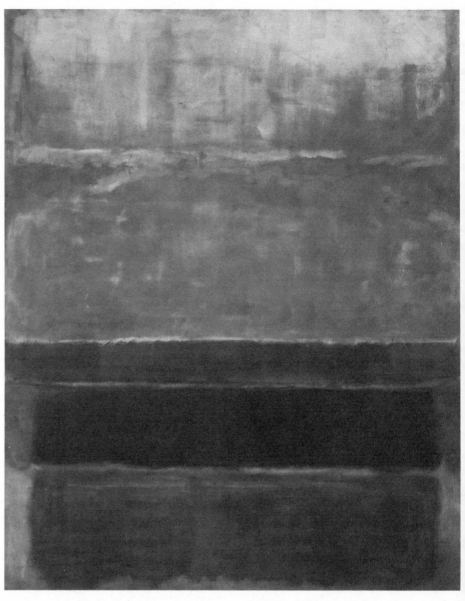

30
Untitled, 1951, oil on canvas, 103
× 83 in. Collection of Mr. and
Mrs. Paul Mellon, Upperville,
Virginia. (See also plate XV)

lutions involved breaking open closed forms and shattering and intermingling the forms of the figure and the figure's surroundings such that neither can be read as more void or solid than the other and the picture's identity as a conceptual representation, rather than an illusionistic one, is affirmed.

Rothko's work could be described as relatively conservative compared with his peers', as his pictures may be seen as retaining the standard figure-ground relation—the basis for representation that cubism had long since produced the tools to dissolve. Rothko continued the received practice of setting discrete and detached figures (in his case, abstract figures or rectangles) on top of or against a ground that extends to the

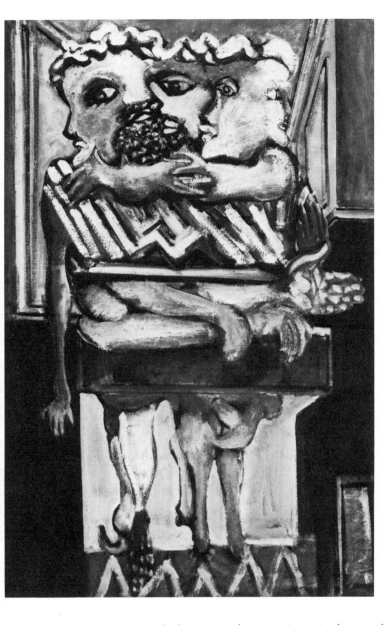

edges of the support. As such, his rectangles participate in the standard pictorial fiction or illusion, lending themselves to being read as positive things situated in open, empty space (though, admittedly, they are not read this way by everyone). From another perspective, however, Rothko's art has been described as more innovative or radical than Pollock's and de Kooning's. As Greenberg finally saw it, the expansive sheets of color painted by Rothko, Newman, and Still circumvented the, however slightly, illusionistic spatial structures that emerge from Pollock's and de Kooning's use of a tonal, colorless palette—the palette that underpins the traditional techniques for modeling form in the round, the palette of analytic cubism.[75] Rothko's art is more grounded in the legacy of the post-

31
Untitled, circa 1941–42, oil on canvas, 35¹³⁄₁₆ × 23⁷⁄₈ in. Collection of the National Gallery of Art, Washington, D.C. Gift of the Mark Rothko Foundation, Inc.

impressionists, late Monet, and Matisse, who structured their pictures with flat planes of color, than in the intricate, fractured structures of cubism.

The New York School artists are sometimes said to have pioneered ways of making art characterized by a radically nonhierarchical structure—a description that especially fits the so-called all-over paintings of Pollock. And, to the extent this is true, the practice may have latent political implications. Whereas Pollock made paintings that were virtually all line and no shape, the paintings of Rothko and Newman were nearly all shape and no line, paintings with a bare minimum of drawing. What sets Rothko apart, in a sense, is the way the drawing in his characteristic paintings, minimal though it is, implements a traditional, vertical hierarchical structure in contrast with the nonhierarchical horizontal organization of Newman's pictures.[76]

Of the principal artists of the New York School, de Kooning is often represented as the most conservative figure—in some critics' eyes as practically an academic figure—because of his explicit focus on the human figure. However different their art is in other respects, I maintain that de Kooning's preoccupation with the figure was not something that separates him from Rothko, but something they had in common. De Kooning's figures are not as abstract as Rothko's insofar as viewers can still decipher certain of their physiological features—eyes, mouths, and limbs. But in a sense, de Kooning's figures are more abstract than Rothko's because they are not comprised of discrete, coherent, and symmetrical parts but a maelstrom of splintered forms. In *Woman VI* of 1953 (fig. 17), for example, the fractured forms of the woman's body are scrambled irreparably with the fractured forms of the environment that surrounds her. Viewers may deduce that they are looking at a figure and her surroundings, but they will not find the normative figure-ground relationship, with each integer as a distinct entity: "The landscape is in the Woman, and there is Woman in the landscapes," de Kooning observed of his pictures in 1953. He spoke also of the importance for artists of being "both inside and outside at the same time. A new kind of likeness!"[77]

*Interior for Exterior* was the title David Smith gave to a sculpture that he made in the 1930s, and the human figure is no less prevalent in Smith's work (if not in that particular piece) than it is in de Kooning's. With his open-work figures, which he liked to see outdoors, the viewer can see the figure in the landscape while there is real landscape or at least open space in the figure; this is the case with *Running Daughter* of 1956 (fig. 32), for example. Nor was the New York School's most noted radical, Jackson Pollock, immune to this preoccupation with the human figure and the figure-ground paradigm: "There is not a single year (with the possible exception of 1950) when he [Pollock] is not operating specifically with the binary opposition figure/non-figure which means infiltrating a nonspecific figuration into the linear matrix of even the allover

32
David Smith, *Running Daughter,*
1956, painted steel, 100½ × 37
x 17 in. Collection of Whitney
Museum of American Art, New
York. 50th Anniversary Gift of
Mr. and Mrs. Oscar Kolin.
Acq. no. 81.42.

paintings," Rosalind Krauss has observed.[78] In Pollock's most figurative
mature work, in *Number 7,* 1952 (fig. 18), for example, the lacy skeins of
paint that comprise the open-work figure are tangled inextricably with the
skeins that establish the figure's environment.

Pollock found his authentic voice as an artist when he went beyond
cubism, which entailed breaking open the figure and meshing its shapes
with those of the ground to demolish shape altogether. In his classic pic-
tures, which virtually extinguish shape in a mode of painting constituted
entirely by line, Pollock went further than any other artist toward elimi-
nating the age-old split between figure and ground; by the same stroke,
in a sense, he was repudiating the traditional (Cartesian) separation
of subject and object or, to cast the matter in a different light, he was
repudiating the separation of the human being and nature. Like Rothko,
Pollock was looking for a new kind of unity. But, if in Rothko's predomi-
nantly vertical mature paintings the percept of the subject is the govern-
ing one, in the classic, predominantly horizontal, all-over paintings by
Pollock the percept of the ground predominates; the entire picture *is*
ground, in a sense, and the figural elements are dissolved in that ground,
with no distinct identity as closed shapes. As Pollock aphoristically put it,
'I work from the inside out, like nature.'[79]

Pollock's privileging of ground over figure in his radical dismantling
of the figure-ground paradigm can be considered, then, in relation to
Adorno's vision of the subject-object dialectic. Whereas Fichte and Hegel
had privileged the subject over the object, as Rothko's paintings might be
said to do, Adorno proposed the "dialectical primacy" of the object, ar-

guing that, "Potentially, even if not actually, objectivity can be conceived without a subject; not so subjectivity without an object. No matter how we define the subject some entity cannot be juggled out of it." Further: "Ever since the Copernican turn, what goes by the name of phenomenalism—that nothing is known save by a knowing subject—has joined with the cult of the mind. Insight into the primacy of the object revolutionizes both. What Hegel intended to place within subjective brackets has the critical consequence of shattering them. The general assurance that innervations, insights, cognitions are 'merely subjective' ceases to convince as soon as subjectivity is grasped as the object's form."[80]

Adorno criticized Hegel's vision of the ultimate unity of subject and object as a romantic fantasy, but he also saw an insidious aspect to the (Cartesian) insistence on the separation of subject and object and, in the end, he formed his own idealistic vision of a unity between the two. "Once radically parted from the object, the subject reduces it to its own measure; the subject swallows the object, forgetting how much it is an object itself," wrote Adorno.[81] Adorno and Horkheimer saw (as Martin Jay paraphrased it), that "the domination of nature ensued once man's primal embeddedness in nature was transcended and then forgotten . . . [and that] from the first, the domination of nature was intertwined with social hierarchy and control."[82] Pollock very keenly felt his own embeddedness in nature: when Hans Hofmann suggested to him that he should try to paint from nature, he famously retorted: "I am nature!"[83] And that consciousness permeates his art, as many of his pictures' titles imply. Adorno observed that "the reified consciousness that mistakes itself for nature is naive: having evolved and being very much mediated in itself."[84] But Pollock's vision of nature is unmistakably that of a mediated subject, and the unity he achieved in his art is not a wholesome or integral vision of an organic "pre-reflective unity." Instead, the opposing black and white of Pollock's pictures holds them in a vivid state of tension. The subject that emerges from Pollock's work, as Krauss describes it, is the "provisional unity of the identity of opposites: as line becomes color, contour becomes field, and matter becomes light."[85]

With a painting by Pollock even more than with a Rothko, the artist's gestural technique lends viewers a sense of connection with the process by which the picture was made and so with the presence, subjectivity, and experience of the maker. The New York School artists in general are often seen as having made themselves the centerpiece of their art, and an invidious distinction is sometimes made between the New York School group and those first-generation abstract artists who hoped to make their art selfless or suprapersonal—and thereby universal. For their stress on subjectivity, for reintroducing the terms of the self in abstract art, the New York School artists have drawn fire: charges of solipsism and charges that they were merely expressing themselves. Rothko reportedly responded to the latter formulation by saying he was expressing his "not-self" rather than his self,[86] but it was Newman's tactic to

turn the charge around: in his eyes the New York School artists were engaged in nothing less than making "cathedrals" out of themselves—"Instead of making Cathedrals out of Christ, man or 'life', we are making it [sic] out of ourselves, out of our own feelings."[87] And Clyfford Still unabashedly claimed, "I paint only myself, not nature." "When I expose a painting, I would have it say: 'Here I am: this is my presence, my feelings, myself."[88]

Statements like Newman's and Still's could be used as further ammunition for the charges of solipsism against the New York School. It might better be argued, however, that the self that emerges at the center of this art is less a solipsist than a responsibly thoughtful, self-examining, post-Freudian being. A distinction should be drawn between the notion of the individual and the notion of the ego, self (or *Ich*). For although the New York School artists were versed, however informally, in Freud and Jung, they did not look to the reality and the experiences of the self or inner self for something personally individual or unique but for something shared—even universal. The New York School artists did not propose simply to express themselves in the sense of seeking a merely personal form of release; on the contrary, they shared the ambition of the first-generation abstract artists to find a universal mode of visual expression. The New York School artists believed that the path to the universal would be found not by vanquishing subjectivity, however (as Mondrian, for one, had expressly hoped to do), or by rising above it to a realm of pure spirituality but instead by exploring, reifying, and even celebrating subjectivity and experience. Much of New York School art avers, in a sense, that selfhood and experience, the intersection of the self and the world, are precisely what is universal; such were the "Subjects of the Artist."

# 5

# The Human Drama:
# From the Womb to the Tomb

In his classic paintings, Rothko implemented pictorial structures that un-
derlie established conventions of pictorial art and that were instrumental
in his own earlier work; so I have argued. Insofar as pictorial structures
are coded or symbolically pregnant, then, Rothko's classic pictures may
be seen as at once recapitulating and transforming certain genres or
themes of mimetic art, transforming them by implementing only traces of
preexisting codes and by layering or recombining those traces in unex-
pected but suggestive ways. The subjects I have considered up to this
point follow from the compounding of the signs or structural schemata
for landscape and portraiture that Rothko first broached in some of his
surrealist pictures and that can also be seen as underpinning the basic
format of his classic paintings. In imaging the intersection of figure and
landscape, Rothko effectually found an icon for the interrelation of pres-
ence and absence, of microcosm and macrocosm, of subjectivity and
objectivity. Further, by imaging presence as absence, the "there" as the
"not there," Rothko found an icon for the central theme of myth and the
central theme of art (by his own account)—death. Some of Rothko's
classic paintings reveal his preoccupation with mortality in other ways,
however, that again entail using pictorial structures made symbolically
pregnant by their relation to preexisting pictorial codes. Elucidating these
additional layers of metaphor embedded in Rothko's pictures will again
require comparing the structures of those pictures to the structures of cer-
tain types of old master paintings, then, as well as to some of Rothko's
own surrealist pictures, in which he first began to tamper with and trans-
form those structures. Rothko created other images in his surrealist period
besides his fantasy portraits and "picture-beings," and the structures of
some of these other images can also be seen to recur, transmuted into
abstract form, in some of the classic paintings. The palimpsest consti-
tuted by Rothko's pictures becomes denser still, in other words, though
as it does so the readings retrieved from it admittedly become increas-
ingly recondite or provisional.

   To an extent, the format of Rothko's characteristic paintings was for-
mulaic and constant, but within the overriding terms of that format, some
distinct types of images emerged, marked by the particular arrangements
of their component rectangles. In the previous chapter I suggested that

Rothko painted a recurrent type of picture in which the proportion and distribution of the rectangles approximates, somewhat less crudely than in other pictures, the proportion and distribution of human body parts, paintings with an especially small rectangle at the top of the composition. In this chapter I will focus primarily on those pictures with an especially small or narrow rectangle at the center or bottom of the picture instead of or in addition to a narrow rectangle at the top of the image. These images will be associated with the "single theme" of myth, in ways beyond those already suggested.

Besides his picture-beings and his mythological portraits, another favored theme of Rothko's surrealist period was that of rituals connected with death. Rothko painted *Gethsemane,* scene of Christ's psychological confrontation with death on the eve of the crucifixion, and crucifixion imagery may be found repeatedly in pictures of the early and mid-1940s (see fig. 33 discussed below). Apart from this use of specifically Christian imagery, Rothko painted *The Sacrifice of Iphigenia* and *The Horizontal Phantom,* discussed earlier, as well as an *Immolation* and at least four paintings entitled *The Entombment* (two of which are discussed below), and many paintings that loosely conform to a lamentation or pietà format, such as *Prehistoric Memory* (fig. 36). By the late 1940s Rothko no longer used such descriptive titles, and he stopped treating the theme of mortality in a figurative or narrative way. He did so not out of disinterest in the theme but out of frustration with the painted figure's inability to "raise its limbs with a single gesture that might indicate its concern with the fact of mortality." Even after he abandoned such illustrative figures as the horizontal phantom, "a clear preoccupation with death" remained the essential impetus for his art, by his own account. When he listed the 'ingredients' for his art in a lecture delivered in 1958, "intimations of mortality" headed the list.[1]

Among the paintings of the 1940s that address the theme of mortality is an untitled crucifixion image of circa 1941–42 (fig. 33), in which Rothko depicted not just one martyr or Jesus but a group of martyrs, their bodies unexpectedly and brutally hacked to pieces, recombined, and redistributed around the canvas in isolated compartments. On the right side of the picture is a summarily rendered flayed male torso, its drapery nailed to a wall or support at the far right. A smaller figure is found to the left of the torso reaching up past its right armpit; this attendant figure, drawn in right profile, is a nearly nude, bald man, his thigh and buttock rounded with bulky muscles. On the left side of the picture at the top is a multiheaded, bearded Christ or, conceivably, Christ's head fused with and reduplicated by the heads of the thieves who were crucified with him. The heavy-lidded eyes of this fused row of heads are sorrowful and pleading, and the raised mouth seen in profile at the far right seems to be calling out in anguish. Below the multiple severed heads are two dismembered arms, the hands exhibiting stigmata; these arms are stacked one on top of the other, backed by the boards from the cross's transverse.

33
Untitled, circa 1941–42, oil on
canvas, 29¹⁵⁄₁₆ × 35¹⁵⁄₁₆ in.
Collection of the National Gallery
of Art, Washington, D.C. Gift of
the Mark Rothko Foundation, Inc.
(Photo:Quesada/Burke)

Below the severed arms are six or seven slender, naked legs topped by a
row of dangling male genitalia, the whole vignette looking like meat
crudely displayed on a meat rack. Near the lower center of the picture,
finally, are two dismembered feet with stigmata and a dismembered hand
exhibited in boxlike compartments. The use of symbolic attributes like
the stigmata lend this picture some familiar notes, but this is a composi-
tion more unconventional than not, a picture disjointed in its fragmenta-
tion, reordering, and multiplication of the martyr's body. That multiplicity
is perhaps best understood, however, in light of the thesis of *The Golden
Bough*; in Frazer's scheme, there is no single privileged martyr, and the
crucifixion of Christ emerges as no more than a footnote to millennia of
religious or ritual sacrifices.

## Pietàs and Entombments

A somewhat more conventionally composed and representative picture from Rothko's surrealist period may shed more light on Rothko's classic paintings. In *The Entombment* of the mid-1940s (fig. 34), for example, a dead figure of reptilian aspect lies in the lap of a green triple woman seated on the ground in a barren landscape. Within the ashen form of the corpse (which looks something like a male version of the horizontal phantom of circa 1943 [fig. 20]), dark lines delineate a schematic skeletal and physiognomic structure, outlining arms, legs, knees and feet, a spine, ribs and vertebrae, a phallic tail, and a prominent eyelike navel. Three broad bosoms and three faceless heads loom over this dead creature, and a cluster of kneeling legs support it from underneath. Where the corpse intersects the body of the triple woman, there is an unexpected division in her figure, a schism articulated with white scratches in the greenish brown paint of the background. This schism could be seen as demonstrating literally or graphically how the woman is torn apart (to use a colloquial phrase) by the death of the figure she cradles. At the same time, the schism creates the impression that the dead figure lies inside the woman, that it reposes, figuratively speaking, in both the womb and the tomb. The association of womb and tomb is common in the symbolic language of mythology: "People almost everywhere have conceived of the earth as female since it gives forth the sustenance of life. The earth is also our home after death; in Greek metaphorical language the tomb is sometimes equated with the womb."[2] By splitting the body of the mourning mother figure apart, then, Rothko could allude not simply to an entombment but to the larger theme of the cycle of life.

The triple goddess in *The Entombment* (fig. 34) raises her two massive arms in a gesture of wailing or lamenting. This picture is more similar to a conventional pietà or lamentation, in fact, than to an entombment, in which the deceased is typically on the ground or on the verge of entering the grave. The basic composition of *The Entombment* parallels the composition of a *Pietà* (fig. 35) by the sixteenth-century Flemish painter, Quentin Massys, for instance, in which a seated Mary holds the outstretched, supine body of Christ while Saint John cradles his head. But Rothko created a three-legged birdlike creature in place of Saint John and a fantastic triple female in place of the Virgin Mary, thereby assuring the distance between his own image and conventional Christian art. His green triple woman may suggest the legendary "three Marys" who appear in some lamentation scenes, but she could equally recall the three Fates, three-headed Hecate, or Diana triformis.[3] In his treatise *The White Goddess*, Robert Graves described the triple-goddess as a distinct mythological type whose identity reflects the several ritual identities of the female as perceived by the male "hero" at successive stages of his life.[4] The triple goddess is mother, bride, and mourner, or maiden, nymph, and hag. As such, she signifies past, present, and future—life-in-death and death-in-life. The Virgin Mary qualifies as a triple goddess because she

34
*The Entombment,* mid-1940s, oil on canvas, 23 × 40 in. Collection of Herbert Ferber, New York.

35
Quentin Massys, *Pietà,* oil on panel. Louvre Museum, Paris. Photograph from the National Museums, Paris.

presided over the full cycle of Christ's life—as mother, bride, and mourner. By working variations on the image of the pietà, then, Rothko depicted a theme pivotal to myth in general. In *The Entombment,* the theme of the life cycle is signified by the placement of the male figure in the womb and the tomb, by the presence of the triple goddess, and by the distinct position of the goddess' spread, upraised arms—her open clawlike hand prepares to grasp her other clenched hand to close a full circle.

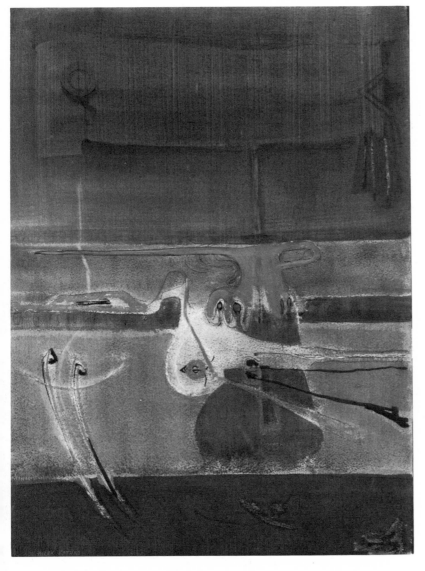

36
Prehistoric Memory, 1946, pen and
ink, watercolor, gouache on paper,
25¾ × 19⅜ in. Collection of
Steingrim Laursen, Copenhagen.

Another example of pietàlike imagery in Rothko's surrealist work can
be found in *Prehistoric Memory,* done with gouache, watercolor, and ink
on paper in 1946 (fig. 36). The principal figure in this picture is a female
personage with five breasts (ergo, a kind of triple woman?), wearing an
ochre blouse and a long grey skirt. Her outsized, broad, rectangular
head, balanced on top of a long polelike neck, almost fills the upper area
of the sheet. On the far left side of the head is a large round eye that
appears to emit a tear, as a drip streams off the face there. A protruber-
ance that extends from the lower left corner of the rectangular face might
be seen as a proboscislike nose rendered in profile. And at the lower
right corner of the blocky head is a small cluster of lines that may indi-
cate hair gathered in a short, straight ponytail. The woman's skinny left
arm is crooked to her side above her breasts, and her right arm is ex-

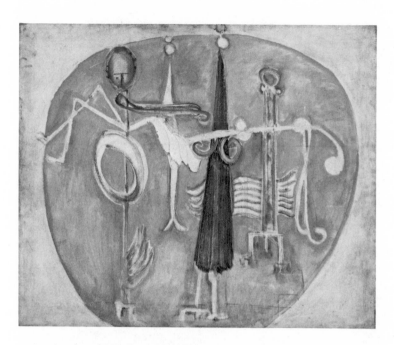

37
Untitled, early 1940s, oil and
chalk on canvas, 29¾ × 35¹³/₁₆
in. Collection of the National
Gallery of Art, Washington,
D.C. Gift of the Mark Rothko
Foundation, Inc.
(Photo: Quesada/Burke)

tended, as if pointing emphatically or accusingly toward someone or
something outside the frame of the picture.

Lying across the narrow lap of the woman in *Prehistoric Memory* is
the spindly, elongated, white and yellow body of another humanoid crea-
ture. Judging from its length, it is the body of an adult; but judging from
the scrawniness of its limbs or the size of its head relative to the wom-
an's, it is the body of an infant. This recumbent humanoid has long
white legs that extend horizontally to the right edge of the picture. The
round bulk of its midsection rests off-center on the woman's lap, and its
reclining upper body, with yellow arms reaching over its small black
head, is seen against a narrow black strip behind the woman or mother
figure. The body of the creature is presented partly against the mother
figure's lap and partly against the dark black stripe behind her—a stripe
that could be interpreted as a schematic rendering of a grave. Most often
a figure shown recumbent in another figure's lap will be a sleeping infant
or someone who has died, someone close to the womb or close to the
tomb. In the supine creature's stomach area is a blue bird's head stem-
ming from a long blue line that follows the posture of the supine figure's
body, and birds are associated symbolically with the soul or spirit, which
supposedly flies from a dying body to enter the afterlife.

Rothko's entombments and many of his untitled surrealistic pictures
are similar to *Prehistoric Memory* and *The Entombment* discussed above
(figs. 36, 34), similar, that is, in how they both observe and break or ef-
face the pictorial codes or conventions for this type of scene. Entomb-
ment or pietàlike scenes are also discernible in two untitled canvases of
the mid-1940s, for example (fig. 37 and pl. III). In the first instance, the
ritualistic image is presented in a makeshift tondo, that is, an image com-

posed inside a somewhat wobbly circle. Slightly above the midpoint of that circle, the white, limp body of an elongated, spindly figure cuts horizontally across the picture, supported by the arms of four other spindly figures who stand in a straight row, evenly spaced across the face of the picture. At the right edge of the picture the supine, limp figure's head droops from its long neck, forming an inverted comma. Below that comma, the recumbent figure's arms dangle like wet strands of spaghetti, curled up at the ends where the hands would be; its bent legs and feet may be found at the picture's left edge. Supporting the sticklike torso of this corpse or martyr is a tall figure located just to the right of the painting's center, clad in a long triangular or cone-shaped black shift. This mourner or attendant figure has two curlicue arms (visible halfway down its body), which reach under the back of the martyr's body in a gesture of support. Stubby white legs and feet can be seen below the mourner's black triangular shift, and a small white circle at the triangle's apex signifies its head. A halolike effect is created above that head by a tiny circlet (which exceptionally extends, moreover, outside the larger circle that frames the scene as a whole). Also supporting the martyr's body, just at the juncture of its legs and torso on the left side of the picture, is a red, polelike figure with a large, red head (the face, or eyes and nose, cursorily indicated by a *T*) and a doughnut-shaped abdomen. To the right of the black-clad and red figures are two smaller attendant figures painted red and white respectively (the white one, with a halo of its own, is either partly obscured by or appears to share the white loincloth on the martyred figure's body). These diminutive figures appear to be levitated, as their feet are raised substantially above the ground plane suggested by the positioning of the larger, erect or vertical figures' feet.

An entombment or pietà also appears to be the subject of a colorful, almost Miró-like picture of the mid-1940s (pl. III). In this image, the supine or prone body of the deceased is formed by a long, smooth, orange shape, like a softly undulant tube. At the right-hand end of this orange shape is a small circular black eye and an open fishlike mouth; at the left end are short, bent, and splayed legs. The conglomerate of mourner figures supporting this recumbent creature's body form a tight, bouquetlike grouping at the center of the picture. The mourners' bodies are top-heavy with outsized curvaceous heads of white outlined in red; their legs are like a tight row of matchsticks (visible beneath the recumbent orange body). Their diminutive hands, two of which have distinct fingers outlined in black, grasp the orange figure from above and below around its middle. Near the martyred figure's head at the right side of the picture stands an additional, distinct attendant, whose body is rendered with sprightly calligraphic black and red lines, a stain of green paint, and a small red dot that serves as a face.

Comparable in structure to both of these oil paintings is a watercolor, *Entombment I* of 1946 (fig. 38, diagram 2), in which three large mourner figures are seen ritualistically attending a corpse. The vertical or standing

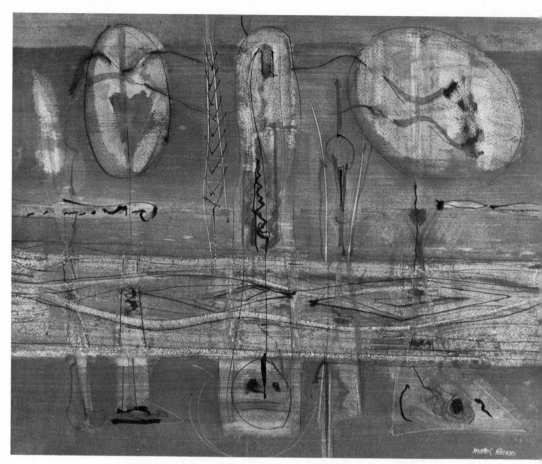

38
*Entombment I,* 1946, gouache,
pen and ink, 20⅜ × 25¾ in.
Collection of the Whitney
Museum of American Art,
New York. Purchase. Acq.
no. 47.10.

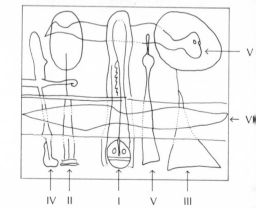

Diagram 2. *Entombment I,* 1946

figure (I) found at the center of the sheet might be read as an exception-
ally tall person who is doubled over at the waist; this would explain why
her face, with its big black eyes and its mouth agape, stares out from the
bottom of the picture. Flanking this central figure are two figures (II, III)
with giant, blank, balloonlike heads atop long, skimpy necks, a pen-line
in width. To the left of each of these balloon-headed figures is a more

diminutive figure (IV, V), whose relative scale may imply an auxiliary role. These five vertical figures stand in a row and are intersected at about the level of their torsos by a light-toned, rectangular horizontal stripe. This stripe constitutes or contains what might be construed as an additional figure (VI) made up of circumscribed and adjacent lozenge shapes forming a long, sideways figure eight. Although this abstract figure has no evident humanoid traits, it occupies a conventional position for a deceased figure (across the laps of its attendants) and might thus be seen as the wrapped or shrouded counterpart of the figure lying across the triple woman's lap in *The Entombment* painted on canvas (fig. 34). In *Entombment I* (fig. 38), however, the medium—watercolor, gouache, and ink—lends itself to effects of transparency, and the dead figure is for the most part superimposed over its attendants instead of obscuring a section of their bodies.

Another difference between these two *Entombments* is the unexpected presence of a second horizontal figure (VII) in the latter picture. This second horizontal personage has a long, undulant, tubelike body with small bulblike sections pinched off at either end. This abstract body intersects the heads of three of the vertical or standing figures: the small bulb at the right end of the horizontal body (which can be read as a face with inky black eyes) overlaps the featureless balloon-head of the large figure on the right, and the small bulb at the left end of the horizontal body (which might be read as its feet) overlaps the balloon-head of the figure on the left. This second horizontal personage appears to levitate or float unsupported and might therefore illustrate a sequel to the rite of the entombment: ascension and rebirth. By showing the horizontal figure at two different levels, earthbound and airborne, Rothko may again have been exploring possibilities for an image that could encompass a suggestion of the full cycle of life. Although the solution represented by *Entombment I* involves a number of evident departures from tradition—for one thing, ascending figures in the imagery of Christian art are more often oriented vertically than horizontally, in token of their new afterlife—the basic structure of Rothko's picture remains founded on received pictorial convention.

Basic Elements and their Placement

In the late 1930s Rothko was already thinking of "the artist having analyzed his problem through to these basic elements of plastic shapes and emotional symbols." The child, the "madman," and the artist were all similar, he suggested then, because "all of them employ the basic elements of speech."[5] This interest in using a process of analysis to arrive at basic elements was one that Rothko pursued less intensively at the time than he would in subsequent decades. So thoroughly did he analyze the composition of *The Entombment* (fig. 34) that he required only three col-

ors and a modicum of drawn details to realize this image, which retains the rudiments of a conventional pietà. But in his classic pictures, Rothko came much closer still to establishing a vocabulary of basic elements of speech—that is, in his own terms, the basic elements of plastic shapes and emotional symbols.

As Rothko's vision changed over the 1940s, the process of analysis that he implemented in his art was effectually one of distilling basic or simple forms from the intricate forms of his earlier compositions while retaining traces of the structural patterns that underpinned those compositions. This admittedly characterizes the development of Rothko's art in a reductive way, and he himself would surely not have seen it in such terms. But viewed retrospectively and telescopically, as it were, the changes Rothko's art underwent could pass for an aesthetic demonstration of what psychologists of visual perception call "the tendency toward the simplest structure." The elements of "simple form" have been described by Rudolf Arnheim as follows: "A straight line is simple because it uses one unchangeable direction. Parallel lines are simpler than lines meeting at an angle because their relation is defined by one constant distance. A right angle is simpler than other angles because it produces a subdivision of one and the same angle. An additional simplifying factor is conformity to the spatial framework of vertical and horizontal orientation." Symmetry is another attribute of simple form. And "true simplicity" also involves a "correspondence in structure between meaning and tangible pattern."[6] After 1949 the elements of simple form were the only elements that Rothko admitted in his art. Though he used softly brushed, not hard-edged geometric figures, he restricted himself to orthogonal forms conforming to a horizontal and vertical orientation. To state this is to state the obvious, but the obvious in Rothko's case is impressive, as he never allowed a diagonal or curve into his pictures except in the covert play of his brushwork.

As a perceptual experiment, the primary players of the drama enacted in *The Entombment* (fig. 34) could be transposed or analyzed into the elements of "simple form." The gestalts of the triple woman's upper and lower body areas could each be simplified into a rectangular horizontal mass, that is, and the corpse in her lap could be simplified as a long, thin horizontal bar wedged or suspended between those two masses. Finally, the two plain fields that make up the background could be simplified further to one nonspecific contextual space. Transposed into simple form, to follow Arnheim's terms, the schema of *The Entombment* would look like the schema of an untitled painting, 1952 (pl. XVI), or like *White Band (Number 27)*, 1954 (pl. XVIII), to take two of many examples. It follows that a rigorously analyzed version of *Entombment I*, 1946 (fig. 38), with its two horizontal figures, one high and one in the middle of the picture, might look like *Number 22*, 1949 (pl. XII), with the bar at the top of the latter painting doubling as the head-analogue of the vertical abstract figure.

39
Untitled, mid-1940s, watercolor,
pencil, pen, ink and chalk on
paper, 17³/₁₆ × 22⁷/₁₆ in.
Collection of the Saint Louis Art
Museum. Gift of the Mark Rothko
Foundation, Inc.
(Photo: Quesada/Burke)

The identification of the focal protagonist in a pietà or entombment scene, the deceased, with the narrowest rectangular zones in Rothko's pictures is, in a sense, foreshadowed in *Entombment I* (fig. 38). There the stronger of the two images of a horizontal figure, the lower one, fills or coincides with a distinctly contrasting whitish rectangular strip that extends from edge to edge across the lower center of the grey pictorial field. Nor is this picture an isolated example; an untitled watercolor of the mid-1940s (fig. 39) (among others that could also be shown) follows a similar plan. In the latter picture is a row of five or six standing stick figures. Their upper bodies—some, as on the far right, with small delineated pinheads and arms—are evenly interspersed across the dark grey rectangular zone at the top of the tripartite composition. Their stick-figure legs are correspondingly interspersed along the dark grey rectangular zone at the bottom of the picture. Occluding the torso areas of these standing stick figures (except for some shadowy suggestions of polelike torsos, visible especially in the figure second from the right) is the broad, comparatively pale rectangular zone at the center of the picture. Amidst the welter of lively pen markings in this central zone, a long horizontal line runs directly across the center of the sheet, almost fully from side to side. This line reads roughly as the spine of an attenuated stick figure with various appendages studded along it. The strongest gestalts in this picture (even more than in *Entombment I* (fig. 38), however, are not the spindly figures outlined in pen but the broader tonal areas or rectangular zones that structure the picture overall. A viewer needs only to squint at

this picture, defocusing the line drawings slightly, to perceive a miniaturized version of Rothko's classic image. Setting aside the change in scale and medium, the critical difference is that the rectangular zones in a classic image would be released from the edges of the support and so take on an independent presence.

I do not mean to suggest that Rothko deliberately recapitulated his entombments (or his surrealist portraits or his microcosm-macrocosm pictures) five or ten years after painting them but rather that the pictorial codes he used and adapted in the 1940s continued to serve him in the 1950s and '60s. By continuing to manipulate those pictorial conventions, which form the basis for a kind of visual semiotics, Rothko hoped to maintain a "correspondence in structure between meaning and tangible pattern," to return to Arnheim's phrase. Religious imagery—which had attracted Rothko for the themes it addressed—especially lent itself to being transposed into abstract emblematic forms, because sacred art is particularly tradition-bound or prone to formal conventions. Those conventions are not mere formalities but are grounded phenomenologically and coded symbolically, often (at least in part) through a hierarchical use of space. "In certain systems of representation—which depend on systems of content," as Meyer Schapiro has observed,

the distinctive values of the different places of the field and the different magnitudes reinforce each other. The fact that the use of these properties of the sign-space is conventional, appearing especially in religious art, does not mean that the significance of the various parts of the field and the various magnitudes is arbitrary. It is built on an intuitive sense of the vital values of space, as experienced in the real world. For a content that is articulated hierarchically, these qualities of the field become relevant to expression and are employed and developed accordingly. A corresponding content today would elicit from artists a similar disposition of the space of a sign-field.[7]

After 1949 Rothko created many pictures of this type, with one or two narrow bandlike rectangles set in between, above, or below two more massive rectangles. If these pictures are thought of as icons (or hypoicons), those horizontal bands that cut across the center of these compositions might be seen as constituting an abstract metaphor for the martyr in a conventional pietà, as the martyr's recumbent body occupies a corresponding space in the picture field. Accordingly, I have described the narrow rectangle often found at the top of Rothko's images as an image-sign for the risen or resurrected martyr, as well as for the head of the martyr's attendant, based on its correspondence with the pictorial and symbolic function of comparable areas in traditional sacred imagery. Narrow, stripelike rectangles can also be found at the bottom of Rothko's pictures, as in an untitled painting of 1953 (pl. XVII) or Four Darks in Red of 1958 (pl. XXI), for example; such compositions may be considered in relation to the pictorial structure of a conventional entombment (as opposed to a pietà), in which the martyr's body appears in the lowest sec-

tor of the pictorial space, on or part way in the ground. From this perspective, a picture such as *Four Darks in Red* instantiates a diachronic time frame, as it involves at once a metaphor for the entombed martyr (the narrow stripe at the bottom of the picture) and a metaphor for the raised martyr (the narrowest rectangle at the top of the picture). Nor did Rothko realize his subjects through structure alone: the smoldering palette of *Four Darks in Red,* with its dark brown and charcoal black strips scumbled over a fiery red ground, might equally be seen as expressing a feeling of suppressed violence or morbidity.

The position of the narrowest rectangles in Rothko's compositions has been isolated for discussion here because of its, however provisional, connection with the protagonist of sacred or mythological art—the hero or martyr. To isolate a particular element in compositions that involve the interaction of an ensemble of elements may be a questionable tack, but the viewers' attention is often drawn to the narrowest rectangles in Rothko's pictures, not only because of the sheer discrepancy in scale (which can vary in magnitude) but also because the artist often painted these rectangles a color that contrasts markedly with the palette of the rest of the picture. So it is in *Number 22,* 1949 (pl. XII) and in *White Band (Number 27),* 1954 (pl. XVIII), for example—although *Four Darks in Red* (pl. XXI) is an exception in this regard. There are rectangles of all different sizes in Rothko's pictures; but after an initial period from 1949 to around 1951 when he created many profusely layered compositions, such as *Number 11,* 1949 (pl. X), he began to limit the number of rectangles in his pictures, usually to between two and four. His typical pictures always include big or intermediate-sized rectangles, most often two of them, one largely in the top half and one in the bottom half of the picture; but the smallest bandlike rectangles come and go, varying in their number (from none to three) and in their placement, whether up high, at the center, or down low.

The basic premise for the argument I am framing here is that the placement of forms in a pictorial space carries symbolic inflections, however ambiguous or indeterminate those inflections might be in the case of an abstract image. Whether or not viewers are conscious of the parallels between the structure of the conventional landscapes or portraits and the structure of Rothko's classic paintings, the high and low rectangular zones in such hierarchically structured pictures will still tacitly and reflexively evoke basic associations—with sky and ground, with head and feet—ensuing from the viewers' elemental familiarity with their own and others' bodies and with the organization of the world around them. The association of placement with hierarchy and a scale of values is a deeply embedded one, further, as the idioms of language usage readily demonstrate. Many words or phrases commonly used to convey relative social status, esteem or censure, as well as abstract human qualities and emotions, are terms of placement—up or down, high and low, head or foot—as in "highest office," "head of state," "top priority," "high spirits"

or "high-life," and "lowlife," a "low blow," "low-down heel," or "down in the dumps." So ingrained are the symbolic resonances or associations of placement that the placement of forms in abstract pictures will have a symbolic significance for viewers, no matter how hard-pressed they may be to pinpoint or describe that significance. This is a function of memory and of knowledge, both the painter's and the viewers', knowledge that is tacit and shared by all functioning members of a community or culture.

Although I have made a number of jarring comparisons between Rothko's pictures and mimetic images of various genres, I want to reiterate that it is not my point to argue away the substantial differences between Rothko's images and pietàs or entombments, portraits or landscapes. Nor is the issue whether Rothko was an abstract artist, which he clearly was, but whether and how abstract art may be coded, and how and why it may communicate or resist communicating. To claim that *White Band (Number 27),* 1954 (pl. XVIII), is a pietà or that *Four Darks in Red,* 1958 (pl. XXI), portrays an entombment and a resurrection would be a blatant distortion. Had Rothko intended to explicitly portray such subjects, he was perfectly capable of doing so. Instead, he was committed to implicit forms of expression and to the notion that "there is more power in telling little than in telling all."[8] Working with faint traces of mimetic imagery and with the expressivity of color, Rothko hoped to find a more pregnant, direct, and effective means for conveying his subjects; he intended his subjects to reach the viewer through evocation and shared cultural knowledge or experience rather than through any more conventional narrative means. Because he was working in an abstract mode, the metaphors embedded in his images could be layered and made symbolically complex in new and unexpected ways, even if the gestalt of the image itself remained a resolutely simple one. Rothko's images could be relatively simple and clear, then, although his subjects were anything but.

Some of what abstract artists inscribe only faintly in their pictures can be gone over in darker ink by art historians, then, which is not to imply that it should or could have been in darker ink in the first place. Much of abstract art involves a "residual sign system," to borrow a phrase from Lawrence Alloway. A distinctive and engaging tension results from the way such pictures explore the penumbra between an art that makes its referents explicit (such as Rubens' or Matisse's) and an art that is bent on banishing referent to the fullest possible extent (such as Malevich's or Stella's). Viewers are left in the tense and tantalizing position of feeling that they can almost but never quite grasp a message that they may sense as inhering in the pictures.

## Birth and Death: Nativities and Pietàs

Numerous layers of the palimpsest constituted by Rothko's pictures have been examined here. *Number 22,* 1949 (pl. XII), for example, has been discussed in relation to the pictorial codes for absence and presence (or landscape and portraiture) and in connection with the pictorial codes for pietàs and resurrections. *Four Darks in Red,* 1958 (pl. XXI), was discussed in relation to the conventions for entombments and resurrections, and the same picture may also be seen as manipulating the codes for portraiture and landscape, as rendering absence as presence or vice versa. Both of these pictures may be seen as icons or hypoicons, then, for the theme of death and rebirth. *White Band (Number 27),* 1954 (pl. XVIII), differs from these images in being a tripartite rather than a quadrapartite painting. With the placement of its white band, the structure of this painting bears a schematic relation to the pictorial structure of a pietà, where the sacrificial hero is stretched across the center of the pictorial space. Although it lacks a second, raised horizontal band, this image and others structurally similar to it (such as pl. XVI) may also be seen as engaging the theme of the full cycle of life, because the basic format for the image of a deceased martyr stretched across his mother's lap may parallel the format for a traditional image of a mother and child.

It is admittedly more usual to see an infant-hero standing or raised in his mother's arms than stretched across her lap, but the symbolic value in showing the infant's figure supine appealed to a number of painters. The pose of the sleeping infant Christ in Bellini's *Madonna and Sleeping Child* (fig. 40) prefigures the martyred Christ in the "sleep of death," as found in Bellini's *Pietà* (fig. 41), for example. Those images of Rothko's that parallel the pictorial structure of a pietà, such as *White Band (Number 27),* 1954 (pl. XVIII), and *Number 20,* 1950 (fig. 42 and pl. XIII) might be said at the same time to parallel the structure of a conventional mother and child image. Further, and by the same logic, such tripartite pictures as an untitled yellow and black painting of 1953 (pl. XVII), which bear a relation to the pictorial structure of an entombment, also bear a relation to certain conventional adoration or nativity images; in the first instance the deceased is laid on the ground before its attendants, and in the second, the infant lies sleeping on the ground at its mother's feet. But because Rothko's abstract figures are far removed from human form, in any case, the specific scale of the supine or horizontal figure relative to that of the erect or vertical figure—the factor that explicitly tells viewers of a mimetic image whether they are looking at an entombment or a nativity—has no bearing in Rothko's work. This basic schema, with a narrow band sandwiched between or below two larger masses, could yield an icon for the entire "human drama," then, from the "tomb of the womb" to the "womb of the tomb."[9] His abstract figures could do (at the least) a double symbolic duty, that is, even where the symbols involved were opposing ones, such as birth and death. Rothko's image-sign enabled him to elide or dismantle such conventional bi-

40
Giovanni Bellini, *Madonna and Sleeping Child,* Gallerie dell'Accademia, Venice. *above left*

41
Giovanni Bellini, *Pietà.* Gallerie dell'Accademia, Venice. *above right*

naries and present them not as polar opposites but as interconnected, two sides of the same process or phenomenon.

In his statements about his work, Rothko pointed to mortality, not birth or creation, as his primary focus, and at times he was heard to associate the rectangular forms in his pictures with the forms of graves. Rothko was concerned with the human drama in its entirety, however: "No one could have summarized birth, dissolution and death so well," suggested Dore Ashton. "It was his theme from the beginning."[10] His engagement with the theme of creation and birth emerged in the 1940s in the imagery and titles of some of his surrealist works. Such titles as *Genesis* and *Beginnings* are found in published lists of pictures shown in the mid-1940s (although it is difficult to know now which works they were attached to). And among the untitled paintings of the later 1940s are numerous images that may be related, however tentatively, to the pictorial conventions of sacred art for scenes involving pregnancy or newborns. A case in point is *Number 17,* 1947 (pl. VI and diagram 3), which I will compare here with a conventional *Madonna and Child* (fig. 43) from the workshop of Bellini. The narrow red rectangle or capsule shape (encasing a blue capsule) at the top of Rothko's picture may be seen as an analogue for the mother's head, whereas the large, earth brown mass below it serves as an abstract body. Nestled into the massive, brown shape is a configuration of red and blue forms at the left side of the picture. This aggregate of blurry splotches occupies the space corresponding to that filled by the infant in the Renaissance painting, and the configuration formed by the splotches may be seen as very loosely suggesting the seated body of an infant held at or raised to a three-quarters position. A small, ball-like, blue head-shape can be found high up against what would be the mother figure's right shoulder. Below that ball-like form, the rest of the red and blue splotches are organized roughly into a tipped

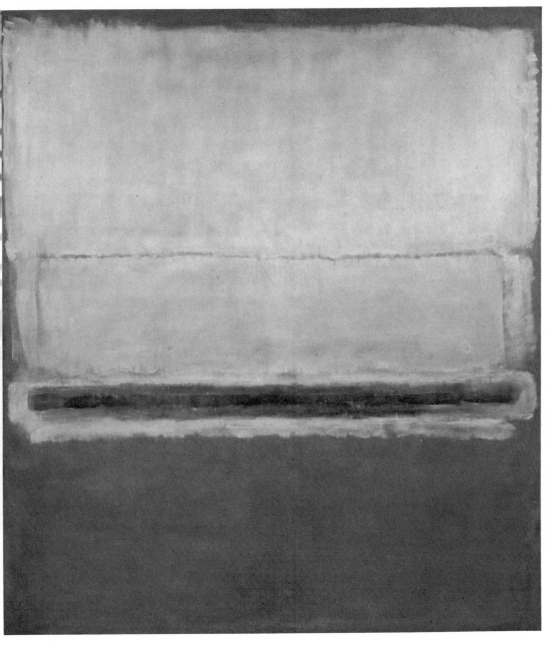

42
*Number 20,* 1950, oil on canvas,
116½ × 102 in. Collection of Mr.
and Mrs. Paul Mellon, Upperville,
Virginia. (See also plate XIII)

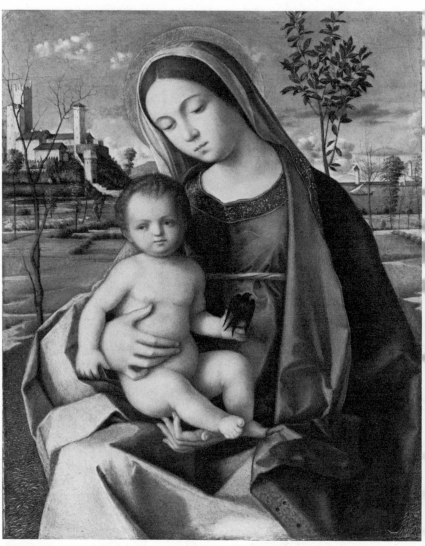

43
Giovanni Bellini and workshop,
*Madonna and Child,* tempera and
oil on wood, 13½ × 10⅞ in. The
Metropolitan Museum of Art, New
York. The Jules Bache Collection,
1949.

Diagram 3. *Number 17,* 1947  (cf. plate VI)

figure eight configuration, with the top half of that configuration (cut off at the far left by the picture edge) paralleling the upper-body and the lower section of the figure eight paralleling the lower body of the form of the child in the conventional image.

Besides these broader gestalts, some of the specific shapes in *Number 17*, 1947, may suggest particular physiognomic elements, though such readings are ventured here only in the most provisional spirit. The more specific the associations attached to these ambiguous shapes, the more risky they become and the more viewers there will be who remain unconvinced. In the upper-body area of the configuration that I have associated with an infant, however, can be found a shape that lends itself to being read as the infant figure's left arm, crooked at a right angle and posed across its lap with a large open mittlike left hand. The thumb of that hand points upward at a frayed-looking heart shape in the center of the infant figure's chest. As for the massive brown shape identified here with the mother figure's body (seen in three-quarters length or perhaps kneeling on the ground): above the narrow waist, a full breast-shape is visible in profile by the infant figure's left elbow (that is, at the junction of the two rough circles that form its body). The mother figure's body is entirely brown, but her head is red and blue, the same colors as the body of the child figure (and for that matter, the same colors traditionally used in such scenes, with brown standing for humility, blue for purity and red for sacrificial blood). Given the coloristic association or identity between the mother figure's head area and the infant figure's body, further, the scheme of this picture might be related loosely to the schema of those classic paintings associated previously with pietà and resurrection images. Although the blue and red infant figure is posed vertically rather than horizontally across the lap of the mother figure in the present painting, the identity of the colors involved may lead us to see the top rectangle or capsule shape in this picture not only as the head area of the mother figure but also as a later incarnation of the infant figure.

In keeping with Rothko's interest in the themes of the nativity, a painting that might be seen as evoking a type of visitation, the meeting between the two pregnant cousins Mary and Elizabeth, is an untitled picture of around 1948 (fig. 44, diagram 4), involving two prominent abstract figures. On the left side of the painting is a standing, blocky, white figure whose squarish head is pink in tonality; above the pink head is a narrow white rectangle, like a headdress or a shining aureole. This figure is seen in profile facing right, and its columnar white lower body reveals a large low bulge at the level of the abdomen or womb. This pregnant-looking figure's right arm is drawn in an *L* shape, with the forearm crossing over the stomach just above her bulging abdomen. Framed by the *L* of the arm and the square pink head, a squarish white bosom (marked by several vertical light blue stripes), reveals a slighter swelling. What may be a second, larger arm protrudes forward from the edge of the body, where the right arm terminates. This left arm reaches out toward

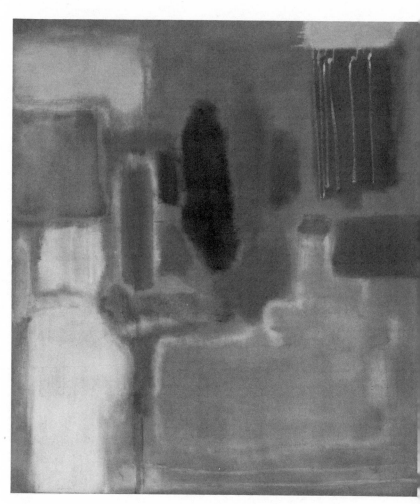

44
Untitled, 1948, oil and mixed
media on canvas, 53 × 46⅝ in.
Collection of the National Gallery
of Art, Washington, D.C. Gift of
the Mark Rothko Foundation, Inc.

Diagram 4. Untitled, 1948

he bigger yellow body of the second major figure, on the right side of he picture. This second figure appears to be seated, as the bulk of its imply proportioned rectangular body stretches out horizontally along the base of the picture. Its upper body (continuous with the yellow rectangle of the lower body) is marked by two rounded, breastlike shapes (one silhouetted to the left, the other silhouetted to the right), and by a long, thin neck. Above the neck is a bright, red rectangle striped with vertical, white lines, which might be read as signifying the figure's hair. A pale orange or peach-colored face might be seen as bordering on the left edge of the hair area, as if the figure's head were seen in profile, facing left (facing the white figure), although the area I am identifying as a face is barely distinguishable from the pale orange color of the background. Above the red hair area is a small, white rectangle like that atop the white figure's head, which might again be read as an aureole or headdress.

Another painting from the late 1940s that might be associated with a nativity scene is a painting known variously as *Number 18,* 1948, and *Number 1,* 1949 (pl. VII, diagram 5)—one of the most vivid and compelling pictures from this period in Rothko's art. In particular, the composition of this painting might be seen as bearing a relation to the structure of a conventional *Adoration of the Magi* (fig. 45). There are a variety of conventions for portraying such scenes, but a picture by Quentin Massys will illustrate in this instance the type of image or composition in question. The Madonna in the painting by Massys and what I would call the abstract mother figure in the work by Rothko are found in corresponding areas, in the left lower quadrant of their respective pictures. There, in Rothko's painting, is a large, bright red-orange shape with perimeters that roughly form a vertically oriented rectangle (one that encompasses two white shapes). Surmounting that rectangle is a pale, peach-colored half-circle that might serve as a face for this abstract figure. Mary holds Jesus on her lap in the Massys' picture, and in Rothko's picture two bright white shapes interrupt the orange body of the mother figure; the lower one (with white paint brushed lightly over a bluish shape) might be seen as an infantlike bundle, whereas the upper one, a glowing white square, occupies the area of the mother figure's breast.

The right side of *Number 18* (or *Number 1)* may also be seen, in relation to the structure of the Massys picture, as imaging, however ambiguously, a congregation of abstract visitors waiting in attendance on the shining infant-figure. The right lower quadrant of Rothko's picture contains a large, dark blue form that could conceivably be seen as a side view of the principal visitor, an abstract personage who is doubled over at the waist and girdled with a white *L*-shaped belt. This personage's bulky blue feet would then be found in the right lower corner of the picture below thin stiff legs. A large, dark blue triangle comprises the upper body of this abstract figure, and attached to the left edge of that triangle is a blotchy, red-orange blob that could be read as a face. This face-shape

45
Quentin Massys, *Adoration of the
Magi,* 1526, tempera and oil on
wood, 40½ × 31½ in. The
Metropolitan Museum of Art, New
York. John Stewart Kennedy Fund,
1911.

Diagram 5. *Number 18,* 1948
(or *Number 1,* 1949)
(cf. plate VII)

just overlaps the similarly colored upper body area of the mother figure, and it is posed as if the blue figure were peering closely at the white and blue infant figure. Above the blue figure, in the right upper quadrant of *Number 18* (or *Number 1*), is a lighter blue shape, an irregular mass topped by a row of white splotches. This area of the painting might be read as a distant cluster of figures comparable to the crowd assembled in the background at the upper right of Massys' painting. The row of small, puffy, white splotches in Rothko's pictures might be seen as suggesting a row of heads, then, whereas the pale blue configuration below them could be a mass of upper bodies. Finally, the broad white rectangle reaching across the top of *Number 18* (or *Number 1*) suggests a sky area or cloud formation, albeit a fairly solid one. This shape is similar to the roughly rectangular shape spanning the top of *Number 17*, 1947 (pl. VI), and to the narrow rectangles at the tops of many of the classic pictures yet to come. As such, it too may bear a metaphorical relation to a resurrected figure.

A more standard, simple, and intimate nativity grouping might be suggested by an untitled painting of 1949 (fig. 46 and diagram 6), a composition with several abstract figures that form a grouping broadly comparable to the grouping of figures in a *Holy Family* by Roger van der Weyden, for example (fig. 47). On the left side of Rothko's picture is a tall, narrow, blocky figure. The head area of the figure, in the upper left-hand corner, has some articulated features that might suggest a right three-quarters profile view of a round, pale face with a wide, clear brow and a big eye. This abstract figure's long, red upper body area is roughly rectangular (though swelling here and there) and is posed vertically. The figure's lower body area, in the lower left corner, is a smaller, green rectangle, posed horizontally and shaped as if the personage were seated on the ground with its legs tucked beneath it. On the right side of the picture stands what can be read as another, albeit less coherent, abstract figure, of different proportions. A squarish, red shape in the upper right-hand corner of the picture serves as this figure's head, whereas another squarish, paler red shape in the lower right-hand corner serves as its squat legs or base. In between these two squares demarcating the top and bottom of the abstract figure, a series of three rectangular shapes posed horizontally compose the upper-body area. The outer two of these rectangles (a very small one just below the head area and a larger one above the figure's base) are red; the rectangle in between is pale blue and might be seen as the figure's short, boxy arm reaching out across its broad girth.

Up until this point, then, the format of this untitled picture can be related to the format of the abstract double portraits of around the same time, discussed in the previous chapter (pls. VIII, IX). But the area between the pair of blocky personages in this picture is occupied by what might be read as a third, more diminutive, blocky figure, poised atop the horizontal base of the largest figure, at the left. In between the head-

47
Roger van der Weyden(?), *Holy Family* (side panel of a triptych). Museum of the Royal Chapel, Granada.

46
Untitled, 1949, oil on canvas, 54½ × 35½ in. Collection of the Wadsworth Atheneum, Hartford. Anonymous gift. *above right*

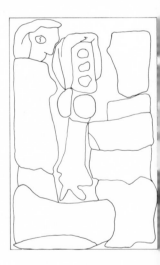

Diagram 6. Untitled, 1949

forms, round and squarish respectively, of the personages at either side of the picture is what might be read as a third rectangular head area, long and white, with three blotchy red features, one on top of the other. Below this white form is a small, round, red shape that could be seen as the upper-body area of this small, abstract figure, and below this round, red shape is a vertically posed, roughly rectangular, red shape that might be read as the little figure's lower-body area.

I am arguing that much of Rothko's art from the late 1940s retained the vestiges or traces of mimetic or figurative art, however faint those traces may have become. The rather detailed readings of the four transitional paintings offered above are bound to persuade some readers more than others and some readers not at all. Generally, only with protracted study do the pictures of this period reveal their relation to the more overtly figurative images that preceded them—if they reveal it at all. But Rothko's early work is not the primary focus of this book; the subjects and the structure of the surrealist and transitional pictures have been examined here simply in an effort to help elucidate the structure and subjects of the classic pictures. The larger arguments being framed in this chapter do not hinge on the persuasiveness of the readings of specific surrealist or transitional pictures. They hinge instead on the analysis of the parallels between the structure of certain of Rothko's classic pictures and the structure of traditional entombment and pietà images, as well as on the compositional parallels between conventional entombment or pietà images and conventional nativity or Madonna and Child pictures. On that basis rests the case that certain types of paintings by Rothko may be seen, in a particular way, as icons or hypoicons for the "single theme" of myth.

# 6

# Rothko's Instruments

"A painting is not a picture of an experience; it is an experience," said Rothko in 1959.[1] For a decade he had been making images intended to evoke directly from viewers the emotions associated with the "human drama," rather than pictures *of* nativities or entombments with cipherlike performers who struggled to evoke such emotions by staging manufactured ritualistic tableaux. Though Rothko talked of his pictures' "subjects" until the very last, those subjects finally became so deeply identified with the structure of his pictures that any disjunction in the experience of his art—any sense of there being a subject that might be extricated or considered apart—was effectually averted. Rothko had successfully formulated a signifier that is or incarnates its referent: an icon or hypoicon in Peirce's terms. Although his classic paintings are coded—or so I have tried to demonstrate—they use only traces of established pictorial codes, traces faint enough to resist and deflect deciphering. If the classic pictures are symbolic, they constitute a plain, singular, and condensed symbol or image-sign. In their centrality, frontality, expansiveness, and simplicity, Rothko's pictures were calculated to have an intense perceptual impact, to address or confront viewers as clearly and immediately as possible, engaging their emotions and responding, at the least, to their nonmaterial needs.

Communicating to viewers was always a focal concern of Rothko's: painting is a "language" to "communicate something about the world," he asserted in 1958.[2] This book has, in a sense, been devoted to parsing the syntax of Rothko's complex language. The typology of the compositions of Rothko's paintings has been analyzed here in relation to the typology of preexisting pictorial structures with a view to how those structures are coded. Up to a point, Rothko's pictures readily lend themselves to this semiological exercise, but in the end they do not conform exactly to a code structure insofar as that implies a system where signs can be neatly paired with meanings. Rothko was prone to deleting pictorial codes, after all, even more than he was to reinscribing them. In the end, then, he worked with a kind of trace structure, at once inscribing and erasing known pictorial languages, effacing conventional pictorial syntax wherever it verged on becoming legible. It was by mixing or recombining the traces of an array of pictorial conventions that Rothko

opened up new spaces for meaning, and new kinds of experience for the viewer. Some aspects of Rothko's art do not lend themselves to analysis by reference to pictorial codes or schemas, however. And in this chapter I will focus on ways in which Rothko's art moves beyond codes and language in an effort to restore additional flesh to the skeletal schemas that have served here as a necessary but necessarily artificial analytical tool. My aim is to finish reconstituting what was forcibly prized apart here in the interests of examining the stratification or palimpsest of traces at play in Rothko's pictures.

To approach Rothko's pictures strictly in terms of codes and schemas would be to do them an injustice. The experiences that sympathetic viewers describe having in the presence of Rothko's art are far removed from the experiences that any schema or diagram could offer a Western viewer. There are Eastern religions such as Tantraism, in which diagrammatic pictures are sometimes used as aids to meditation; a few critics have wondered whether such belief systems might be germane to an understanding or appreciation of Rothko's art. Others have invoked the realms of mystical experience and the philosophical category of the sublime. Rothko consistently turned aside such recondite approaches to his work, but he was equally dismissive of narrow, empirical suggestions that his paintings were simply about color and space and painting itself. What was critical to his art, from his point of view, was neither so esoteric nor so straightforward: what was crucial were emotions; he designed his pictures to garner an authentic emotional response from the viewer. He explained to one critic that he regarded color as "merely an instrument," a tool he could use to attain his real objective, which was "poignancy of mood."[3] What would make his best paintings so compelling and save them from being mere schematic designs, finally, was the artist's way with his painterly instruments—not only color, but measure or scale, touch, and a sensitivity to nuances in the rendering and relationships of forms: how sheer, how impermeable, how close, how far apart. Just how these instruments work cannot be codified or precisely explained, but they are what equipped Rothko to make of his elementary image-sign such poignant experiences for so many viewers.

Rothko's art was a continuing essay in picturing feeling and cognition—a prolonged effort at imaging, with subtlety and pungency, certain vital apperceptions and instances of experience. Rothko saw distinctly the limits of accepted modes of describing sensation and ideas. Insofar as his paintings were directed at dislocating or circumventing those modes, they were bound to be deemed enigmatic, if not baffling. But the notorious indescribability and inscrutability of Rothko's paintings is precisely a factor of their opposition to those modes of imaging most readily translated to prose, of their rejection, as it were, of the limiting means of speech and text. For that audience of whatever size to which abstract art in general, and Rothko's project in particular, appeals, however, what is perhaps most rewarding about it, in the end, is that it opens spaces in

the culture that are assured of remaining just outside the reach of the authority, or rather the tyranny, of that Logos, or those linguistic structures, which presumes to order, regulate, legitimize and contain virtually all experience, ideas, and social transactions. Rothko's art is subversive, finally, as it refuses a coherent (visual) narrative by erasing and, however carefully, scrambling the traces of conventional visual syntax. He ventured in his paintings to describe and so to validate what preexisting languages, whether verbal or visual, denied or disallowed. He tried to say what language cannot. That so many people describe being touched and somehow rendered speechless by Rothko's art may point, however contradictorily, to its very muteness as a source of its eloquence.

## Separations and Divisions

Once he stopped painting in a mimetic way, Rothko devoted himself to evolving alternative means to express what mimetic art had represented; more important still, he looked for the means to express what narrative art had proved incapable of conveying—as the limitations of narrative ways of painting were what had initially caused him to explore other avenues. The shift that Rothko's mode of making pictures underwent during the 1940s, could be described as a shift from the use of largely denotative means to the use of largely connotative means. As Norman Bryson defines these terms, "The denotation of painting consists in its intersection with all the schemata of recognition . . . codified in iconology: . . . procedures of recognition which are governed by the iconographic codes," that is, "publicly sanctioned, didactically transmitted codes." In opposition to the "one-to-one pairings of denotative readings" are the "comparatively uncertain connotations on the 'far side' of the schema of recognition." The means of connotation are not subject to codification, but "operate within the general social formation."[4]

In *The Entombment* of the mid-1940s (fig. 34), Rothko created a picture that engages the schemata of recognition. Even without a title, this picture's relation to the conventions for scenes of this type would be discernible, albeit with some difficulty. That difficulty is a function of the picture's numerous departures from the conventions for an entombment. Instead of leaving the body of the mother figure whole, for example, Rothko divided it in two, opening up a rift in the middle of the triple woman's body. Because this rift is unexpected, it cannot be decoded through the usual denotative codes. But the absence of a recognized point of reference for decoding this aspect of the picture does not put the viewer at a total loss, because there are various connotations attached to the presence of rifts. In the present instance, certain of those connotations appear to be implied or reinforced because the rift occurs within what would otherwise be a whole entity—a body—and not between two independent entities. In view of the context, in other words, the connotations associated with this rift might best be described with those colloquial phrases that are used to describe intensely difficult emotional states

or situations: a mother "torn up" by her child's death or a country "torn apart" by civil war, for instance. Without a sure basis for doing so, then, a viewer might still feel confident associating the rift in Rothko's triple woman with her loss, that is, with the gap or rift, figuratively speaking, that this death has created in her life.

Rothko's mature paintings also capitalize on the connotations attaching to rifts, tearing, separation, and division but in a nonnarrative, nonmimetic way. The discrete separateness of the forms in Rothko's paintings, which at most abut one another but almost never interpenetrate or overlap, conveys a poignant sense of isolation. That poignancy is enhanced by the torn-looking edges of the forms, as tearing acts as a graphic description of the process of separation. In other words, the schisms between Rothko's rectangles, the way their frayed edges touch or fail to touch, may carry emotional meanings for viewers by triggering private associations with the process of becoming separated or, more generally, with the states of closeness and distance. Such meanings or connotations cannot be codified or described in any programmatic way, but that does not make them any the less real or intense. In *White Band (Number 27),* 1954 (pl. XVIII), for example, the white band at the center of the painting is snugly attached to the blue-black rectangle at the top of the picture but is separated from the black rectangle at the bottom of the picture. The separateness and heavy blackness of the bottom rectangle give it a note of finality; it appears to have dropped off from what would otherwise have been a consolidated unit of three—or perhaps two: because the top and bottom rectangles are related or allied in coloration, the white band might be seen as having broken or interfered with their connection. From this perspective, the slight but noticeable rift or schism between the white band and the black rectangle may carry a special emotional charge.

At times the rifts or schisms between the rectangles in Rothko's pictures suggest not separation but division: when there are opposed elements confronting one another across a charged schism rather than allied or related elements that appear to have been forced apart. The emotional tenor that Rothko most consistently looked for in his work was one of intensity and tension—tension being third on the list of his work's ingredients, just after intimations of mortality and sensuality. With its two massive rectangles of radically opposed hues poised in close proximity, *Green and Tangerine on Red* of 1956 (pl. XIX), for example, is a model of visual tension. The extreme closeness of the rectangles conveys less a sense of intimacy or connectedness than a sense of confrontation and friction. The tension imparted by this picture follows not only from the sharp contrast or clash of the rectangles' colors but also from the constricted spatial situation in which they appear. And although there is some extra available space in the margins of this picture, the rectangles have not gravitated into it, as it were, but have gravitated toward each other, toward conflict, instead.

The relation between the contrasting rectangles in *Green and Tanger-*

*ine on Red* might be seen as connoting a subtle and undecidable power struggle. At first glance the two rectangles might appear to share the picture space evenly, but a closer look reveals that the orange rectangle holds slightly more ground, being fractionally taller and wider. Further, the reddish color of the background is closer to, more allied with, the hue of the bottom rectangle than with that of the top rectangle; visually, that is, the background seems to reinforce the presence of the red-orange rectangle. The heavy green rectangle occupies the privileged superior position, however, and what it has in its favor is precisely and strictly that it is on top. Although the dark rectangle may appear to hold or weigh down the bright rectangle beneath it, however, the green rectangle does not rest solidly atop the red-orange rectangle, as an initial glance at the painting (or at a reproduction) might suggest. Instead the fine, frayed threads of the bottom edge of the green rectangle (its nerve endings, as it may seem) just barely touch the frayed threads of the top edge of the red rectangle, and the two are divided by a delicate, but critical fissure.

During the first few years he painted his classic pictures, Rothko tended to sandwich his rectangles close together, as in *Number 11,* 1949 (pl. x), *Violet, Black, Orange, Yellow on White and Red,* 1949 (pl. XI), and *Number 22,* 1949 (pl. XII), for example. From 1949 through the early 1950s, the background color tends to emerge between the stacked rectangles only slightly, if at all: and the interstices that do occur are sometimes filled in with a line of color, like the line of deep green that "seals" the white horizontal bar to the blue-grey mass above it in *White Band (Number 27),* 1954 (pl. XVIII). In later paintings, the schisms between the rectangles often became quite pronounced; in *Four Darks in Red,* 1958 (pl. XXI), and *Reds, Number 16,* 1960 (pl. XXII), for example, the rectangles are no longer so much stacked as floating or hovering one above the other. But even before he tended to put actual distance between the rectangles, Rothko had found ways to impart a sense of separation or division to his pictures. Sometimes he accomplished this by painting the narrowest rectangles red, black, or white, as in *Number 22,* 1949 and *Number 20,* 1950 (pls. XII, XIII), *Violet, Black, Orange, Yellow on White and Red* (pl. XI), or *White Band (Number 27,)* 1954, for example. Black and white are associated with a sense of absoluteness, owing in part to their respective identities as the presence of all colors together and the absence of any color at all. That black and white, as well as red, are widely associated with pivotal life events, rituals, and substances further helps to imbue those narrow bars with a specially arresting presence, despite their being the smallest elements in the pictures. (In fact, the smallness of these elements is part of what sets them off, to varying degrees, from the other rectangles in the pictures.) The narrow horizontal bars may suggest an interruption or division, too, because they often cut across the pictures at or near the center, where a rent is most noticeable and drastic. The black stripe slashing across the center of *Violet, Black, Orange, Yellow on White and Red,* 1949 (pl. XI), for example, interjects a

severe, divisive, and effectually morbid note in an otherwise vivid and highly colored painting. And the sunny, tranquil effect created by the outsized, soft yellow and orange rectangles in *Number 22,* 1949 (pl. XII), is sundered by the scarlet bar that comes between them. The white bar in *White Band (Number 27)* (pl. XVIII), is a less disruptive element, but it has a singular, somewhat ghostly presence in the encompassing blue-grey penumbra.

## Measure

When Rothko was once asked whether color meant more to him than any other element of his pictures, he answered, "No not color, but *measures.*"[5] In some paintings—more often those from the late 1950s onwards—Rothko effectively directed the viewers' attention to distinctions of measurement or size by reducing or minimizing color distinctions among the picture's rectangles; such is the case with *Four Darks in Red* of 1958 (pl. XXI), for example. But measure, or the relative size and placement of the rectangles, is important in Rothko's pictures whether or not the rectangles are of a similar color. The relative scale and the distribution of visual weight among the rectangles have effects with connotations that are at once aesthetic, emotional, psychological, and by extension symbolic. These connotations are at once phenomenologically grounded and rooted in those cultural assumptions that once were associated with the microcosm-macrocosm model: that the highly placed human head and heart and the highly situated sky or mountain top are lofty and noble domains, whereas low-lying regions, either of the body or the cosmos, are associated with more base and ignoble functions and activities.

One way to demonstrate how crucial measure is in Rothko's art is to compare reproductions of his pictures seen right side up and upside down. *Number 18,* 1951 (pl. XIV), turned upside down, for example, would be similar in the relative proportions of its components to *Number 20,* 1950 (pl. XIII). But when these paintings are oriented correctly, their impact differs considerably. The main difference has to do with the placement of the largest rectangle, which is in the upper part of *Number 20,* 1950, and in the lower part of *Number 18,* 1951. In most of Rothko's pictures, the most expansive rectangle is located predominantly in the upper area of the canvas. By placing the most massive shape at or near the top of his composition, Rothko showed the viewer something 'heavy" raised up high—a feat requiring strength, energy, and balance when performed in reality. By contrast, a composition that is weighted at the bottom may tend to appear staid, sluggish, inert, or bottom-heavy. In *Number 18,* 1951, however, Rothko foiled that effect by painting the large lower rectangle a cloudlike white, whereas the smaller rectangle at the top of the picture is a darker, heavier orange.

Rothko used structure, measure, and color in concert to constitute his subjects. The structure of an untitled painting of 1953 (pl. XVII), for

example, bears the, however faint, traces of a relation to conventional structures of entombments and nativities, as well as of portraits and landscapes. As such, it may be seen as an abstract image-sign of the cycle of life or of the play of absence and presence. This relation to prior pictorial codes, this trace structure that is at work in this painting will be illegible to the uninitiated viewer, but the idea of a cycle may be conveyed nonetheless by the painting's radical color shifts: from orange and yellow to black to yellow, as if from day to night to day or from birth to death to rebirth. As the viewer scans from top to bottom and bottom to top, the color and dimensions of the dominant yellow and white rectangle impart an almost triumphant aura; this rectangle is up high, emphatically vertical, and set off on either side by even brighter yellow-white uprights (or arms, to exploit a physiological metaphor). This area stands out all the more because it was painted with a light and brushy touch that yields a gossamer, almost shimmering surface. These factors conspire to sharpen the contrast between this incandescent rectangle and the dark, squat, and solid rectangle beneath it. Whereas the top rectangle appears almost to shed light, to glow like a candle, the black rectangle seems to swallow light, admitting no flickers or variations on its surface and projecting an aspect of irremediable finality. Further, in a departure from his regular format, Rothko extended the black rectangle fully from edge to edge of the canvas, making of it a bulwarklike blockage. Although the black rectangle has an immutable presence, the force of that presence is mediated by the radiant presence of the rectangle surmounting it, as well as by the smallest rectangle, the diminutive horizontal bar at the base of the picture rendered with a layer of orange scumbled over a smaller, brighter yellow shape. When Rothko talked of the importance of measure to his art, he meant not only size, proportion, and scale but also the measurement of light reflected by the hues and tones in his pictures.

## Darkness and Light: The Dionysiac and the Apollonian

The symbolic opposition of light and darkness is age-old and virtually universal, though it is imbued with different meanings in different cultures and contexts. As corollaries of day and night, waking and sleeping or conscious and unconscious states, heat and cold, light and darkness have also been associated variously with life and death, awareness (enlightenment) and ignorance (benightedness), happiness (delight) and sadness (dark moods), good and evil, God and Satan, and as Nietzsche would have it, the Apollonian and the Dionysiac. In the painting of 1953 discussed above (pl. XVII), viewers may well attach symbolic connotations to the vigorous blast of yellow light burning, as it seems, above and below, before and after, the lightless sinkhole created by the rectangle of black. Such startling contrasts of brilliant and dark colors side by side are not uncommon in Rothko's art. He alluded to his awareness of manipulating this opposition of dark and light when he showed what would be

his final project, the series of black on grey and brown on grey paintings that he created in 1969 (fig. 48, for example) to Dore Ashton and reminded her that "the dark is always on top." Ashton understood this to mean that "the dark prevails metaphorically," that the paintings were 'emblems of his despair." "His generation had been intimate with Angst," she observed, "he above all, and the subject of these paintings (he still believed they had to have a subject, as he told me many times) could be no other than Dame Care."[6]

48
Untitled, 1969, acrylic on canvas, 81⅜ × 76¼ in. Collection of the National Gallery of Art, Washington, D.C. Gift of the Mark Rothko Foundation, Inc.

Ashton's inference seems to be corroborated by a statement Rothko made some years earlier to Marjorie and Duncan Phillips about *Green and Tangerine on Red* of 1956 (pl. XIX), a painting in their collection. As Marjorie Phillips remembered it, Rothko said that the red tone in the lower section of the picture "could symbolize the normal, happier side of living; and in proportion the dark, blue-green rectangular measure above it could stand for the black clouds or worries that always hang over us."[7] Rothko again made a symbolic distinction between bright and dark colors when he talked with Nathan Pusey, then president of Harvard, about the meaning of the cycle of detachable murals that the artist was donating to the university. Rothko told Pusey—in the literal or narrative terms he reserved for conversations with persons outside his immediate professional sphere—that "the dark mood of the monumental triptych was meant to convey Christ's suffering on Good Friday and the brighter hues of the last murals, Easter and the Resurrection." Rothko further indicated that he saw these paintings (which were installed on the two facing walls of a room with window-walls at either end) as forming a sequence that progressed from dark to light.[8]

Rothko sometimes talked of his art in terms of dualisms, as establishing or bridging various binaries or oppositions. To one reporter, he suggested (in 1961): "If people want sacred experiences, they will find them here. If they want profane experiences, they'll find those too. I take no sides."[9] To the patrons who had commissioned paintings for a chapel, he indicated that "he wanted to recreate the same opposition, the same tension, that exists in Torcello's church," that is, the opposition between "The Last Judgment at the door and the inviting and glorious apse" that contained "a celestial vision of the Madonna and Child."[10] In describing the leading ingredients for his art in 1958, he invoked the opposition of mortality and sensuality. And to the Phillips, to reiterate, he talked of the opposition of bright and dark colors in terms of the opposition of happiness and suffering.

In view of his interest in *The Birth of Tragedy,* Rothko may also have associated the opposition of light and darkness with the opposition of Apollo and Dionysos, the dualism that Nietzsche described as the mainspring of Greek tragedy. Nietzsche associated Apollo, god of sun and light, with the *"principium individuationis"*: with self-knowledge, enlightenment, and self-control. Dionysos, by contrast, pointed the way to the dark, primal "maternal womb of being," to the reconciliation of the individual with nature, to "the end of individuation." Apollo was god of the plastic arts, answering the need for beauty, joy, and tranquility, whereas Dionysos was god of music, the primordial art "which precedes all else." Nietzsche envisioned Greek tragedy as issuing from a marriage of Apollonian and Dionysiac tendencies, as "the Apollonian embodiment of Dionysiac insights and powers." He suggested further that all "art owes its continuous evolution to the Apollonian-Dionysiac duality, even as the propagation of the species depends on the duality of the sexes."[11]

Based on interviews with Rothko conducted in the mid-1950s, William Seitz confirmed that Nietzsche's concept of "dualism as the essence of tragic art made a deep impression on Rothko": antitheses, Rothko feels, are neither synthesized nor neutralized in his work, but held in a confronted unity which is a momentary stasis."[12] Visually, this image of a struggle between opposites, of antitheses held in a confronted unity, is vividly realized in *Green and Tangerine on Red*, 1956 (pl. XIX), and in numerous other pictures that Rothko made with two massive rectangles, one dark, one light, one above the other. (In his dualistic confrontations of dark and light, Rothko usually gave the dark rectangle "top priority," as in *Green and Tangerine on Red* and *Number 18*, 1963 [pl. XXIV].) In Rothko's art a struggle between opposites is also played out visually in the subtle pull of vertical against horizontal gestalts (as previously discussed). Through the use of a trace structure, Rothko's art was involved with dualisms—of subject and object, presence and absence, life and death—in other, more subtle ways, or so I have tried to demonstrate. What is involved here, however, is neither a polarizing nor a neutralizing of the opposed terms (as Rothko indicated) but a structure that calls the very status of these oppositions into question by overlapping their terms.

Many of Rothko's dualistic bright-dark paintings, as well as some bipartite paintings with close-valued, often light or bright hues, were painted from 1954 to 1956. As with most artists, Rothko's characteristic uses of color changed over time. These years in the mid-1950s were pivotal ones in a shift from the use of a predominantly bright palette to a progressively darker one. In his early work, before around 1948, Rothko had tended to use brilliant color sparingly; off-whites, greys, browns, and greyed-out colors were the rule, although he painted a bright picture from time to time. The intensity of the colors in the earliest pictures (through the early 1940s) was further diminished by the scraping, scumbling, and rubbing that Rothko indulged in and by his penchant for diluting paint—both oil paint and watercolor—to a thin, runny consistency. Around 1948 or 1949, Rothko retired this muted palette, and until around 1956, bright hues were dominant in his pictures. Many of his most arresting paintings come from these years when he worked with intense color juxtapositions involving the "hot" colors—red, yellow, orange, and bright pink—sometimes contrasted with black and white. Dark colors filtered into Rothko's paintings increasingly beginning around 1954, notably in those bipartite paintings that set up a confrontation of bright and dark. In the late 1950s and throughout the 1960s, dark colors prevailed; deep maroons, plums, and red-browns were preferred, along with what Rothko called "no-color," that is, murky mixtures of paint in which no one color dominates. Throughout, Rothko's most favored colors—the colors with which he was especially identified—were red and its darker and brighter variants: red-brown or maroon and red-orange.[13]

Numerous dark paintings from the early 1950s (such as an untitled painting of 1951 [pl. XV]) and bright paintings from the later years belie

these generalizations about Rothko's use of color. But as a broad trend, the move from bright to dark in Rothko's art is unmistakable, and this shift was attended, logically enough, by changes in how he wanted his paintings lighted. Rothko wanted to correlate the light on his paintings with the light in his paintings. "From first to last," Dore Ashton has suggested, "he has been concerned with the disclosure of light when measured out in perfect proportions."[14] Gallery and museum officials have attested that in the early 1950s Rothko liked to show his mostly bright paintings in as much light and as brilliant light as he could persuade them to provide. Later on, he was equally adamant about showing his paintings in the lowest light possible.[15] (In either case, his pictures benefit from being shown in artificial rather than natural light, which tends to rob them of their power, whether they are ebullient or restrained in their coloration.)

The change in Rothko's palette from light to dark accompanied a shift from light to dark in the artist's mood. His friends and acquaintances have recalled that by the late 1950s, Rothko was increasingly depressed. They have speculated, too, that his beclouded emotional state was instrumental in the darkening of his palette. Ironically, Rothko's bright palette was a factor in his depression in the first place: the bright paintings of the early 1950s brought him his first significant measure of recognition but on different terms than he had hoped for. Appreciative critics found the colorful paintings decorative and beautiful, and Rothko found himself identified with a hedonistic "art for art's sake" tradition that he held in contempt. In conversation with critics, Rothko increasingly stressed that his was not an art of pleasure or optimism but, on the contrary, an art of violence: "Rothko claims that his is the most violent painting in America today," Dore Ashton reported in 1957, and he made the same claim to many others.[16] The bright, exciting, clashing colors of the early classic paintings were not cheerful or voluptuous but violent and tragic, Rothko insisted. His emphasis on this point was probably aimed at countering the more common response, however, as he indicated in his list of ingredients for his art that sensuality was also important to him, although secondary to morbidity or violence. One of the rare essays on his art that appealed to Rothko was a review by David Sylvester, the British critic who (after consulting with the artist) discerned a paradox in his paintings: "He uses the apparatus of serenity in achieving violence. . . . violence and serenity are reconciled and fused—this is what makes Rothko's a tragic art"[17]—phrases that ring with the artist's own rhetoric.

Rothko's bright paintings brought him the reputation of being a splendid colorist, but it was not a reputation he enjoyed. Elaine deKooning reported that Rothko "says he is not interested in color, 'but since there is no line, what is there left to paint with'?" Many others heard him say comparable things.[18] Rothko became convinced that bright colors were too beguiling or "seductive," that they distracted people from thinking about his paintings' tragic subject matter. Eventually, he told a

friend, "he tried, consciously, to create works that were equal in meaning but with as little color as possible . . . so that no one who had not the interest or the courage to face the 'subject' would be tempted to look at or buy the painting."[19] Another source reported: "To a lady who wanted to exchange a dark painting that 'depressed' her, he [Rothko] said, 'By all means bring it back'. But when she wished to replace it with a brighter one, he refused and returned her money."[20] His brighter paintings have generally held the greatest appeal for critics and collectors, but with an artist's usual partiality for his latest efforts, Rothko finally regarded his dark paintings as his most profound work. According to Dan Rice, Rothko "watched in wry amusement as Lloyd [the president of Marlborough Gallery] and his vice-president, Donald McKinney, passed up what Rothko knew to be his latest and greatest paintings—the final black and grey sequence—for more colorful works."[21]

Donald McKinney has said that he was aware that Rothko "was impatient that so many people on coming to his studio, would be drawn immediately to his brighter canvases—the ones he referred to as 'easier to understand', and they did not feel the same affinity for his darker 'more difficult' canvases."[22] The brighter paintings were not easier to understand, however, but easier to misunderstand—to view in the wrong spirit, as Rothko saw it, that is, in a light-hearted way. Rothko wanted his paintings to affect people deeply: "He felt he had really succeeded when the visitor was moved, even to tears, by the encounter with his own humanity or his own tragic vision," said Morton Levine, a friend during the artist's later years.[23] Because dark colors are readily associated with despair in our culture, Rothko apparently believed that his most somber paintings would more effectively convey the tragic, poignant emotions that he especially wanted to express. And he believed that viewers who turned from the dark paintings were really turning from their own darkest, deepest emotions.

Rothko may also have moved to a darker palette because dark paintings are more difficult to see; that is, differences between dark colors are less easily discerned than those between bright or light colors, and this is especially the case when dark pictures are displayed in low light. Rothko wanted his pictures "to arrive slowly in one's consciousness," McKinney observed,[24] and he hoped to foster a more intense aesthetic experience by fostering a longer viewing experience. "The purpose of art is to impart the sensation of things as they are perceived and not as they are known," Victor Shklovsky has suggested. "The technique of art is to make objects 'unfamiliar', to make forms difficult, to increase the difficulty and length of perception because the process of perception is an aesthetic end in itself and must be prolonged."[25] In his later years, said a friend, the critic Katharine Kuh, Rothko "saw art as a reflective process that demanded the last ounce of concentration from both painter and viewer."[26] McKinney observed as well: "We are back with Mark Rothko's insistence on our attention. He wants us always to take a closer look—closer and closer."[27]

## Suspension and Suspense

Rothko's dark palette may have exacerbated the viewers' sense of the difficulty of apprehending his pictures. He left viewers increasingly, literally, in the dark, struggling to read the traces of his brush, his faint painterly language, and to bring his murky, blurry rectangles into focus. But even in his bright paintings, Rothko's rectangles were equally defocused. In some critics' eyes, this blurriness is associated with atmospheric qualities, and the rectangles are often described as vaporous clouds. Rothko's forms are never quite so undefined, amorphous, or insubstantial as this metaphor implies, however, and they do not drift aimlessly. To the contrary, they are unmistakably if not precisely squared off, centered, aligned, and hierarchically ordered. Whereas Rothko's rectangles are often seen as mists or clouds, his paintings' borders are often described in architectural terms—as windows or doorframes, for example. But it is the paintings' borders, if anything, that evince an insubstantiality—sometimes through their very narrowness, sometimes through their relative darkness, and sometimes through a ghostly fragility of surface that was achieved by dry-brushing a thin layer of color over another white or light tone.

By contrast with the insubstantiality of the borders in Rothko's paintings, the rectangles take on the appearance of something material or in the process of materializing and emerging. Many critics have remarked that Rothko's rectangles "hover" before the viewers eyes, and they would not appear to do so if they seemed to be securely bracketed by a solid architectural frame. To see the rectangles as floating or hovering is to see them as constituted not of void but of substance and to see that substance as suspended, unanchored, in space, in a void. This accounts for some of the mystery and magic that Rothko's images are famous for; this effect of a vision—not quite focused but expansive and majestic, vividly real if not quite solid—materializing out of thin air, just as genies, gods, or heavenly visions are supposed to do. To hover is to hang in the air, "to remain suspended over a place or object," and also "to be in a state of uncertainty, irresolution and suspense" (*Webster's Ninth New Collegiate Dictionary*). In creating forms that seem to hover, Rothko continued in a subtle way along that (symbolist) brink that he discovered through surrealism; he had come to understand the affective power of a state of irresolution or undecidability, but he could manipulate it now in a more abstract, and so more direct, way. He created suspense through suspension, in other words—by suspending plain rectangles in a nonspecific space—rather than by creating fantastic creatures hovering on the borderline between legibility and illegibility. In creating shapes that were almost but not quite focused, almost but not quite solid, he found a way to describe the brink or border between being and not-being, presence and absence. This, in essence, was his subject.

# 7

# Conclusion

In 1942 in his "Prolegomena to a Third Manifesto of Surrealism or Else," André Breton wrote:

Such a sudden convulsion of this planet as we witness today is enough to make us question the adequacy, let alone the necessity, of the modes of knowledge and action chosen by man during the last historical period. . . . I need only point out that minds very different from one another, but among the boldest and most lucid of our time . . . have all been irresistibly led to searching for a prompt answer to the question: can a society exist without a social myth? To what extent can we choose or adopt and impose a social myth which we judge desirable.[1]

Mark Rothko wrestled with these questions most actively during the war years, but they continued to preoccupy him for the remainder of his life. In 1947 he lamented that he lived in a less "practical" society than the archaic artist, a society in which the "urge for transcendent experience" was no longer accorded "official status." The archaic artist could enlist a group of intermediaries, monsters, hybrids, gods and demi-gods . . . [and] the human figure and other elements from the familiar world could be combined with, or participate as a whole in the enactment of the excesses which characterize this improbable hierarchy."[2] In the early and mid-1940s Rothko had enlisted just such a cast of characters in his art, even though they enjoyed no official status. Buoyed by the theories and the visions of the surrealists, he made a quixotic attempt to impose borrowed and fabricated myths on a society that was bound to profess indifference, but which might be affected in spite of itself and its better judgment. Rothko's was a vision of art as an antidote, unasked for by the public but administered anyway—a vaccination charged with toxins from the potent fluids of the unconscious that were otherwise liable to poison the system as a whole.

Ultimately, Rothko decided that he could not continue with his surrealistic, mythic dramas in the face of the unflinching resistance of critics and viewers. "The unfriendliness of society to his activity is difficult for the artist to accept. Yet this hostility can act as a lever for . . . liberation," he resolved in 1947.[3] Rothko had concocted "monsters and gods" and contrived mythological titles for his pictures, because "I hoped to help the onlooker by means of an association with the art of the past."[4]

When onlookers persisted in being baffled and unmoved, Rothko recognized that his mythic performers were only becoming "embarrassed" by openly enacting their mysterious rituals in a society that insisted it had no use for ritual or for mystery. The public's hostility or indifference to his performers' best efforts became the justification or the lever Rothko needed to release himself further from adherence to familiar pictorial codes: "Both the sense of community and of security depend on the familiar," he declared in 1947. "Free of them, transcendental experiences become possible."[5] As I see it, Rothko continued to try to help the onlooker by means of an association with the art of the past, but he allowed that association to become increasingly tenuous and fragile—a mere trace of what it formerly was. The automatic drawing that he had once used to make exotic monsters and gods was used instead to create a play of marks that never formed anything fully legible or recognizable, marks or brushstrokes that read instead as the faint traces of a bygone pictorial language. In addition, as I have demonstrated, in contriving the structure or format of his paintings Rothko also worked with, or played with, traces of preexisting pictorial codes. By creating his art with a structure of traces, he exploited the only available pictorial language for presenting the subjects that mattered so much to him, without being confined by the premises and terms of that language.

To be understood by the viewer was all along an important objective for Rothko, and his initial strategies for accomplishing that aim had failed him. To continue to practice painting as a form of "mythical action," as he hoped to do, Rothko determined that he would need to create the unfamiliar, to "disguise" the performers in his pictorial dramas. "With us," he said in 1947 (meaning with the modern artist and viewer), "the disguise must be complete." Besides disguising his ritual performers, the only other viable course of action that Rothko saw was to use his paintings to call attention to the dearth of meaningful rituals in modern society and to the dreadful sense of emptiness or nothingness that had ensued from the demise of myth. "Without monsters and gods, art cannot enact our drama: art's most profound moments express this frustration."[6] In a sense, Rothko did this as well—did both these things—in his classic paintings. He did so by working with a structure of traces, as a ⌐ ⌐e is "the mark of the absence of a presence, an already absent present, of the lack at the origin," in Derridean terms.[7]

The task that Rothko had set himself as an artist was a humanistic and spiritual or mythological one. With his high ideals about what paintings should aspire to, he had resolved in 1947 to offer viewers nothing less than a "revelation," a "miracle," and a "resolution of an eternally familiar need."[8] This was the last time he wrote of revelations, miracles, or in fact of resolutions, but in the 1950s he still alluded to a "religious feeling" that he had when he painted, to painting as a form of "mythical action," and to the "sense of community" that always moved him while he worked.[9] As one of his studio assistants explained, "Leaving the figur-

ative work and subsequently the surrealist period meant for Rothko a reaching into a deeper level of communication."[10] But Rothko had to communicate to a disjointed community, one whose religious structures had long since fallen into disarray. The generation of artists that followed Rothko's acknowledged that this extreme fragmentation precluded making works of art capable of any universally meaningful act of signification. To Rothko and some others of his generation, however, the society's fragmentation made the need for such signification still more urgent and the possibility of achieving it all the more momentous.

"A social culture that has fallen away from its religious traditions expects more from art than is in accordance with aesthetic consciousness," Hans-Georg Gadamer has observed.

The romantic support for a new mythology . . . gives the artist and his task in the world the consciousness of a new consecration. He is something like a "secular saviour" . . . whose creations are expected to achieve in a small way the propitiation of disaster, for which an unsaved world hopes. This claim has since determined the tragedy of the artist in the world, for any fulfillment of it is always only a particular one, and that means in fact its refutation. The experimental search for new symbols or a new myth which will unite everyone may certainly create a public and create a community, but since every artist finds his own community, the particularity of this community-creating merely testifies to the disintegration that is taking place.[11]

That Rothko was playing out just such a tragic and messianic role was suggested haltingly (in an interview) by one of his longtime colleagues, Willem de Kooning, some time after his death: "Barney [Newman] and Mark I call 'messiah'. . . . Paintings have so many overtones . . . but the initial message, idea of the subject matter should be tragic. . . . For me they [Rothko's paintings] bring news. Which is not only in painting news. Every painting brings news—it's beyond the painting—right?" Interviewer: "Like a messenger, you mean?" De Kooning: "A messenger—a message."[12]

Rothko's own insistence that his enterprise was a tragic one must stem partly from his struggle with the difficult reality that he could not create messages that would answer the spiritual cravings of the human community as a whole. He was forced instead to locate, or to create, that smaller public or community to which Gadamer refers. He was deeply concerned with the extent to which even that partial community really existed and desirous as well that it should extend beyond the limited circle of artists, critics, historians, curators, and dealers who surrounded him and whose trained and conditioned responses he mistrusted. "One does not paint for design students or historians, but for human beings, and the reaction in human terms is the only thing that is really satisfying for the artist," Rothko once asserted—thus summarily discharging design students and historians from the human race.[13] Repeatedly, Rothko expressed his concern with the relation between his pic-

tures and viewers, and it gratified him deeply to hear of people being intensely moved by encounters with his work. In conversation with a skeptical critic, he defended his achievement by saying: "I'm interested only in expressing basic human emotions . . . and the fact that lots of people break down and cry when confronted with my pictures shows that I *communicate* those basic human emotions."[14] Rothko's solicitousness about the viewer was matched by his tender feeling for his pictures, however. He is often said to have referred to his paintings as his "children," and he felt that whether his offspring would thrive or expire depended on their reaching the custody of sensitive and sympathetic viewers, collectors, or curators. "A picture lives by companionship, expanding and quickening in the eyes of the sensitive observer. It dies by the same token." Further, a picture might be "permanently impaired by the eyes of the vulgar and the cruelty of the impotent who would extend their affliction universally!" Rothko wrote in the columns of a little magazine in 1947.[15]

By the 1950s, Rothko mostly declined to make written statements about his work, explaining to one curator that to do so would serve only to cause a "paralysis" of the viewer's "mind and imagination." He wanted instead to place his trust "in the psyche of sensitive observers who are free of the conventions of understanding. I would have no apprehension about the use they would make of these pictures for the needs of their own spirits. For if there is both need and spirit, there is bound to be a real transaction."[16] To the sensitive viewer, the meanings of the pictures would be clear: their explanation would come "out of a consummated experience between picture and onlooker," as Rothko had phrased it in 1943, and there would be no necessity for collateral explanations.[17] The special transaction that was to occur between the sensitive observer and Rothko's pictures would ideally be a highly intimate and private one: "When a crowd of people looks at a painting, I think of blasphemy. I believe that a painting can only communicate directly to a rare individual who happens to be in tune with it and the artist," said Rothko in the 1950s.[18]

To be in tune with a painting by Rothko, a viewer would have to understand, for one thing, why the artist spoke of "blasphemy" (meaning to show contempt for God, or "irreverence toward something considered sacred or inviolable" [Webster's Ninth New Collegiate Dictionary]) in connection with ostensibly secular paintings. Such understanding viewers were not as rare as Rothko feared—even if they were not as plentiful as he must have hoped for. The sense that there was some, however ambiguous, sacred dimension to Rothko's art occurred to many critics. "Rothko's art was always putting people in mind of chapels," to return to Lawrence Alloway's phrase, and chapels were on the artist's mind as well. A story related by Werner Haftmann, the German art historian, is illustrative. When he visited Rothko to invite him to participate in the Documenta exhibition of 1959, Haftmann found the painter initially re-

uctant to exhibit in a country that was "guilty of so many crimes against ewry." The pictures on view in the studio at the time of Haftmann's visit were the murals Rothko was executing on commission for an elegant restaurant in the Seagram's building in New York City (a commission he ultimately withdrew from, deeming the site inappropriate for his art). Haftmann reports that his mention of a "sacred" quality that he sensed in these pictures caused Rothko at once to reverse his position and to offer not to lend to the exhibition pictures already completed but to create for it a chapel. Rothko said that "if I could manage to have even a very small chapel of expiation erected in memory of Jewish victims, he would paint this without any fee. He then said it need only be a tent." Haftmann did not take Rothko up on this proposal, but as the artist talked to him further about the Seagram's paintings, Haftmann noted that he was so exuberant about what he had accomplished that he "did not hesitate to speak of the 'Sistine Chapel'." Haftmann agreed that the paintings were evocative of a chapel, and Rothko "said in all seriousness, that this was just the meaning of this space."[19]

In talking to Nathan Pusey, then president of Harvard, about the cycle of paintings he was donating to the university, Rothko alluded to Christian themes, to the crucifixion and the resurrection, as if he envisioned creating a hallowed, chapellike place out of the meeting room that his paintings were to adorn.[20] And when in the late 1960s he got the commission he had been waiting for, to do a group of paintings for a chapel to be built in Houston, Texas, he related his own endeavor, in conversation with his patrons, to the cycle of murals encompassing the Madonna and Child and the Last Judgment in a church at Torcello. The three groups of paintings that Rothko executed on commission do not conform to his characteristic schema, and as such they fall outside the scope of this book. With his mural commissions, Rothko was able to command a place, to create an entire environment by filling a room with his paintings. But it was not only his murals that inspired religious feelings; those critics who discerned a spiritual or religious aspect to the murals saw the classic paintings also as motivated by a spiritual impetus. I have argued that the classic paintings evince religious associations because they are iconic and implement traces of the conventional structures of sacred art. Although viewers will not generally be cognizant of the specific associations involved, the painting "memories" or traces in Rothko's art may resonate in the viewers' unconscious, along with those aspects of the classic pictures that are not associated with preexisting pictorial codes: the use of the torn edge and the rift, for example, and of defocused, suspended forms that appear to have materialized, as if by magic, out of nothingness.

49
Kasimir Malevich, *Suprematist Composition: Red Square and Black Square,* 1914 or 1915(?), oil on canvas, 28 × 17½ in. Collection of the Museum of Modern Art, New York.

## Malevich, Rothko, and Nothingness

As a Russian-born artist trying to find a spiritual basis for art through abstraction, Rothko was in the distinguished art historical company of Vasily Kandinsky and Kasimir Malevich. Points of comparison between Rothko and Kandinsky have been noted on several occasions in this book. The comparison with Malevich is a suggestive one, too, particularly given that both of these artists devised a mode of painting employing nothing but rectangles or squares and no more than a few of those. Malevich's most stark suprematist canvases (fig. 49) were executed in Russia when Rothko was a boy living in the United States, however, and by the time Rothko painted his own stark canvases, Malevich had been dead for more than a decade. The distance between Rothko and Malevich is more than one of miles and years, moreover; Malevich's religious ties and affinities lay not with Judaism but with the Russian Orthodox church, especially with its mystical dimension.

The campaign Malevich embarked on, to "free art from the ballast of objectivity," was a response to what he saw as a plague of materialism that had beset modern society. His suprematist program was aimed at redirecting the viewers' attention to what matters most in art—not the material things it reproduces but the feeling it expresses. Malevich defined suprematism as an expression of "the supremacy of pure feeling in creative art," by which he meant "non-objective feeling" in particular. As

Malevich conceived it, the squares in his pictures were equivalents of pure feeling whereas the blank white background around them was the void beyond feeling."[21] As arguably the most fundamental of shapes, the square may be seen as a form so elemental and adaptable as to be capable of standing for a complement of nonspecific meanings. The choice of a square or rectangle to represent spiritual feeling may have been based also, however, on the conceit (held by Mondrian as well) that the square is an oppositional form, representing a unity of opposites—of horizontal and vertical forces—and that, as a formal unity, it could stand in turn for spiritual unity. Like Malevich, Rothko was seeking unity in his art: "I have created a new type of unity; a new method of achieving unity," Rothko said in the early 1950s. "My own work has a unity like nothing—(I do not mind saying even if I appear immodest)—the world has ever seen."[22]

Brian O'Doherty discerned some kinship between Malevich's program and Rothko's when he heard Rothko claim that his "squares were not squares, but all my feelings about life, about humanity."[23] Unlike Malevich, Rothko did not refer strictly to "non-objective" feelings, however. Malevich was a devout Christian mystic who believed in the possibility of a direct contact with god and who considered that a central task of the artist was that of rendering god, or spiritual feeling, itself. The tradition of the Russian icon—a tradition with which Malevich felt some affinity—construed the picture as a devotional object that functioned as an agent for a direct contact with god; the worshipper was to look not at but through the icon to the spiritual presence it invoked. Malevich's simple black square set in a blank white field (of circa 1915) was "the icon of my time," in his own words, and he exhibited it in the traditional location for the principal icon hung in the "beautiful corner" of a Russian Orthodox home: high in a corner, spanning two walls. What Malevich's squares were icons of was nothingness. But in the mystical tradition he subscribed to this was not a nihilistic vacuousness but the sensation of the total absence of objects—a pure, full, transcendent feeling. Malevich's nothingness was akin to nothingness in the Hegelian sense of all being, that is, being purified or "stripped of every quality that would materialize or limit it in any way."[24]

Malevich's black square emerged from an essentially spiritual and utopian program; it was, in the artist's own terms, "the face of the new art . . . the embryo of all potentials."[25] Late in his life, Rothko also painted some paintings with a single black square, most notably in fulfilling the commission for the chapel in Houston. By contrast with Malevich, however, Rothko was not a utopian and his single squares were most likely not intended as a promise of spiritual unity. Rothko's was a kind of neoRomantic and tragic world view, and his vision of art was suffused by that pessimism. While lecturing in 1958 on his art, he declared that "tragic art, romantic art deals with the fact that a man is born to die." In his suggestion that art was primarily concerned with "intimations

of mortality," he was at once invoking and negating (and so, in a sense, denegating) a well-known Romantic phrase.[26] Wordsworth's "Ode: Intimation of Immortality from Recollections of Early Childhood," with its famous epigraph beginning "The Child is father of the Man," concerns the cycles of life and nature:

> Our birth is but a sleep and a forgetting:
> The Soul that rises with us, our life's Star,
> Hath had elsewhere its setting,
> And cometh from afar.

What Wordsworth offered to soothe and console his readers about the ephemerality of life was "natural piety" and "the faith that looks through death." He promised that

> Our souls have sight of that immortal sea
> Which brought us hither,
> Can in a moment travel thither,
> And see the children sport upon the shore,
> And hear the mighty waters rolling evermore.

The cycle of life or, more accurately, the play of presence and absence was Rothko's subject as well, but his vision centered on mortality, not immortality or heaven—and in this it might be said that he manifested not only his modernity but also his Jewishness. Unlike Wordsworth or Malevich, however, Rothko was a man without a firm spiritual vision, without the settled convictions of his faith. The critic Robert Goldwater asserted that: "though Mark Rothko had no concern with dogma or doctrine he was an intensely religious man";[27] but to be a religious man without a doctrine is to be in a peculiarly modern position. It was, in all its awkwardness and uneasiness, a position equally familiar to some other New York School artists. When David Smith was asked by Thomas Hess whether his many totem sculptures were "ritual objects for a new religion," he replied, "No. I don't believe in anybody's religion. The bug is in all those social implications in your words." When Smith then described himself as an idealist, however, Hess responded "What's the ideal? Are your totems for . . ." and Smith interrupted: "a true socialist society, but I don't know any ideology that meets my theoretical ideals. That goes for religions or any social ideals. In other words, there is nobody I belong to or belong with."[28]

Many people saw Rothko as being deeply, individualistically mystical in his vision, but this he denied. One friend recalled: "My wife once told him [Rothko] that she thought he must be a mystic. . . . He denied it. 'Not a mystic. A prophet perhaps—but I don't prophesy the woes to come. I just paint the woes already here'."[29] Whereas mysticism implies a faith in the possibility of unmediated contact with a supreme being, Rothko seems to have shared that profound doubt about the existence of god that underpins Kierkegaard's writings, and it is not clear that he was

able to make the absurd leap of faith that the philosopher made in remaining a believing Christian. In fact, Rothko was disdainful of hope, professing in later years to admire the Greeks precisely because they "didn't concern themselves with hope."[30] When talking with Werner Haftmann some time in the late 1950s, "Once he [Rothko] quoted Kierkegaard and his 'fear of nothingness'. He said that 'nothingness' did not concern him, but that his paintings should cover up something similar to this 'nothingness'."[31] There is a concept of god as nothingness in the Jewish mystical tradition, as in the Christian and the Moslem one, but there is no basis for assuming that Rothko was engaged with any of those mystical traditions or that the nothingness he was covering up was some reassuring revelation of god.[32]

Early in his career Rothko had insisted that, "There is no such thing as good painting about nothing."[33] Later he fended off the charges of hostile critics that he was wasting his own and everyone else's time by painting nothingness; Rothko, "Busy Drawing Blanks," was the headline of a review by Emily Genauer of the *New York Herald Tribune* (who antagonized Rothko perhaps more than any other critic). Otis Gage of *Arts and Architecture* decided that Rothko must be a "painter of the void; [though] his corner of the void is colored." "The problem of how to paint nothing is, indeed, difficult but boring," he added. To Kenneth Evett of the *New Republic,* a blank canvas, or "death to painting," was the logical endpoint of Rothko's path, and said the critic, "I find that direction . . . a bore."[34] Rothko's response to such charges was that, "You have here nothing—but content."[35] Another response would have been to invoke Freud's suggestion that the state of boredom (which afflicted all these critics) signals that those defense mechanisms are in place by which people shut out information, ideas, or phenomena they prefer to deny or repress. Ernest Jones has suggested that "only what is repressed is symbolized; only what is repressed needs to be symbolized." Further, the primary ideas of life [are] the only ones that can be symbolized— those namely concerning the bodily self, the relation to the family, birth, love and death."[36] There was such symbolism, such a "message" to Rothko's art, and as such it engaged those emotions most subject to repression, those insufferable "intimations of mortality" and that invasive sense of nothingness that permeates modern experience. "The greatness of works of art lies solely in their power to let those things be heard which ideology conceals," Adorno has observed.[37] The revelations Rothko's "mythical actions" finally yielded were revelations of this kind—less reassuring than troubling.

## The Finite and the Infinite

In 1947 Rothko had spoken regretfully of that "urge for transcendence" that no longer enjoyed any "official status" in our society.[38] In conversation with Werner Haftmann in the 1950s, "Rothko spoke, as he liked to do, of certain 'transcendental experiences,' without defining them more closely."[39] And to Dore Ashton in a conversation about his chapel commission, Rothko declared that he aspired "to paint both the finite and the infinite." Ashton reported also, however—Werner Haftmann to the contrary—that Rothko "reacted with irritation to those who dared use the word 'transcendent' about his work. . . . He disliked the reverent suggestions of mystical experience made by well-meaning art critics. 'When I wrote the introduction to the Still catalogue'," he remarked to her wistfully (while misremembering the essay in question), "'I spoke of earth worms—far from otherworldliness'."[40] A studio assistant who worked with Rothko in the 1960s reports further: "He'd always say 'I'm not a religious man'. That bit. Because he didn't want his pictures to be thought of in a religious sense."[41]

In general Rothko tended to stress his hold on the finite over his quest for the infinite. He referred to himself as a "materialist," who put "things" on top of canvases in exercising a "trade" or "enterprise," which culminated in a "transaction" with a viewer. It is, moreover, in his identity as a materialist, as well as in his dismantling of received pictorial convention, that the political moment in Rothko's work arises. Those antipathetic to modernist abstraction often consider, as the painter Stuart Davis asserted, that

the abstract artist did not concern himself with the life problems of the people around him. . . . He has not been realistic. But the abstract artist was realistic at least with regard to his materials. If the historical process is forcing the artist to relinquish his individualist isolation and come into the arena of life problems, it may be the abstract artist who is best equipped to give vital artistic expression to such problems—because he has already learned to abandon the ivory tower in his objective approach to his materials.

Further, "In the materialism of abstract art in general, is implicit a negation of many ideals dear to the bourgeois heart."[42] "If any care to call this viewpoint 'art for art's sake,' let them make the most of it. I call it art for society's sake."[43] In the same vein, as Martin Jay describes it, Adorno had suggested, using music as his point of reference, that "pure sounds were also expressions of an external social reality. 'Musical material,' as he liked to call the tone combinations, at once form and content, available to any composer at a particular time, was related to the material reality of society."

It is elemental to modernist thinking as Adorno saw it that "only a music that refuses easy communicability can be said to be truly revolutionary," for such music or art constitutes a critical force insofar as it undermines the status quo, breaking open accepted, stable, or organically

whole modes of depiction.[44] Because it does this, modernist art or music "encounters a vehement resistance" from the public, a resistance "which surpasses the resistance against all use music and communal music, no matter how literary or political its accents might be." This resistance is indicative of how such art functions socially as a destructive or critical force, indicative of its negative capability, so to speak, and so points the way to its, however oblique or inobvious, political force. In the view of Adorno, "politics has migrated into autonomous art, and nowhere more so than where it seems to be politically dead."[45]

In his identity as a materialist, too, to a degree, Rothko distinguished himself from Malevich. Malevich's pictures are flatly, dryly painted with small hidden strokes, and his rectangles, by contrast with Rothko's, tend to have a disembodied presence, as they float freely often at angles to the framing edge in a relatively spacious blank white void. Rothko's canvases tend to bear more openly the imprimatur of his gestures; he does not deny the materiality of the paint by suppressing the presence of the painter. In comparison with the diminutive scale and almost humble presence of Malevich's canvases, Rothko's expansive canvases have a boldly physical presence, underscored by the strong, stable orthogonal orientation of the rectangles and the explicit evidence of the artist's authorship. Insofar as Rothko had chapels in mind in his work, he was, in Barnett Newman's terms, "making a cathedral out of [himself], out of [his] own feelings."

Rothko seems to have been torn, finally, between whether his work was capable of making transcendental references or not. He was uncertain, that is, whether in using traces of sacred or mythological imagery he was successfully ministering a tonic unawares to nonbelieving viewers or whether the very fact of the trace and the necessity for it rendered the paintings de facto tokens of the impossibility of creating art with such a tonic effect at all. In conversation with a reporter in 1961 (to reiterate), Rothko issued a disclaimer: "If people want sacred experiences, they will find them here. If they want profane experiences, they'll find those too. I take no sides."[46] In his use of the trace, however, Rothko was in a sense taking a side; he was declining, at least, to create anything unequivocally recognizable as sacred art, anything unmistakably reassuring of a metaphysical presence. Traces are the "mark of an anterior presence, origin, master," and as such the trace "is the enigmatic relationship of the living to the other and of an inside to an outside," as Derrida has suggested. In Derrida's view, further, "The trace is the erasure of selfhood, of one's own presence, and is constituted by the threat or anguish of its irremediable disappearance, of the disappearance of its disappearance. . . . This erasure is death itself."[47]

Rothko's penultimate project, the commissioned paintings for the Houston chapel (of which fig. 50 gives a partial view), are symptomatic of the dilemma he faced. In planning the chapel he did not hesitate to avail himself of traditional forms for projects of this kind; he designed a

suite of fourteen paintings, including three triptychs—the center panel raised in two of them—for an octagonal room. He thus engaged well-known pictorial conventions for the stations of the cross, for altarpieces, and for the architecture of a Christian Orthodox church. To his patrons, further, he spoke of emulating the church at Torcello, of recreating the opposition between a Madonna and Child and a Last Judgment. But there were, of course, no Madonnas, Christs, or Last Judgments in the pictures Rothko made. There were seven huge, blank canvases, each stained a mottled blackish purple or wine color, four huge canvases (a triptych and a single painting) with a solitary large greenish black rectangle set against a black or reddish black background, and three paintings (a triptych) with a slightly more complex image, involving a black background and a dark green rectangle with a darker green form inside of it. If the rectangles in Rothko's paintings are abstract figures, "things" (as he would have it) or signifiers of presence, it is significant that, when it came time to make a group of paintings for an explicitly religious setting, for the first time in his mature career Rothko painted pictures with no rectangles at all. Half of the paintings in the chapel are all ground (or void), and no figure, all absence and no presence. The rectangles in the other seven paintings are mainly solitary forms, dark and expansive rectangles floating in a darker, blacker space. Said his patron, Dominique de Menil, "He would have liked to use more beguiling colors. He tried, he told me, but he had to renounce those pleasurable options."[48]

When viewers first enter the Rothko chapel, they face a trio of huge, blank canvases in a line (fig. 50) on the longest wall in the most prominent position. To the viewers' right and left as they face this giant triptych are the two smaller triptychs (not visible in the photograph reproduced here) with their simple images and their center panels raised. At the viewers' back—what they see on the entranceway wall when they turn around—is a solitary canvas with a solitary rectangle on it. And on the four angled walls between each of these paintings or sets of paintings are four more solitary canvases (two of which are visible to the right and left of the triptych in fig. 50), all of them blank and purplish black. What Rothko did in executing his commission for the chapel was what he had been doing all along: at once inscribing and erasing received pictorial language, working with a structure of traces, constructing a play between presence and absence. In his paintings for the chapel, however, known pictorial conventions were more "under erasure," to borrow a phrase from Derrida, than ever before; absence had come to the fore. In Derridean terms, "The name of this gesture effacing the presence of a thing . . . is 'writing' [ecriture]" (as his translator, Gayatri Spivak, describes it); a text "whether 'literary,' 'psychic,' 'anthropological'," or pictorial, is precisely "a play of presence and absence, a play of the effaced trace." Such a practice—Rothko's practice—is directed against the closure of metaphysics that "found the origin and end of its study in presence." Through the strategy of erasure, writing becomes "the gesture that both frees us from and guards us within the metaphysical enclosure."[49]

In a lecture in 1958 Rothko reportedly said: "I want to mention a marvelous book, Kierkegaard's *Fear and Trembling / The Sickness Unto Death,* which deals with the sacrifice of Isaac by Abraham. Abraham's act was absolutely unique. There are other examples of sacrifice. . . . But what Abraham was prepared to do was beyond understanding. There was no universal that condoned such an act. This is like the role of the artist."[50] Like Abraham when he was instructed to sacrifice his son, Rothko was wracked with doubts, torn between belief and nonbelief. But unlike Abraham, or Kierkegaard, it seems that he could not conclusively make up his mind to believe. In a sense Rothko's art both created and existed in this same uneasy limbo, representing nothingness or vapidity to some viewers and dignified "mute icons" offering "the only kind of beauty we find acceptable today," to others.[51] What many critics enthralled by Rothko's paintings say of them, in essence, is that they endlessly suggest and evoke, while just as endlessly declining to confirm or deny. There is finally a special poignancy in such faintly legible language, such inaudible speech. There is the sense that a concerted effort has been made to give voice to a message that is destined to be choked off before it can be heard—choked off, that is, because of the impossibility of formulating audible, meaningful messages in a society without a shared faith or mythology.

# Notes

## Introduction

1 Hilton Kramer, "Rothko: Art as Religious Faith," *New York Times,* 12 Nov. 1978, sec. 2, p. 1.

2 William Packer, "Mark Rothko: The Inward Landscape," *London Financial Times,* 6 Nov. 1978, 1.

3 Lawrence Alloway, "Art," *Nation,* 15 Mar. 1971, 349.

4 Belle Krasne, "Youth: France vs. U.S., *Art Digest,* 1 Nov. 1950, 17.

5 John Canaday, "Is Less More and When for Whom? Rothko Show Raises Questions About Painters, Critics and Audience," *New York Times,* Jan. 1961, X17.

6 Serge Guilbaut, *How New York Stole the Idea of Modern Art: Abstract Expressionism, Freedom, and the Cold War,* trans. Arthur Goldhammer (Chicago: Univ. of Chicago Press, 1983). The reality that the center of the art market moved to New York after World War II has never been open to question, but the notion that the New York School artists precipitated that move by proving themselves the most path-breaking or originative and influential artists of their time has never had the currency among European critics that it has with their American counterparts. The American public generally, however, has had perhaps no less difficulty than the Europeans in perceiving the interest or value of the production of the New York School and has greeted with implacable skepticism the considerable claims that are made for this work by the (self-identified) cognoscenti. This entrenched aversion or resistance to New York School art helps explain the warm welcome that was generally extended by American reviewers to Guilbaut's book: it evidently served to reassure many readers that the substantial value and prestige accorded to this art was never a reflection of its real interest or merit but strictly a function of its suitability or adaptability as a propaganda tool for American authorities in the postwar and cold war era.

7 William C. Seitz, notes from an interview with Rothko, 22 Jan. 1952, Seitz Papers, box 15, Archives of American Art, Smithsonian Institution, Washington D.C. (My thanks to Bonnie Clearwater for alerting me that Seitz's interviews with Rothko had been put on deposit.) Also, Rothko, letter to Lloyd Goodrich, 20 Dec. 1952, Whitney Museum of American Art Library; and Dore Ashton, *A Reading of Modern Art,* rev. ed. (New York: Harper and Row, Icon, 1971), 27.

8 Jackson Pollock, interview-statement, *Art and Architecture,* February 1944, repr. in Francis V. O'Connor, *Jackson Pollock* (New York: Museum of Modern Art, 1967), 32.

9 Said the painter Friedel Dzubas, for example, Rothko "kept himself separate. He was friendly with everyone, but he never took part. And I can tell you, most of the people I knew, they just laughed about his painting. They just didn't take him seriously at all. He and Barney [Newman] were ridiculed. . . . I asked [Milton] Resnick whether he had seen Rothko's show [at Sidney Janis gallery, around 1955] and he replied "Those goddamned Indian blankets. They bore the hell out of me'" (Max Kozloff, "Interview with Friedel Dzubas," *Artforum,* September 1965, 49).

10 See, for example, Irving Sandler, *The Triumph of American Painting: A History of Abstract Expressionism* (New York: Harper and Row, 1970); H. H. Arnason, *American Abstract Expressionists and Imagists* (New York: Solomon R. Guggenheim Museum, 1961); and Sam Hunter, *Modern American Painting and Sculpture* (New York: Dell, 1959).

11 Emily Genauer, "Exhibit Holds Art Without Subject Line," *New York Herald Tribune,* 18 Jan. 1961.

12 Rothko, statement made from the floor at a symposium at the Museum of Modern Art, New York, "How to Combine Architecture, Painting and Sculpture" (*Interiors,* May 1951, 104). Further, in a letter of 25 September 1954 to Katharine Kuh, a curator at the Art Institute of Chicago (where the letter is now on deposit), Rothko said of his work: "The pictures are intimate and intense, and are the opposite of what is decorative; and have been painted in a scale of normal living rather than an institutional scale." He recommended that Kuh, who was organizing a small exhibition of his work, "hang

the largest pictures so that they must be first encountered at close quarters, so that the first experience is to be within the picture. This may well give the key to the observer of the ideal relationship between himself and the rest of the pictures. I also hang the pictures low rather than high, and particularly in the case of the largest ones, often as close to the floor as is feasible, for that is the way they are painted."

13 William C. Seitz, *Abstract-Expressionist Painting in America* (Cambridge: Harvard Univ. Press, 1983), 116. (This book constitutes the posthumous publication of a dissertation of the same title but with a subtitle "An Interpretation Based on the Work and Thought of Six Key Figures," completed at Princeton University in 1955.)

14 Ashton, *A Reading*, 20, 139.

15 David Sylvester, interview with de Kooning, *Location*, Spring 1963, repr. in part in Thomas B. Hess, *Willem de Kooning* (New York: Museum of Modern Art, 1968), 149; and Harold Rosenberg, "Interview with Willem de Kooning," *Art News*, September 1972, 58.

16 Harold Rosenberg, "American Action Painters," *Art News*, Dec. 1952, rev. and repr. in *Tradition of the New* (New York: McGraw-Hill, 1965), 23–39.

17 "The Wild Ones," *Time*, 20 Feb. 1956, 70–75.

18 Harold Rosenberg, *Arshile Gorky: The Man, the Time, the Idea* (New York: Horizon, 1962), 24. In the mid-1940s, Rothko admired Rosenberg, but by 1959, he was singling Rosenberg out as an especially inept and "pompous" critic who "keeps trying to interpret things he can't understand" (John Fischer, "Mark Rothko: Portrait of the Artist as an Angry Man," *Harpers*, July 1970, 17).

19 Sally Yard demonstrated this point most vividly in a lecture at Yale University in the late 1970s, but it is also discussed in her *Willem de Kooning: The First Twenty-Six Years in New York* (New York: Garland, 1986); see, for example, 192–93.

20 Elaine de Kooning, "Two Americans in Action: Franz Kline, Mark Rothko," *Art News Annual* 27 (1958): 86; and Rothko, letter, *Art News*, December 1957, 6.

21 E. de Kooning, "Two Americans," 94, 96.

22 Peter Selz, *Mark Rothko* (New York: Museum of Modern Art, 1961), 10; Seitz, interview with Rothko, 22 Jan. 1952; and Rothko, letter to Katharine Kuh, 14 July 1954, Archives of the Art Institute of Chicago.

23 Max Kozloff, "An Answer to Clement Greenberg's Article, 'After Abstract Expressionism,'" *Art International*, June 1963, 91.

24 Carter Ratcliff, "New York Letter," *Art International*, January 1971, 26.

25 Canaday, "Is Less More," X17.

26 Willem de Kooning, "What Abstract Art Means to Me," statement for a symposium at the Museum of Modern Art, New York, 1951, repr. in Hess, *de Kooning*, 144.

27 Donald Kuspit, "Illusion of the Absolute in Abstract Art," *Art Journal* 3 (Fall 1971): 26.

28 See Dore Ashton, *New York School: A Cultural Reckoning* (1972; repr., New York: Penguin, 1979); Sandler, *Triumph;* and Guilbaut, *How New York.*

29 See, for example, the first two sections ("Mondrian et Rothko" and "New York Encombré") of Michel Butor, "Les Mosques de New York ou l'Art de Mark Rothko," *Critique*, October 1961, 843–47; Thomas Hess, "Mondrian and New York Painting," in *Six Painters* (Houston: Univ. of St. Thomas, 1967); and Barbara Rose, "Mondrian in New York," *Artforum*, December 1971, 54–63.

30 Rothko's so-called murals consist of groups of interrelated canvases commissioned and conceived for specific sites. In 1958 Rothko began work on a commission he eventually refused for the restaurant at the Seagram's Building in New York City (a group of these canvases are now at the Tate Gallery in London). In 1961–62 he executed a set of pictures for the penthouse of Holyoke Center at Harvard University (but no longer in situ there). And in 1964 he began work on paintings commissioned by John and Dominique de Menil for a chapel in Houston, Texas—the building (opened in 1971) having been specially designed and built, in consultation with the artist, for the pictures in question. These commissions do not fall within the scope of this book, which centers on Rothko's classic paintings.

31 Thomas B. Hess, "Rothko: A Venetian Souvenir," *Art News*, November 1970, 72.

32 E. de Kooning, "Two Americans," 176.

33 A compelling discussion of this issue is Rosalind Krauss' "Originality of the Avant-Garde," in her book *The Originality of the Avant-Garde and Other Modernist Myths* (Cambridge: MIT Press, 1985), 151–70.

34 Rosenberg, "American Action," 30.

35 Max Kozloff, "American Painting During the Cold War," *Artforum*, May 1973, 54.

36 Annette Cox, *Art-As-Politics: The Abstract Expressionist Avant-Garde and Society* (Ann Arbor, Mich.: UMI Research Press, 1982).

37 E. de Kooning, "Two Americans," 174.

48 Dore Ashton, "Introduction" in Bonnie Clearwater, *Mark Rothko: Works on Paper* (New York: Hudson Hills, 1984), 13.

49 John Ashbery, "Paris Notes," *Art International*, 25 Feb. 1963, 72.

40 See, for example, Robert Rosenblum, "The Abstract Sublime," *Art News*, February 1961, repr. in Henry Geldzahler, *New York Painting and Sculpture, 1940–1970* (New York: E. P. Dutton and the Metropolitan Museum of Art, 1969), 350–59; Robert Rosenblum, *Modern Painting and the Northern Romantic Tradition: Friedrich to Rothko* (New York: Harper and Row, Icon, 1975); Lawrence Alloway, "The American Sublime," *Living Arts*, June 1963, 11–22; Peter Schjeldahl, "Rothko and Belief," *Art in America*, March–April 1979, 79–85; and Irving Sandler, *Mark Rothko: Paintings, 1948–1969* (New York: Pace Gallery, 1983).

41 Jean-François Lyotard, *The Postmodern Condition: A Report on Knowledge,* trans. Geoff Bennington and Brian Massumi (Minneapolis: Univ. of Minnesota Press, 1984), 77–79.

42 As far as I know, Rothko is nowhere on record as having uttered the word *sublime.* Irving Sandler has argued, however, that what "accounts for and in part may have even inspired his 'progression' into nonobjectivity . . . " was "Edmund Burke's philosophic inquiry into the sublime of 1757, which Rothko read, most likely before 1948." Sandler's (footnoted) evidence for this categorical assertion is that "Rothko, Newman and Still were close friends in the late forties. It is likely that if one considered a book important, the others read it or, at least, heard it discussed at length. Newman was sufficiently impressed with Burke's treatise to remark on it in 'The Sublime Is Now'" (*The Tiger's Eye,* December 1948, 51). Further in an interview with Sandler in 1964 Rothko is said to have spoken "favorably" of the articles by Rosenblum and Alloway cited above "partly because of their reliance on Burke" (Sandler, *Rothko,* 6, 13, n. 20).

43 Lyotard, *The Postmodern,* 77.

44 Sandler, *Rothko,* 10.

45 Katharine Kuh, "A Maximum of Poignancy," *Saturday Review,* 17 April 1971, 52.

46 Selden Rodman, *Conversations with Artists* (New York: Devin-Adair, 1957), 93.

47 Dore Ashton, "Art: Lecture by Rothko," *New York Times,* 31 Oct. 1958, 26.

48 Rothko, statement, in *Personal Statement: Painting Prophecy, 1950* (Washington, D.C.: David Porter Gallery, 1945).

49 Dore Ashton, "The Rothko Chapel in Houston," *Studio International,* June 1971, 274.

50 Robert Goldwater, "Rothko's Black Paintings," *Art in America,* March 1971, 62.

51 Joseph Liss, "Willem de Kooning Remembers Mark Rothko," *Art News,* January 1979, 42.

52 Selz, *Rothko,* 12.

53 Rothko and Adolph Gottlieb [with Barnett Newman], letter to Edward Alden Jewell, *New York Times,* 7 June 1943, published 13 June 1943, X9 (copy of original in Museum of Modern Art Library, New York); and Dore Ashton, "L'Automne à New York: Letter from New York," *Cimaise,* December 1958, 39.

54 Harold Rosenberg, "Rothko," *New York,* 28 Mar. 1970, 92.

55 Rosenberg, "American Action," 37.

56 "Is today's artist with or against the past? Part 2," editors of *Art News,* September 1958, 40, 58.

57 "Is today's artist with or against the past? Part I," editors of *Art News,* Summer 1958, 27.

58 From his earliest years as a painter, Rothko informed himself about the history of art. Around 1927, when he was cross-examined during his suit against the author of a religious book he had illustrated (without being credited), the author's lawyer hoped to expose the painter's limited expertise "by giving him a kind of oral exam on the representative symbols of various ancient civilizations—Babylonian, Egyptian, Persian, Chaldean; Rothko passed the test and in the process showed that he was already quite familiar with the ancient art collections at the Metropolitan Museum of Art" (James E. B. Breslin, "The Trials of Mark Rothko," *Representations* 16 [Fall 1986]: 31). Such was his continued engagement with the history of art that "sometime in the fifties . . . Rothko jotted down his view of Western art from Egypt to the present. About a hundred pages long, the manuscript was intensely subjective" (Lee Seldes, *Legacy of Mark Rothko* [New York: Holt, Rinehart and Winston, 1978] 347).

59 Eliza Rathbone, "Mark Rothko: The Brown and Gray Paintings," in E. A. Carmen, Jr., Eliza Rathbone and Thomas B. Hess, *American Art at Mid-Century: The Subjects of the Artist* (Washington, D.C.: National Gallery, 1978), 266.

60 The dates assigned to Rothko's pictures in this text should be regarded as approximate, particularly in the case of works painted before 1950, as a reliable chronology of his work remains to be established (although a catalogue raisonné is said to be in the plan-

ning stages at the National Gallery of Art in Washington, D.C.). Most of the dates on the early pictures were inscribed years after the fact when Rothko did an inventory of his work in the late 1960s. The artist remembered *Antigone* as his earliest surrealistic picture, assigning it a date of 1938 and the others a date of 1939 or later. Rothko told Dore Ashton, as well, that he experimented with surrealist automatism as early as 1938 (Ashton, *New York School,* 98). There is no corroborative evidence that he was working in a surrealist idiom quite so early, however, and there is some evidence that he occasionally backdated pictures slightly, perhaps to make the important transitions in his career appear more like clean breakthroughs achieved at somewhat earlier moments than was actually the case. *Number 1,* 1949 (pl. VII), in the Vassar College Art Gallery, for example, was retitled by Rothko *Number 18,* 1948 at the time of his 1961 Museum of Modern Art retrospective, ostensibly because he remembered finishing the picture earlier. And *Number 22,* 1949 (pl. XII), was published in the 1961 exhibition catalogue (Selz, *Rothko*) as *Number 22, 1950* but was later donated by the artist to the museum as *Number 22,* 1949. The date of Rothko's first exhibition of a surrealistic painting—January 1942—suggests that his experiments in this mode date from late in 1941, at least.

61 Edward Alden Jewell, "Toward Abstract or Away? A Problem for Critics," *New York Times,* 1 July 1945, sec. 2, p. 2.

62 Bruce Glaser, "Questions to Stella and Judd," in *Minimal Art: A Critical Anthology,* ed. Gregory Battcock (New York: Dutton, 1968), 157–58.

63 See, for example, Peg Weiss, *Kandinsky in Munich: The Formative Jugendstil Years* (Princeton: Princeton Univ. Press, 1979), 128–32.

64 Seitz, interview with Rothko, 22 Jan. 1952.

65 Rodman, *Conversations,* 93.

66 Barnett Newman, "The Plasmic Image," circa 1943–45, in Thomas B. Hess, *Barnett Newman* (New York: Museum of Modern Art, 1971), 38.

67 Ad Reinhardt, "Monologue," 1966, in *Art as Art: The Selected Writings of Ad Reinhardt,* ed. Barbara Rose (New York: Viking, 1975), 23.

68 George Heard Hamilton, *Painting and Sculpture in Europe, 1880–1940,* rev. ed. (New York: Penguin, 1983), 411.

69 Rothko's position as summarized by Wil-

liam C. Seitz on the basis of interviews (Seitz, *Abstract-Expressionist,* 116). Rothko had other reasons for disliking "Bauhausism," as he termed it: in 1954 the Bauhaus-oriented faculty of the art department at Brooklyn College denied him tenure because he was "too inflexible," that is, unwilling to teach anything besides the "fine" arts. The "Bauhaus philosophy has filled our cultural vernacular with false and facile chatter," Rothko wrote angrily at that time (Seldes, *Legacy,* 27, 30–31).

70 Seitz, *Abstract-Expressionist,* 104.

71 Rothko, *Personal Statement.*

72 Mark Rothko, "The Romantics Were Prompted," *Possibilities* 1 (Winter 1947–48): 84. Kandinsky's move toward abstraction was also influenced by "the nightmare of materialism which turned life into an evil, senseless game" (Vasily Kandinsky, *Concerning the Spiritual in Art* [1912; New York: Wittenborn, 1947]), 24. But Rothko did not become engaged with the mystical traditions that engaged Kandinsky and such pioneer abstract artists as Malevich, Mondrian, and Brancusi. His disinterest in Mondrian was made plain in his interview with Seitz on 22 Jan. 1952. That "he had nothing but contempt . . . for Kandinsky" emerged in conversation with John Fischer in 1959 (Fischer, "Mark Rothko," 22).

73 Rothko, Gottlieb, [Newman], Letter, 13 June 1943, X9.

74 From a theoretical standpoint, this position is most fully articulated by Clement Greenberg, and after him by Michael Fried. Greenberg argued that, "the history of avant-garde painting is that of a progressive surrender to the resistance of its medium; which resistance consists chiefly in the flat picture plane's denial of efforts to 'hole through' it for realistic perspectival space. In making this surrender, painting not only got rid of imitation—and with it, 'literature'—but also of realistic imitation's corollary confusion between painting and sculpture. . . . Painting abandons chiaroscuro and shaded modelling. . . . Most important of all, the picture plane itself grows shallower and shallower, flattening out and pressing together the fictive planes of depth until they meet as one upon the real and material plane which is the actual surface of the canvas" ("Towards a Newer Laocoon," *Partisan Review,* July–August 1940, 307–8). Though Greenberg talked of "purity" (using scare quotes) in relation to this impetus toward the self-definition of the individual

arts, the moral overtones of this drive toward material integrity were emphasized more by Michael Fried in the 1960s, in his criticism of a subsequent generation of artists. Fried cited Wittgenstein's tenet, for example, that "ethics and Esthetics are one and the same," *Tractatus logico-philosophicus* 6.422.

75 Rothko, Sketchbook with writings from the late 1930s, George C. Carson family collection, on extended loan to the Menil Museum, Houston, Texas.

76 Mark Rothko, letter, *New York Times,* 8 July 1945, 2X.

77 Mark Rothko and Adolph Gottlieb, *The Portrait and the Modern Artist,* WNYC broadcast, 13 Oct. 1943; transcript published as "Appendix B" in Lawrence Alloway and Mary Davis MacNaughton, *Adolph Gottlieb: A Retrospective* (New York: Arts Publisher, 1981), 170–71.

78 Peter Wollen, *Semiotic Counter-Strategies: Readings and Writings* (London: Verso Editions, 1982), 95. This formulation or assumption is a standard one, though it is phrased in different terms by various critics. I could equally cite Craig Owens' assertion, for example, that the modernist avant-garde sought to "transcend representation in favor of presence and immediacy; it proclaimed the autonomy of the signifier, its liberation from the tyranny of the signified." I am arguing (with those apostates Owens seeks to counter) that the modernist avant-garde did not eradicate the subject or abolish representation but rather "put the subject of representation in crisis." To look at such icons of modernism as Picasso's *Demoiselles d'Avignon,* with its jarring brothel scene, or Duchamp's *Bride Stripped Bare by Her Bachelors, Even,* for example, and see there no subjects, but only free-floating signifiers, must take a willful act of denial (Owens, "The Discourse of Others: Feminists and Postmodernism," in *The Anti-Aesthetic: Essays on Post-Modern Culture,* ed. Hal Foster [Port Townsend, Wash.: Bay Press, 1983], 59).

79 See, for example, Stephen Polcari, "The Intellectual Roots of Abstract Expressionism: Mark Rothko," *Arts,* September 1979, 124–34; Rathbone, "Rothko," 242–69; as well as my own *Mark Rothko: Subjects* (Atlanta: High Museum of Art, 1983).

80 Stanley Cavell, *Must We Mean What We Say?* (Cambridge: Cambridge Univ. Press, 1976), 198.

81 Richard Wollheim, *Art and Its Objects: An Introduction to Aesthetics* (New York: Harper and Row, Torchbooks, 1971), 103.

82 Rothko, "Romantics," 84.

83 David Couzens Hoy, *The Critical Circle: Literature, History, and Philosophical Hermeneutics* (Berkeley: Univ. of California Press, 1982), 35.

84 "Catalogue for 1948–49," Subjects of the Artist School, excerpt repr. in Carmean et al., *American Art,* 15.

85 Erwin Panofsky, *Meaning in the Visual Arts* (Garden City, N.Y.: Doubleday, Anchor, 1955), 29.

86 For Clement Greenberg, the distinction between content and subject matter was one of conscious intentions "in the sense that every work of art must have content, but that subject matter is something the artist does or does not have in mind when he is actually at work" ("Towards," 301). No art can escape meaning, in other words—meaning attaches itself to all art irrespective of the artist's intentions—but to discern or discuss subject matter is to presuppose an intended program on the artist's part.

87 Greenberg, "Towards," 307.

88 Clement Greenberg, "Art Chronicle: Irrelevance versus Irresponsibility," *Partisan Review,* May 1948, 577.

89 Thomas B. Hess, "Introduction to Abstract," *Art News Annual* 20 (1951): 158.

90 Rosenberg, "American Action," 31.

91 E. de Kooning, "Two Americans," 89.

92 Hess, *Newman,* 33.

93 Panofsky, *Meaning,* 28.

94 Rothko, "Romantics," 84.

95 E. C. Goossen, "Rothko: The Omnibus Image," *Art News,* January 1961, 40.

96 Selz, *Rothko,* 10.

97 Meyer Schapiro, "On Some Problems in the Semiotics of Visual Art: Field and Vehicle in Image-Signs," *Semiotica* 1 (1969): 240.

98 Hubert Damisch, "Semiotics and Iconography," in *The Tell-Tale Sign: A Survey of Semiotics,* ed. Thomas A. Sebeok (Lisse: Peter de Ridder, 1975), 31, 30, 34, 35. My thanks to Maud Lavin for directing me to this essay.

99 Damisch, "Semiotics," 36, 29.

100 Peter Bürger, *Theory of the Avant-Garde,* trans. Michael Shaw (Minneapolis: Univ. of Minnesota Press, 1984), 82.

101 "A Certain Spell," *Time,* 3 Mar. 1961, 75.

102 Packer, "Rothko," 21.

103 Gerhart B. Ladner, "Concept of the Image in the Greek Fathers and the Byzantine Iconoclastic Controversy," *Dumbarton Oaks Papers* 7 (1953): 10. "Years ago, he [Rothko] told me, he had read the Patristic fathers,

especially Origen. He liked what he called the 'ballet' of their thoughts, and the way everything went toward ladders" (Ashton, "Rothko Chapel," 274).

104 *Academic American Encyclopaedia* (Danbury, Conn.: Grolier, 1987), s.v. "Icons."

105 *Collected Papers of Charles Sanders Peirce,* ed. Charles Hartshorne and Paul Weiss (Cambridge: Harvard Univ. Press, 1931–66), 2:249, 4:447; James Feibleman, *An Introduction to Peirce's Philosophy Interpreted as System* (New York: Harper and Brothers, 1946), 91; and Peirce, *Collected Papers,* 2:247.

106 Peirce, *Collected Papers,* 4: 448, 4: 447, 2: 247.

107 As quoted in Dore Ashton, *About Rothko* (New York: Oxford Univ. Press, 1983), 144.

108 Newman, "Plasmic Image," 38.

109 Meredith Anne Skura, *Literary Use of the Psychoanalytic Process* (New Haven: Yale Univ. Press, 1981), 3.

110 William Rubin, "The New York School— Then and Now, Part II," *Art International,* May–June 1958, 19, 20; and "The New York School—Then and Now, Part I," *Art International,* March–April 1958, 24.

## 2 The Mutilated Figure

1 "A Certain Spell," 75.

2 "The Iconoclastic Opinions of M. Marcel Duchamp Concerning Art and America," *Current Opinion,* November 1915, as cited in the "Introduction" to *New York Dada,* ed. Rudolf E. Kuenzli (New York: Willis, Locker and Owens, 1986), 2.

3 "French Artists Spur on an American Art," *New York Tribune,* 24 Oct. 1915, repr. in Kuenzli, ed., *New York,* 132.

4 As cited in Joshua C. Taylor, *America as Art* (New York: Harper and Row, Icon, 1976), 190.

5 Henry McBride, "American Art is Looking Up," *New York Herald,* 15 Oct. 1922, repr. in *The Flow of Art: Essays and Criticisms of Henry McBride,* ed. Daniel Catton Rich (New York: Atheneum, 1975), 165–66. McBride's expectations were evidently fulfilled thirty years later when he visited the "Fifteen Americans" exhibition at the Museum of Modern Art—in which Rothko and Still were included: "A few American artists, at long last, seem to have gone completely native, and for the first time since these wars it has not been necessary to stumble over references to Matisse, Juan Gris, Leger, etc., etc. before arriving at the exhibitor's part of the work. . . . A new cycle begins" (McBride, "Half Century or Whole Cycle?" *Art News,* June–August 1952, 125).

6 Fernand Leger, "New York," 1931, repr. in *Functions of Painting,* ed. Edward F. Fry, trans. Alexandra Anderson (New York: Viking, 1973), 86.

7 See, for example, Guilbaut, *How New York;* Kozloff, "American Painting"; Eva Cockcroft, "Abstract Expressionism, Weapon of the Cold War," *Artforum,* October 1973, 48–52; David and Cecile Shapiro, "Abstract Expressionism: The Politics of Apolitical Painting," *Prospects* 3 (1977): 175–214.

8 Henry McBride, "American Expatriates in Paris," *Dial,* April 1929, repr. in *The Flow,* ed. Rich, 256.

9 In the 1950s Rothko was heard to refer derisively to Ben Shahn as "essentially a journalist" (Rodman, *Conversations,* 93), and "a kind of cheap propagandist" (Fischer, "Mark Rothko," 22).

10 Rothko was less forthright about the debt to Weber or Marin than that to Avery, the friend and mentor who painted Rothko on numerous occasions: "During those early years . . . in those memorable studios. . . . [w]e were there, both the subjects of [Avery's] paintings and his idolatrous audience" (Rothko, "Commemorative Essay," 1965, in Adelyn Breeskin, *Milton Avery* [Washington, D.C.: National Collection of Fine Arts, 1969]).

11 Max Weber, *Essays on Art* (New York, 1916), 10, 12. This book was published nine years before Rothko studied with Weber, and in the interim he became more explicitly focused on depicting Jewish experience.

12 "Whitney Symposium," *Art Digest,* 1 May 1933, 6.

13 Wallace Putnam, "Mark Rothko Told Me," *Arts,* April 1974, 45.

14 Lee Simonson, "The Painter and His Subject, Part I," *Creative Art,* July 1928, xxvi.

15 Jacob Kainen, "Tribute to Mark Rothko, Part 1," *Potomac Magazine,* Sunday supplement to the *Washington Post,* 4 Apr. 1971, 44.

16 Ashton, "Rothko Chapel," 274.

17 Rothko's father reportedly had his youngest son, alone of all his children, undergo this training and regarded the act of sending a child to *cheder* as a defiant political gesture, made in response to a particular affront against the Jewish community (Breslin, "Trials," 10–12).

18 Seldes, *Legacy,* 36; and Paul Gardner, "The Ordeal of Kate Rothko: The War Isn't Over in Marlborough Country," *New York,* 7 Feb.

1977, 47. In the latter article, Kate Rothko is further quoted as saying that she had heard her father speak Hebrew but not Russian, though she was told he still had some command of the language.

9 "The people who weep before my pictures are having the same religious experience I had when I painted them" (Rodman, *Conversations* 93–94). The offer to build a "small chapel of expiation" in Germany was made to Werner Haftmann in 1959 (Haftmann, untitled essay, trans. Margery Schärer, in Felix Andreas Baumann, comp., *Mark Rothko* [Kunsthaus Zurich; New York: Marlborough Gallery, 1971], ix).

20 Ashton, "Rothko Chapel," 274.

21 E. de Kooning, "Two Americans," 176.

22 Jacob Kainen, "Our Expressionists," *Art Front,* February 1937, 14.

23 Rothko, "Romantics," 84.

24 Joseph Solman, "Easel Division of the W. P. A. Federal Art Project," in *New Deal Art Projects: An Anthology of Memoirs,* ed. Francis V. O'Connor (Washington, D.C.: Smithsonian Institution, 1972), 122.

25 Mark Rothko and Bernard Braddon, *The Ten: Whitney Dissenters* (New York: Mercury Galleries, 1938), excerpts repr. in "Whitney Dissenters," *Art Digest,* 15 Nov. 1938, 9.

26 Herbert Lawrence, "The Ten," *Art Front,* February 1936, 12. Jacob Kainen and Charmion von Wiegand took similar positions; the latter, for example, wrote, "Only now, after seven years of economic stagnation and unemployment, has the American artist began [*sic*] to revolt against the conditions of capitalist society. Only now has appeared a situation favorable to the creation of Expressionist art in the United States. Expressionism as a form in art . . . arises always in a period of great social change when the individual is forced to repudiate the principles on which society is built. Rebelling violently but without program, he turns to the inner voice of conscience and to his own repressed instincts for new wisdom and guidance. . . . the general movement of Expressionism which seeks to break up the old forms is *forward* moving. Its destructive activism is necessary in clearing the ground for future building" ("Expressionism and Social Change," *Art Front,* November 1936, 10).

27 Oskar Pfister, *Expressionism in Art: Its Psychological and Biological Basis* (London: Kegan Paul, Trench, Trubner, 1922; New York, 1923), 210–11. Pfister, (1873–1956), a Swiss pastor who practiced psychoanalysis, was friendly with both Freud and Jung. Pfister is mentioned in Rothko, sketchbook, Carson family collection.

28 Pfister, *Expressionism,* 160.

29 Kainen, "Our Expressionists," 14.

30 Lukacs, as excerpted in and translated by Benjamin H. D. Buchloh, "Figures of Authority, Ciphers of Regression: Notes on the Return of Representation in European Painting," 1981, repr. in Brian Wallis, ed., *Art After Modernism: Rethinking Representation* (New York: New Museum of Contemporary Art; Boston: David R. Godine, 1984), 131–32.

31 Buchloh, "Figures," 108, 121.

32 Quotation from Rothko and Braddon, *Whitney Dissenters,* cited in Diane Waldman, *Mark Rothko, 1903–1970: A Retrospective* (New York: Solomon R. Guggenheim Museum, 1978), 31.

33 Rothko, Gottlieb, [Newman], letter, 13 June 1943, X9.

34 Useful historical information on Dvinsk and a discussion of Rothko's memories and fabricated memories of his early experiences in Russia can be found in Breslin, "Trials," 8–12. In particular, Rothko told numerous people either that he had heard accounts of or witnessed himself the forced digging of a mass grave by Jews, for Jews, in the woods near Dvinsk—sometimes intimating that this memory of a large, square, shallow grave helped inspire the large, shallow squares in his pictures (see, for example, "Bud Hopkins on Bud Hopkins," *Art in America,* Summer 1973, 92–93); Breslin notes, however, that "there were no mass graves in any of the Russian pogroms" and suggests that Rothko effectually "appropriated the holocaust to his own experience," thereby expressing an "emotional reality" rather than a historical one.

35 Cynthia Jaffee McCabe, *The Golden Door: Artist-Immigrants of America, 1876–1976* (Washington, D.C.: Hirshhorn Museum, Smithsonian Institution, 1976), 163.

36 Ashton, "Rothko Chapel," 274.

37 Fischer, "Mark Rothko," 17.

38 In a letter to his high school magazine (undated issue, between December 1920 and March 1921) Rothko complained specifically of "race prejudice" in the selection of club members: "Anyone who has a name ending in 'off' or 'ski' "—and, one supposes, 'witz'—"is taboo and branded a Bolshevik" (Breslin, "Trials," 17).

39 Although it has been variously reported that Rothko was a math or a science major at Yale, according to the university's records

(which do not list a major) his courses included two years of English (Chaucer, Spenser, Shakespeare, Milton, Pope, and Byron), two years of French ("translation of recent authors"), European History, Elementary Mathematics, Elementary Physics, General Biology ("study of the lower forms of life," "the structure and function of man," and "the heredity and evolution of organisms in general"), Elementary Economics, History of Philosophy, and General Psychology ("dealing primarily with the mental life of the normal human being").

40 Marcus Rothkowitz, Aaron Harry Director, and Simon Whitney (essays in the *Pest* did not have bylines), "Leaders in the Making," *Yale Saturday Evening Pest,* 7 Apr. 1923, Yale University Archives, Sterling Library; and the *Pest,* 17 Feb. 1923.

41 New Haven Journal-Courier, 19 Mar. 1923, as cited in the *Pest,* 24 Mar. 1923; the *Pest,* 26 May 1923; and the *Pest,* 26 May 1923.

42 Fischer, "Mark Rothko," 17.

43 Solman, "W.P.A.," 119–20.

44 Martha Davidson, "Government as a Patron of Art," *Art News,* 10 Oct. 1936, 12.

45 Martha Davidson, "Art or Propaganda? Problems of the Artists' Congress," *Art News,* 25 Dec. 1937, 14.

46 H. R. Hays, as quoted in Waldman, *Mark Rothko,* 31.

47 Rothko, "Romantics," 84.

48 Ashton, "Art: Lecture," 26.

49 Meyer Schapiro, "The Nature of Abstract Art," 1937, repr. in his *Modern Art, Nineteenth and Twentieth Centuries: Selected Papers* (New York: Braziller, 1978), 202.

50 Meyer Schapiro, "The Liberating Quality of Avant-Garde Art," 1957, repr. as "Recent Abstract Painting" in his *Modern Art,* 217.

51 André Breton, "André Masson," 1939, repr. in his *Surrealism and Painting,* trans. Simon Watson Taylor (New York: Harper and Row, Icon, 1972), 151. The reader should not assume that Rothko was familiar with specific texts cited here unless he is explicitly said to have read them; quotations such as the present one are intended simply to illustrate contemporaneous ideas to which Rothko would likely have been exposed through one channel or another.

52 Barnett Newman, "What About Isolationist Art?" 1942, published in part in Hess, *Newman,* 35.

53 Mary Fuller, "Was There a San Francisco School?" *Artforum,* January 1971, 48. Rothko taught with Clyfford Still at the California School of Fine Arts in San Francisco in the summers of 1947 and 1949.

54 William C. Seitz, notes from an interview

with Rothko on 1 Apr. 1953, Seitz Papers, Archives of American Art, Washington, D.C.

55 Sandler, *Triumph,* 181, 183. William Rubin likewise recalled that Rothko "was always anxious lest he be taken for a painter in the vein of Matisse, whom he nonetheless dearly loved" (Rubin, "Mark Rothko, 1903–1970," *New York Times,* 8 Mar. 1970, sec. 2, p. 21). In 1954, years after he had stopped titling pictures altogether (but for numbers; the titles involving colors were almost certainly not given by Rothko), he painted an *Homage to Matisse,* who had died that year. After 1949, when it was permanently installed at the Museum of Modern Art, Rothko developed a special attachment to Matisse's *Red Studio* (Ashton, *About Rothko,* 112–13, 187).

56 E. de Kooning, "Two Americans," 94.

57 A. M. F. [Alfred M. Frankfurter], "Editor's Review; The Year in Art: A Review of 1940," *Art News,* 28 Dec. 1940, 10.

58 A. M. F. [Alfred M. Frankfurter], "Vernissage," *Art News,* 1–14 Oct. 1941, 7.

59 Wolfgang Paalen, "The New Image," trans. Robert Motherwell, *Dyn,* Apr.–May 1942, 7.

60 Max Kozloff, "An Interview with Matta," *Artforum,* September 1965, 25.

61 Sidney Simon, "Concerning the Beginnings of the New York School, 1939–1943: An Interview with Peter Busa and Matta Conducted in December 1966," *Art International,* Summer 1967, 18.

62 Simon, "Interview with Busa and Matta," 18.

## 3 Mythmaking

1 As cited in Marcel Jean, ed., *Autobiography of Surrealism* (New York: Viking, 1980), 123.

2 Jean, ed., *Autobiography,* 123.

3 See Martica Sawin, "The Cycloptic Eye, Pataphysics, and the Possible: Transformations of Surrealism," in Paul Schimmel, comp., *The Interpretive Link: Abstract Surrealism into Abstract Expressionism: Works on Paper, 1938–1948* (Newport Beach, Calif.: Newport Harbor Art Museum, 1986).

4 Gordon Onslow-Ford, *Towards a New Subject in Painting: Gordon Onslow-Ford* (San Francisco: San Francisco Museum of Art, 1948), 11, 12, 28, 16.

5 John Graham, *System and Dialectics of Art* (1937; repr., Baltimore: Johns Hopkins Press, 1971), 95. In the 1960s Rothko told Eila Kokkinen, a Graham specialist, that he had perused Graham's book when it was first published but that he had not read it

carefully (personal conversation with Kokki-nen, Summer 1978).

6 Rothko, "Romantics," 84.

7 "Sculpture Kick-Off Title: The Spontaneous and Design, Part I," transcript of a panel discussion, *It Is* 6 (Autumn 1965): 8.

8 Newman, "Plasmic Image," 39.

9 James Johnson Sweeney, *Joan Miró* (New York: Museum of Modern Art, 1941), 13.

10 Paalen, "New Image," 7.

11 Paalen, "New Image," 8.

12 André Breton, "Artistic Genesis and Perspective of Surrealism," 1941, repr. in *Surrealism and Painting,* 68.

13 Gordon Onslow-Ford, statement quoted by Mona Hadler in "William Baziotes: Four Sources of Inspiration," in *William Baziotes* (Newport Beach, Calif.: Newport Harbor Art Museum, 1978), 82.

14 Hess, *Newman,* 43.

15 See Jacques Derrida, "Freud and the Scene of Writing," in *Writing and Difference,* trans. Alan Bass (Chicago: Univ. of Chicago Press, 1978), 230.

16 *Greek Anthology,* trans. W. R. Paton (London: W. Heinemann, 1916–18), vol. 3, bk. 9, no. 10.

17 A decade before the surrealists, Kandinsky had taken this position, that viewers would be affected by veiled images even if they were not consciously aware of the significance of those images; Rothko never became engaged with Kandinsky's art as he did with the surrealists', however.

18 Seitz, notes from an interview with Rothko, 25 Mar. 1953, Seitz Papers, Archives of American Art, Smithsonian Institution, Washington, D.C.

19 Sidney Simon, "Concerning the Beginnings of the New York School, 1939–1943: An Interview with Robert Motherwell Conducted in January 1967," *Art International,* Summer 1967, 23.

20 Rothko, "Romantics," 84.

21 Simon, "Interview with Motherwell," 23. One of Rothko's studio assistants from his later years recalled that his "brushes were a big thing with him. They felt like velvet, those brushes, because they were very, very old and they'd been so well taken care of." Except for the backgrounds, the paintings were "all done with brushes. That's the marvelous thing. He had such a *touch* with a brush," Roy Edwards and Ralph Pomeroy, "Working with Rothko," *New American Review* 12 (1971): 115–16.

22 Rodman, *Conversations,* 82.

23 Onslow-Ford, *Towards,* 47, 38.

24 Haftmann, essay, ix. Quotation is from a conversation in 1959.

25 Quoted in Waldman, *Mark Rothko,* 39.

26 David Sylvester, "Interview with Adolph Gottlieb," *Living Arts,* June 1963, 4–5.

27 Ashton, "L'Automne," 39; and Haftmann, essay, ix.

28 Quoted in Hess, "Rothko," 73.

29 Friedrich Nietzsche, *Birth of Tragedy and the Genealogy of Morals,* trans. Francis Golffing (Garden City, N.Y.: Doubleday, Anchor, 1956), 136.

30 Seitz, *Abstract-Expressionist,* 8. Rothko may first have read Nietzsche at Yale, as a (misspelled) mention of the philosopher's name appeared in the 28 Apr. 1923 issue of the *Pest.*

31 Nietzsche, *Birth,* 53.

32 Nietzsche, *Birth,* 124. Pfister also conceived of art as promising a kind of redemption: "In all art there lies a symbolic overcoming of the sufferings of Reality with a view to transfiguration of the world" (Pfister, *Expressionism,* 236).

33 Nietzsche, *Birth,* 136–37.

34 Rothko, "Romantics," 84.

35 Nietzsche, *Birth,* 54.

36 Cavell, *Must We Mean,* 157.

37 Rothko, Gottlieb, [Newman], letter, 13 June 1943, X9; and Rodman, *Conversations,* 93–94.

38 Rothko, Gottlieb [Newman], letter, 13 June 1943, X9; Rothko, personal draft for collaborative letter to the *New York Times,* George C. Carson family collection (on extended loan to the Menil Museum, Houston, Texas); Rothko, *Personal Statement.*

39 Rothko, personal draft for collaborative letter to the *New York Times,* published in part in Bonnie Clearwater, "Shared Myths: Reconsideration of Rothko's and Gottlieb's Letter to *The New York Times,*" *Archives of American Art: Journal* 24, no. 1 (1984): 25. The collaborative, published version of this statement was "To us art is an adventure into an unknown world which can be explored only by those willing to take the risks."

40 André Breton, "Prolegomena to a Third Manifesto of Surrealism or Else," *VVV,* June 1942, 22.

41 Edward Renouf, "On Certain Functions of Modern Painting," *Dyn,* July–August 1942, 20.

42 Renouf, "On Certain Functions," 22.

43 Nietzsche, *Birth,* 94, 52.

44 Terry Eagleton, *Literary Theory: An Introduction* (Minneapolis: Univ. of Minnesota Press, 1983), 41. Milton Avery's widow, Sally Avery, recalled that Rothko was reading *The Waste Land* when he vacationed with them in the 1930s (interview with Tom

Wolf on 19 Feb. 1982, on file at the Archives of American Art).

45 Mircea Eliade, *The Myth of the Eternal Return or, Cosmos and History*, trans. Willard R. Trask (1949; Princeton, N.J.: Princeton Univ. Press, 1965), 153.

46 Rothko, sketchbook, Carson family collection.

47 Rubin, "Mark Rothko," 21.

48 Selz, *Rothko*, 12.

49 Re *Either/Or*, see Seldes, *Legacy*, 100. Dore Ashton referred to Rothko's "frequentes allusions à Kierkegaard, en particulier à *Crainte et Tremblement*," in Ashton, "La Voix du Tourbillon dans l'Amerique de Kafka," *XX$^e$ Siècle*, May 1964, 94.

50 Soren Kierkegaard, *Either/Or*, trans. David F. Swenson and Lillian Marvin Swenson (Princeton, N.J.: Princeton Univ. Press, 1971), 1:141.

51 Rothko, letter, 8 July 1945, 2X.

52 Oscar Collier, "Mark Rothko," *New Iconograph*, Fall 1947, 41.

53 Sidney Janis, *Abstract and Surrealist Art in America* (New York: Reynal and Hitchcock, 1944), 118.

54 The imagery at the base of this picture is similar to the aggregate of hoofs and feet at the base of Max Ernst's *The Bride and the Bridegroom of the Wind*, 1926 (reproduced in Breton, *Surrealism*, 30).

55 Ernst Cassirer, *An Essay on Man: An Introduction to a Philosophy of Human Culture* (1944; repr., New Haven: Yale Univ. Press, 1962), 82.

56 Aeschylus, *Oresteia: Agamemnon, The Libation Bearers, The Eumenides*, trans. Richmond Lattimore (Chicago: Univ. of Chicago Press, 1953); *Agamemnon* 228–30, 240–42.

57 Aeschylus, *Agamemnon* 48–54; and *Libation Bearers* 258, 247.

58 J. E. Cirlot, *Dictionary of Symbols*, trans. Jack Sage, 2d ed. (New York: Philosophical Library, 1971), 91.

59 Barnett Newman, "The New Sense of Fate," 1945, in Hess, *Newman*, 43.

60 Newman, "New Sense," 42.

61 Aeschylus, *Agamemnon* 250–51, 121, 138, 159.

62 Aeschylus, *Eumenides* 867–69.

63 Robert Goldwater, "Genesis of a Picture: Theme and Form in Modern Painting," *Critique*, October 1946, 12.

64 Rothko, "Romantics," 84.

65 Mark Rothko, "Preface" in *Clyfford Still* (New York: Art of This Century Gallery, 1946), excerpt repr. in Lawrence Alloway, "Residual Sign Systems in Abstract Expressionism," *Artforum*, November 1973, 38–39.

66 Rothko, letter, 8 July 1945, 2X.

67 Adolph Gottlieb, statement in "Ides of Art: Attitudes of Ten Artists on their Art and their Contemporaneousness," *Tiger's Eye*, December 1947, 43.

68 Rothko, letter, 8 July 1945, 2X.

69 Howard Devree, "Diverse New Shows," *New York Times*, 9 Mar. 1947, sec. 2, p. 7.

70 Edward Alden Jewell, "Art: Diverse Shows," *New York Times*, 14 Jan. 1945, sec. 2, p. 8.

71 Seitz, interview with Rothko, 25 Mar. 1953.

72 Rothko and Gottlieb, *Portrait*, 171.

73 Rothko, *Personal Statement*.

74 Cassirer, *Essay*, 81. If Rothko himself did not read Cassirer, he most likely read a Cassirer-influenced essay, "On Mythology," by Andrea Caffi, because reproductions of his paintings were interleafed with it in *Possibilities* (Winter 1947–48), 87–95. Caffi argued that mythology is as necessary and germane to "civilized" societies as to "primitive" societies; and by the term "mythology," Caffi meant "what everyone else understands as language, literature, art, religion, philosophy, science, etc."

75 Ernst Cassirer, *Myth of the State* (New Haven: Yale Univ. Press, 1946), 43.

76 M. Merleau-Ponty, *Phenomenology of Perception*, trans. Colin Smith (London: Routledge and Kegan Paul, 1962), 291.

77 Carl Gustav Jung, "Preface," *Psyche and Symbol: A Selection from the Writings of C. G. Jung*, ed. Violet S. deLászló (Garden City, N.Y.: Doubleday, Anchor, 1958), xvi. Whether, or to what extent, Rothko read Freud and Jung is not clear. Rothko recalled that he was "very much interested in the Oedipus myth" by 1938, according to Dore Ashton (*New York School*, 98). A studio assistant who worked with Rothko in the 1960s formed the decided impression that Rothko was versed in Jung's writings; said Dan Rice, Rothko "wanted to reach the deeper level in each human being, very much like Jung's writings—oddly enough, I never spoke directly to Mark about it, but you know he was a widely read man and I'm sure that he knew Jung's writings quite accurately" (Arnold Glimcher, "Dan Rice Interviewed by Arnold Glimcher," in *Rothko: The 1958–1959 Murals* [New York: Pace Gallery, 1978], n. pag.). Artists that Rothko knew early on were at least superficially familiar with and excited by the ideas of Freud and Jung; David Smith (whom Rothko had known since the early 1930s) wrote in 1940 that Freud "had been the greatest single influence on the theoretical side of contemporary art, providing an ana-

lytical system for establishing the reality of the unconscious, that region of the mind from which the artist derives his inspiration and proclaims the super reality which permits use of all manifest experience" (Garnett McCoy, ed., *David Smith* [New York: Praeger, 1973], 40).

78 Jung acknowledged that "The theory of preconscious primordial ideas is by no means my invention, as the term 'archetype,' which belongs to the first century of our era, denotes. With special reference to psychology we find this theory in the works of Adolf Bastian and then again in Nietzsche. . . . I gave only an empirical foundation to the theory of what were called formerly primordial or elementary ideas" (Jung, *Psychology and Religion* [New Haven: Yale Univ. Press, 1938], 64).

79 Jung, *Psychology,* 61, 11, 41.

80 Morris Philipson, *Outline of a Jungian Aesthetics* (Evanston, Ill.: Northwestern Univ. Press, 1963), 38.

81 "Point of *View:* An Editorial," 3d ser. April 1943, 5.

82 Rothko and Gottlieb, *Portrait,* 171.

83 Seitz, interview with Rothko, 25 Mar. 1953.

84 Douglas MacAgy, "Mark Rothko," *Magazine of Art,* January 1949, 21.

85 Rothko, *Personal Statement.*

86 Mircea Eliade, *The Sacred and the Profane: The Nature of Religion,* trans. Willard R. Trask (New York: Harcourt Brace, 1959), 213.

87 Joseph Campbell, *Hero with a Thousand Faces* (1949) 2d ed. (Princeton, N.J.: Princeton Univ. Press, 1968), 4. During the winter of 1949–50, Campbell lectured at the Club, a New York artists' organization the activities of which Rothko, a nonmember, attended from time to time (Irving Sandler, "The Club," *Artforum,* September 1965, 30).

88 T. S. Eliot, "Ulysses, Order and Myth," 1923, repr. in *James Joyce: Two Decades of Criticism,* ed. Seon Givens (1948) New York: Vanguard, 1963), 198, 201–2. Some artists in Rothko's circle were intrigued by Joyce. Newman was inspired by *Ulysses* to attempt automatic writing (Hess, *Newman,* 43). Motherwell did a painting called *Ulysses* in 1947 and titled his ex post facto "self-portrait," the *Homely Protestant* of 1948, by pointing spontaneously to a phrase "in either *Ulysses* or *Finnegan's Wake* (I forget which)," (H. H. Arnason, *Robert Motherwell* [New York: Abrams, 1977], n. pag.). Motherwell recalled talking to David Smith in the 1940s about the French symbolists and having Smith reply: "I don't know

about those guys, I don't read French, but I don't need them. I've read James Joyce!" Commented Motherwell: "He was right, all of it is in *Ulysses*" (Motherwell, "A Major American Sculptor: David Smith," *Vogue,* 1 Feb. 1965, 135).

89 Merleau-Ponty, *Phenomenology,* 292, 293.

90 Cassirer, *Essay,* 25.

91 Campbell, *Hero,* 269, 12.

92 Robert Graves, *The White Goddess: A Historical Grammar of Poetic Myth* (1948) rev. ed. (New York: Farrar, Straus and Giroux, 1976), 21.

93 Cassirer, *Essay,* 84.

94 John B. Vickery, *Literary Impact of the Golden Bough* (Princeton, N.J.: Princeton Univ. Press, 1973), 235.

95 Those surrealists who were most interested in myth were aware of *The Golden Bough.* Kurt Seligmann, for example, acknowledged Frazer in his book, *The Mirror of Magic* (New York: Pantheon, 1948). According to Robert C. Hobbs, who bases his statement on a conversation with Motherwell in February 1975, "Sir J. G. Frazer's *Golden Bough . . .* was known by all of these artists," that is, by the artists of the New York School (Barbara Cavaliere and Hobbs, "Against a Newer Laocoon," *Arts,* April 1977, 111). Rothko indicated his awareness of *The Golden Bough* in conversation with John Fischer in 1961; noting how younger artists gradually displace older ones in the public eye, Rothko remarked, "The kings die today in just the same way they did in Frazer's *Golden Bough*" (Fischer, "Mark Rothko," 22).

96 Rothko, "Romantics," 84.

97 Rothko and Gottlieb, *Portrait,* 171.

98 Rothko, in Janis, *Abstract and Surrealist,* 118.

99 Rothko, *Still,* excerpt repr. in Alloway, "Residual Sign," 38–39.

100 Rothko and Gottlieb, *Portrait,* 171; and Clearwater, "Shared Myths," 24.

101 Rothkowitz, Director, and Whitney, *Pest,* 2 Feb. 1923 and 3 Mar. 1923.

102 Wilhem Viola, *Child Art,* 2d ed. (Kent: Univ. of London Press, 1944), 18. This book is an exegesis of Cizek's theories with lengthy quotations from Cizek. Rothko's considerable enthusiasm for Cizek is expressed in his sketchbook (Carson family collection), where the first edition of this book (cited below) is quoted at length.

103 Wilhelm Viola, *Child Art and Franz Cizek* (Vienna, 1936), 34.

104 Viola, *Child Art,* 2d ed., 20.

105 Viola, *Child Art and Franz Cizek,* 26.

106 Rothko and Braddon, *Whitney Dissenters,* excerpt repr. in Waldman, *Mark Rothko,* 31.

107 J. L. [Jeannette Lowe?], "Three Moderns: Rothko, Gromaire, and Solman," *Art News,* 20 Jan. 1940, 12.

108 Rothko and Gottlieb, *Portrait,* 171.

109 Newman, "New Sense," 43, 41.

110 Rothko, letter, 8 July 1945, 2X.

111 Waldman, *Mark Rothko,* 42.

112 Clearwater, "Shared Myths," 24.

113 Merleau-Ponty, *Phenomenology,* 290, 292.

114 Franz Boas, *Primitive Art* (1927; repr. New York: Dover, 1955), 7. (At least one member of Rothko's circle was enthusiastic about Boas' writings; see McCoy, ed., *David Smith,* 58, 64.)

115 Rothko, *Still,* excerpt repr. in Alloway, "Residual Sign," 39.

116 Rothko and Gottlieb, *Portrait,* 171.

117 Newman, "Plasmic Image," in Hess, *Newman,* 37.

118 Nietzsche, *Birth,* 55.

119 Rothko, letter to Barnett Newman, 31 July 1945, Archives of American Art, Newman Papers. My thanks to Michael Leja for bringing this letter to my attention.

120 Seitz, interview with Rothko, 25 Mar. 1953.

121 Rothko, *Personal Statement.*

122 Seitz, interview with Rothko, 25 Mar. 1953.

123 Rothko, *Personal Statement.*

124 Rothko, "Romantics," 84.

125 Barnett Newman, "Introduction," to *The Ideographic Picture* (New York: Betty Parsons Gallery, 1947).

126 Jackson Pollock, "My Painting," *Possibilities* 1 (Winter 1947–48): 79; Hans Hofmann, "Painting and Culture," 1931, in *Search for the Real and Other Essays,* eds. Sara T. Weeks and Bartlett H. Hayes, Jr., rev. ed. (Cambridge: MIT Press, 1967), 55; Graham, *System,* 168; Rothko, "Ides of Art," 44.

127 Rothko, Gottlieb, [Newman], letter, 13 June 1943, X9.

## 4 The Portrait and the Landscape: Microcosm and Macrocosm

1 Rothko, "Romantics," 84.

2 Rothko, "Romantics," 84.

3 Sandler, *Triumph,* 183.

4 Seitz, interview with Rothko, 22 Jan. 1952.

5 So he said in his lecture at Pratt in 1958 (Ashton, "L'Automne," 38).

6 Ashton, "Art: Lecture," 26.

7 Rothko and Gottlieb, *Portrait,* 170.

8 Rothko and Gottlieb, *Portrait,* 170.

9 Waldman, *Mark Rothko,* 45.

10 Cirlot, *Dictionary,* 306.

11 See, for example, Robert Hobbs' discussion of the symbolism of the spiral in relation to Smithson's *Spiral Jetty* (Hobbs, *Robert Smithson: Sculpture* [Ithaca, N.Y.: Cornell Univ. Press, 1981], 35, 194–95).

12 Cirlot, *Dictionary,* 281. Some other of Rothko's pictures from this period were given aquatic settings—*Figure in Archaic Sea, Oceanea, Sea Animals, Sea Birds,* and *Aquatic Drama,* for example. At least two other paintings have titles referring to spiraling movements—*Gyrations on Four Elements* and *Gyrations on Four Planes.*

13 Rothko, letter to Newman, 31 July 1945.

14 Rothko, *Tiger's Eye,* October 1949, 114.

15 Rothko, Gottlieb [Newman], letter, 13 June 1943, X9.

16 Seitz, interview with Rothko, 25 Mar. 1953.

17 Clearwater, "Shared Myths," 24.

18 F. M. W. [Francesca M. Wilson], *The Child as Artist: Some Conversations with Professor Cizek* (London: Children's Art Exhibition Fund, 1921), 3.

19 Rudolf Arnheim, *Art and Visual Perception: A Psychology of the Creative Eye,* rev. ed. (Berkeley: Univ. of California Press, 1974), 141.

20 That Rothko was himself prone to seeing abstract shapes in a symbolic way is suggested by an anecdote related by Dore Ashton: when Rothko was visiting the studio of Toti Scialoja, a painter, in Rome in 1966 he "looked seriously at one of Scialoja's abstractions with vertical forms and finally said, 'I can understand that two are man and woman, three are man, woman and child, but five are nothing.'" Scialoja noted that Rothko "tended to look at painting as a message," that "[il] voyait avec des yeux symbolique" (Ashton, *About Rothko,* 181–82).

21 Seitz, interview with Rothko, 22 Jan. 1952.

22 Rothko and Gottlieb, *Portrait,* 170.

23 Rothko, "Romantics," 84.

24 Ashton, "Art: Lecture," 26.

25 Rothko, "A Symposium," 104. In 1959, while he was making up his mind to refuse the commission for the restaurant in the Seagram's building, Rothko declared in conversation with John Fischer, "I've come to believe that no painting should ever be displayed in a public place" (Fischer, "Mark Rothko," 16).

26 Schjeldahl, "Art and Belief," 82.

27 Ashton, *About Rothko,* 166–67. Around 1957 Kenzo Okada, the painter, told an interviewer in broken English about a visit to Rothko's studio: "Mark had big one and small one other day at his studio. I look at

big one and say, 'A sad Jewish grandmother!' and then at small one: 'Her daughter!' Mark glad to hear that" (Rodman, *Conversations*, 96).

28 Rathbone, "Mark Rothko," 256.

29 Rothko, letter, 8 July 1945, 2X.

30 Lawrence Alloway, "The Spectrum of Monochrome," *Arts*, December 1970, p. 32.

31 Schjeldahl, "Art and Belief," 82.

32 Brian O'Doherty, *American Masters: The Voice and the Myth* (New York: Random House, 1973), 164.

33 E. de Kooning, "Two Americans," 176.

34 Wollheim, *Art*, 27, 32.

35 Wollheim, *Art*, 29, 97.

36 Wollheim, *Art*, 97, 120.

37 Dore Ashton, "Art: Mark Rothko," *Arts and Architecture*, August 1957, 8, 31.

38 See Victor Shklovsky, "Art as Technique," 1917, repr. in *Russian Formalist Criticism: Four Essays*, trans. and ed., Lee T. Lemon and Marion J. Reis (Lincoln: Univ. of Nebraska Press, 1965).

39 Rothko, letter, 8 July 1945, 2x.

40 Barnett Newman wrote a brief statement in 1944 for the brochure accompanying an exhibition of Gottlieb's drawings (at the Wakefield Gallery in New York) that was premonitory of Rothko's approach to the figure: "In the art of the Western world, [the human figure] has always stayed an object, a grand heroic one, to be sure . . . , [but] an object nevertheless. The artist never dared to contemplate the human figure in terms of body and soul. That he left to the poets and philosophers." Newman congratulated Gottlieb for facing "the age-old philosophic problem of mind and matter, the flesh and the spirit, on equal grounds with the philosophers." In his pictures, as Newman saw them, "The body is no devil. Rather it is a great imp, ephemeral, unmoral, and mortal—a cloud-like reality. In these burning heads that are the soul there glows that inner splendor, the 'dry-light' of man's eternal quest for salvation."

41 As quoted in Boris Eichenbaum, "Theory of the 'Formal Method,'" 1926, repr. in *Russian Formalist*, ed. and trans. Lemon and Reis, 118.

42 Theodor W. Adorno, "Music and Technique," *Telos* 32 (Summer 1977): 83.

43 Katharine Kuh, "Mark Rothko," *Art Institute of Chicago Quarterly*, 15 Nov. 1954, 68.

44 "Certain Spell," 75.

45 Rothko, Gottlieb, [Newman], letter, 13 June 1943, X9.

46 Ashton, *About Rothko*, 144; and E. de Kooning, "Two Americans," 174.

47 Kuh, "Mark Rothko," 68.

48 Sandler, *Rothko*, 11.

49 Wollen, *Semiotic*, 102.

50 Harold Bloom, *Anxiety of Influence: A Theory of Poetry* (London: Oxford Univ. Press, 1973), 109.

51 Dorothy Seiberling, "Part 1: Baffling U.S. Art: What is it About?" *Life*, 9 Nov. 1959, 68–80, and "Part 2: The Varied Art of Four Pioneers," *Life*, 16 Nov. 1959, 74–86, with section on "Mark Rothko: Luminous Lines to Evoke Emotions and Mystery," 82–83.

52 Donald McKinney, "Introduction," in Baumann, *Mark Rothko*, xiii.

53 Rathbone, "Mark Rothko," 269. The artist Stephen Pace asked Rothko whether his work was about landscape, and Pace reported Rothko's reply in conversation with Rathbone.

54 Andrew Carnduff Ritchie, *Salute to Mark Rothko* (New Haven: Yale University Art Gallery, 1971), n. pag.; and Kynaston McShine, ed., *Natural Paradise: Painting in America, 1800–1950* (New York: Museum of Modern Art, 1976).

55 Joseph Liss, "A Portrait by Rothko," *East Hampton Star*, 2 Sept. 1976 (ms. in Whitney Museum of American Art Library); and Dore Ashton, "Oranges and Lemons: An Adjustment," *Arts*, February 1977, 142.

56 Rosenblum, *Modern Painting*, 10–11, 212–18, and passim.

57 Rosenblum, "Abstract Sublime," 353.

58 Rosenblum, *Modern Painting*, 214.

59 Charles Moritz, ed., *Current Biography Yearbook* (New York: H. W. Winston, 1961), 399.

60 Seitz, interview with Rothko, 25 Mar. 1953. In an interview by Seitz on 22 Jan. 1952, Rothko observed, "Mondrian divides a canvas; I put things on it."

61 Rothko, *Personal Statement*.

62 G. W. F. Hegel, *Phenomenology of Mind*, trans. J. B. Baillie (New York: Harper and Row, Colophon, 1967), 791–92, 339.

63 Theodor W. Adorno, "Subject and Object," in Andrew Arato and Eike Gebhardt, eds., *Essential Frankfurt School Reader* (New York: Continuum, 1985), 499.

64 Certainly it was part of the program of those first generation abstract artists who were embarked on self-consciously spiritual errands; Kandinsky spoke repeatedly "of the inner and the outer man, of the inner and outer world, and their inevitable unity, defining the harmony of the work of art as the highest equilibrium between inner and outer" (Will Grohmann, *Kandinsky: Life and Work* [New York: Abrams, 1958], 70).

65 Pythagorean doctrine "as preserved by Photius, the Byzantine lexicographer, in *Life of Pythagoras*, excerpt repr. in E. M. W. Tillyard, *Elizabethan World Picture* (London: Chatto and Windus, 1948), 61.

66 Plato, *Timaeus*, trans. Francis M. Cornford (Indianapolis: Bobbs-Merrill, 1959), 41.

67 Tillyard, *Elizabethan World*, 85.

68 H. P. Blavatsky, *Isis Unveiled* (New York: J. W. Bouton, 1877), 1:22. Although Theosophy counted numerous sympathizers, or at least interested parties, among such figures in the first generation of abstract artists, as Mondrian, Kandinsky, and Malevich, it was not of any direct importance to Rothko or the artists of his circle.

69 Erich Neumann, *The Great Mother: An Analysis of the Archetype*, trans. Ralph Manheim, 2d ed. (Princeton, N.J.: Princeton Univ. Press, 1963), 41–42.

70 Wolfgang Paalen, "On the Meaning of Cubism Today," *Dyn*, November 1944, 8.

71 Wollheim, *Art*, 123.

72 Schapiro, "On Some Problems," 240.

73 Simon, "Interview with Motherwell," 23.

74 Clement Greenberg, "Art Chronicle: The Role of Nature in Modern Painting,"[ *Partisan Review*, January 1949, 81.

75 Clement Greenberg, "American-Type Painting," *Partisan Review* 22 (Spring 1955): 179–96.

76 The artists themselves were not necessarily oblivious or indifferent to the political implications of their abstract structures. Newman, for one, boldly claimed that "if my work were properly understood, it would be the end of state capitalism and totalitarianism. Because to the extent that my painting was not an arrangement of objects, not an arrangement of spaces, not an arrangement of graphic elements, was an open painting, in the sense that it represented an open world, to that extent I thought and I still believe that my work, in terms of its social impact, does denote the possibility of an open society, of an open world," quoted in Emile deAntonio and Mitch Tuchman, *Painters Painting* (New York: Abbeville, 1984), 159. (This book is based on transcripts of deAntonio's documentary film of the same name, released in 1972.)

77 Hess, *de Kooning*, 100, 145.

78 Rosalind Krauss, "Reading Jackson Pollock, Abstractly," in *Originality*, 239.

79 B. H. Friedman, *Jackson Pollock: Energy Made Visible* (New York: McGraw-Hill, 1974), 228.

80 Adorno, "Subject," 502, 504.

81 Adorno, "Subject," 499.

82 Martin Jay, *Adorno* (Cambridge: Harvard Univ. Press, 1984), 62. See also Max Horkheimer and Theodor W. Adorno, *Dialectic of Enlightenment*, trans. John Cumming (1944; New York: Herder and Herder, 1972), 233: "Man has reduced nature to an object for domination, a raw material. The compulsive urge to cruelty and destruction springs from the organic displacement of the relationship between the mind and body."

83 O'Connor, *Pollock*, 26.

84 Adorno, "Subject," 505.

85 Krauss, "Reading Pollock," 239.

86 See Rosenberg, "Rothko," 94. Also, in his lecture at Pratt in 1958 Rothko declared categorically that "painting a picture is not a form of self-expression" (Ashton, *About Rothko*, 144).

87 Barnett Newman, "The Sublime is Now," *Tiger's Eye*, 15 Dec. 1948, 51–53.

88 Benjamin J. Townsend, "An Interview with Clyfford Still," *Gallery Notes* (of the Albright-Knox Gallery, Buffalo, N.Y.) 24 (Summer 1961): 11; and John P. O'Neill, ed., *Clyfford Still* (New York: Metropolitan Museum of Art, 1979), 10.

## 5 The Human Drama: From the Womb to the Tomb

1 This was followed by (2) "sensuality . . . a lustful relation to things that exist" and "the basis for being concrete about the world," (3) "tension," (4) "irony," (5) wit or humor," (6) "the ephemeral and chance," and (7) "hope, if you need that sort of thing; the Greeks never mentioned it." Dore Ashton and Irving Sandler both have published excerpts from notes taken at this lecture. There is no conflict between their versions of Rothko's list, but there are slight variations in the terms or phrases they noted in recording how Rothko amplified the list. The present version makes use of both sources (Sandler, *Rothko*, 10–11; and Ashton, "L'Automne," 39). Additional, less complete accounts of this lecture by Ashton are in "Art: Lecture," 26, and *About Rothko*, 144–46, and 154.

2 Eva C. Keuls, *The Reign of the Phallus: Sexual Politics in Ancient Athens* (New York: Harper and Row, 1985), 129. The phrase used in the title (and elsewhere) in the present chapter is adapted from a phrase by Joseph Campbell—"Full circle, from the tomb of the womb, to the womb of the tomb, we come"—cited previously in chapter 3, note 91.

3 In a painting called *Protectress* of 1932 (shown at the "Fantastic Art, Dada, Surrealism" exhibition at the Museum of Modern Art in New York in 1936 and included in that catalogue), Paul Klee created a triple woman similar to Rothko's.

4 For a Jungian source on this topos of mythology, see Neumann, *Great Mother.*

5 Rothko, sketchbook, Carson family collection.

6 Arnheim, *Art and Visual,* 57, 63.

7 Schapiro, "On Some Problems," 236.

8 Rothko, as quoted in Sandler, *Rothko,* 11.

9 Rothko had personal reasons for being especially aware of the cycle of life during the year that he decisively settled on the format of his classic pictures. His mother, Anna Goldin Rothkowitz, who had taken the name Kate when she emigrated, died early in 1950; in December 1950 his daughter, Kathy Lynn, called Kate, was born. The younger Kate (who eventually took the trouble to change her name legally) has recalled that her father made a point of showing her a painting he had done of his mother, her namesake (Gardner, "The Ordeal," 53).

10 Ashton, "Rothko Chapel," 275.

## 6 Rothko's Instruments

1 Seiberling, "Rothko," 82.

2 Ashton, *About Rothko,* 144.

3 E. de Kooning, "Two Americans," 176.

4 Norman Bryson, *Vision and Painting: The Logic of the Gaze* (New Haven: Yale Univ. Press, 1983), 61, 68.

5 Marjorie Phillips, *Duncan Phillips and His Collection* (Boston: Little, Brown, 1970), 288. This exchange probably took place around 1957.

6 Ashton, *Reading,* 27.

7 Phillips, *Duncan Phillips,* 288.

8 Seldes, *Legacy,* 51. In an interview conducted by Karyn Esielonis in December 1985, Pusey explained that he thought Rothko was speaking "more metaphysically than in a specifically Christian way" about the paintings, that he was speaking "about the generally tragic nature of man's life."

9 "Art: Stand Up Close . . . ," *Newsweek,* 23 Jan. 1961, 60.

10 Dominique de Menil, "Address at the Opening of the Rothko Chapel, 26 Feb. 1971," offprint (Houston, Texas: Rothko Chapel); and Dominique de Menil, "Rothko Chapel," *Art Journal* 30 (Spring 1971): 251. There are two churches on the island of Torcello, near Venice—a smaller, octagonal, Byzantine structure without images on the walls and a cathedral with fine early mosaics, including scenes of the Madonna and Child, Christ in Limbo, and the Last Judgment. Rothko evidently combined the two churches in his mind in envisioning his own project.

11 Nietzsche, *Birth,* 19.

12 Seitz, *Abstract-Expressionist,* 102.

13 In this preference perhaps there was some, however unconscious, connection to his identity as a "red," a sobriquet this left-leaning Russian undoubtedly encountered from his adolescence onward through the 1950s.

14 Ashton, *Reading,* 27.

15 When he was one of *Fifteen Americans* exhibiting at the Museum of Modern Art in 1952, Rothko "insisted that an extra bright light be put in the ceiling, so that it would be a flaming gallery" (John Gruen, "Dorothy Miller in the Company of Modern Art," *Art News,* November 1976, 57). By 1955, however, Rothko was insisting on minimal light: "No matter how low it was, he would reduce it," recalled his dealer at that time, Sidney Janis (Seldes, *Legacy,* 34). When he was given a retrospective at the Museum of Modern Art in 1961, Rothko no longer demanded extra lights. He "was quite dissatisfied with our whole system of overhead lighting," according to Monroe Wheeler. "There was too much light and it wasn't distributed as he would have liked. And there was too much daylight, because it was at the north side of the building" (McKinney, "Introduction," xiv).

16 Ashton, "Art: Mark Rothko," 8, 31. See also Lawrence Alloway, "American Sublime," 14; Rubin, "Rothko," 21; Robert Goldwater, "Reflections on the Rothko Exhibition," *Arts,* March 1961, 44.

17 David Sylvester, "Rothko," *New Statesman,* 20 Oct. 1961, 574.

18 E. de Kooning, "Two Americans," 176. Others who heard Rothko say similar things include Hess ("Rothko," 72), Sandler (*Triumph,* 183), Goldwater ("Reflections," 43), Seitz (*Abstract-Expressionist,* 68), Phillips (*Duncan Phillips,* 288), McKinney ("Introduction, xiii), and a *Time* reporter ("Wild Ones," 74).

19 Anne Marie Levine, letter, *New York Times,* 17 Dec. 1978, D39.

20 Seldes, *Legacy,* 66.

21 Lee Seldes, "The Passion of Mark Rothko," *Esquire,* November 1974, 123.

22 McKinney, "Introduction," xiii.

23 Morton Levine, "Foreword to James B. Byrnes, *Ten Major Works: Mark Rothko* (Newport Beach, Calif.: Newport Harbor Art Museum, 1974), 5.

24 McKinney, "Introduction," xiii.

25 Shklovsky, "Art as Technique," 12.

26 Kuh, "A Maximum," 81.

27 McKinney, "Introduction," xiii.

## 7 Conclusion

1 Breton, "Prolegomena," 22.

2 Rothko, "Romantics," 84.

3 Rothko, "Romantics," 84.

4 Rothko, draft for collaborative letter to *New York Times.*

5 Rothko, "Romantics," 84.

6 Rothko, "Romantics," 84.

7 Gayatri Chakravorty Spivak, "Translator's Introduction," in Jacques Derrida, *Of Grammatology* (Baltimore: Johns Hopkins Univ. Press, 1976), xvii.

8 Rothko, "Romantics," 84.

9 Rodman, *Conversations,* 93; and Haftmann, essay, ix.

10 Glimcher, "Dan Rice Interviewed."

11 Hans-Georg Gadamer, *Truth and Method* (New York: Crossroad, 1985), 79.

12 Liss, "Willem de Kooning," 42. Rothko's sense of messianism emerged also in a conversation with Dore Ashton, " 'All the crosses we load on our own shoulders,' he [Rothko] wryly remarked in the fall of 1968, 'when the world settles for things *without* crosses' " (*About Rothko,* 188).

13 Seitz, *Abstract-Expressionist,* 116.

14 Rodman, *Conversations,* 93.

15 Rothko, "The Ides of Art," *Tiger's Eye,* December 1947, 44.

16 Kuh, "Mark Rothko," 68.

17 Rothko, Gottlieb, [Newman], letter, 13 June 1943, X9.

18 Fischer, "Mark Rothko," 20.

19 Haftmann, essay, viii, ix. When asked in conversation in May 1978 Kate Rothko Prizel indicated to me that she considered this essay of Haftmann's, along with the essays of Kuh, the most accurate and evocative portraits of her father she had seen in print.

20 Seldes, *Legacy,* 51.

21 Malevich, "Suprematism," 1927, in Robert L. Herbert, ed., *Modern Artists on Art: Ten Unabridged Essays* (Englewood Cliffs, N.J.: Prentice-Hall, 1964), 94, 93, 96.

22 Seitz, interviews with Rothko, 25 Mar. 1953 and 22 Jan. 1952.

23 O'Doherty, *American Masters,* 164.

24 Krauss, "Reading Pollock," 237.

25 Jean-Claude Marcadé, "K. S. Malevich," in Stephanie Barron and Maurice Tuchman, eds., *The Avant Garde in Russia, 1910–1930: New Perspectives* (Los Angeles: Los Angeles County Museum of Art, 1980), 21–22.

26 Ashton, *About Rothko,* 187; Ashton, "L'Automne," 39. I am grateful to Henri Zerner for discussing the significance of this reference with me.

27 As cited in Alloway, "Art," 349.

28 McCoy, ed., *David Smith,* 178–79.

29 Fischer, "Mark Rothko," 22. On the same note, see E. de Kooning, "Two Americans," 176.

30 Ashton, "L'Automne," 39; and Ashton, "La Voix," 94 (my translation).

31 Haftmann, essay, ix.

32 Thomas Hess has related Barnett Newman's work to that Jewish mystical tradition in a suggestive text (Hess, *Newman*).

33 Rothko, Gottlieb, [Newman], letter, 13 June 1943, X9.

34 E. G. [Emily Genauer], "Art: They're All Busy Drawing Blanks," *New York Herald Tribune,* 22 Jan. 1961, 21; Otis Gage, "Art," *Arts and Architecture,* May 1955, 8; "Kenneth Evett on Art: The French Connection," *New Republic,* 5 and 12 Aug. (combined issue), 1972, 26–27.

35 "A Certain Spell," 72.

36 Ernest Jones, as cited in Daniel Sperber, *Rethinking Symbolism,* trans. Alice L. Morton (Cambridge: Cambridge Univ. Press, 1975), 42. In this connection, too, the veil or screenlike quality of Rothko's pictures might evoke Freud's concept of the "screen memory"—imperfectly clear memories signaling that which demands to be, at once, recalled and repressed.

37 Adorno, "Lyric Poetry and Society," *Telos* 20 (Summer 1974): 58.

38 Rothko, "Romantics," 84.

39 Haftmann, essay, ix.

40 Ashton, "Rothko Chapel," 274.

41 Edwards and Pomeroy, "Working," 121.

42 Stuart Davis, "A Medium of Two Dimensions," 1935, in Diane Kelder, ed., *Stuart Davis* (New York: Praeger, 1971), 116, 114.

43 Stuart Davis, "Abstract Art in the American Scene," 1941, in Kelder, ed., *Davis,* 126.

44 Adorno's views as characterized by Jay, *Adorno,* 138, 137.

45 Adorno, as quoted in Jay, *Adorno,* 137, 130. More recently, Jean-François Lyotard has argued (in "On Theory: An Interview," in *Driftworks,* ed. Roger McKeon [New York: Semiotext(e), 1984]) that "the best, the most radical critical activity bears on the formal,

the most directly plastic aspect of painting . . . and not so much on the signified, be it social or anything else" (28); "all the deconstructions which could appear as aesthetic formalism, 'avant-garde' research, etc., actually make up the only type of activity that is effective, this because it is functionally [or] . . . *ontologically* . . . located outside the system; and, by definition, its function is to deconstruct everything that belongs to order, to show that all this 'order' conceals something else, that it represses. . . . This deconstructing activity is a truly radical activity for it does not deal with the *signifieds* of things, but with their plastic organization, their signifying organization" (29).

46 "Art: Stand Up Close . . . ," 60.
47 Spivak, "Translator's Introduction," xv; Derrida, *Of Grammatology,* 70; and Derrida, "Freud," 230.

48 Dominique de Menil, "Address by Mrs. John de Menil at the Opening of the Rothko Chapel, 27 Feb. 1971," offprint.
49 Spivak, "Translator's Introduction," xli, lvii.
50 Sandler, *Rothko,* 11. Dore Ashton has also noted that Rothko discussed *Fear and Trembling* in his lecture at Pratt and added that he "had pondered the parable of Abraham and Isaac for years, and frequently in conversations with friends had cited it, for he was seriously engaged, as had been Kierkegaard, in unraveling the meaning of that Old Testament horror story" (*About Rothko,* 144).
51 Richard Wollheim, "The Work of Art as Object," *Studio International,* December 1970, 235.

# Bibliography

*Academic American Encyclopedia.* Danbury, Conn.: Grolier, 1987.

Adorno, Theodor W. "Lyric Poetry and Society." *Telos* 20 (Summer 1974): 56–71.

———. "Music and Technique." *Telos* 32 (Summer 1977): 79–94.

———. "Subject and Object." In *Essential Frankfurt School Reader,* ed. Andrew Arato and Eike Gebhardt. New York: Continuum, 1985.

Aeschylus. *Oresteia: Agamemnon, The Libation Bearers, The Eumenides.* Trans. Richmond Lattimore. Chicago: Univ. of Chicago Press, 1953.

Alloway, Lawrence. "Notes on Rothko." *Art International,* Summer 1962, 90–94.

———. "The American Sublime." *Living Arts,* June 1963, 11–22.

———. "The Spectrum of Monochrome." *Arts,* December 1970, 30–33.

———. "Art." *Nation,* 15 Mar. 1971, 349–50.

———. "Residual Sign Systems in Abstract Expressionism." *Artforum,* November 1973, 36–42.

Arnason, H. H. *American Abstract Expressionists and Imagists.* New York: Solomon R. Guggenheim Museum, 1961.

———. *Robert Motherwell.* New York: Abrams, 1977.

Arnheim, Rudolf. *Art and Visual Perception: A Psychology of the Creative Eye.* Rev. ed. Berkeley: Univ. of California Press, 1974.

Art: Stand Up Close . . ." *Newsweek,* 23 Jan. 1961, 60.

Ashbery, John. "Paris Notes." *Art International,* 25 Feb. 1963, 72.

Ashton, Dore. "Art: Mark Rothko." *Arts and Architecture,* August 1957, 8.

———. "Art: Lecture by Rothko." *New York Times,* 31 Oct. 1958, 26.

———. "L'Automne à New York: Letter from New York." *Cimaise,* December 1958, 37–40.

———. "La Voix du Tourbillon." *XXᵉ Siècle,* May 1964, 92–96.

———. *A Reading of Modern Art.* Rev. ed. New York: Harper and Row, Icon, 1971.

———. "The Rothko Chapel in Houston." *Studio International,* June 1971, 273–75.

———. "Oranges and Lemons: An Adjustment." *Arts,* February 1977, 142.

———. *New York School: A Cultural Reckoning.* Repr. New York: Penguin, 1979.

———. *About Rothko.* New York: Oxford Univ. Press, 1983.

———. Introduction to *Mark Rothko: Works on Paper,* by Bonnie Clearwater. New York: Hudson Hills, 1984.

Barr, Alfred H., Jr., ed. *Fantastic Art, Dada, Surrealism.* Rev. ed. New York: Museum of Modern Art, 1947.

Baumann, Felix Andreas, comp. *Mark Rothko.* Kunsthaus Zurich; New York: Marlborough Gallery, 1971.

Blavatsky, H. P. *Isis Unveiled.* Vol. 1. New York: J. W. Bouton, 1877.

Bloom, Harold. *Anxiety of Influence: A Theory of Poetry.* London: Oxford Univ. Press, 1973.

Boas, Franz. *Primitive Art.* 1927. Repr. New York: Dover, 1955.

Breslin, James E. B. "The Trials of Mark Rothko." *Representations* 16 (Fall 1986): 1–41.

Breton, André. "André Masson." 1939. Repr. in *Surrealism and Painting,* trans. Simon Watson Taylor. New York: Harper and Row, Icon, 1972.

———. "Artistic Genesis and Perspective of Surrealism." 1941. Repr. in *Surrealism and Painting,* trans. Simon Watson Taylor. New York: Harper and Row, Icon, 1972.

———. "Prolegomena to a Third Manifesto of Surrealism or Else." *VVV,* June 1942, 18–26.

Bryson, Norman. *Vision and Painting: The Logic of the Gaze.* New Haven: Yale Univ. Press, 1983.

Buchloh, Benjamin H. D. "Figures of Authority, Ciphers of Regression: Notes on the Return of Representation in European Painting." In *Art After Modernism: Rethinking Representation,* ed. Brian Wallis. New York: New Museum of Contemporary Art; Boston: David R. Godine, 1984.

Bürger, Peter. *Theory of the Avant-Garde.* Trans. Michael Shaw. Minneapolis: Univ. of Minnesota Press, 1984.

Butor, Michel. "Les Mosques de New York ou l'Art de Mark Rothko." *Critique* 173 (October 1961): 843–60.

Caffi, Andrea. "On Mythology." *Possibilities* 1 (Winter 1947–48): 87–95.

Campbell, Joseph. *Hero with a Thousand Faces.* 1949. 2d ed. Princeton, N.J.: Princeton Univ. Press, 1968.

Canaday, John. "Is Less More and When for Whom? Rothko Show Raises Questions About Painters, Critics and Audience." *New York Times,* 22 Jan. 1961, X17.

Carmean, E. A., Jr., Eliza Rathbone, and Thomas B. Hess. *American Art at Mid-Century: The Subjects of the Artist.* Washington, D.C.: National Gallery, 1978.

Cassirer, Ernst. *An Essay on Man: An Introduction to a Philosophy of Human Culture.* 1944. Repr. New Haven: Yale Univ. Press, 1962.

———. *Myth of the State.* New Haven: Yale Univ. Press, 1946.

Cavaliere, Barbara, and Robert C. Hobbs. "Against a Newer Laocoon." *Arts,* April 1977, 111.

Cavell, Stanley. *Must We Mean What We Say?: A Book of Essays.* Cambridge: Cambridge Univ. Press, 1976.

"A Certain Spell." *Time,* 3 Mar. 1961, 72–75.

Chave, Anna. *Mark Rothko: Subjects.* Atlanta: High Museum of Art, 1983.

Cirlot, J. E. *Dictionary of Symbols.* Trans. Jack Sage. 2d ed. New York: Philosophical Library, 1971.

Clearwater, Bonnie. "Shared Myths: Reconsideration of Rothko's and Gottlieb's Letter to *The New York Times.*" *Archives of American Art: Journal* 24 (1984): 23–25.

Cockcroft, Eva. "Abstract Expressionism, Weapon of the Cold War." *Artforum,* October 1973, 48–52.

Collier, Oscar. "Mark Rothko." *New Iconograph,* Fall 1947, 40–44.

Cox, Annette. *Art-As-Politics: The Abstract Expressionist Avant-Garde and Society.* Ann Arbor, Mich.: UMI Research Press, 1982.

Damisch, Hubert. "Semiotics and Iconography." In *The Tell-Tale Sign: A Survey of Semiotics,* ed. Thomas A. Sebeok. Lisse: Peter de Ridder, 1975.

Davidson, Martha. "Government as a Patron of Art." *Art News,* 10 Oct. 1936, 12.

———. "Art or Propaganda? Problems of the Artists' Congress." *Art News,* 25 Dec. 1937, 14.

Davis, Stuart. "A Medium of Two Dimensions." 1935. Repr. in *Stuart Davis,* ed. Diane Kelder. New York: Praeger, 1971.

———. "Abstract Art in the American Scene," 1941. Repr. in *Stuart Davis,* ed. Diane Kelder. New York: Praeger, 1971.

de Antonio, Emile, and Mitch Tuchman. *Painters Painting.* New York: Abbeville, 1984.

de Kooning, Elaine. "Two Americans in Action: Franz Kline, Mark Rothko." *Art News Annual* 27 (1958): 86.

de Kooning, Willem. "What Abstract Art Means to Me." 1951. Repr. in *Willem de Kooning,* by Thomas B. Hess. New York: Museum of Modern Art, 1968, 143–46.

de Menil, Dominique. "Address by Mrs. John de Menil, 26 Feb. 1971, in the Rothko Chapel." Houston: Rothko Chapel. Photocopy.

———. "Address by Mrs. John de Menil at the Opening of the Rothko Chapel, 27 Feb. 1971." Houston: Rothko Chapel. Photocopy.

———. "Rothko Chapel." *Art Journal* 30 (Spring 1971): 249–51.

Derrida, Jacques. *Of Grammatology.* Trans. Gayatri Chakravorty Spivak. Baltimore: John Hopkins Univ. Press, 1976.

———. "Freud and the Scene of Writing." In *Writing and Difference,* trans. Alan Bass. Chicago: Univ. of Chicago Press, 1978, 230.

Devree, Howard. "Diverse New Shows." *New York Times,* 9 Mar. 1947, sec. 2, p. 7.

Eagleton, Terry. *Literary Theory: An Introduction.* Minneapolis: Univ. of Minnesota Press, 1983.

Edwards, Roy, and Ralph Pomeroy. "Working with Rothko." *New American Review* 12 (1971): 109–21.

Eichenbaum, Boris. "Theory of the 'Formal Method.'" 1926. Repr. in *Russian Formalist Criticism,* ed. and trans. Lee T. Lemon and Marion J. Reis. Lincoln: Univ. of Nebraska Press, 1965.

Eliade, Mircea. *The Myth of the Eternal Return or, Cosmos and History.* 1949. Trans. Willard R. Trask. Repr. Princeton, N.J.: Princeton Univ. Press, 1971.

———. *The Sacred and the Profane: The Nature of Religion.* Trans. Willard R. Trask. New York: Harcourt Brace, 1959.

Eliot, T. S. "Ulysses, Order and Myth." 1923. Repr. in *James Joyce: Two Decades of Criticism,* ed. Seon Givens, 1948. Repr. New York: Vanguard, 1963.

Evett, Kenneth. "Kenneth Evett on Art: The French Connection," *New Republic,* 5 and 12 Aug. 1972 (combined issue), 26–28.

Feibleman, James. *An Introduction to Peirce's Philosophy Interpreted as System*. New York: Harper and Brothers, 1946.

Fischer, John. "Mark Rothko: Portrait of the Artist as an Angry Man." *Harpers*, July 1970, 16.

Fitzgerald, John F. *Peirce's Theory of Signs as Foundation for Pragmatism*. Hague: Mouton, 1966.

A. M. F. [Alfred M. Frankfurter.] "Editor's Review; The Year in Art: A Review of 1940." *Art News*, 28 Dec. 1940, 10–12.

———. "Vernissage," *Art News*, 1–14 Oct. 1941, 7.

"French Artists Spur on an American Art." *New York Tribune*, 24 Oct. 1915. Repr. in *New York Dada*, ed. Rudolf E. Kuenzli. New York: Willis, Locker and Owens, 1986.

Friedman, B. H. *Jackson Pollock: Energy Made Visible*. New York: McGraw-Hill, 1974.

Fuller, Mary. "Was There a San Francisco School?" *Artforum*, January 1971, 46.

Gadamer, Hans-Georg. *Truth and Method*. New York: Crossroad, 1985.

Gage, Otis. "Art." *Arts and Architecture*, May 1955, 8.

Gardner, Paul "The Ordeal of Kate Rothko: The War Isn't Over in Marlborough Country." *New York*, 7 Feb. 1977, 43.

Genauer, Emily. "Exhibit Holds Art Without Subject Line." *New York Herald Tribune*, 18 Jan. 1961.

E. G. [Emily Genauer.] "Art: They're All Busy Drawing Blanks." *New York Herald Tribune*, 22 Jan. 1961, 21.

Glaser, Bruce. "Questions to Stella and Judd." In *Minimal Art: A Critical Anthology*, ed. Gregory Battcock. New York: Dutton, 1968.

Glimcher, Arnold. "Dan Rice Interviewed by Arnold Glimcher." In *Rothko: The 1958–1959 Murals*. New York: Pace Gallery, 1978.

Goldwater, Robert. "Genesis of a Picture: Theme and Form in Modern Painting." *Critique* 1 (1946): 5–12.

———. "Reflections on the Rothko Exhibition." *Arts*, March 1961, 42–45.

———. "Rothko's Black Paintings." *Art in America*, March 1971, 58–63.

Goossen, E. C. "Rothko: The Omnibus Image." *Art News*, January 1961, 38.

Gottlieb, Adolph. Statement in "The Ides of Art: Attitudes of Ten Artists on their Art and their Contemporaneousness." *Tiger's Eye*, December 1947, 43.

Graham, John. *System and Dialectics of Art*. 1937. Repr. Baltimore: Johns Hopkins Press, 1971.

Graves, Robert. *The White Goddess: A Historical Grammar of Poetic Myth*. 1948. Rev. ed. New York: Farrar, Straus and Giroux, 1966.

*Greek Anthology*. Vol. 3. Trans. W. R. Paton. London: W. Heinemann, 1916–18.

Greenberg, Clement. "Towards a Newer Laocoon." *Partisan Review* 7 (July–August 1940): 296–310.

———. "Art Chronicle: Irrelevance versus Irresponsibility." *Partisan Review* 15 (May 1948): 573–79.

———. "Art Chronicle: The Role of Nature in Modern Painting." *Partisan Review* 16 (January 1949): 78–81.

———. "American-Type Painting." *Partisan Review* 22 (Spring 1955): 179–96.

Grohmann, Will. *Kandinsky: Life and Work*. New York: Abrams, 1958.

Gruen, John. "Dorothy Miller in the Company of Modern Art." *Art News*, November 1976, 54–58.

Guilbaut, Serge. *How New York Stole the Idea of Modern Art: Abstract Expressionism, Freedom, and the Cold War*. Trans. Arthur Goldhammer. Chicago: Univ. of Chicago Press, 1983.

Hadler, Mona. "William Baziotes: Four Sources of Inspiration." In *William Baziotes*, comp. Michael Preble. Newport Beach, Calif.: Newport Harbor Art Museum, 1978.

Haftmann, Werner. Untitled essay. Trans. Margery Schärer. In *Mark Rothko*, by Felix Andreas Baumann. Kunsthaus Zurich; New York: Marlborough Gallery, 1971.

Hamilton, George Heard. *Painting and Sculpture in Europe, 1880–1940*. Rev. ed. New York: Penguin, 1983.

Hegel, G. W. F. *Phenomenology of Mind*. Trans. J. B. Baillie. New York: Harper and Row, Colophon, 1967.

Hess, Thomas B. "Introduction to Abstract." *Art News Annual* 20 (1951): 127–52.

———. "Mondrian and New York Painting." In *Six Painters*, comp. Dominique de Menil with Morton Feldman. Houston: Univ. of St. Thomas, 1967.

———. *Willem de Kooning*. New York: Museum of Modern Art, 1968.

———. "Rothko: A Venetian Souvenir." *Art News*, November 1970, 40.

———. *Barnett Newman*. New York: Museum of Modern Art, 1971.

Hirsch, E. D., Jr. *Validity in Interpretation*.

New Haven: Yale Univ. Press, 1967.

Hobbs, Robert. *Robert Smithson: Sculpture.* Ithaca, N.Y.: Cornell Univ. Press, 1981.

Hofmann, Hans. "Painting and Culture." 1931. Repr. in *Search for the Real and Other Essays,* ed. Sara T. Weeks and Bartlett H. Hayes, Jr. Rev. ed. Cambridge: MIT Press, 1967.

Hopkins, Bud. "Bud Hopkins on Bud Hopkins." *Art in America,* Summer 1973, 92–93.

Horkheimer, Max, and Theodor W. Adorno. *Dialectic of Enlightenment.* Trans. John Cumming. 1944. Repr. New York: Herder and Herder, 1972.

Hoy, David Couzens. *The Critical Circle: Literature, History, and Philosophical Hermeneutics.* Berkeley: Univ. of California Press, 1982.

Hunter, Sam. *Modern American Painting and Sculpture.* New York: Dell, 1959.

"Is today's artist with or against the past? Part 1." By the editors of *Art News,* Summer 1958, 26.

"Is today's artist with or against the past? Part 2." By the editors of *Art News,* September 1958, 38.

Janis, Sidney. *Abstract and Surrealist Art in America.* New York: Reynal and Hitchcock, 1944.

Jay, Martin. *Adorno.* Cambridge: Harvard Univ. Press, 1984.

Jean, Marcel, ed. *Autobiography of Surrealism.* New York: Viking, 1980.

Jewell, Edward Alden. "Art: Diverse Shows." *New York Times,* 14 Jan. 1945, sec. 2, p. 8.

———. "Toward Abstract or Away? A Problem for Critics." *New York Times,* 1 July 1945, sec. 2, p. 2.

Jung, Carl Gustav. *Psychology and Religion.* New Haven: Yale Univ. Press, 1938.

———. Preface to *Psyche and Symbol: A Selection from the Writings of C. G. Jung,* ed. Violet S. de Laszlo. Garden City, N.Y.: Doubleday, Anchor, 1958.

Kainen, Jacob. "Our Expressionists." *Art Front,* February 1937, 14–15.

———. "Tribute to Mark Rothko, Part 1." *Potomac Magazine.* Sunday supplement to the *Washington Post,* 4 April 1971, 44.

———. "Tribute to Mark Rothko, Part 2." *Potomac Magazine.* Sunday supplement to the *Washington Post,* 11 April 1971, 28.

Kandinsky, Vasily. *Concerning the Spiritual in Art.* 1912. Repr. New York: Wittenborn, 1947.

Keuls, Eva C. *The Reign of the Phallus: Sexual Politics in Ancient Athens.* New York: Harper and Row, 1985.

Kierkegaard, Soren. *Fear and Trembling and The Sickness Unto Death.* Trans. Walter Lowrie. Princeton, N.J.: Princeton Univ. Press, 1968.

———. *Either/Or.* Vol. 1. Trans. David F. Swenson and Lillian Marvin Swenson. Princeton, N.J.: Princeton Univ. Press, 1971.

Kozloff, Max. "An Answer to Clement Greenberg's Article, 'After Abstract Expressionism.'" *Art International,* June 1963, 88–92.

———. "An Interview with Matta." *Artforum,* September 1965, 23–26.

———. "Interview with Friedel Dzubas." *Artforum,* September 1965, 49–52.

———. "American Painting During the Cold War." *Artforum,* May 1973, 43–54.

Kramer, Hilton. "Rothko: Art as Religious Faith." *New York Times,* 12 Nov. 1978, sec. 2, p. 1.

Krasne, Belle. "Youth: France vs. U.S." *Art Digest,* 1 Nov. 1950, 17.

Krauss, Rosalind. "The Originality of the Avant-Garde." In *The Originality of the Avant-Garde and Other Modernist Myths.* Cambridge: MIT Press, 1985.

———. "Reading Jackson Pollock, Abstractly." In *The Originality of the Avant-Garde and Other Modernist Myths.* Cambridge: MIT. Press, 1985.

Kuenzli, Rudolf E. Introduction to *New York Dada.* New York: Willis, Locker and Owens, 1986.

Kuh, Katharine. "Mark Rothko." *Art Institute of Chicago Quarterly,* 15 Nov. 1954, 68.

———. "A Maximum of Poignancy." *Saturday Review,* 17 Apr. 1971, 52.

Kuspit, Donald. "The Illusion of the Absolute in Abstract Art." *Art Journal* 31 (Fall 1971): 26–30.

J. L. [Jeannette Lowe?] "Three Moderns: Rothko, Gromaire, and Solman." *Art News,* 20 Jan. 1940, 12.

Ladner, Gerhart B. "Concept of the Image in the Greek Fathers and the Byzantine Iconoclastic Controversy." *Dumbarton Oaks Papers,* 7 (1953), 1–34.

Lawrence, Herbert. "The Ten." *Art Front,* February 1936, 12.

Leger, Fernand. "New York." 1931. Repr. in *Functions of Painting,* ed. Edward F. Fry and trans. Alexandra Anderson. New York: Viking, 1973.

Levine, Anne Marie. Letter. *New York Times,* 17 Dec. 1978, p. D39.

Levine, Morton H. Foreword to *Ten Major Works: Mark Rothko*, by James B. Byrnes. Newport Beach, Calif.: Newport Harbor Art Museum, 1974.

Liss, Joseph. "A Portrait by Rothko." *East Hampton Star*, 2 Sept. 1976. Ms. in Whitney Museum of American Art Library.

————. "Willem de Kooning Remembers Mark Rothko: 'His House Had Many Mansions.'" *Art News*, January 1979, 41–44.

Lyotard, Jean-François. "On Theory: An Interview." In *Driftworks*, ed. Roger McKeon. New York: Semiotext(e), 1984.

————. *The Postmodern Condition: A Report on Knowledge*. Trans. Geoff Bennington and Brian Massumi. Minneapolis: Univ. of Minnesota Press, 1984.

MacAgy, Douglas. "Mark Rothko." *Magazine of Art*, January 1949, 20–21.

McBride, Henry. "American Art is Looking Up." 1922. Repr. in *The Flow of Art: Essays and Criticisms of Henry McBride*, ed. Daniel Catton Rich. New York: Atheneum, 1975.

————. "American Expatriates in Paris." 1929. Repr. in *The Flow of Art: Essays and Criticisms of Henry McBride*, ed. Daniel Catton Rich. New York: Atheneum, 1975.

————. "Half Century or Whole Cycle?" *Art News*, June—August 1952, 70.

McCabe, Cynthia Jaffee. *The Golden Door: Artist-Immigrants of America, 1876–1976*. Washington, D.C.: Hirshhorn Museum, Smithsonian Institution, 1976.

McCoy, Garnett, ed. *David Smith*. New York: Praeger, 1973.

McKinney, Donald. Introduction to *Mark Rothko*, by Felix Andreas Baumann. Kunsthaus Zurich; New York: Marlborough Gallery, 1971.

McShine, Kynaston, ed. *Natural Paradise: Painting in America, 1800–1950*. New York: Museum of Modern Art, 1976.

Malevich, Kasimir. "Suprematism." 1927. Repr. in *Modern Artists on Art: Ten Unabridged Essays*, ed. Robert L. Herbert. Englewood Cliffs, N.J.: Prentice-Hall, 1964.

Marcadé, Jean-Claude. "K. S. Malevich: From *Black Quadrilateral* (1913) to *White on White* (1917): From the Eclipse of Objects to the Liberation of Space." In *The Avant Garde in Russia, 1910–1930: New Perspectives*, ed. Stephanie Barron and Maurice Tuchman.

Los Angeles County Museum of Art, 1980.

Merleau-Ponty, M. *Phenomenology of Perception*. Trans. Colin Smith. London: Routledge and Kegan Paul, 1962.

Moritz, Charles, ed. *Current Biography Yearbook*. New York: H. W. Winston, 1961, s.v. Rothko.

Motherwell, Robert. "A Major American Sculptor: David Smith." *Vogue*, 1 Feb. 1965, 135.

Neumann, Erich. *The Great Mother: An Analysis of the Archetype*. Trans. Ralph Manheim. 2d ed. Princeton, N.J.: Princeton Univ. Press, 1963.

Newman, Barnett. "What About Isolationist Art?" 1942. In *Barnett Newman*, by Thomas B. Hess. New York: Museum of Modern Art, 1971, 34–37.

————. "The Plasmic Image." Circa 1943–1945. In *Barnett Newman*, by Thomas B. Hess. New York: Museum of Modern Art, 1971, 37–39.

————. Preface to *Adolph Gottlieb: Drawings*. Brochure. New York: Wakefield Gallery, 1944.

————. "The New Sense of Fate." 1945. In *Barnett Newman*, by Thomas B. Hess. New York: Museum of Modern Art, 1971, 41–43.

————. Introduction to *The Ideographic Picture*. New York: Betty Parsons Gallery, 1947.

————. "The Sublime is Now." *Tiger's Eye*, 15 Dec. 1948, 51–53.

Nietzsche, Friedrich. *The Birth of Tragedy and the Genealogy of Morals*. Trans. Francis Golffing. Garden City, N.Y.: Doubleday, Anchor, 1956.

O'Doherty, Brian. *American Masters: The Voice and the Myth*. New York: Random House, 1973.

O'Neill, John P., ed. *Clyfford Still*. New York: Metropolitan Museum of Art, 1979.

Onslow-Ford, Gordon. *Towards a New Subject in Painting: Gordon Onslow-Ford*. San Francisco Museum of Art, 1948.

Paalen, Wolfgang. "The New Image." Trans. Robert Motherwell. *Dyn* 1 (April–May 1942): 7–15.

————. "On the Meaning of Cubism Today." *Dyn* 6 (November 1944): 4–8.

Packer, William. "Mark Rothko: The Inward Landscape." *London Financial Times*, 6 Nov. 1978, 21.

Panofsky, Erwin. *Meaning in the Visual Arts: Papers in and on Art History*. Garden City, N.Y.: Doubleday, Anchor, 1955.

Peirce, Charles Sanders. *Collected Papers of Charles Sanders Peirce.* Vols. 1, 2, 4. Ed. Charles Hartshorne and Paul Weiss. Cambridge: Harvard Univ. Press, 1931–1966.

Pfister, Oskar. *Expressionism in Art: Its Psychological and Biological Basis.* London: Kegan Paul, Trench, Trubner, 1922; New York, 1923.

Philipson, Morris. *Outline of a Jungian Aesthetics.* Evanston, Ill.: Northwestern Univ. Press, 1963.

Phillips, Marjorie. *Duncan Phillips and His Collection.* Boston: Little, Brown, 1970.

Plato. *Timaeus.* Trans. Francis M. Cornford. Indianapolis: Bobbs-Merrill, 1959.

"Point of *View:* An Editorial." *View,* no. 1, series 3 (April 1943): 5.

Polcari, Stephen. "The Intellectual Roots of Abstract Expressionism: Mark Rothko." *Arts,* September 1979, 124–34.

Pollock, Jackson. "My Painting." *Possibilities* 1 (Winter 1947–48): 78–79.

———. Interview-statement. 1944. Repr. in *Jackson Pollock,* Francis V. O'Connor. New York: Museum of Modern Art, 1967, 31–33.

Putnam, Wallace. "Mark Rothko Told Me." *Arts,* April 1974, 44–45.

Ratcliff, Carter. "New York Letter." *Art International,* January 1971, 26.

Rathbone, Eliza. "Mark Rothko: The Brown and Gray Paintings." In *American Art at Mid-Century: The Subjects of the Artist,* by E. A. Carmean, Jr., Eliza Rathbone, and Thomas B. Hess. Washington, D.C.: National Gallery, 1978.

Reinhardt, Ad. "Monologue." 1966. Repr. in *Art as Art: The Selected Writings of Ad Reinhardt,* ed. Barbara Rose. New York: Viking, 1975, 23–29.

Renouf, Edward. "On Certain Functions of Modern Painting." *Dyn,* July–August 1942, 19–25.

Ritchie, Andrew Carnduff. *Salute to Mark Rothko.* Pamphlet. New Haven: Yale Univ. Art Gallery, 1971.

Rodman, Selden. *Conversations with Artists.* New York: Devin-Adair, 1957.

Rose, Barbara. "Mondrian in New York." *Artforum,* December 1971, 54–63.

Rosenberg, Harold. "American Action Painters." 1952. Rev. and repr. in *Tradition of the New.* New York: McGraw-Hill, 1965.

———. Arshile Gorky: The Man, the Time, the Idea. New York: Horizon, 1962.

———. "Rothko." *New Yorker,* 28 Mar. 1970, 90–95.

———. "Interview with Willem de Kooning." *Art News,* September 1972, 54–59.

Rosenblum, Robert. "The Abstract Sublime." 1961. Repr. in *New York Painting and Sculpture, 1940–1970,* by Henry Geldzahler. New York: E. P. Dutton and the Metropolitan Museum of Art, 1969.

———. *Modern Painting and the Northern Romantic Tradition: Friedrich to Rothko.* New York: Harper and Row, Icon, 1975.

Rothko, Mark. Sketchbook with writings. Late 1930s. George C. Carson family collection. On extended loan to the Menil Museum, Houston, Texas.

———. Individual draft for collaborative letter to *New York Times* (see below). George C. Carson family collection. On extended loan to the Menil Meusum, Houston, Texas. Published in part in "Shared Myths: Reconsideration of Rothko's and Gottlieb's Letter to *The New York Times,*" by Bonnie Clearwater. *Archives of American Art: Journal* 24 (1984): 23–25. 1943. Final letter published 13 June 1943, p. X9; copy of original in Museum of Modern Art Library, New York.

———. Statement in *Personal Statement: Painting Prophecy, 1950.* Washington, D.C.: David Porter Gallery, (February) 1945.

———. Letter. *New York Times,* 8 July 1945, X2.

———. Letter to Barnett Newman. 31 July 1945. Archives of American Art, Newman Papers.

———. Preface to *Clyfford Still.* Pamphlet. New York: Art of This Century Gallery, 1946.

———. Statement in "The Ides of Art." *Tiger's Eye,* December 1947, 44.

———. "The Romantics Were Prompted." *Possibilities* 1 (Winter 1947–48): 84.

———. Statement in *Tiger's Eye,* October 1949, 114.

———. Statement made from the floor at a symposium at the Museum of Modern Art, New York, on "How to Combine Architecture, Painting and Sculpture." *Interiors,* May 1951, 104.

———. Interviews with William Seitz on 22 Jan. 1952, 25 Mar. 1953, and 1 Apr. 1953. Interviewer's notes in Archives of American Art, Smithsonian Institution, Washington, D.C. (Seitz Papers, box 15).

———. Letter to Lloyd Goodrich. 20 Dec. 1952. Whitney Museum of American Art Library.

———. Letter to Katharine Kuh. 14 July 1954. Archives of the Art Institute of Chicago. Published in part in Kuh, "Mark Rothko." *Art Institute of Chicago Quarterly,* 15 Nov. 1954, 68.

———. Letter to Katharine Kuh. 25 Sept. 1954. Archives of the Art Institute of Chicago.

———. Letter. *Art News,* December 1957, 6.

———. "Commemorative Essay." Eulogy delivered 7 Jan. 1965. In *Milton Avery,* by Adelyn Breeskin. Washington, D.C.: National Collection of Fine Arts, Smithsonian Institution, 1969.

Rothko, Mark, and Bernard Braddon. *The Ten: Whitney Dissenters.* New York: Mercury Galleries, 1938.

Rothko, Mark [Marcus Rothkowitz], Aaron Harry Director and Simon Whitney. "Leaders in the Making." *Yale Saturday Evening Pest,* 7 Apr. 1923. Yale University Archives, Sterling Library. Other issues of the *Pest* cited: 2 Feb. 1923, 17 Feb. 1923, 3 Mar. 1923, 24 Mar. 1923, 28 Apr. 1923, 26 May 1923.

Rothko, Mark, and Adolph Gottlieb. *The Portrait and the Modern Artist.* WNYC broadcast, 13 Oct. 1943. Transcript published as "Appendix B" of *Adolph Gottlieb: A Retrospective,* by Lawrence Alloway and Mary Davis MacNaughton. New York: Arts Publisher, 1981.

Rothko, Mark, and Adolph Gottlieb [with Barnett Newman]. Letter to Edward Alden Jewell, *New York Times,* 13 June 1943, p. X9.

Rubin, William. "The New York School— Then and Now, Part 1." *Art International,* March–April 1958, 23–26.

———. "The New York School—Then and Now, Part 2." *Art International,* May–June 1958, 19–22.

———. "Mark Rothko: 1903–1970." *New York Times,* 8 Mar. 1970, sec. 2, pp. 21–22.

Sandler, Irving. *The Triumph of American Painting: A History of Abstract Expressionism.* New York: Harper and Row, 1970.

———. "The Club." *Artforum,* September 1965, 27–31.

———. *Mark Rothko: Paintings 1948–1969.* New York: Pace Gallery, 1983.

Sawin, Martica. "The Cycloptic Eye, Pataphysics, and the Possible: Transformations of Surrealism." In *The Interpretive Link: Abstract Surrealism Into Abstract Expressionism: Works on Paper, 1938– 1948,* comp. Paul Schimmel. Newport

Harbor Art Museum: Newport Beach, Calif., 1986.

Schapiro, Meyer. "The Nature of Abstract Art." 1937. Repr. in *Modern Art: Nineteenth and Twentieth Centuries: Selected Papers.* New York: Braziller, 1978.

———. "The Liberating Quality of Avant-Garde Art." 1957. Repr. as "Recent Abstract Painting" in *Modern Art: Nineteenth and Twentieth Centuries: Selected Papers.* New York: Braziller, 1978.

———. "On Some Problems in the Semiotics of Visual Art: Field and Vehicle in Image-Signs." *Semiotica* 1 (1969): 223–42.

Schjeldahl, Peter. "Rothko and Belief." *Art in America,* March–April 1979, 79–85.

"Sculpture Kick-Off Title: The Spontaneous and Design, Part 1." Transcript of a panel discussion directed by Phillip Pavia, 17 Feb. 1965. *It Is* 6 (Autumn 1965): 7.

Seiberling, Dorothy. "Part 1: Baffling U.S. Art: What is it About?" *Life,* 9 Nov. 1959, 68–80.

———. "Part 2: The Varied Art of Four Pioneers." *Life,* 16 Nov. 1959, 74–86. Including "Mark Rothko: Luminous Lines to Evoke Emotions and Mystery," 82–83.

Seitz, William C. Notes from interviews with Rothko conducted 22 Jan. 1952, 25 Mar. 1953, and 1 April 1953. In Archives of American Art, Smithsonian Institution, Washington, D.C. (Seitz Papers, box 15).

———. *Abstract-Expressionist Painting in America.* Cambridge: Harvard Univ. Press, 1983.

Seldes, Lee. "The Passion of Mark Rothko." *Esquire,* November 1974, 118.

———. *Legacy of Mark Rothko.* New York: Holt, Rinehart and Winston, 1978.

Seligmann, Kurt. *The Mirror of Magic.* New York: Pantheon, 1948.

Selz, Peter. *Mark Rothko.* New York: Museum of Modern Art, 1961.

Shapiro, David and Cecile. "Abstract Expressionism: The Politics of Apolitical Painting." *Prospects* 3 (1977): 175–214.

Shklovsky, Victor. "Art as Technique." 1917. Repr. in *Russian Formalist Criticism: Four Essays,* trans. and ed. Lee T. Lemon and Marion J. Reis. Lincoln: Univ. of Nebraska Press, 1965.

Simon, Sidney. "Concerning the Beginnings of the New York School, 1939–1943: An Interview with Peter Busa and Matta Conducted in December 1966," *Art International,* Summer 1967, 17–19.

————. "Concerning the Beginnings of the New York School, 1939–1943: An Interview with Robert Motherwell Conducted in January 1967." *Art International,* Summer 1967, 20–23.

Simonson, Lee. "The Painter and His Subject, Part 1." *Creative Art,* July 1928, xxii–xxvi.

Skura, Meredith Anne. *Literary Use of the Psychoanalytic Process.* New Haven: Yale Univ. Press, 1981.

Solman, Joseph. "Easel Division of the W.P.A. Federal Art Project." In *New Deal Art Projects: An Anthology of Memoirs,* ed. Francis V. O'Connor. Washington, D.C.: Smithsonian Institution, 1972.

Sperber, Daniel. *Rethinking Symbolism.* Trans. Alice L. Morton. Cambridge: Cambridge Univ. Press, 1975.

Spivak, Gayatri Chakravorty. Translator's Introduction to *Of Grammatology,* by Jacques Derrida. Baltimore: Johns Hopkins Univ. Press, 1976.

Sweeney, James Johnson. *Joan Miró.* New York: Museum of Modern Art, 1941.

Sylvester, David. "Rothko." *New Statesman,* 20 Oct. 1961, 573–74.

————. "Interview with Adolph Gottlieb." *Living Arts,* June 1963, 2–10.

————. "Content is a Glimpse . . ." Interview with Willem de Kooning. *Location* 1 (Spring 1963): 45–53.

Taylor, Joshua C. *America as Art.* New York: Harper and Row, Icon, 1976.

Tillyard, E. M. W. *Elizabethan World Picture.* London: Chatto and Windus, 1948.

Townsend, Benjamin J. "An Interview with Clyfford Still." *Gallery Notes* [of the Albright-Knox Gallery, Buffalo, N.Y.] 24 (Summer 1961): 8–16.

Vickery, John B. *Literary Impact of the Golden Bough.* Princeton, N.J.: Princeton Univ. Press, 1973.

Viola, Wilhelm. *Child Art and Franz Cizek.* Vienna, 1936.

————. *Child Art.* 2d ed. Kent: Univ. of London Press, 1944.

von Wiegand, Charmion. "Expressionism and Social Change." *Art Front,* November 1936, 10.

Waldman, Diane. *Mark Rothko, 1903–1970: A Retrospective.* New York: Solomon R. Guggenheim Museum, 1978.

Weber, Max. *Essays on Art.* New York, 1916.

Weiss, Peg. *Kandinsky in Munich: The Formative Jugendstil Years.* Princeton, N.J.: Princeton Univ. Press, 1979.

"Whitney Dissenters." *Art Digest,* 15 Nov. 1938, 9.

"Whitney Symposium." *Art Digest,* 1 May 1933, 6.

"The Wild Ones." *Time,* 20 Feb. 1956, 70–75.

Wolf, Tom. Interview with Sally Avery. 19 Feb. 1982. Archives of American Art.

F. M. W. [Francesca M. Wilson.] *The Child as Artist: Some Conversations with Professor Cizek.* Pamphlet. London: Children's Art Exhibition Fund, 1921.

Wollen, Peter. *Semiotic Counter-Strategies: Readings and Writings.* London: Verso Editions, 1982.

Wollheim, Richard. "The Work of Art as Object." *Studio International,* December 1970, 231–35.

————. *Art and Its Objects: An Introduction to Aesthetics.* New York: Harper and Row, Torchbooks, 1971.

Yard, Sally. *Willem de Kooning: The First Twenty-Six Years in New York.* New York: Garland, 1986.

# ndex